ALICE TEMPERLEY

# ENGLISH MYTHS & LEGENDS

ALICE TEMPERLEY

# ENGLISH MYTHS
# & LEGENDS

RIZZOLI
NEW YORK

New York · Paris · London · Milan

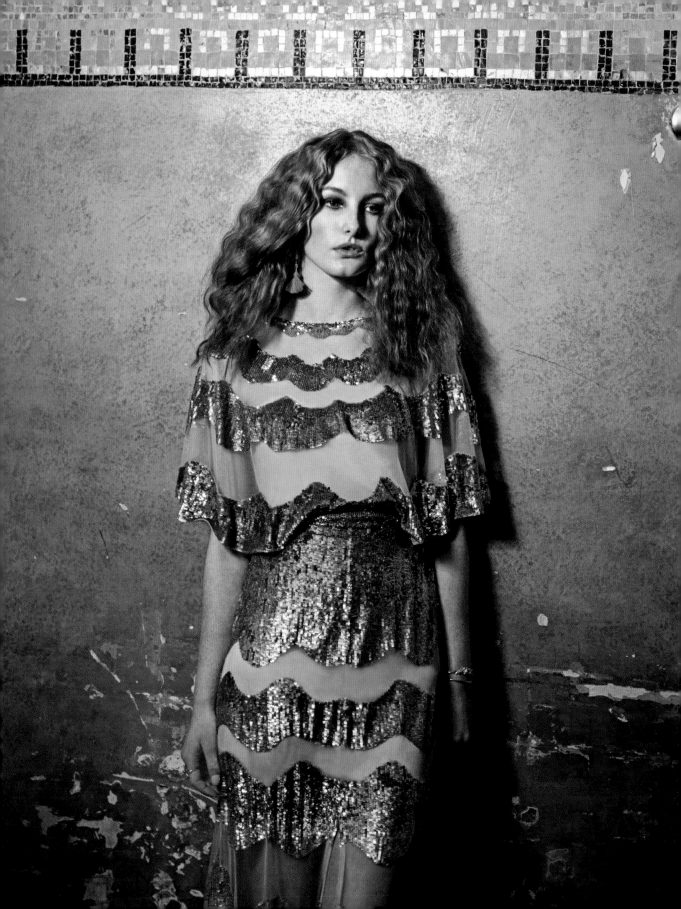

F rom the moment she first burst onto the London fashion scene in 2000 in a cloud of chiffon, sequins, and lace, Alice Temperley has always known exactly who her woman is. Her eponymous brand, Temperley London, quickly amassed a band of glamorous and loyal devotees—from London to Hollywood—as this veritable pied piper of British fashion artfully seduced women the world over with her romantic, bohemian, and exquisitely crafted aesthetic.

One of my most vivid memories of Alice—whose talents as a designer and whose aesthetic are more than matched by her ability to create a perfect mise-en-scène for either her catwalk shows or now-legendary parties—comes from one of her midsummer revelries at her parents' cider farm in Somerset: a glittering will-o'-the-wisp, flitting between groups of fancifully dressed young women and men. Colourfully decorated tepees lined the field, a massive bonfire flared up into the night sky, apple cocktails and cider from her father's farm flowed . . . It was an idyllic English wonderland perfectly conjured up by the mistress of ceremonies.

Alice's designs have always had the power to summon up a mythical and often exotic world—an embroidered and bejewelled blouse that could take you to cocktails in Capri or a sundowner on Lamu, a diaphanous rainbow-coloured

floor-skimming dress that would deliver the perfect mix of romance and glamour for a chic rooftop dinner in Marrakech or a black tie party in Cap Ferrat. And even if life doesn't take you to any of these places, then one of Alice's creations will make you feel as if that's where you might just have come from or be heading sometime soon—surely the ultimate escapism. Temperley London is not just a brand, you see, but rather an aesthetic, a way of living.

ust before writing this, I mentioned to Alice that I was going to Kenya to stay with some mutual friends. Would I take their five-year-old daughter, who happened to be Alice's goddaughter, a gift, she asked? The next day, a small wicker hamper fastened with pale pink velvet ribbons arrived at my office. I will never forget the face of the lucky recipient and her sisters as they rummaged through and delighted in the contents. As the scraps of brightly coloured silk, jars of sequins and beads, and strips of delicate lace and ribbon—an alchemist's dream—were pored over amid much oohing and ahhing, it reminded me of the feelings we grown-up girls get every time we chance upon a rail of Alice's dresses. Joy, admiration, and the knowledge that whatever piece we put on we will soon be transported into her beautiful and intoxicating world.

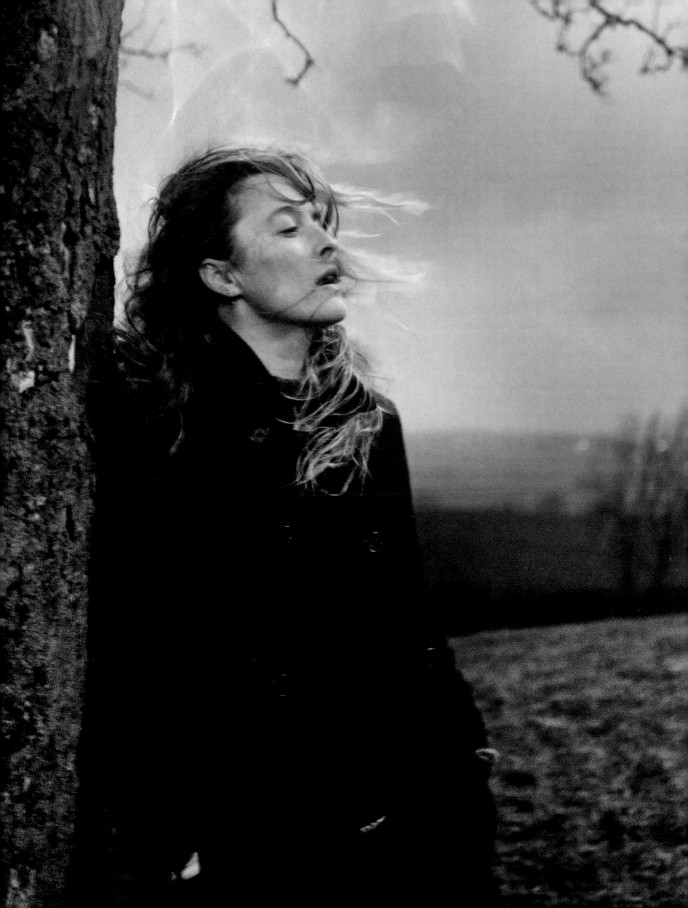

*nglish Myths and Legends* follows our first book, *True British*, a record of our first ten years of Temperley London and the myriad of fun stories, energy, and passion that went into building the business. *English Myths and Legends* has been created to define Temperley as it is today and to show what goes into making the life and soul of our brand.

The first chapter, **The Holy Grail**, shows what I consider the core elements of the brand resulting in our very English aesthetic.

**The Shire** is about the birthplace of the brand, Somerset, and the place that breathes life and magic, passion and freedom into my soul. My siblings and I were lucky to have grown up on the base of Burrow Hill on my parents' cider farm, a spiritual place for all of us and a crucial one in the birth of Temperley.

**Myths** is full of romance and dedicated to our bridal collections' white, beautiful, ethereal gowns that I like to believe will be passed down as heirlooms for generations to come.

**Alchemy** is where we create our gold, our currency. From greige fabrics and thread we weave and print our story each season. This chapter showcases the intricate work my incredibly talented team, our mills, and talented manufacturers do. It is an insight as well as a celebration of the detail and craftsmanship that go into building our collections.

**The Escape** is the final chapter. I believe fashion should be about escapism and fairy tales and the ability to dream, to be exported into another world. The pleasure of the business is the ability to be able to create a colourful fantasy world and here we create our Wonderland.

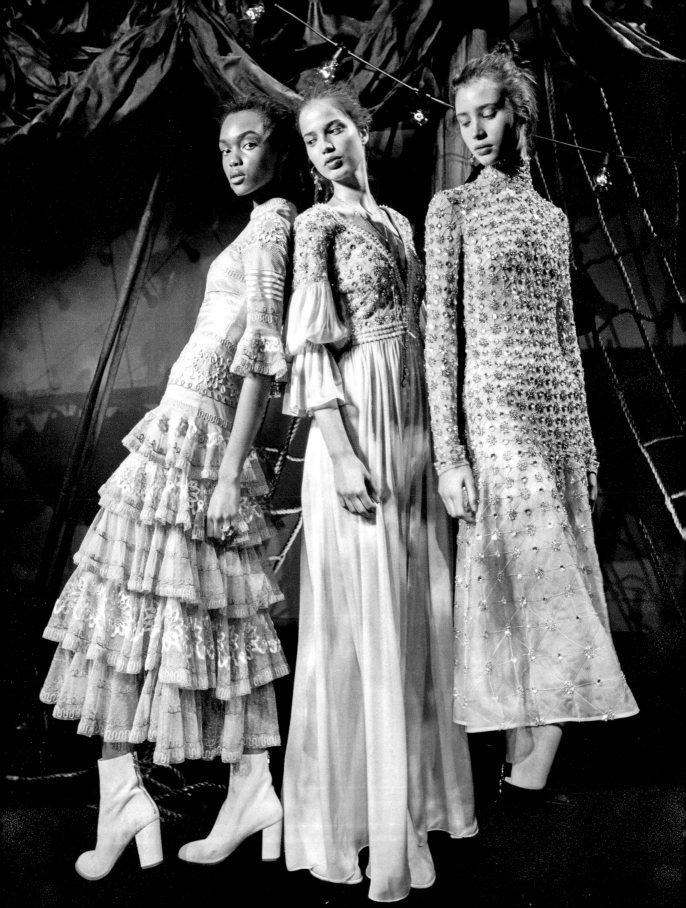

# THE
# HOLY GRAIL

Mermaids, sequins, pirates,
silk, and the tiger tide

A blank page, canvas, or music manuscript is tyranny to the uninspired. Yet for some, that plain piece of paper holds unwritten poetry; the ground of that primed linen canvas is the foundation for unbuilt worlds; that five-line stave holds notes unsung, hearts unquickened.

Bare skin, too, is a story untold.

Herman Melville wrote, "When beholding the tranquil beauty and brilliancy of the ocean's skin, one forgets the tiger heart that pants beneath it."[1] Perhaps it is no coincidence, then, that those who sailed its shining surface took most ardently to tattooing their bodies with inked mementoes of the beast beneath.

Back then, a mariner earned a knotted rope tattoo as a deckhand, an anchor for traversing the Atlantic, and Neptune upon crossing the equator. With each destination and safe return, his skin was pierced either to track his resilience or to protect him from mishap like autographed armour.

*Lost at sea.*

Temperley tattoos are driven with needles through fabric rather than through flesh. Stitched into mesh cut close to the skin, the designs follow the lines of a body: the curve of a Japanese koi swims upstream from the hip, a tiger stalks from shoulder to navel, and a swallow swoops low across a beating heart. Dresses from the Autumn/Winter 2016 collection embroider a form—from wrist to collarbone to ankle—in seafaring symbols. Also treading the catwalk, rather than the plank, at Lindley Hall that February were

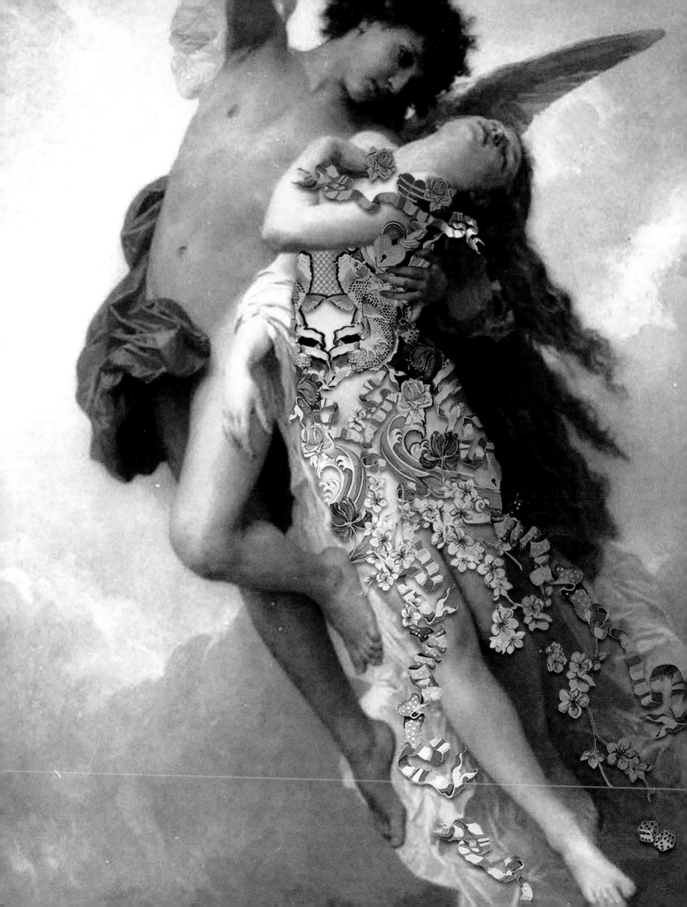

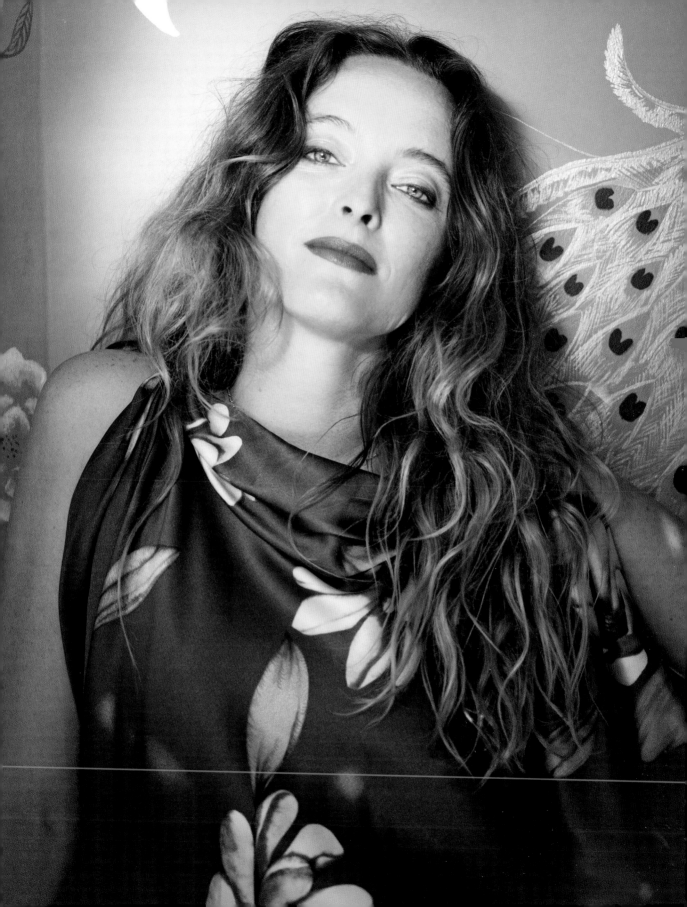

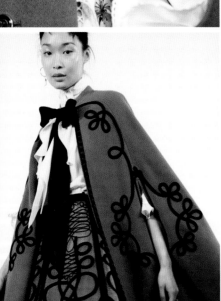
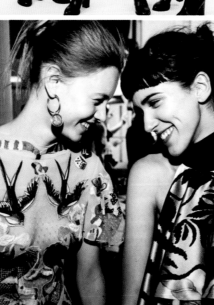

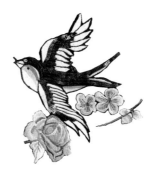

cashmere capes and tailored coats laden with golden-thread frogging on lapels and cuffs. Do the sleeves of these military jackets conceal souvenirs from maritime exploration, or pledges to lovers forgotten on coasts departed? Are these throats brushed by raw-edged silk ruffles lined with naval rum? Sailors? Or worse?

These celestial navigators are pirates of a modern age, pillaging their iconography from a world where seahorses swim amongst cherry blossoms, where flowers from opposing climes bloom entwined, where the crashing tide can swamp a body entirely in black swirls. If their feet aren't clad in buckled boots, their toes are bare. They couldn't care less if their dress gets wet.

The captain of this scattered ship, Alice, has her own adventure inked on her inner-left wrist. The name of her son—Fox—serves as her nautical star in the tiger tide. Her pirate name? In the first collection of 2015, gold-and blue-sequinned skirts evoked mermaids, tails glinting in the sunshine, eyes glinting with the promise of a seaman's demise. The season before, cut mirrors gleamed like the horizon. A year later: heavy crystal latticework and fine grids of silver-thread cords. Each collection its own pillaged treasure, "Magpie" nails her flag to the mast and keeps her crew shining. Whatever she wears, wherever she goes, the Temperley pirate has an offshore wind in her sails, burial gold hung from one ear, and a cork between her teeth. For her, the sea is everything.[2]

"At such times, under an abated sun;
afloat all day upon smooth, slow heaving swells;
seated in his boat, light as a birch canoe;
and so sociably mixing with the soft waves
themselves, that like hearth-stone cats
they purr against the gunwale;
these are the times of dreamy quietude,
when beholding the tranquil beauty
and brilliancy of the ocean's skin, one forgets
the tiger heart that pants beneath it; and would
not willingly remember, that this velvet paw
but conceals a remorseless fang."

— HERMAN MELVILLE, MOBY-DICK (1851)

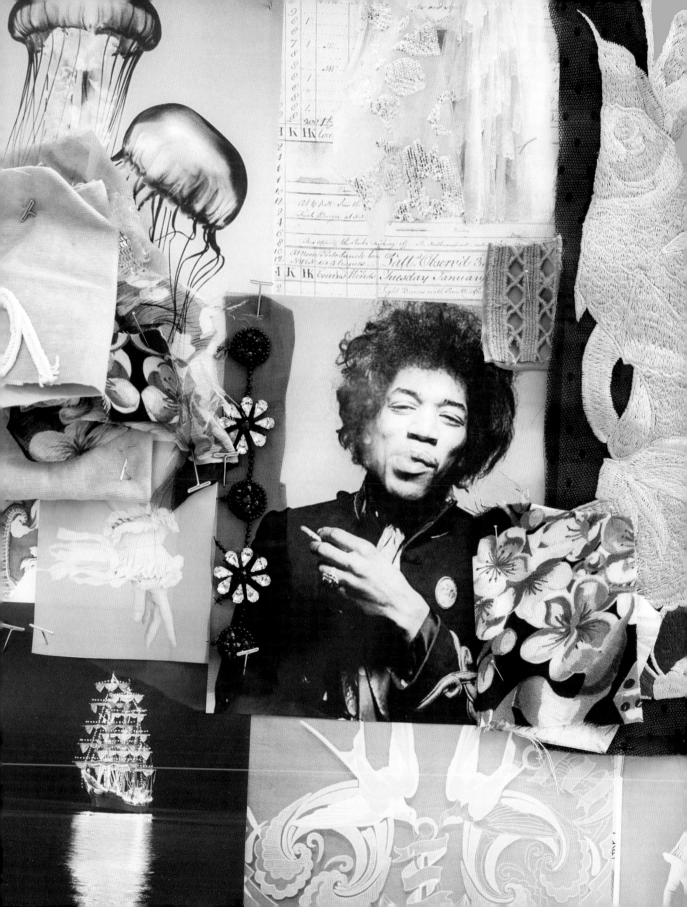

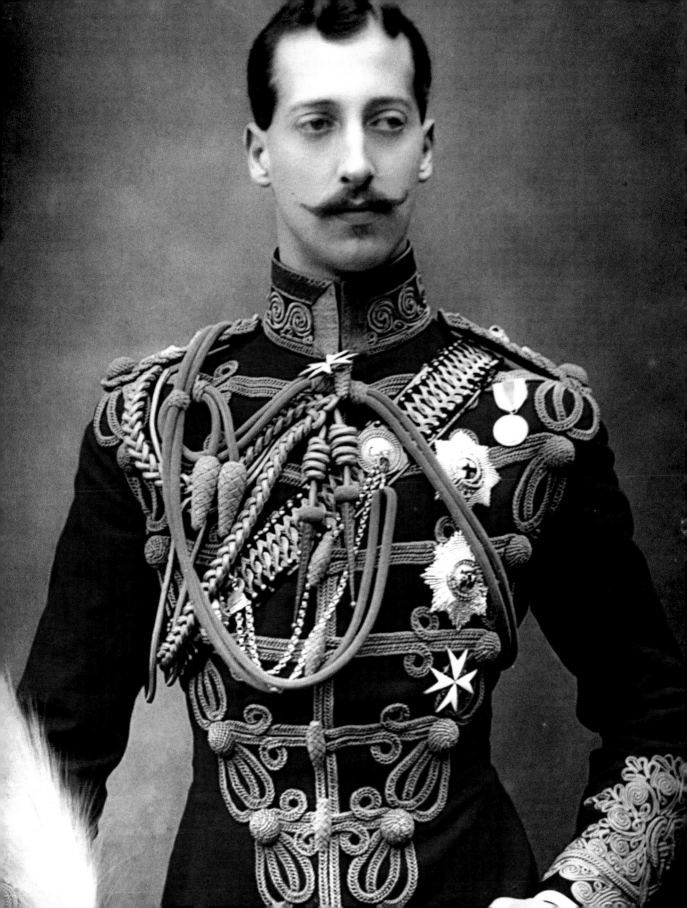

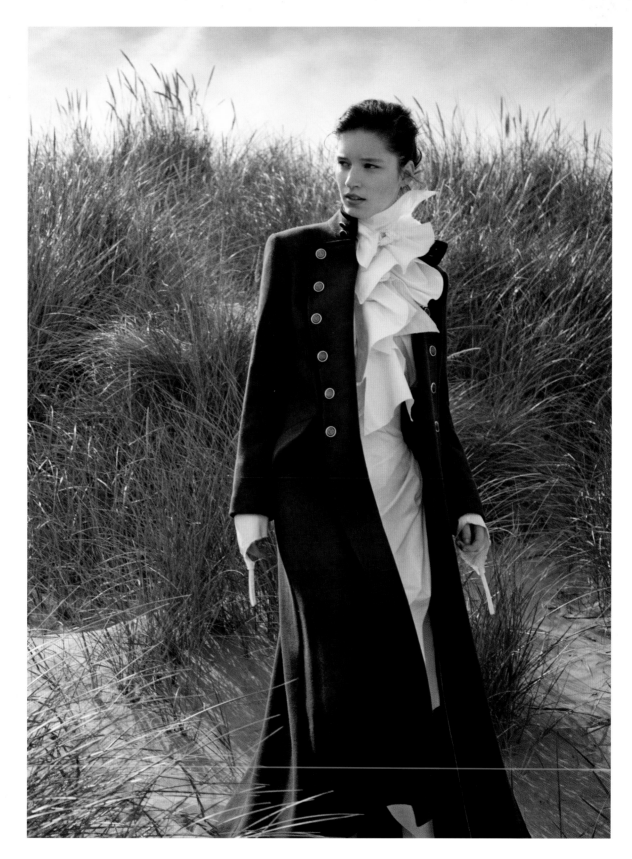

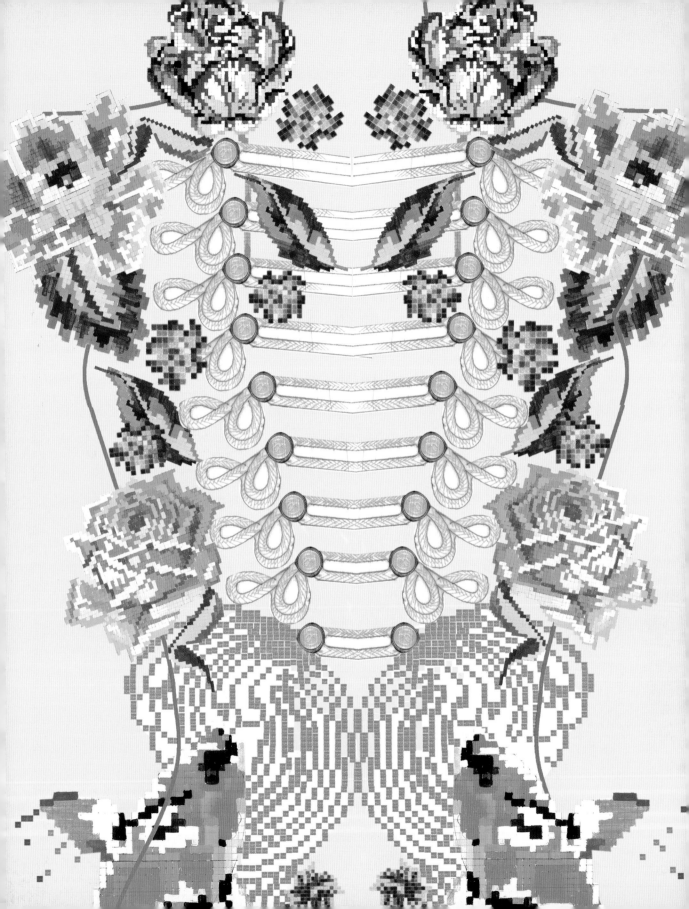

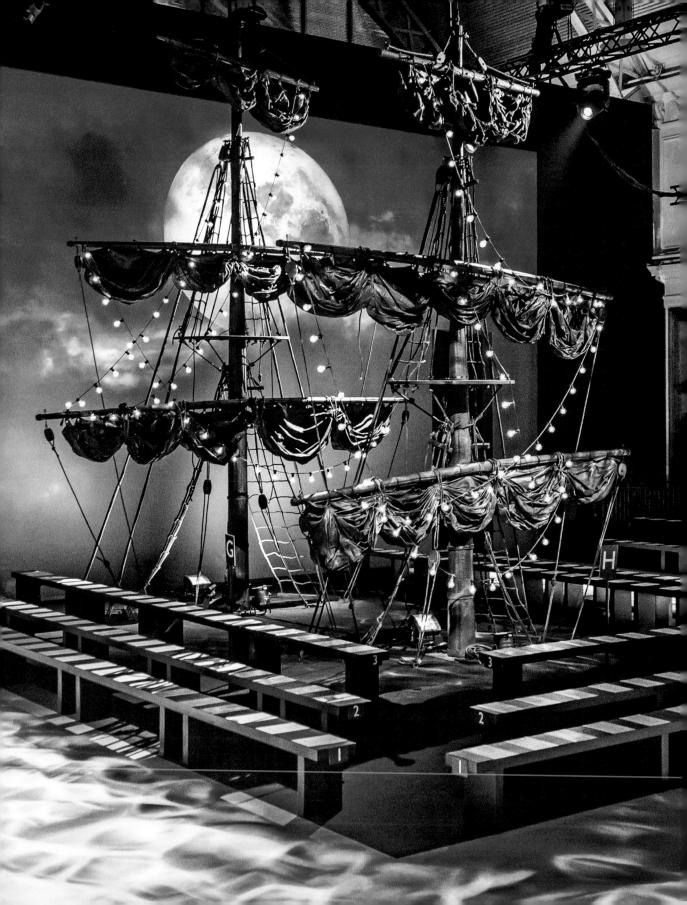

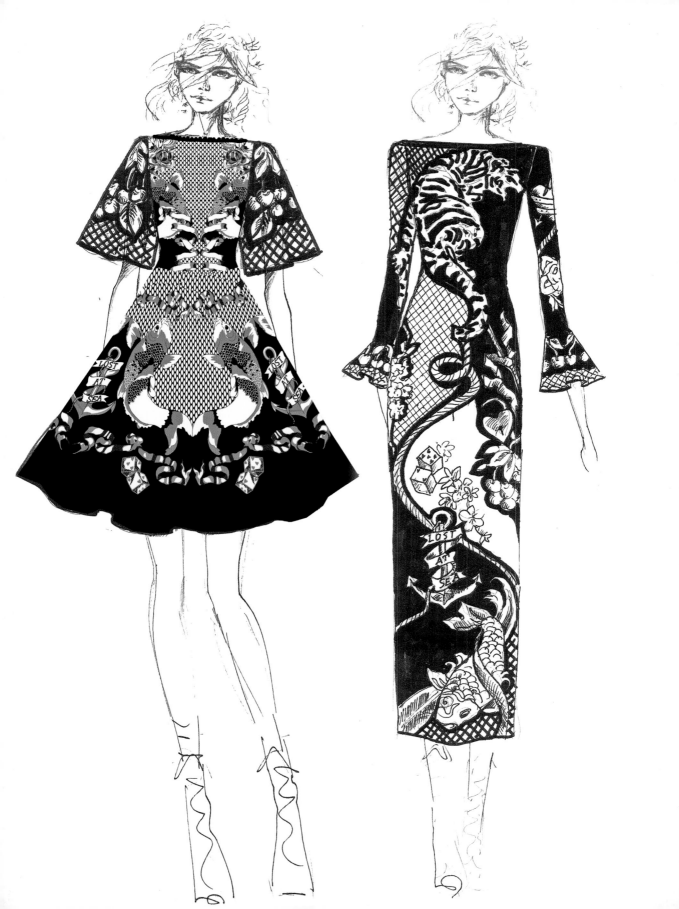

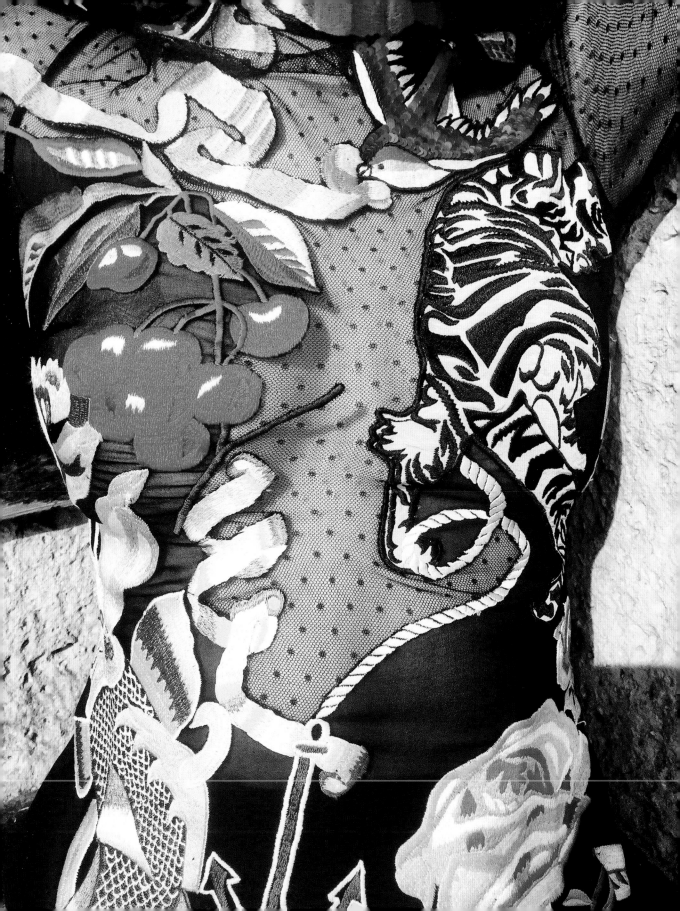

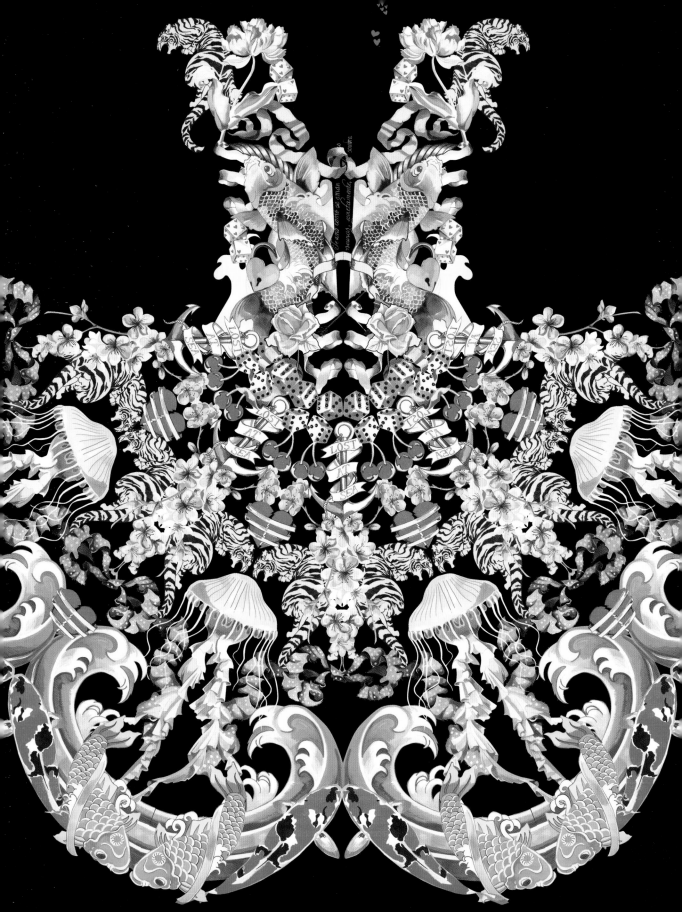

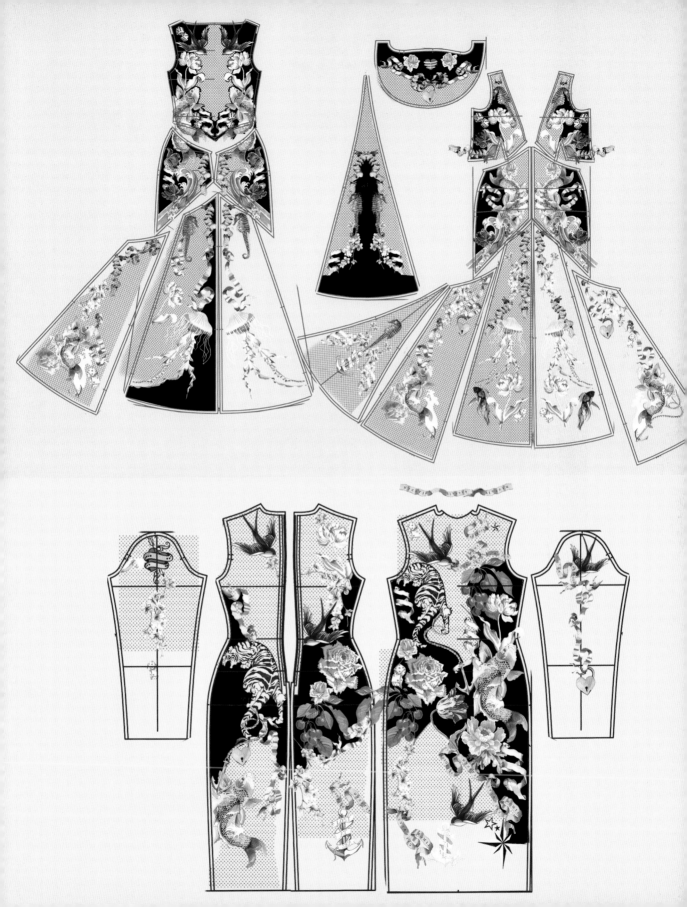

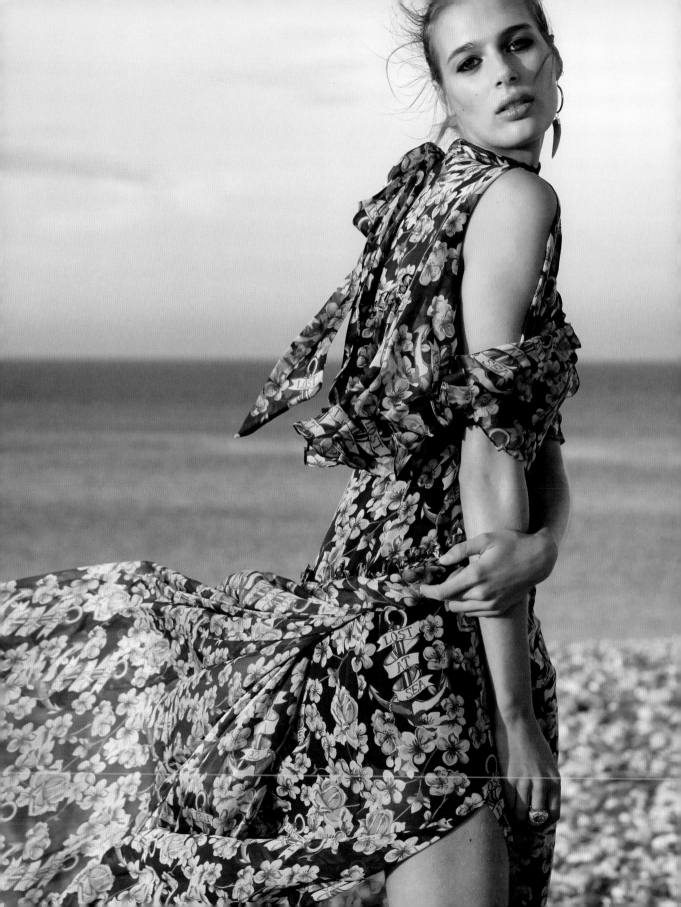

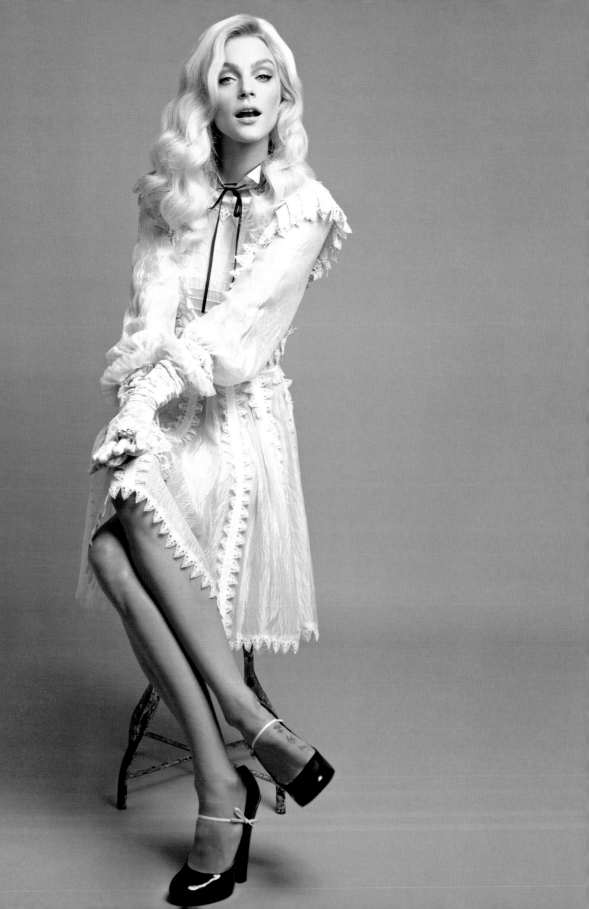

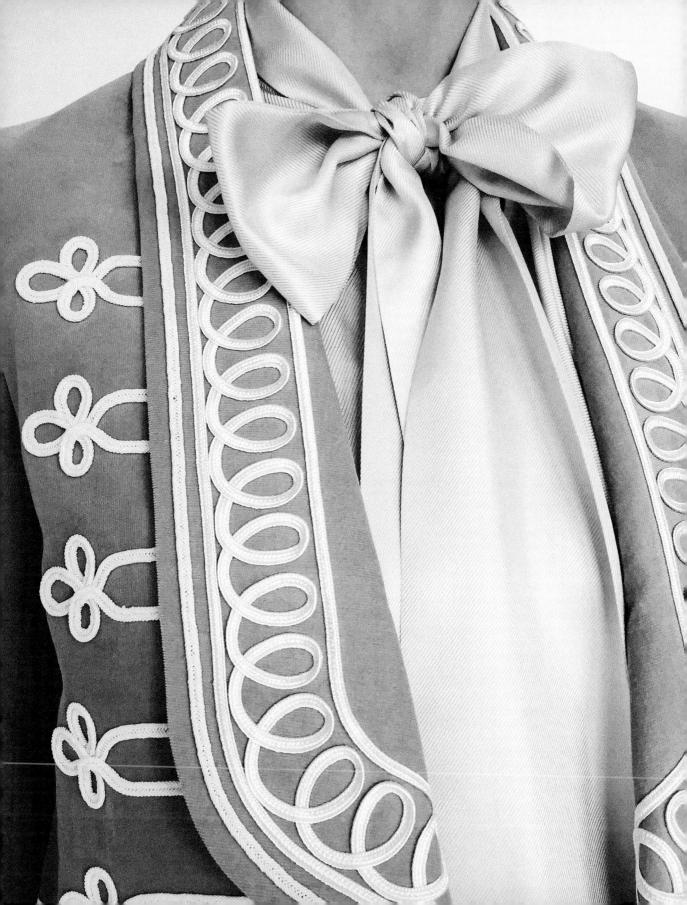

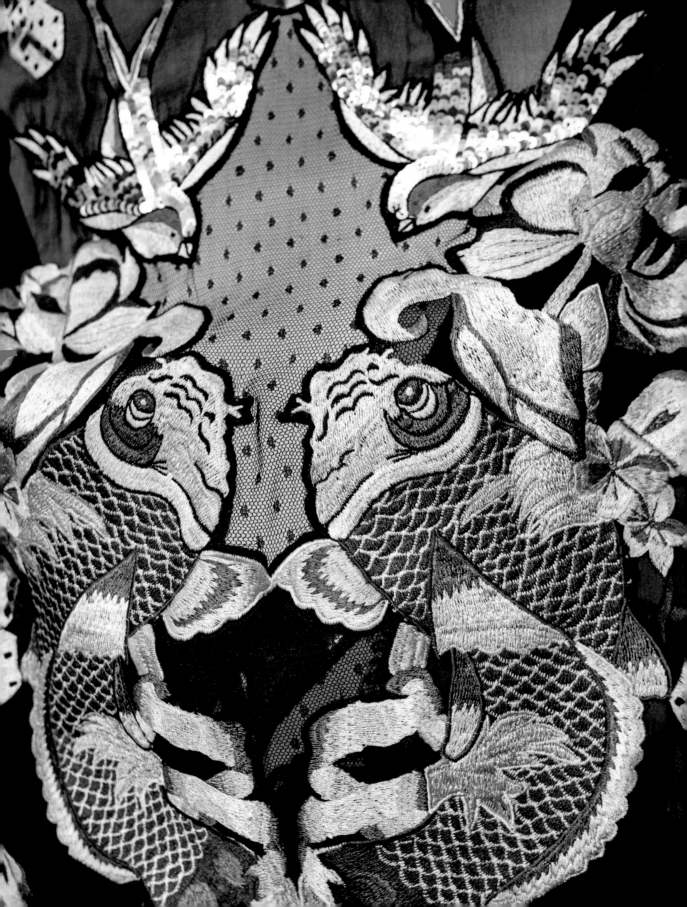

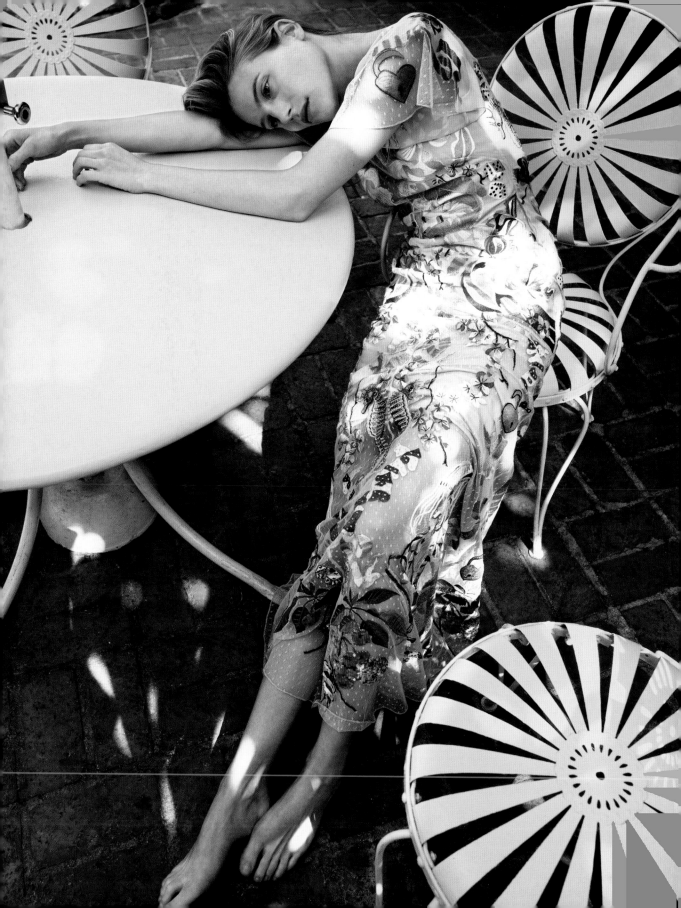

> " I made art a philosophy, and philosophy
> an art; I altered the minds of men, and the colour
> of things; I awoke the imagination of my century
> so that it created myth and legend around me:
> I summed up all things in a phrase,
> all existence in an epigram;
> whatever I touched I made beautiful. "

— OSCAR WILDE, DE PROFUNDIS (1905)

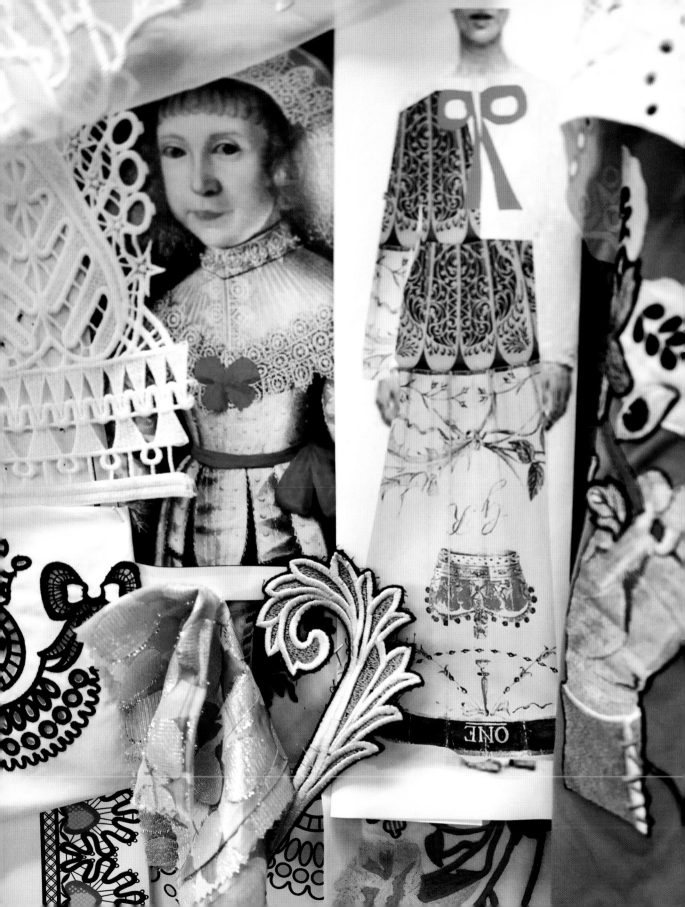

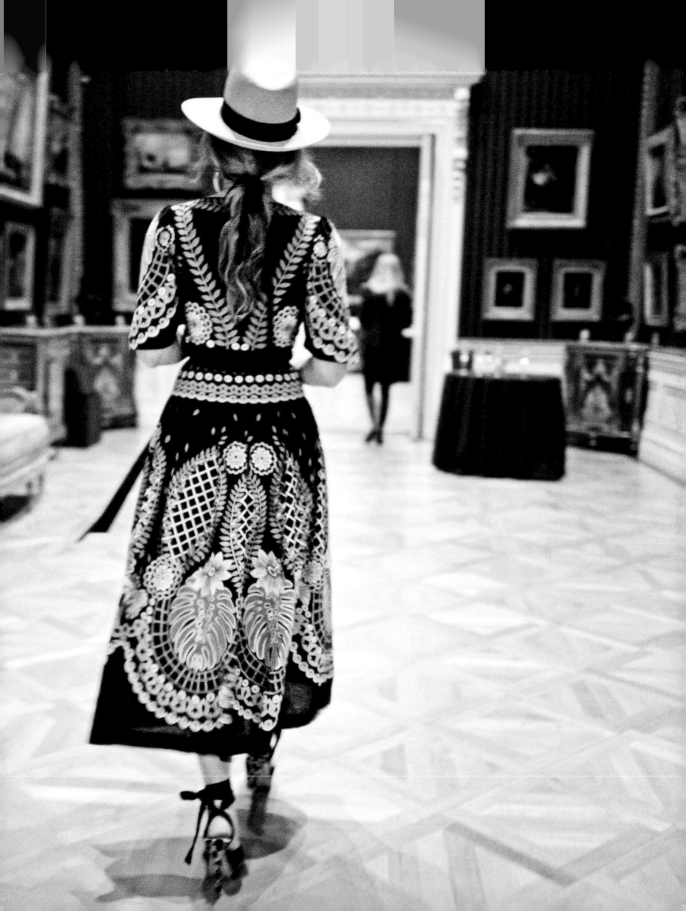

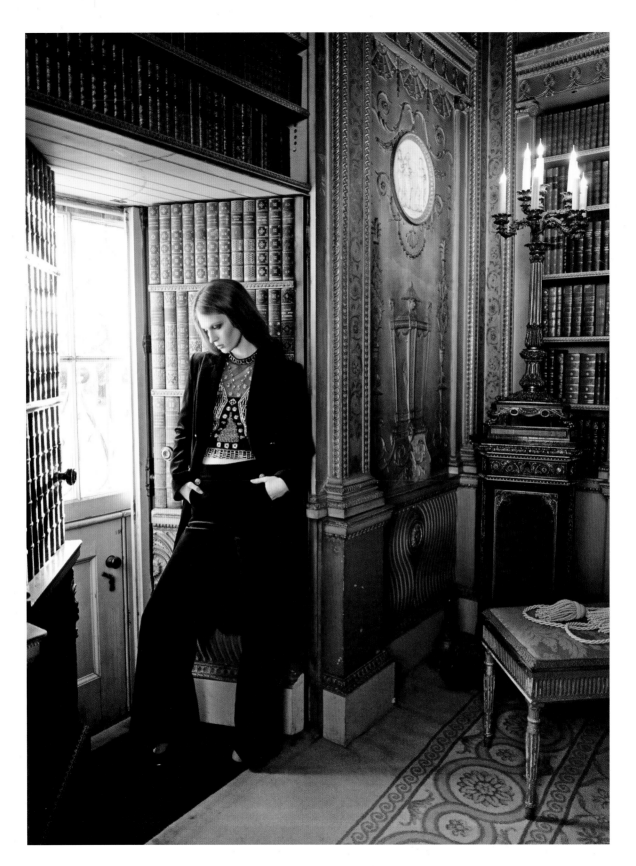

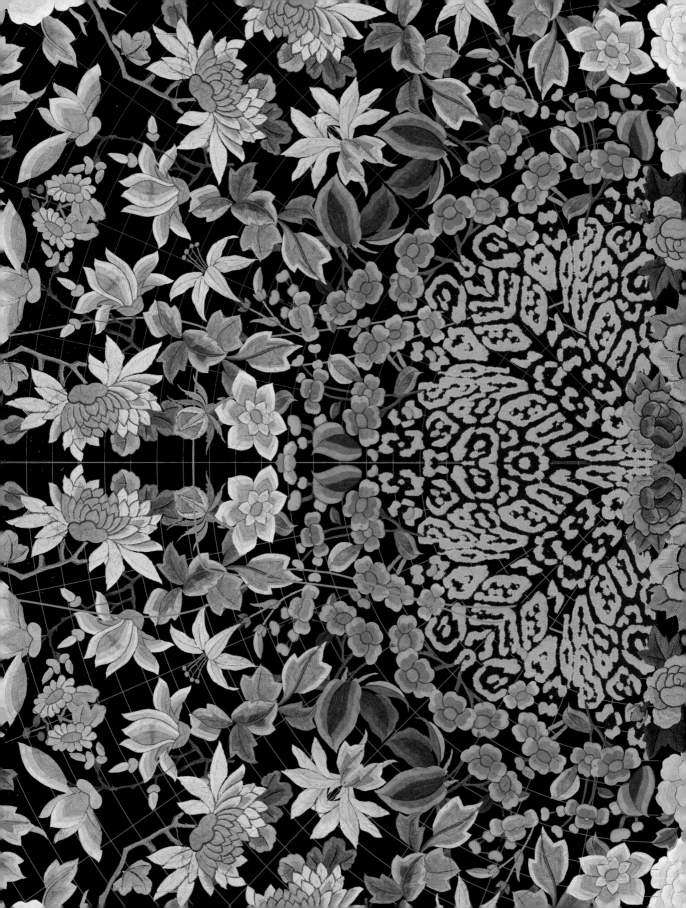

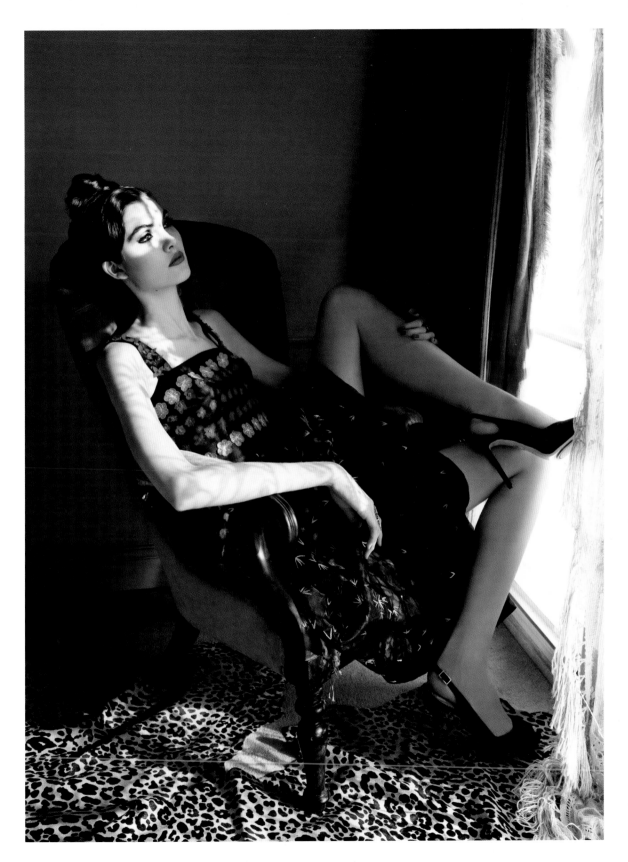

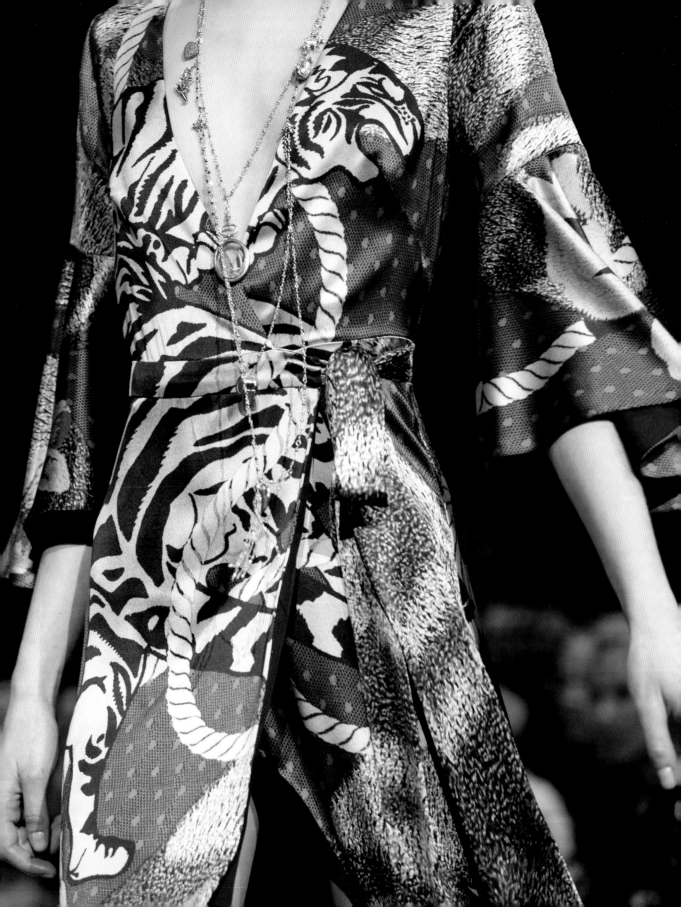

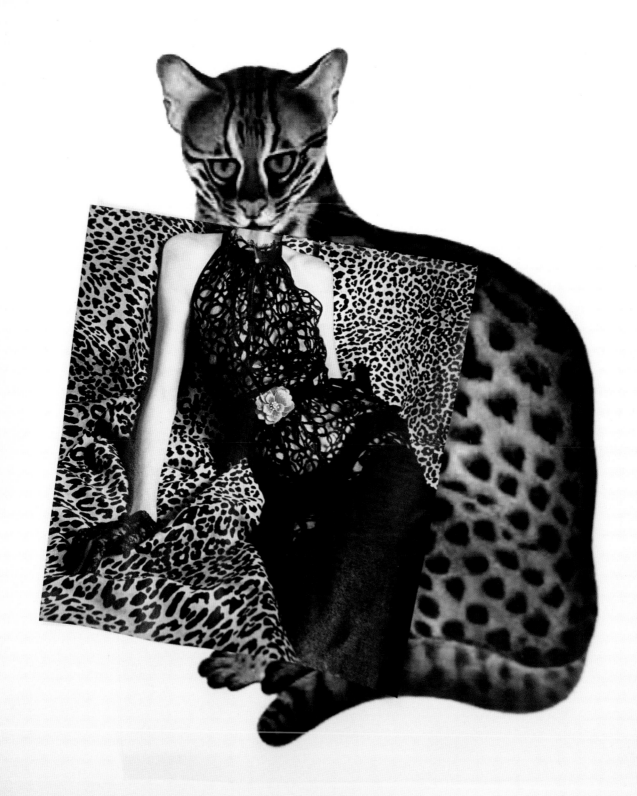

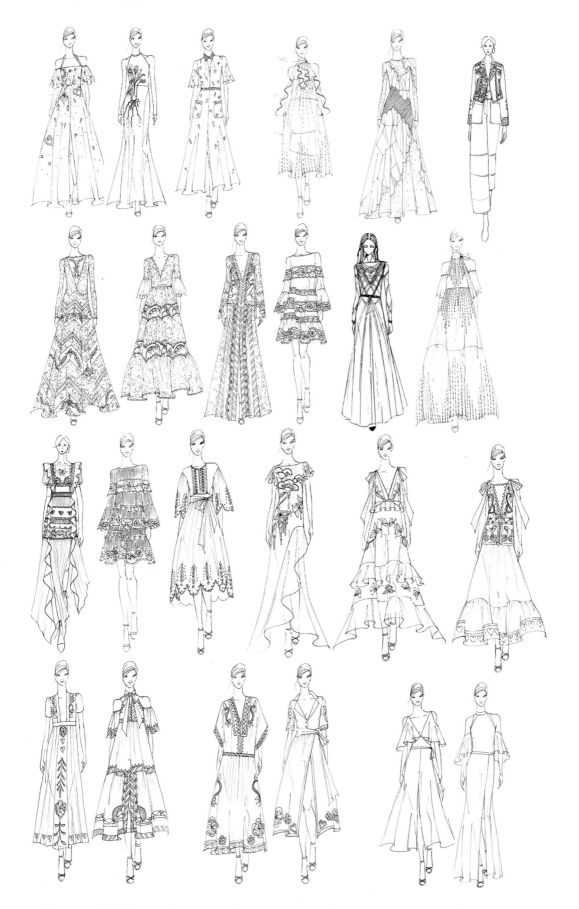

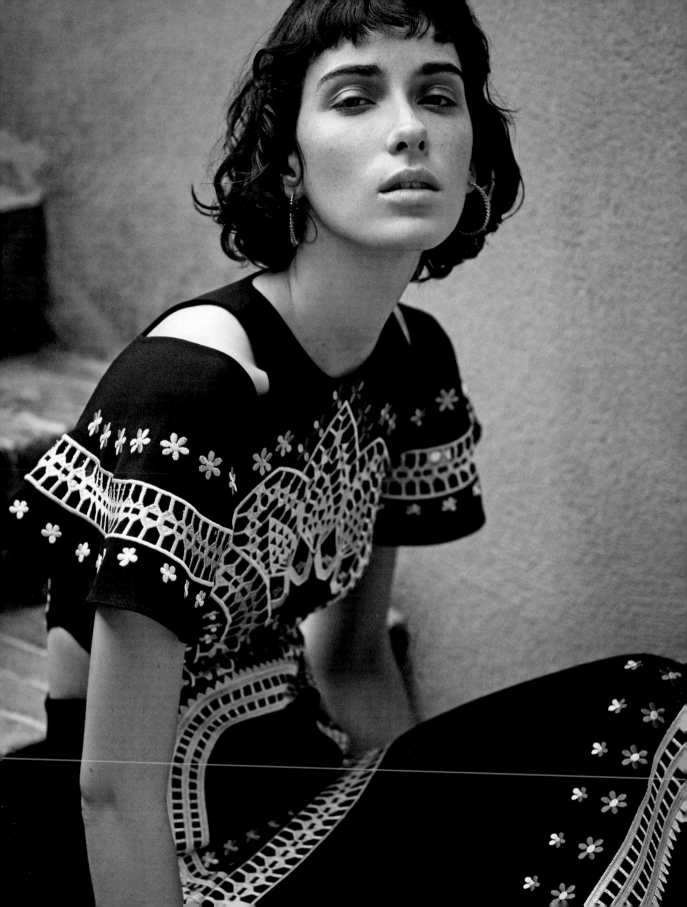

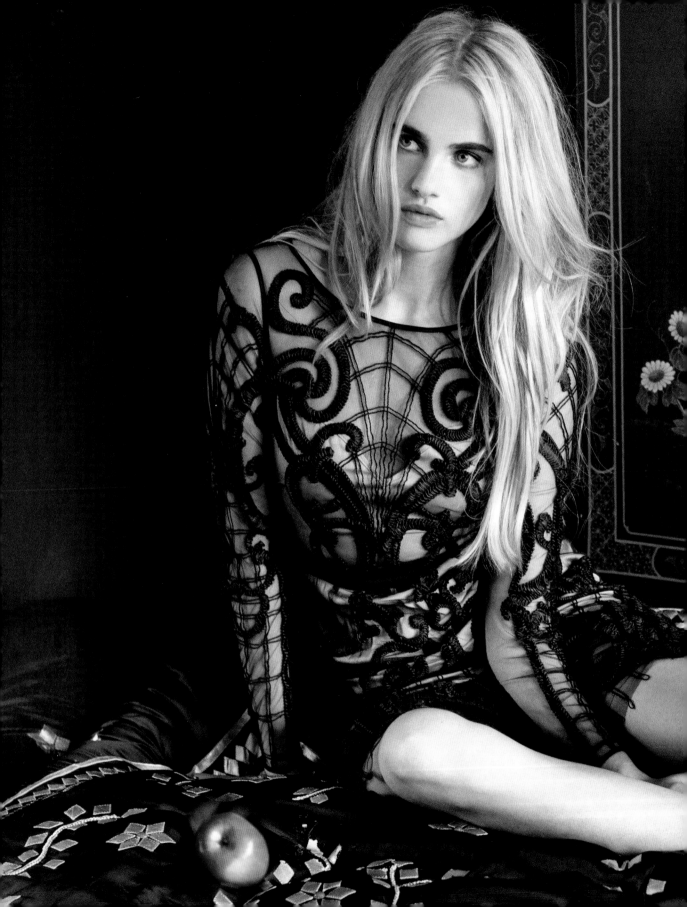

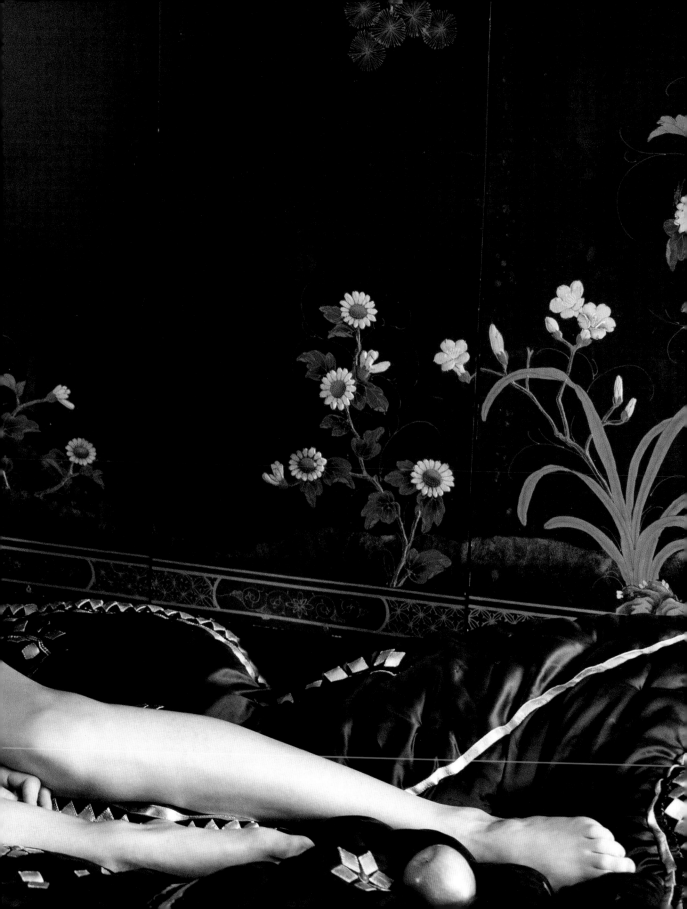

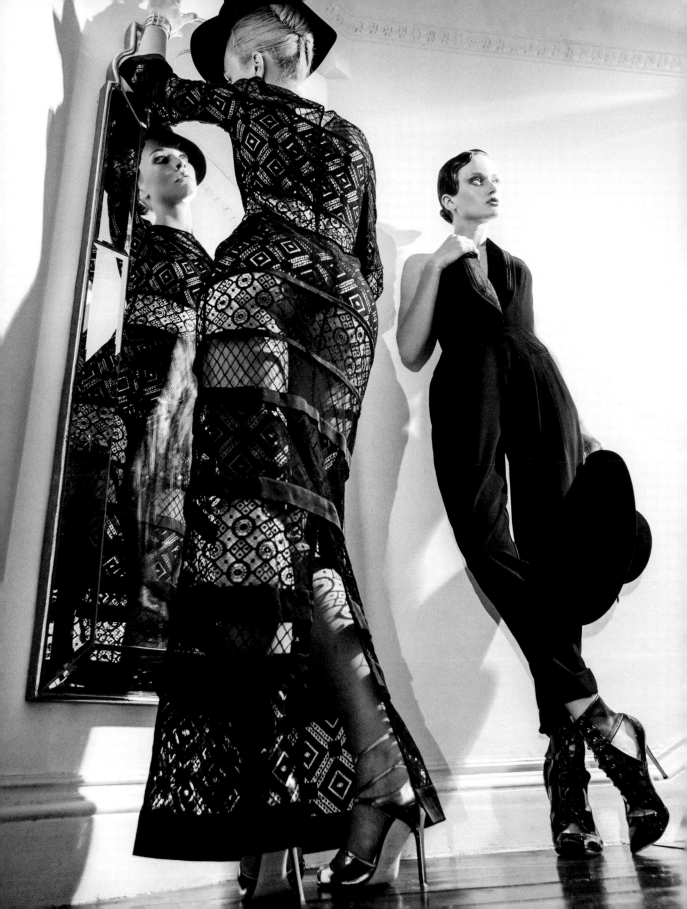

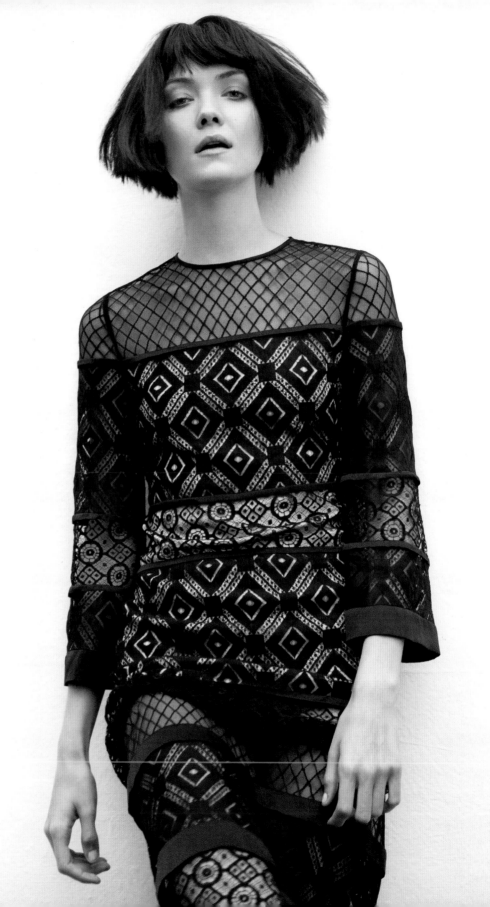

These celestial navigators are pirates of a modern age, pillaging their iconography from a world where seahorses swim amongst cherry blossoms, where flowers from opposing climes bloom entwined, where the crashing tide can swamp a body entirely in black swirls.

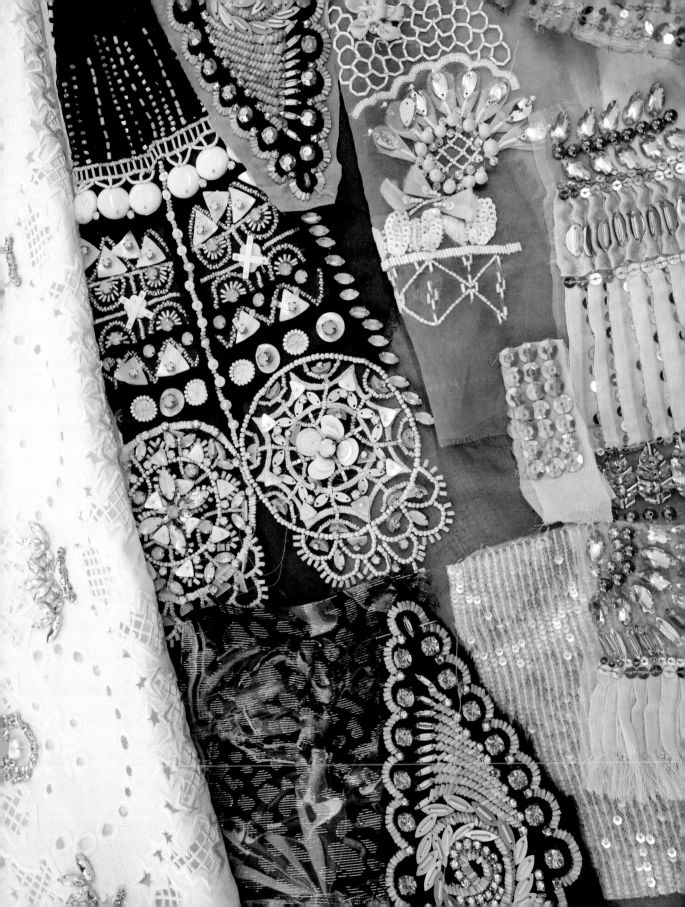

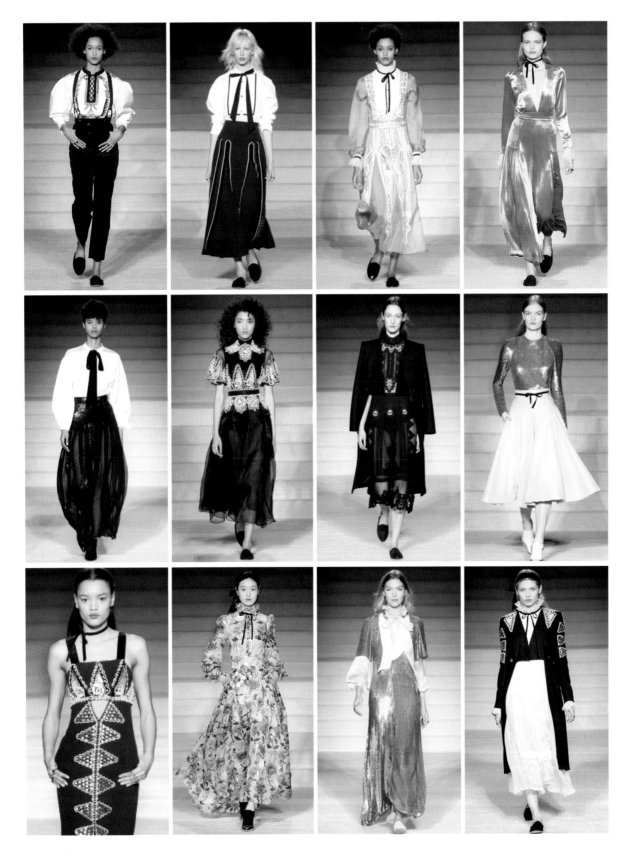

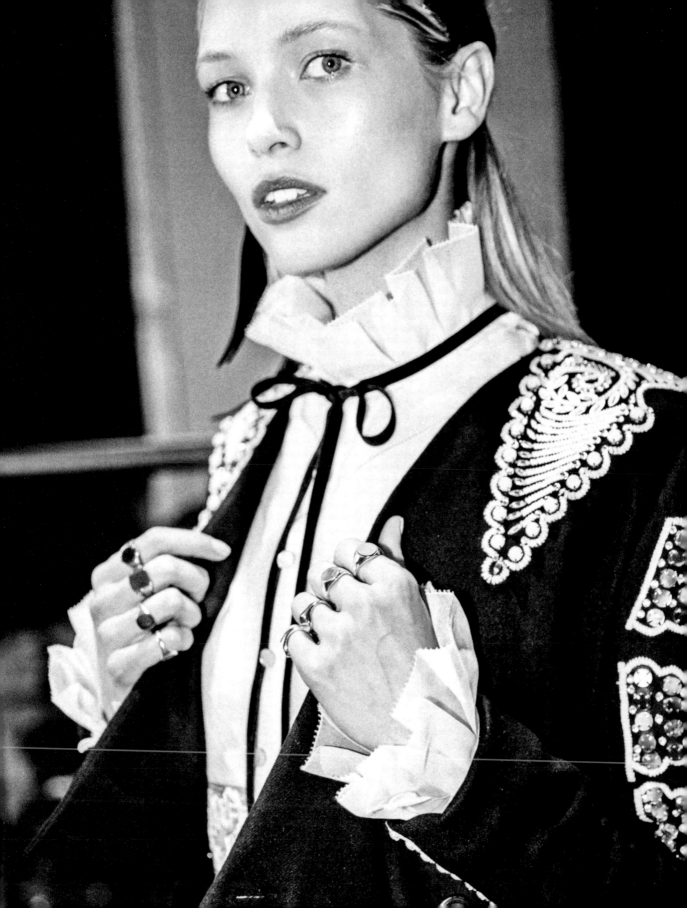

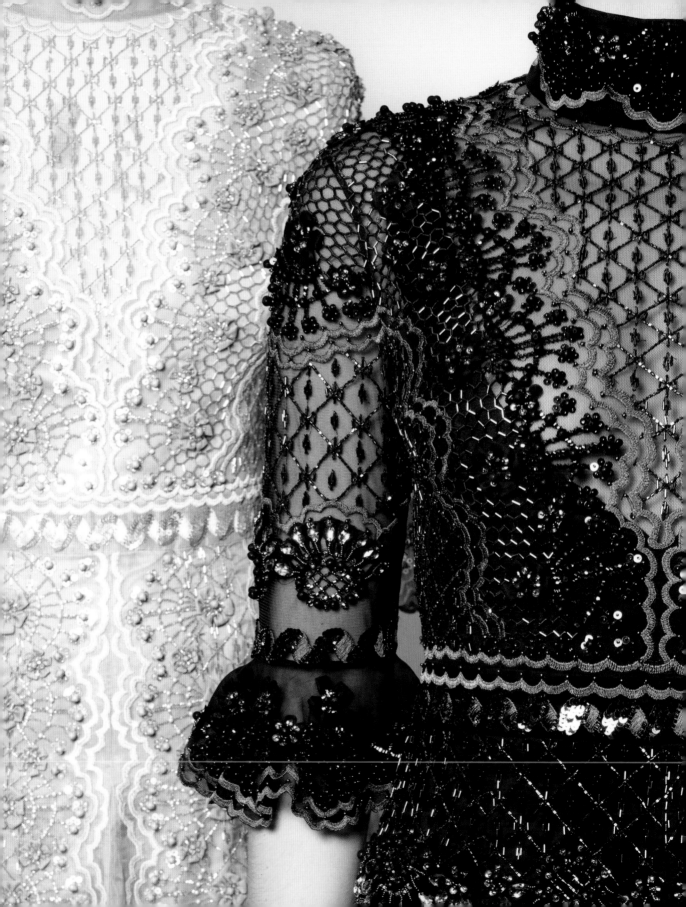

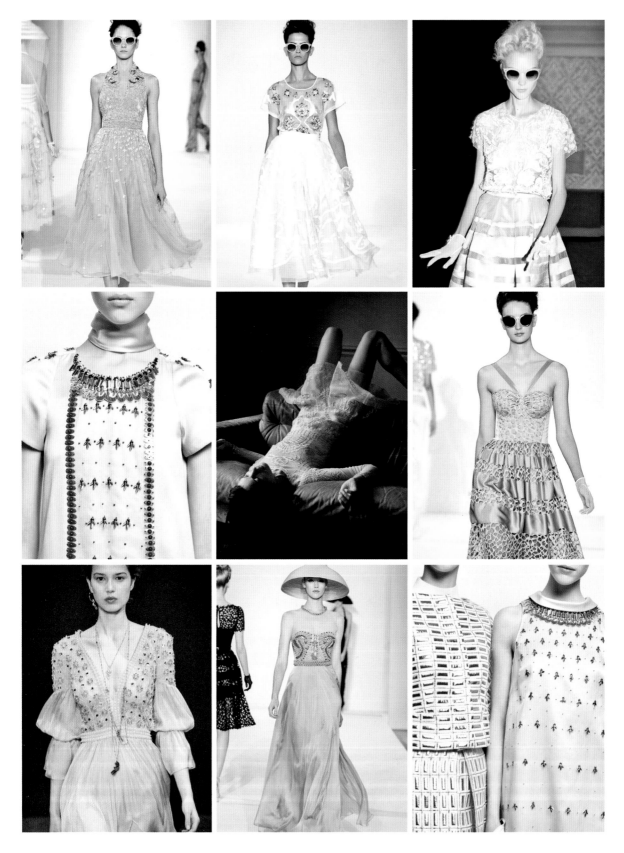

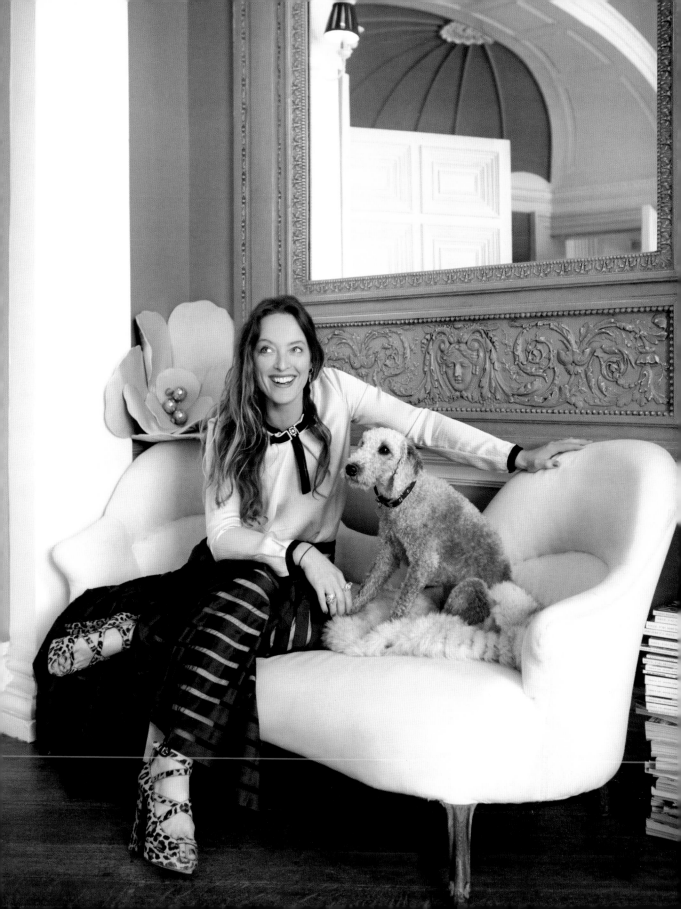

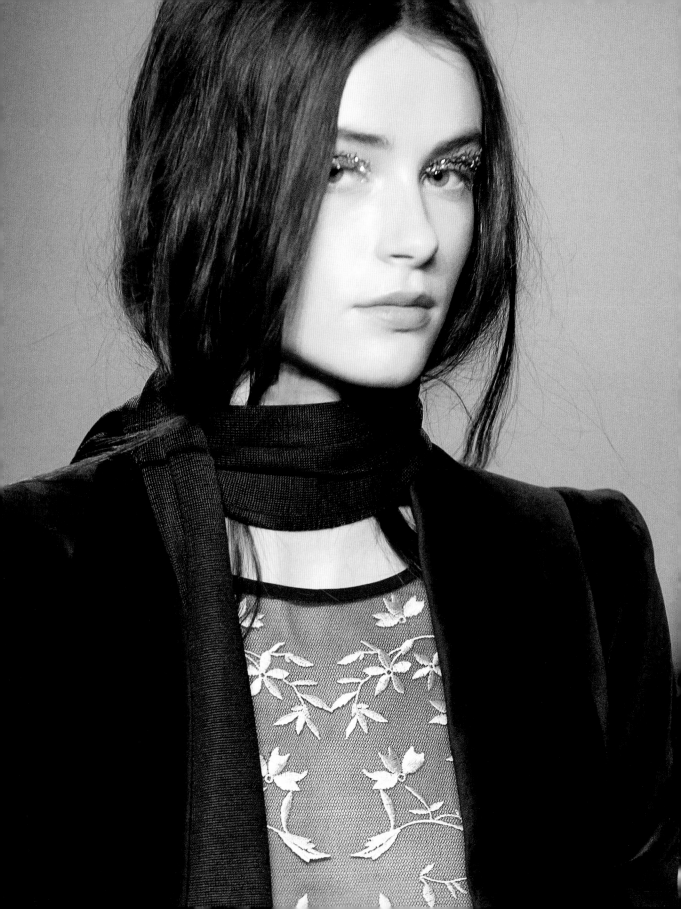

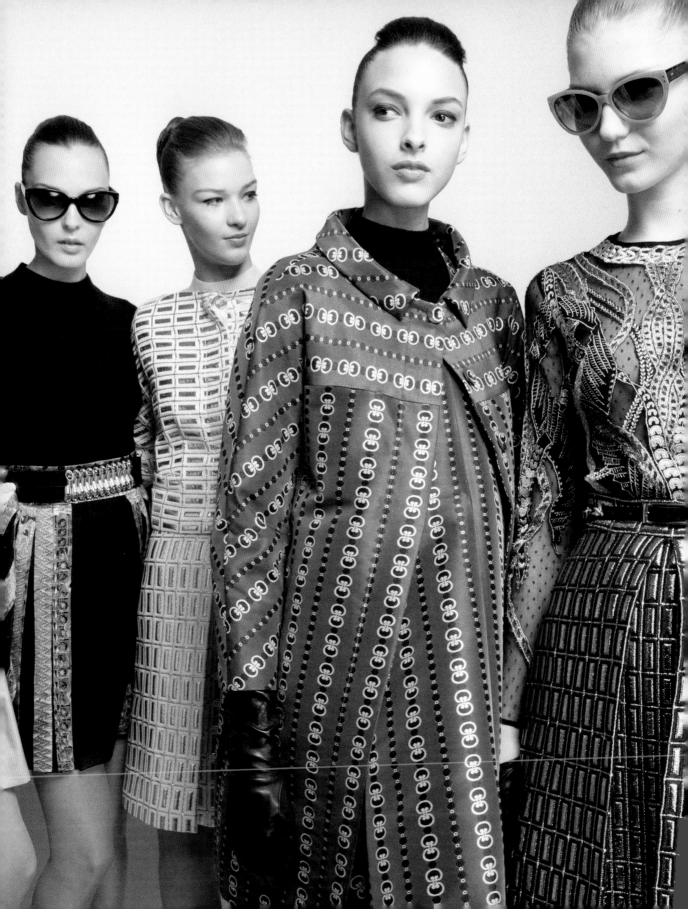

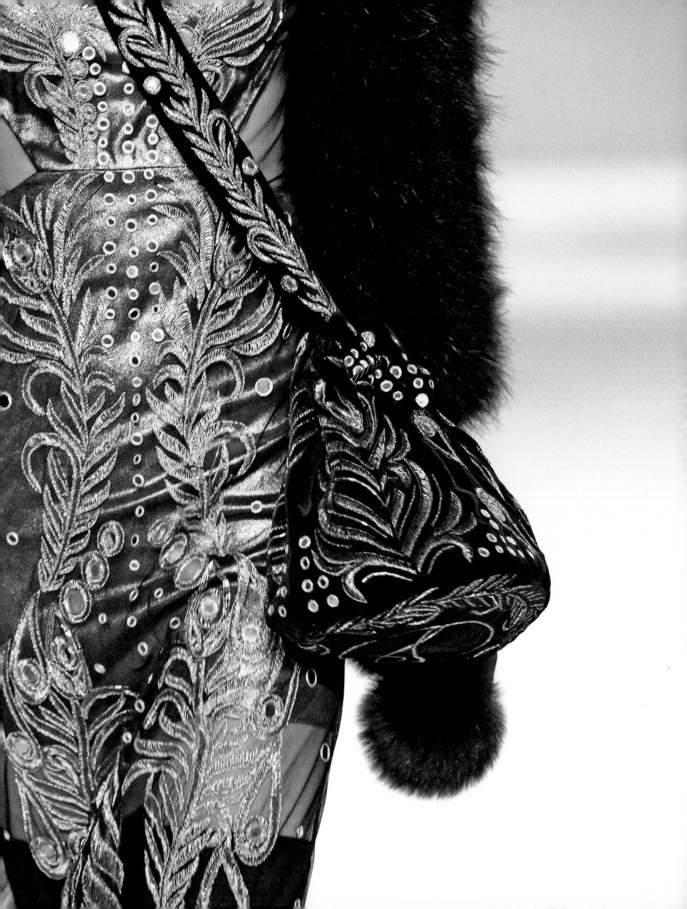

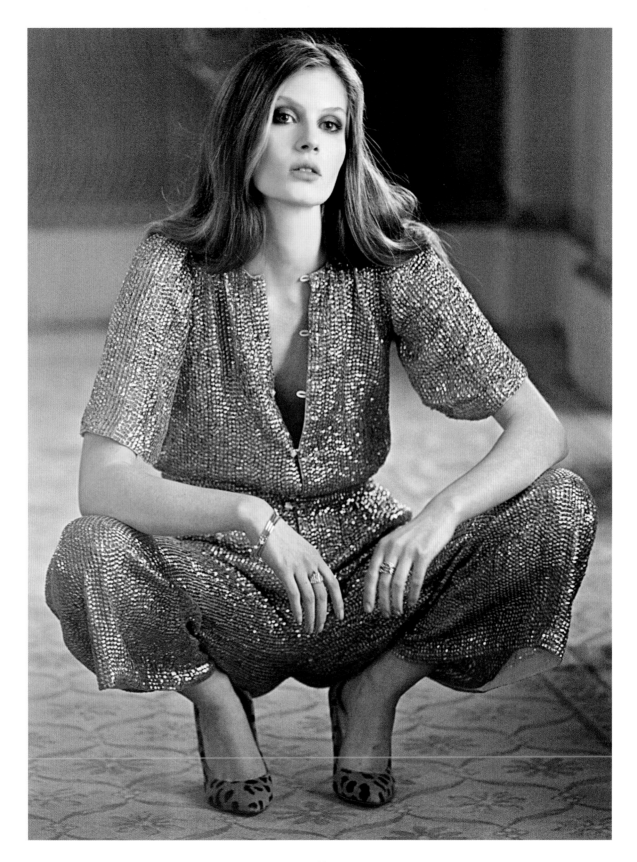

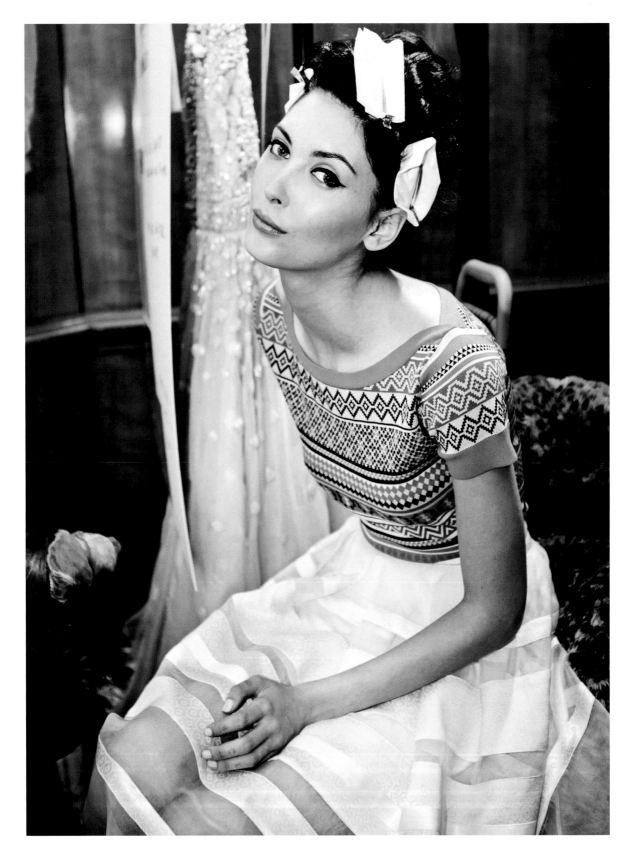

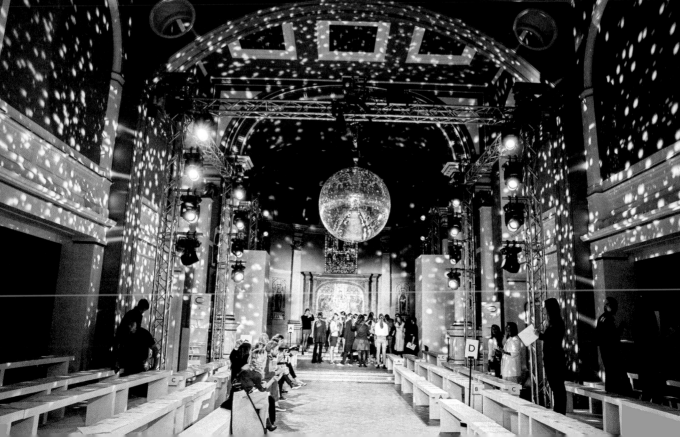

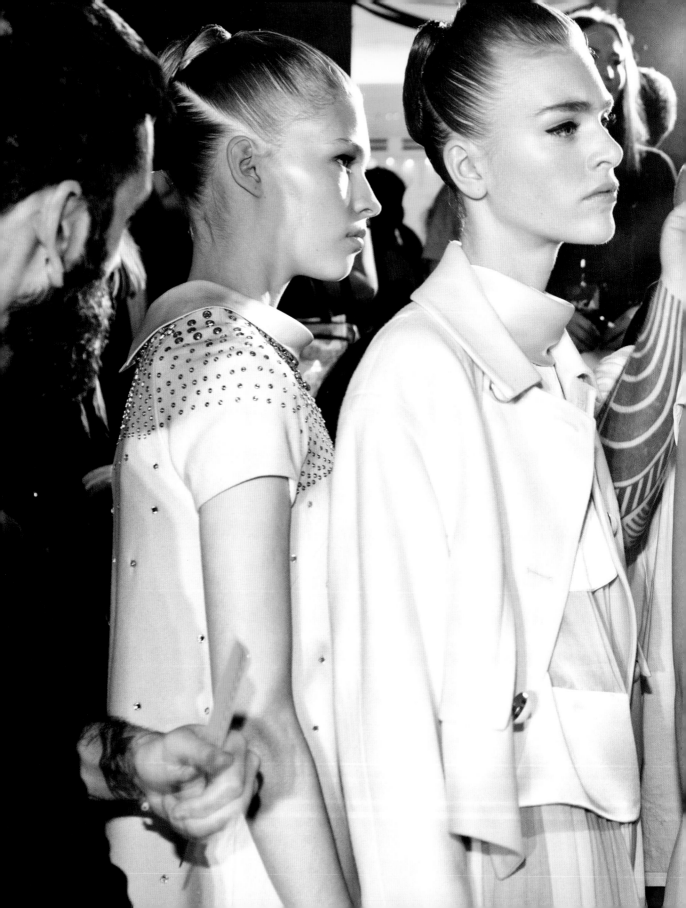

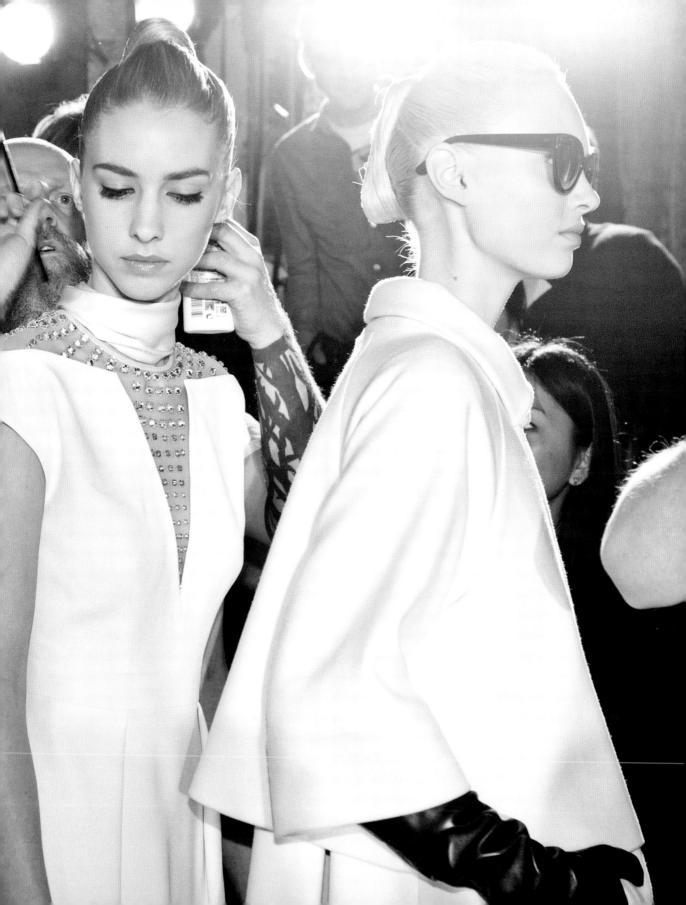

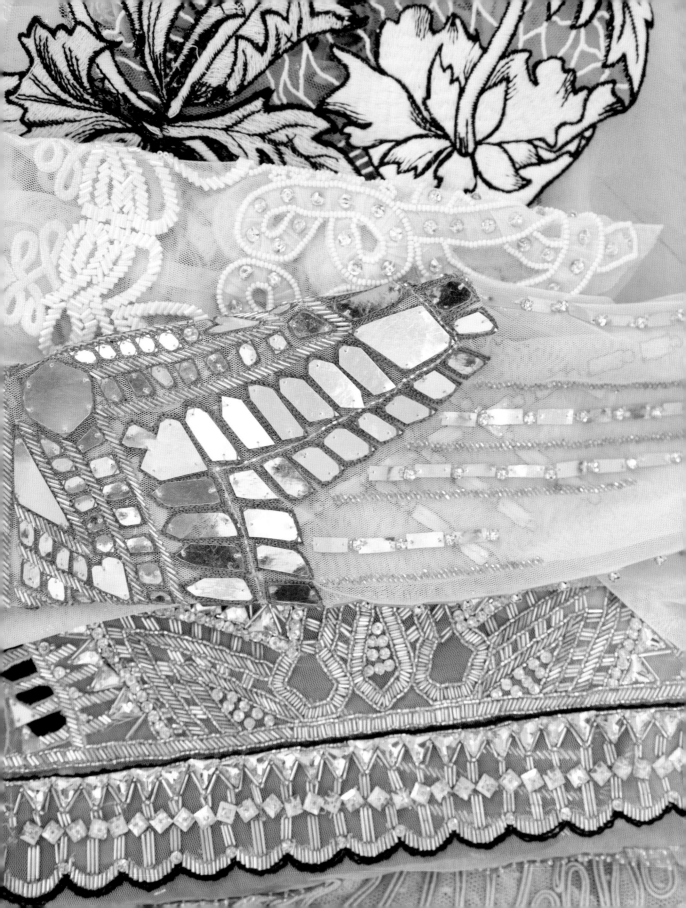

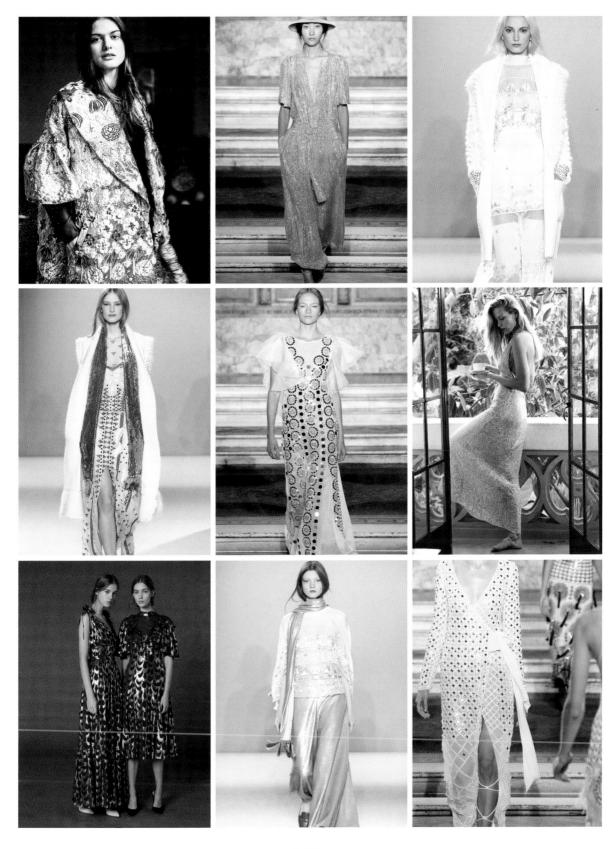

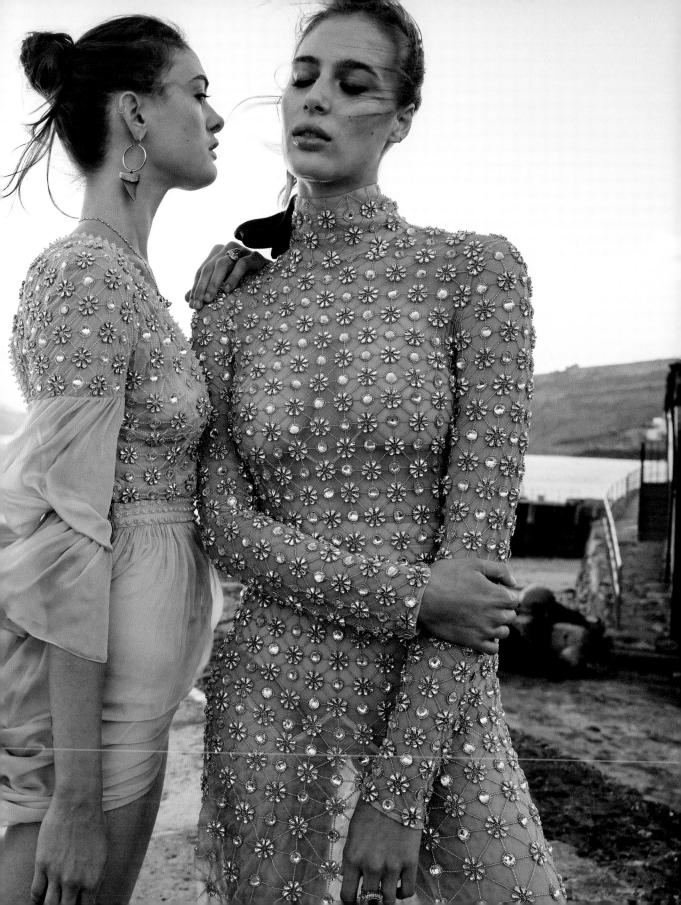

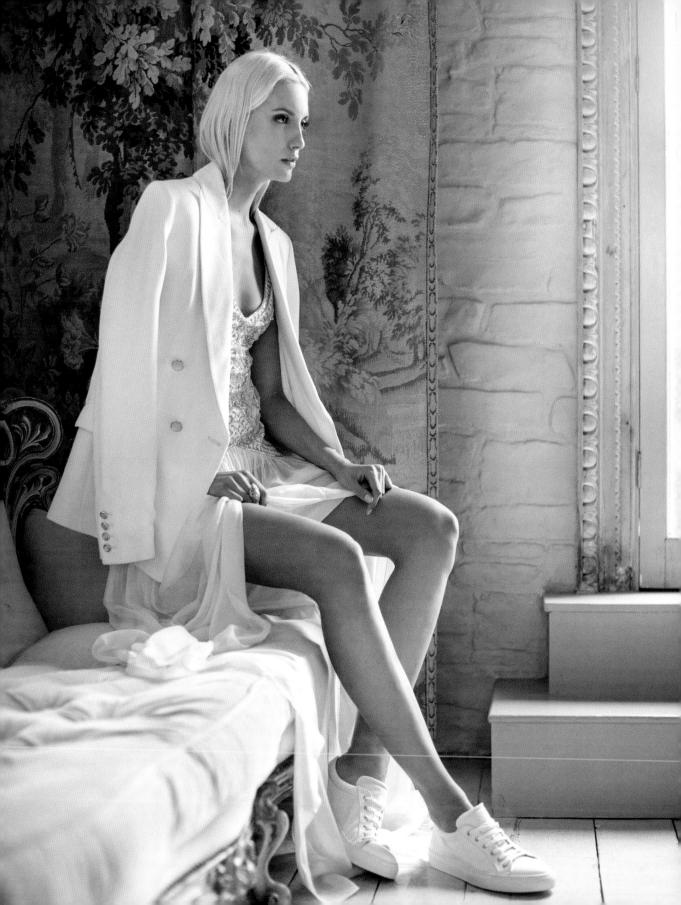

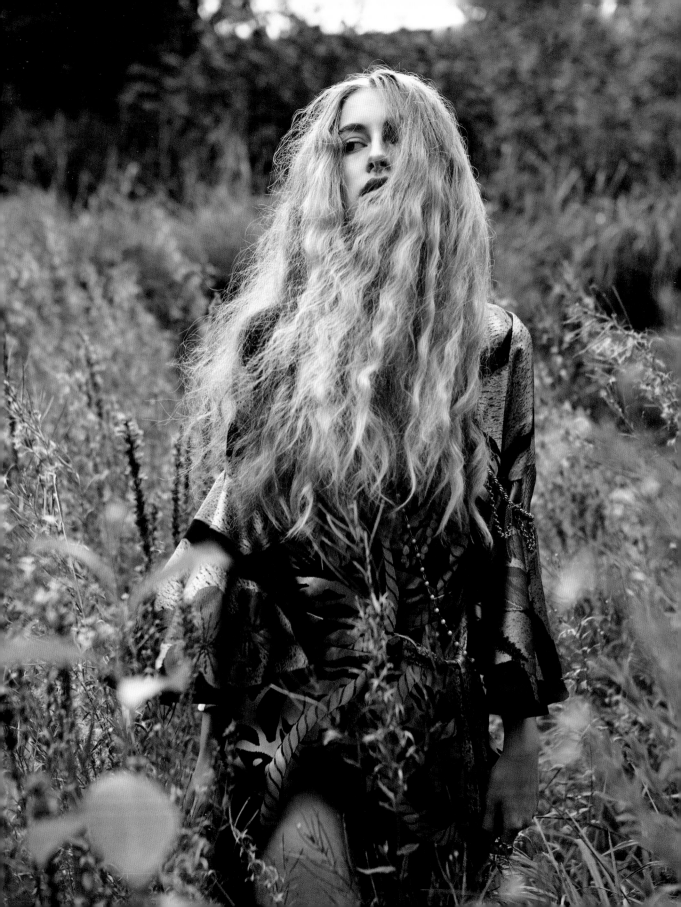

# THE SHIRE

Somerset, embroidery, wildflowers,
sundown, and cider

t began, as most stories do, with an apple.

Much has been made of Alice's childhood played out on a cider farm. Dawn rises for lambing, escapes on horseback, festivals, fruit, fermentation, feet planted firmly on grass with eyes to the sky. When writing about Alice's work, Somerset's immeasurable influences are often distilled into a single word—"bohemian"— poured over and over to toast her career trajectory. Slipping between "glamour-ous" and "feminine" lashed by consecutive commas or tacked staccato in its shortened form to "-chic," "-aesthetic," "-bride," "-style," "-queen": has this noun started to taste at all stale? Before we ditch it completely, let us take a closer look.

Digging to its roots so as to unearth something of Alice's, we find that Bohemia is the West Country of the Czech Republic, flanked by mountains. A region, once a nation, now delineated by dialect, a cultural rather than national divide. The Boii, the Gallic tribe who originally settled there, their *hem*, the same origin as our "home." Driven out by Caesar, the Boii were by the fifteenth century *bohême* to the French: gypsies from or via this ancient country. By the nineteenth century, the definition strayed further still with William Thackeray declaring all those of a "wild, roving nature," spiritual nationals of Bohemia.[3]

Speech decoupled from its origins, roaming free, gathers souvenirs. Romani is a family of languages spoken by itinerant people who in the past would have been called bohemians, nomads, gypsies. This tongue traces the travels of those who speak it, secreting words of Greek, Armenian, German, and Slavonic origin in its pockets. In Persia, it picked up a fruit: *ambról*, a pear. [4] In this micro-occurrence, one tiny part of "bohemian, we find something

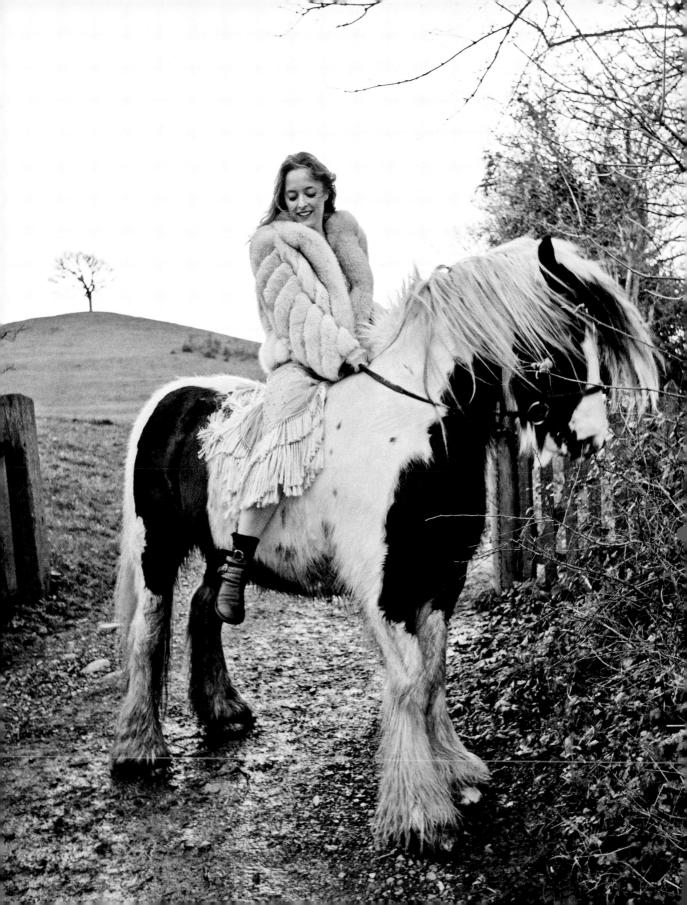

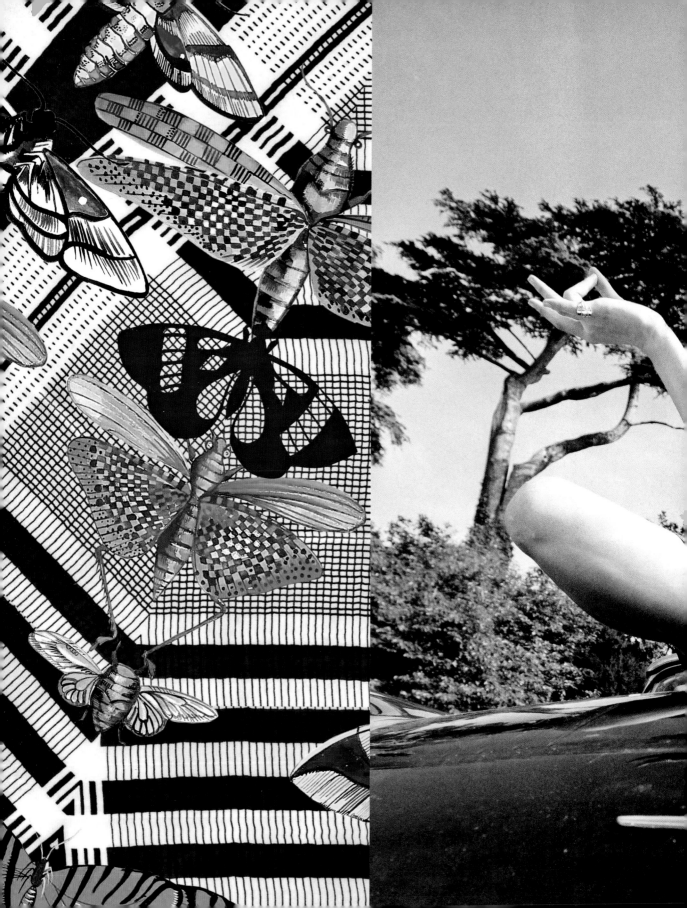

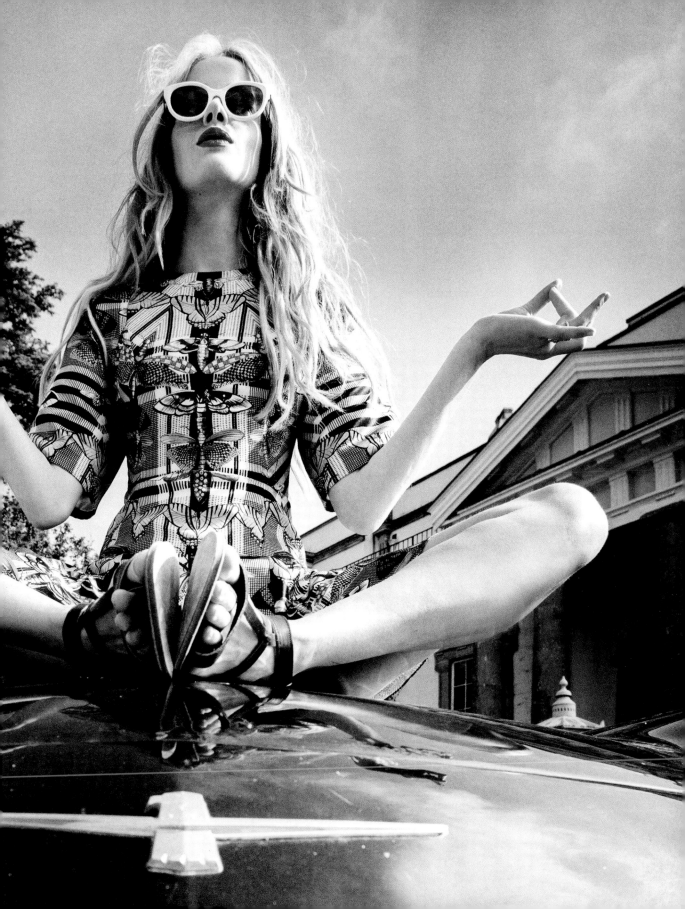

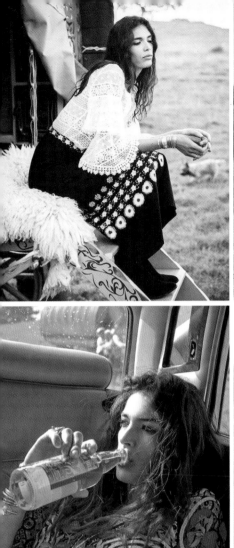

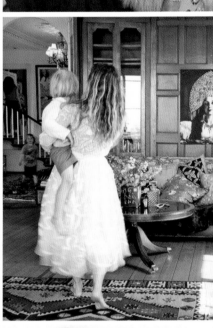
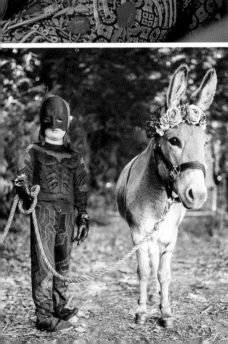
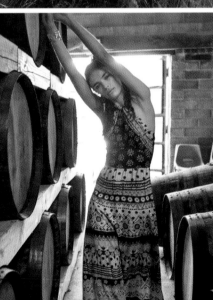
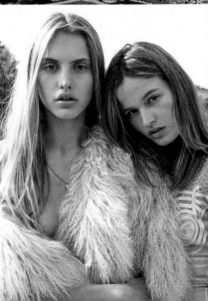

new. Julian Temperley, Alice's father, says you plant apple trees for your children. For your grandchildren, you plant pears. The difference? Until a few hundred years ago there was none. Apple, the original fruit, was *all* fruit. Even as our language branched out to denote oranges (golden apples) and acorns (oak apples) in their own right, the pear still remained the same type, *pome*, borrowed from the French term for apple. So what is the difference between these two fruits that hang so close? Pears got grit.

The Autumn/Winter 2016 collection campaign was shot on Julian's cider farm. Painted wagons, log fires, and a piebald horse—there was no doubt about it: bohemian was back. This time with grit. A masculine-cut jumpsuit recalls the workwear of farm labourers and is set in tiny iridescent green sequins that conjure the sun setting over Burrow Hill orchard. Wildflowers stitched over gauze battle for attention with the easy glamour of bold poppies. But, the sleeves are Spanish, the lace is French, the silver bangles Indian, and the model in possession of a look that any of a few dozen countries would claim their own in a heartbeat.

The artist Cézanne, deploring his fidgeting once-model a wretch, demanded they sit like an apple. But despite descending from this fruit, Temperley won't be still; like the Roma, it moves globe wide, gathering influences that collide unchecked. Alice will always return to where she's from, in body and mind. Each time she does, Somerset burns anew.

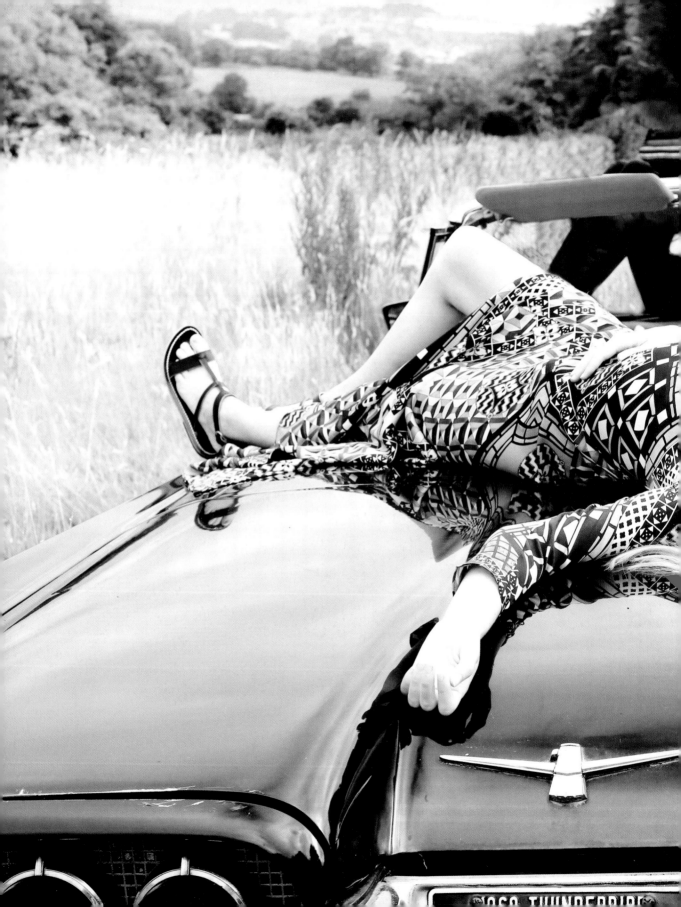

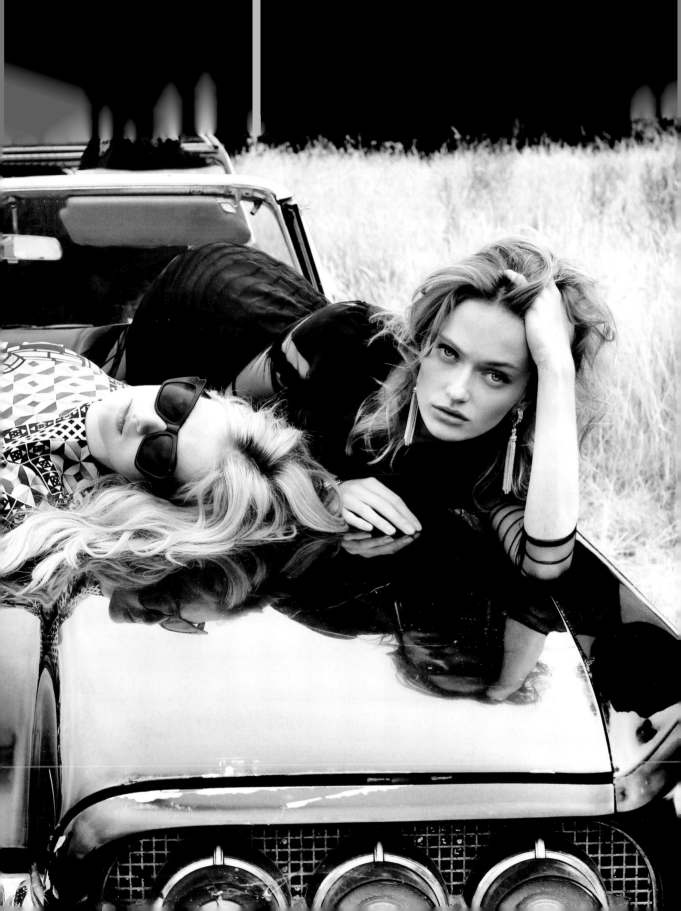

"Everything is made out of magic,
leaves and trees, flowers and birds, badgers
and foxes and squirrels and people.
So it must be all around us.
In this garden — in all the places."

– FRANCES HODGSON BURNETT,
THE SECRET GARDEN (1911)

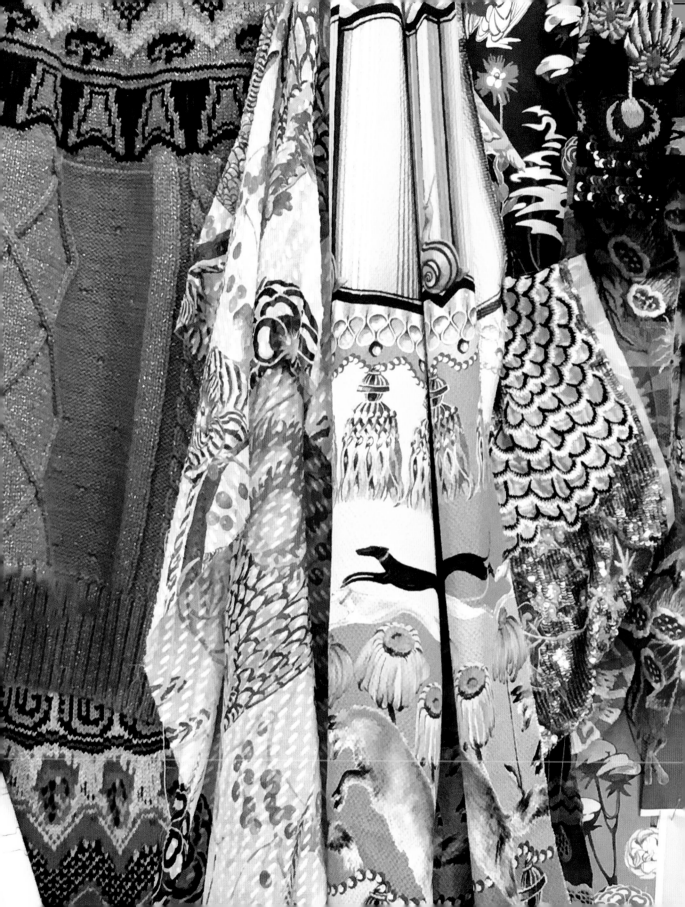

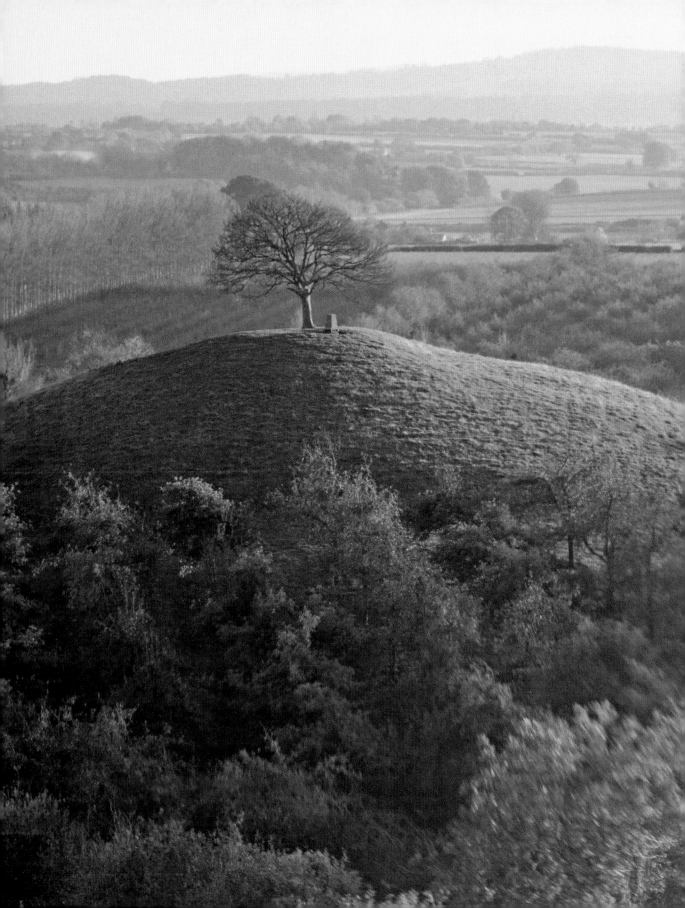

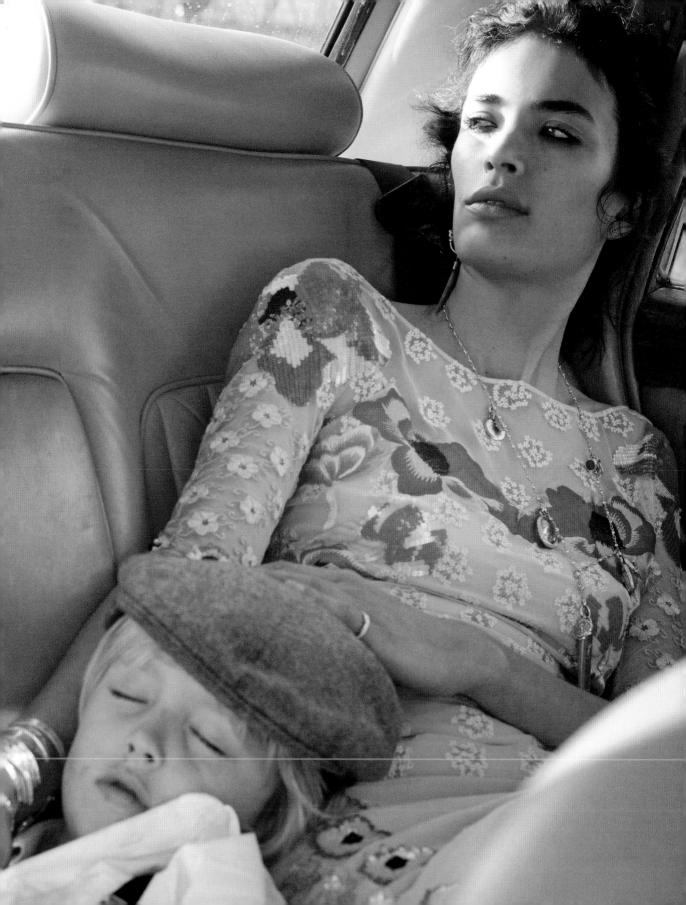

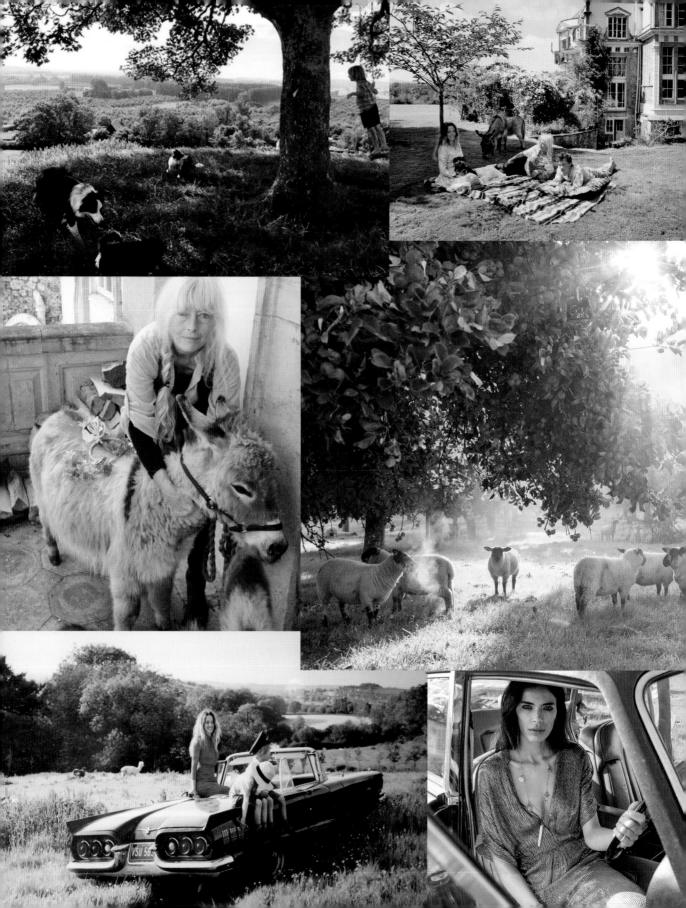

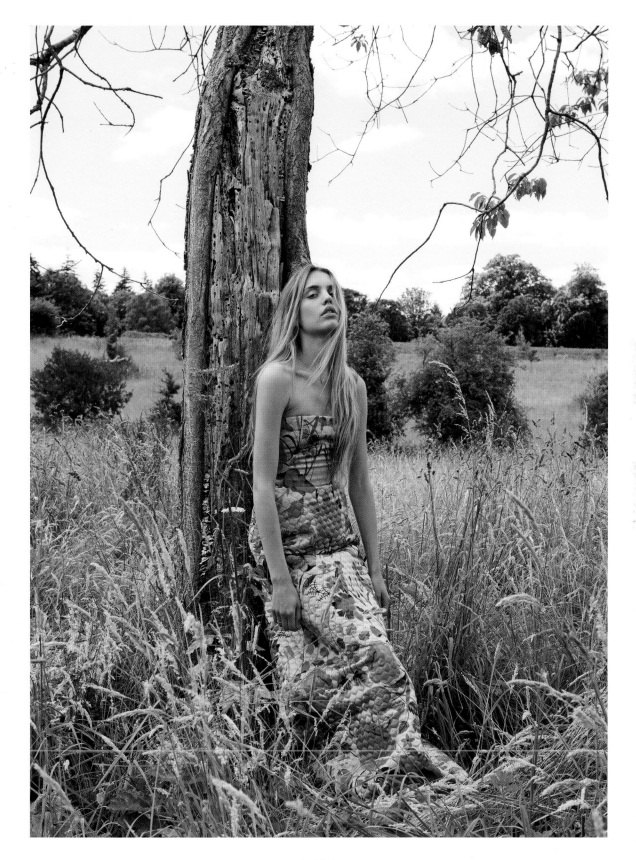

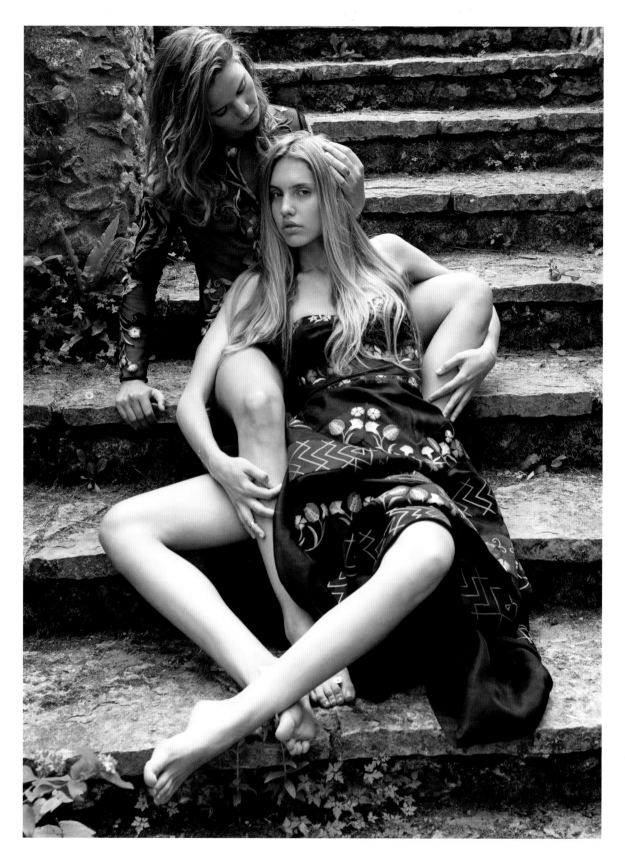

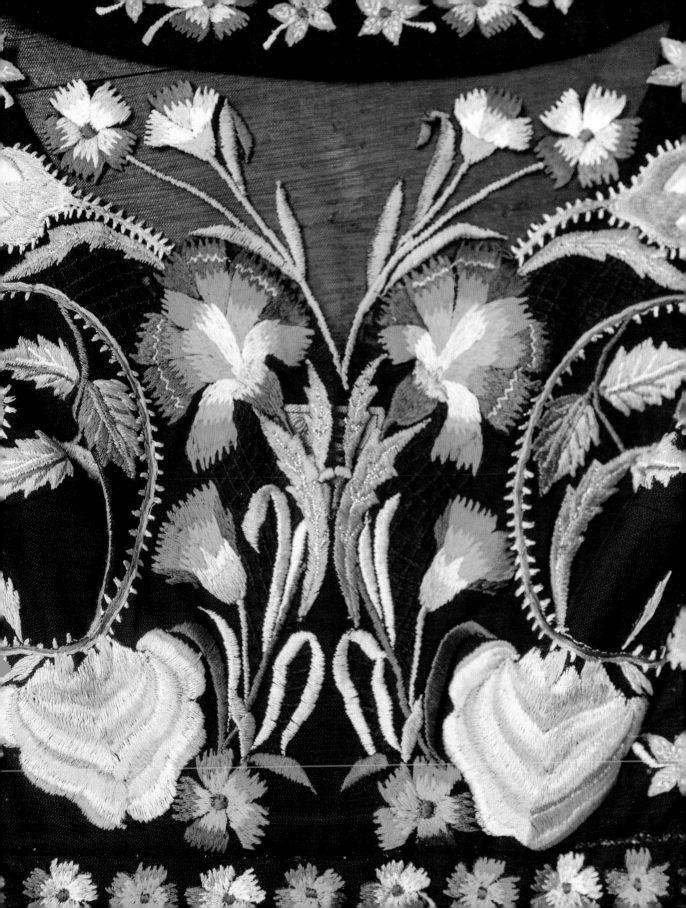

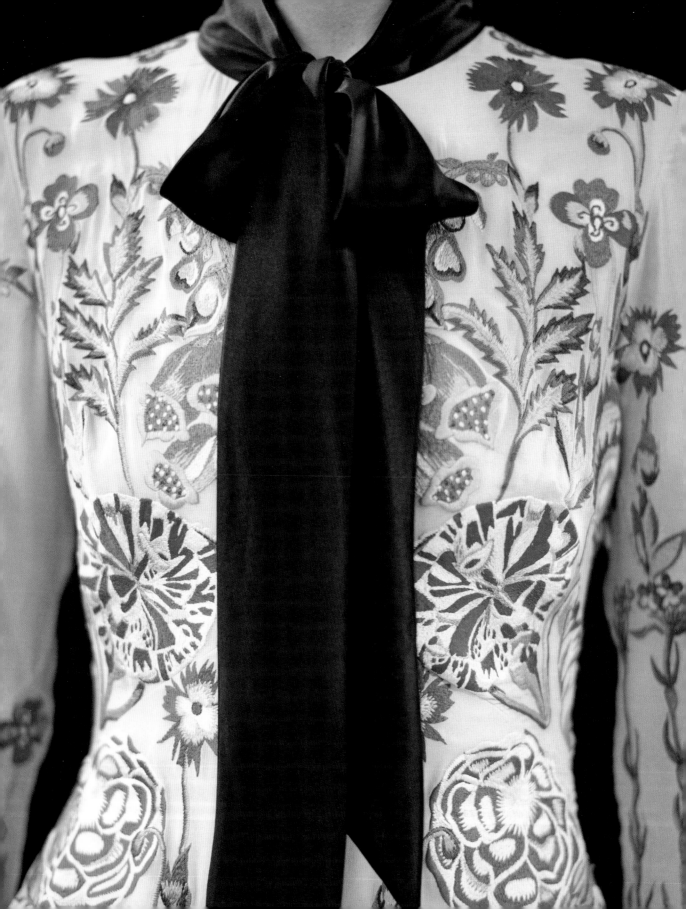

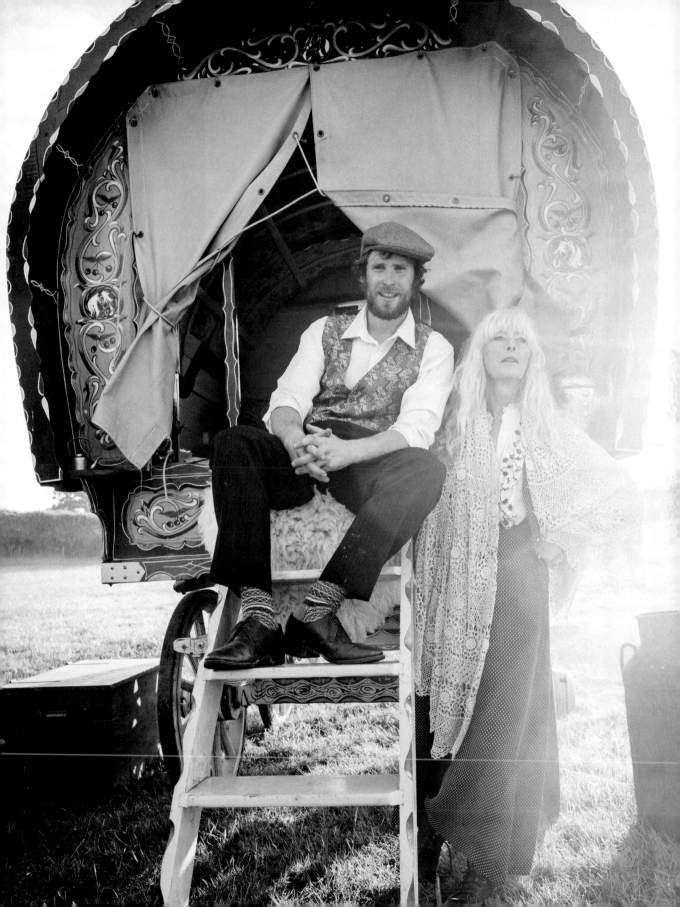

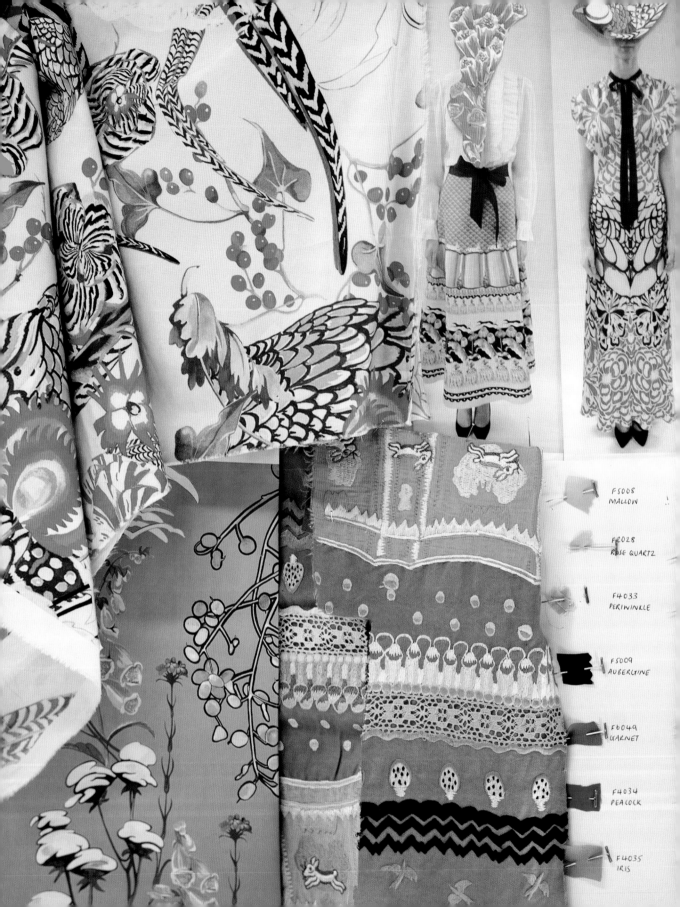

F5008
MALLOW

FR028
ROSE QUARTZ

F4033
PERIWINKLE

F5009
AUBERGINE

F6049
GARNET

F4034
PEACOCK

F4035
IRIS

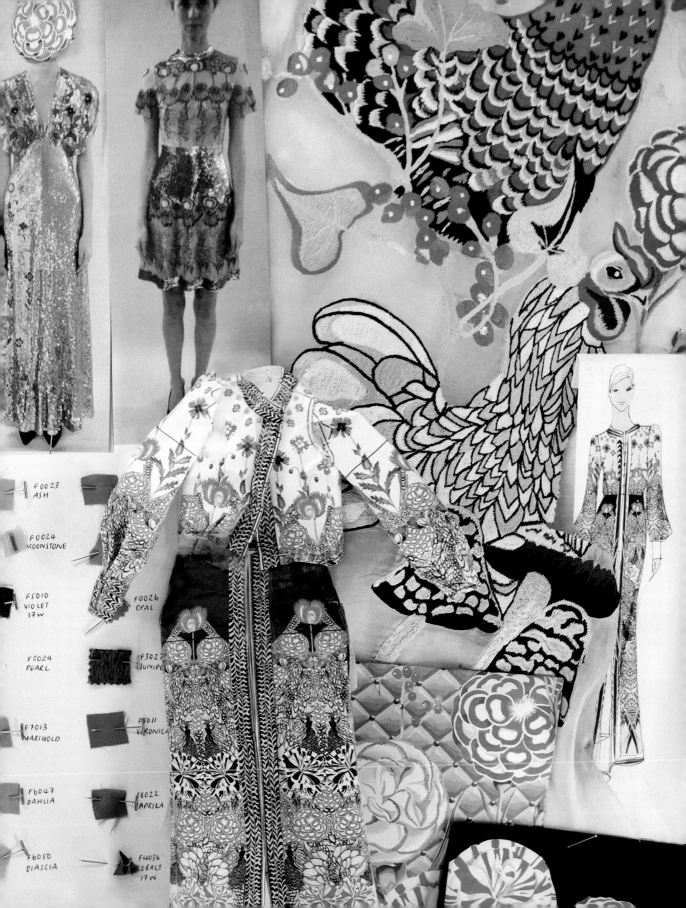

F0023
ASH

F0024
MOONSTONE

F5010
VIOLET
17W

F0026
OPAL

F2029
PEARL

F3027
JUNIPE

F7013
MARIGOLD

F5011
VERONICA

F6047
DAHLIA

F6022
APRILA

F6050
DIASCIA

F4036
COBALT
17W

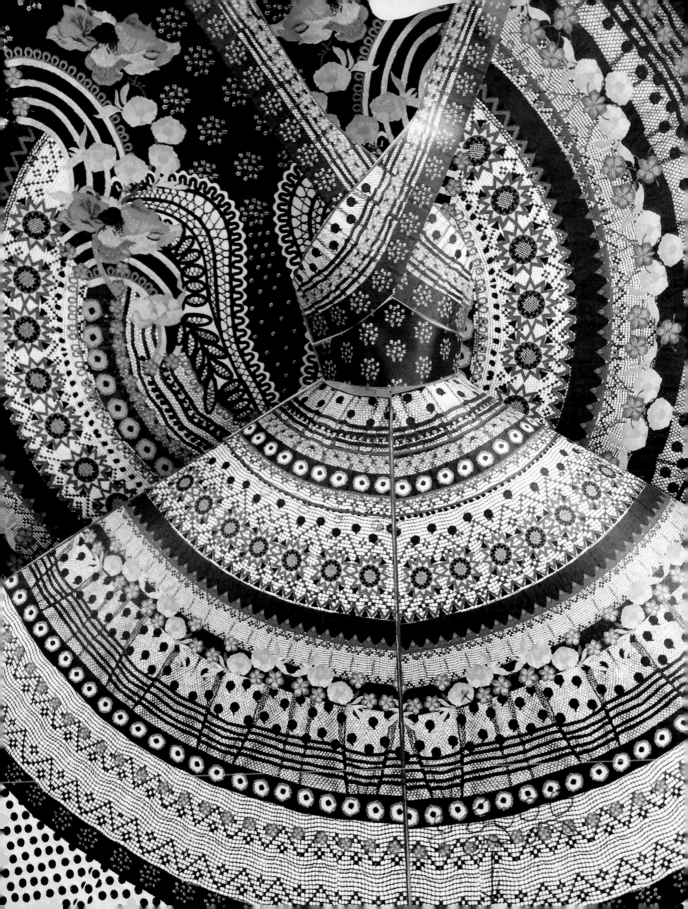

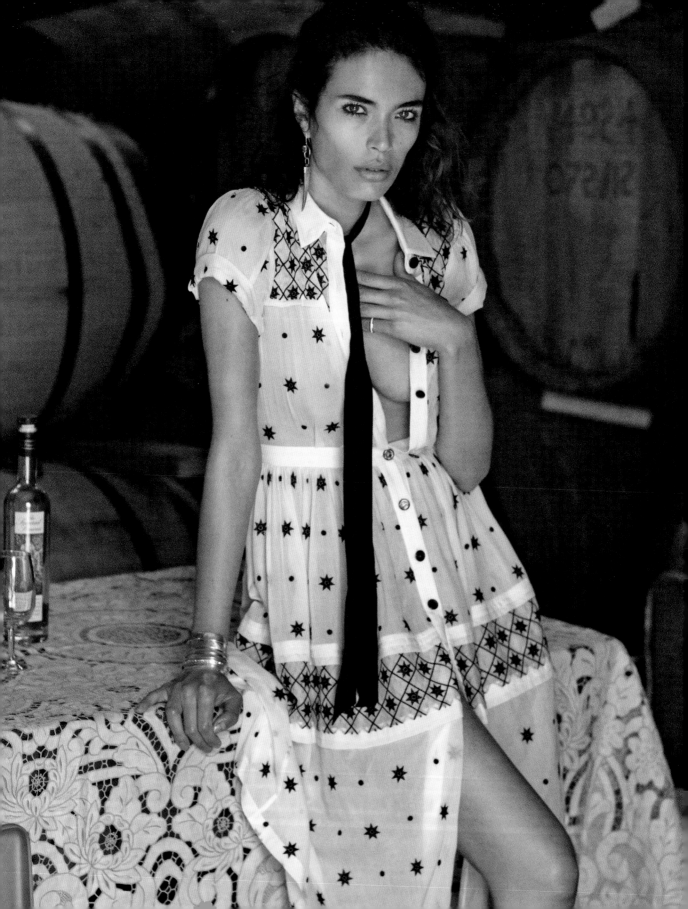

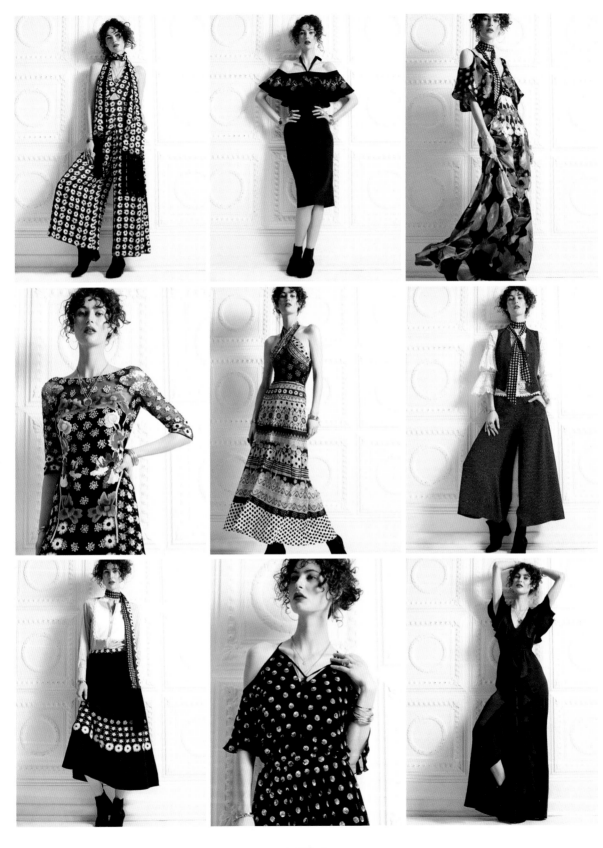

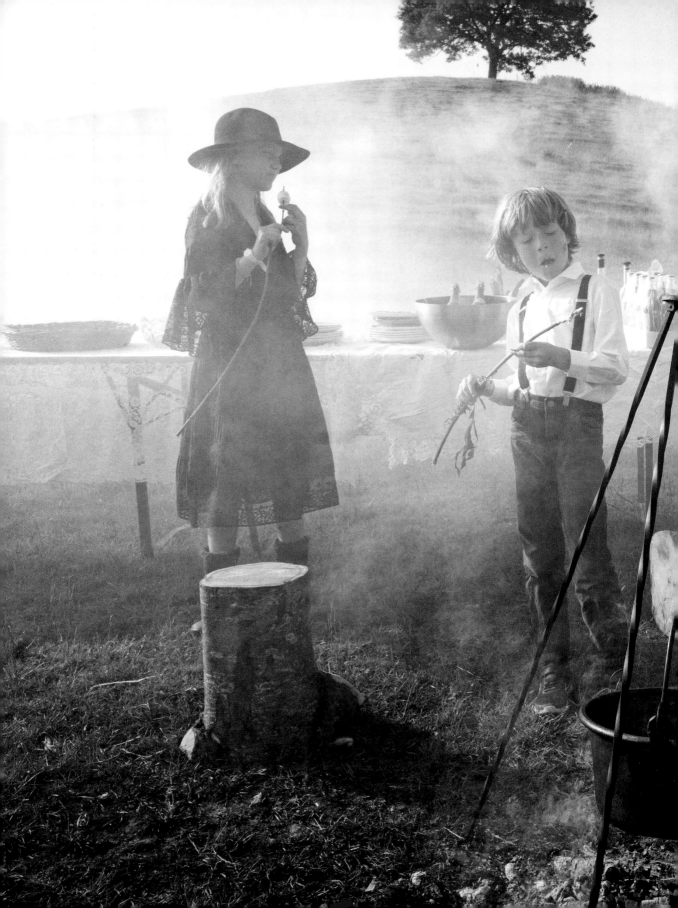

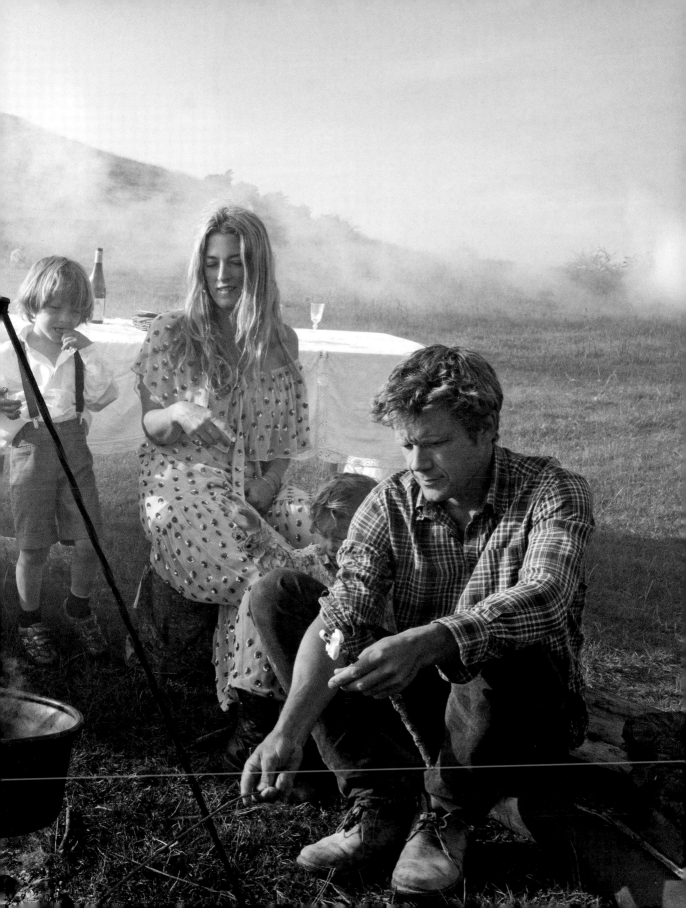

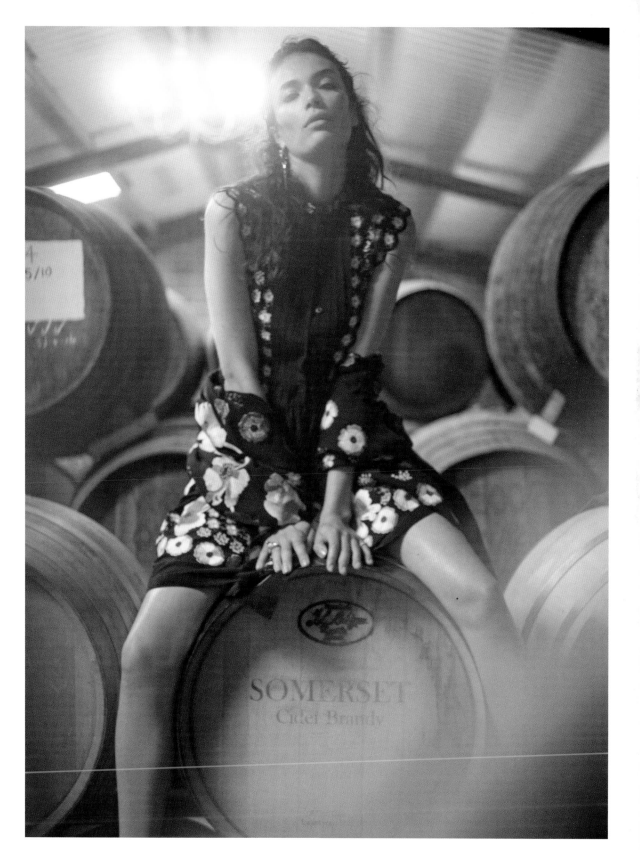

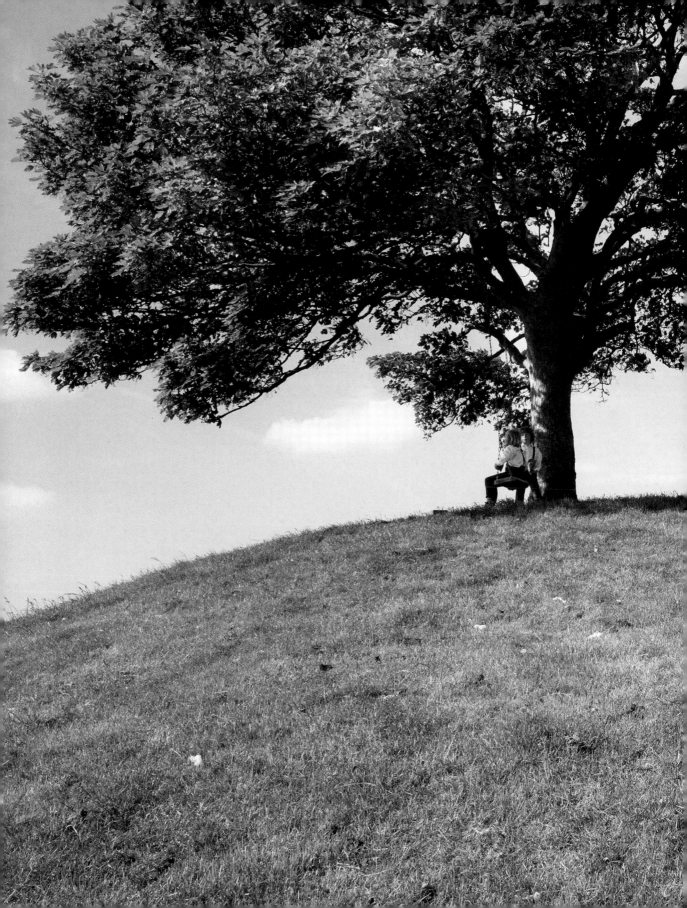

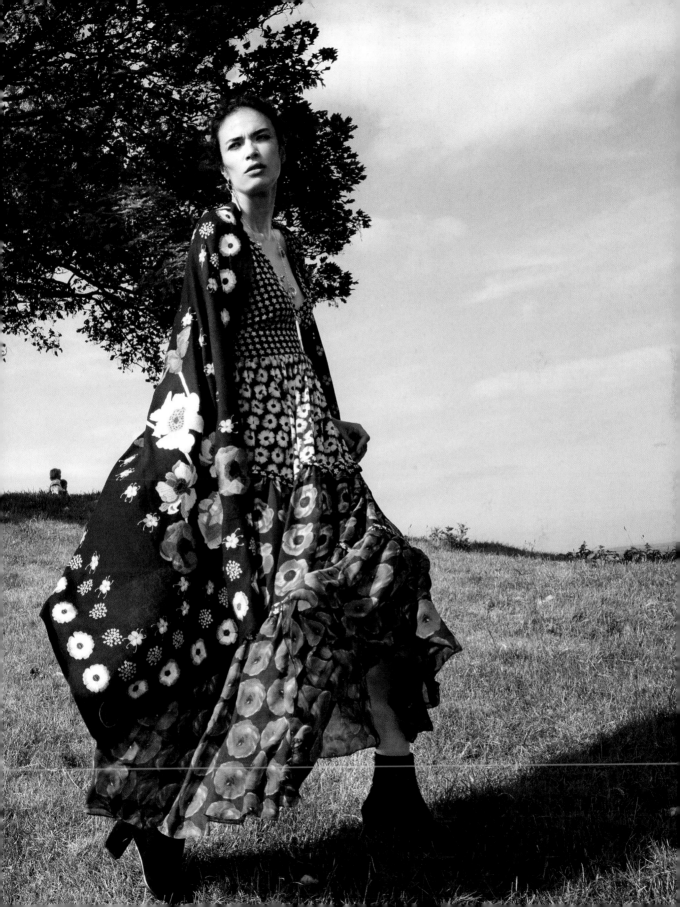

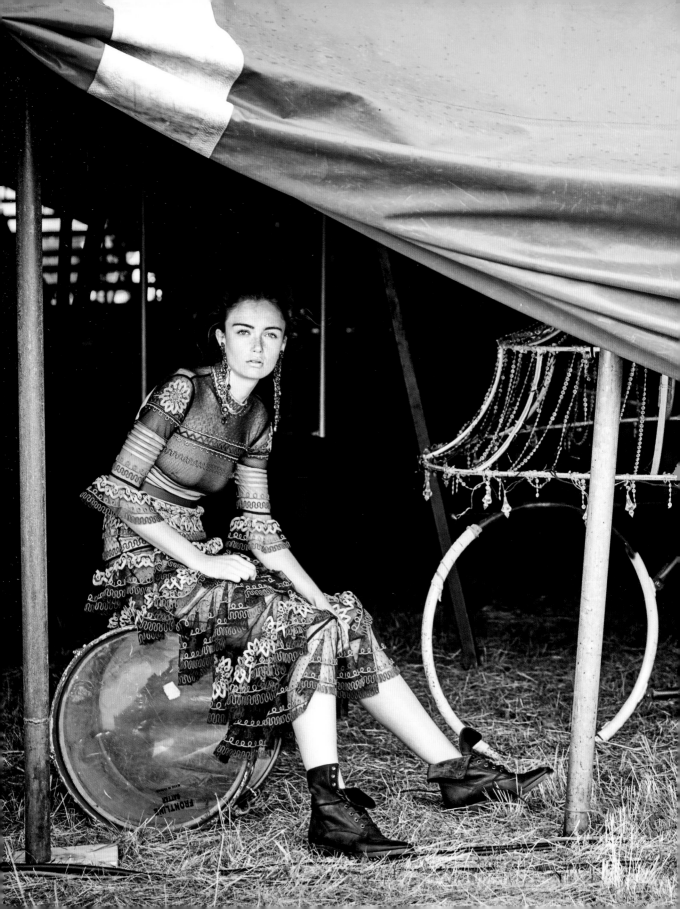

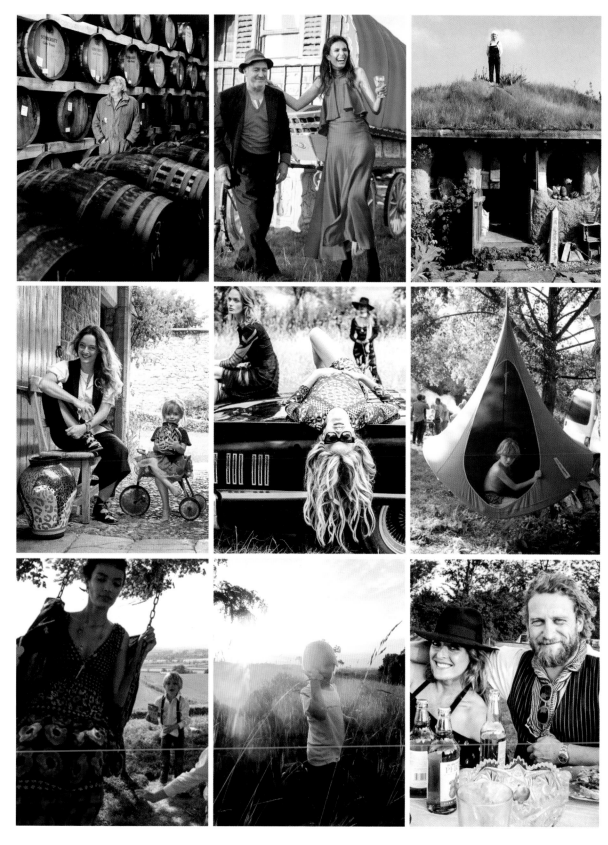

> # If you look the right way,
> ## you can see that the whole world is a garden.

— FRANCES HODGSON BURNETT, THE SECRET GARDEN (1911)

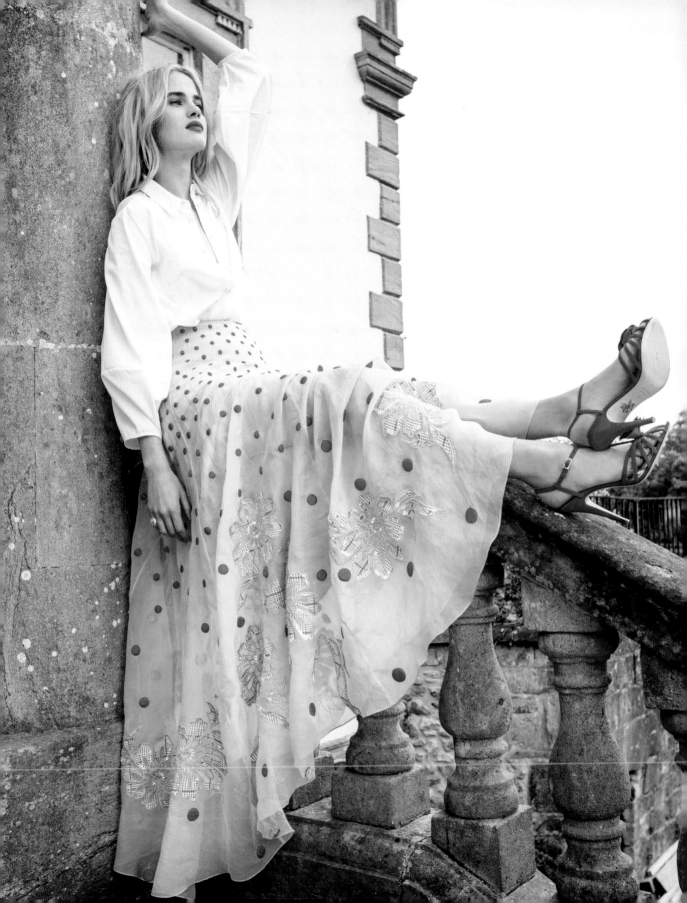

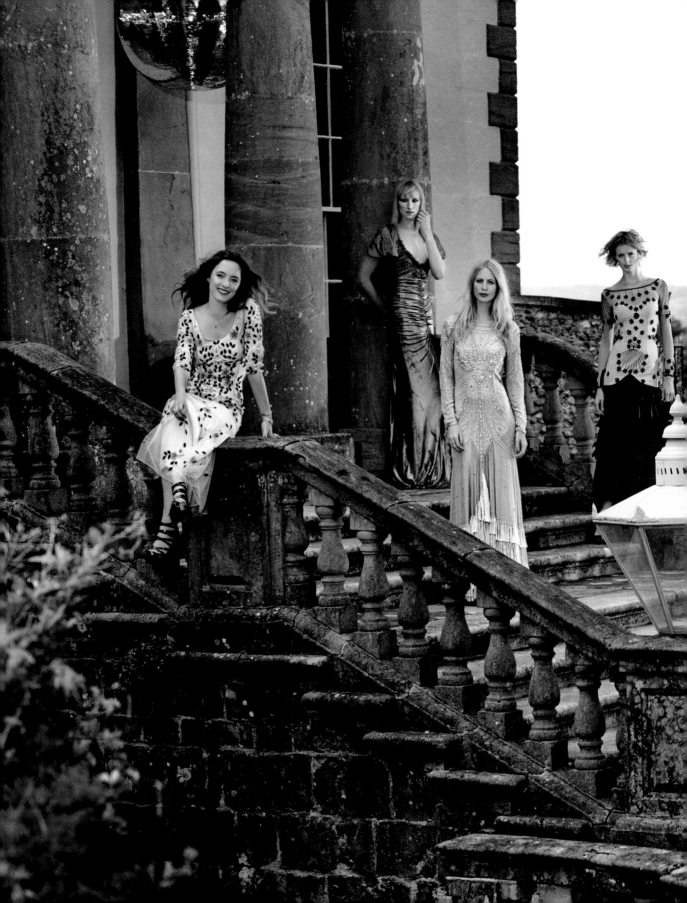

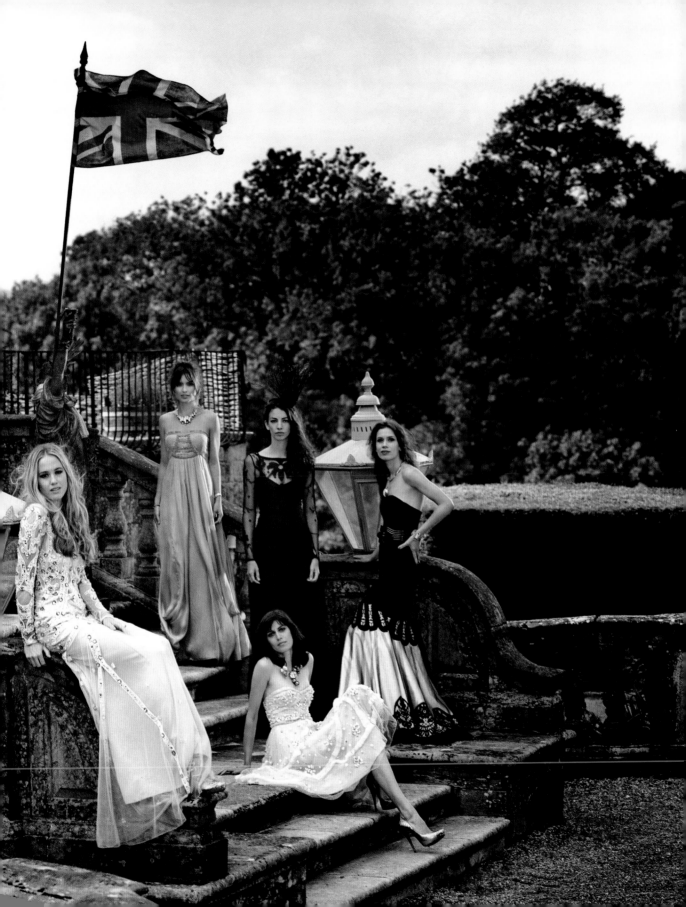

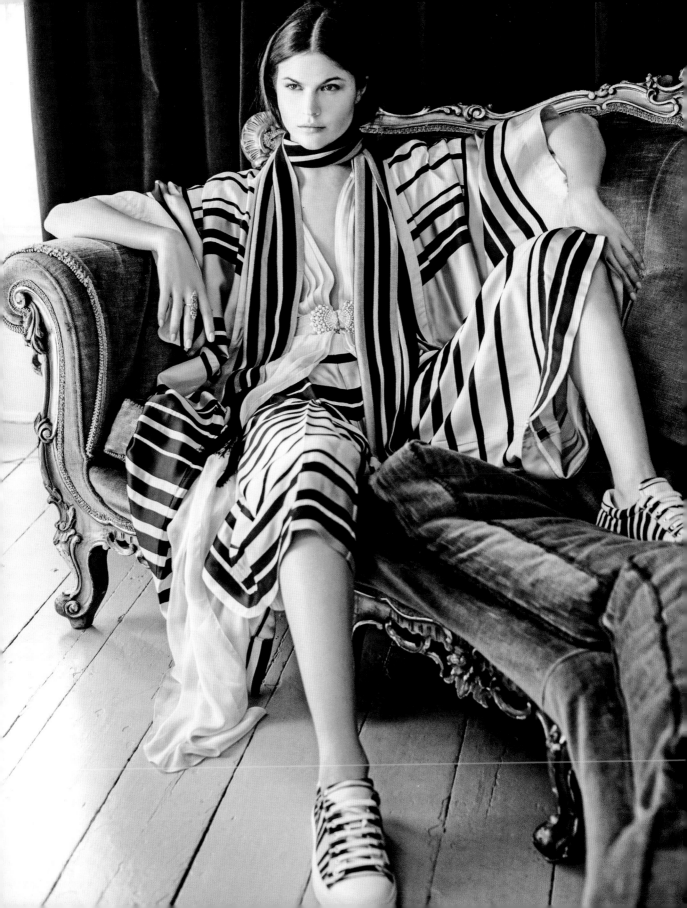

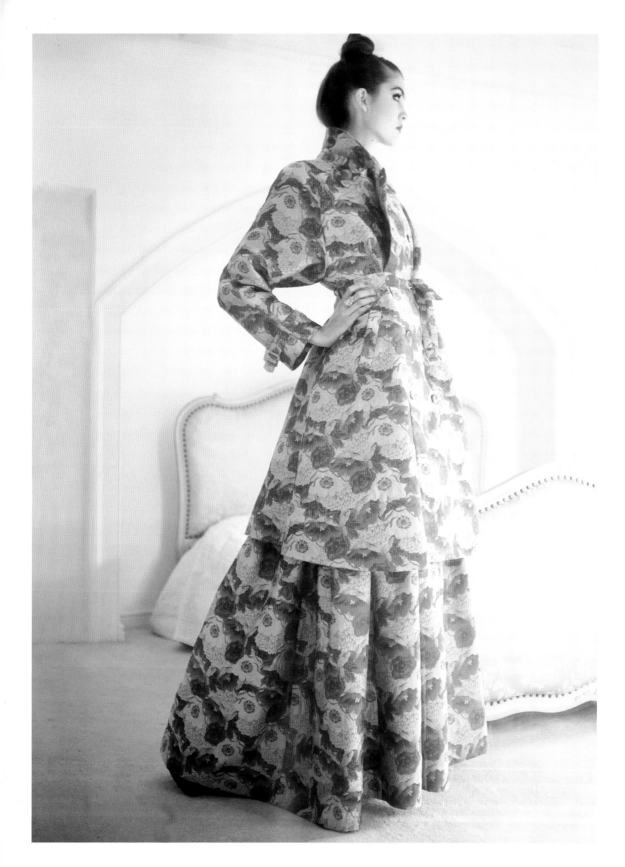

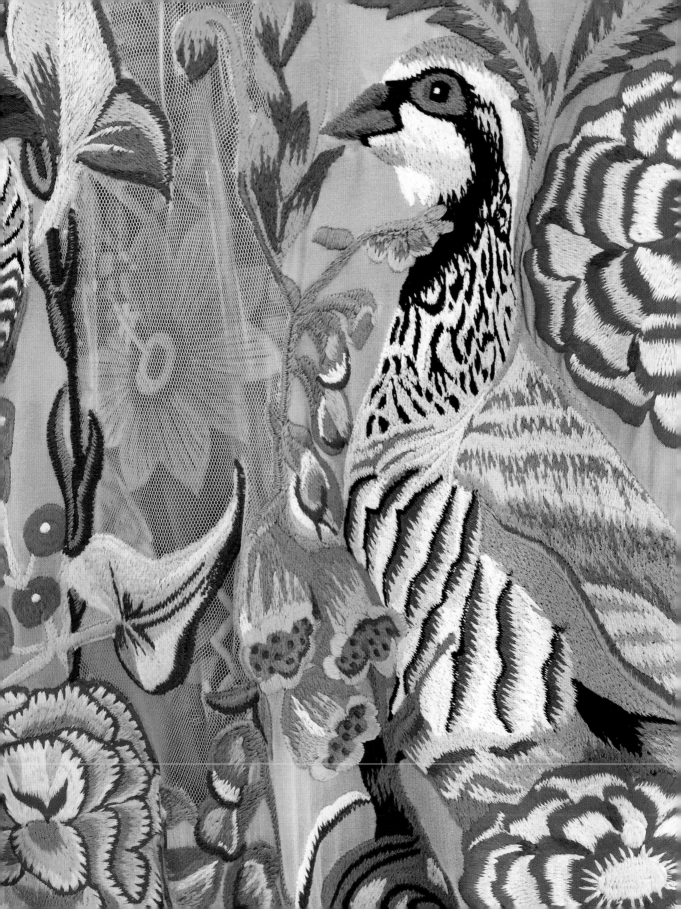

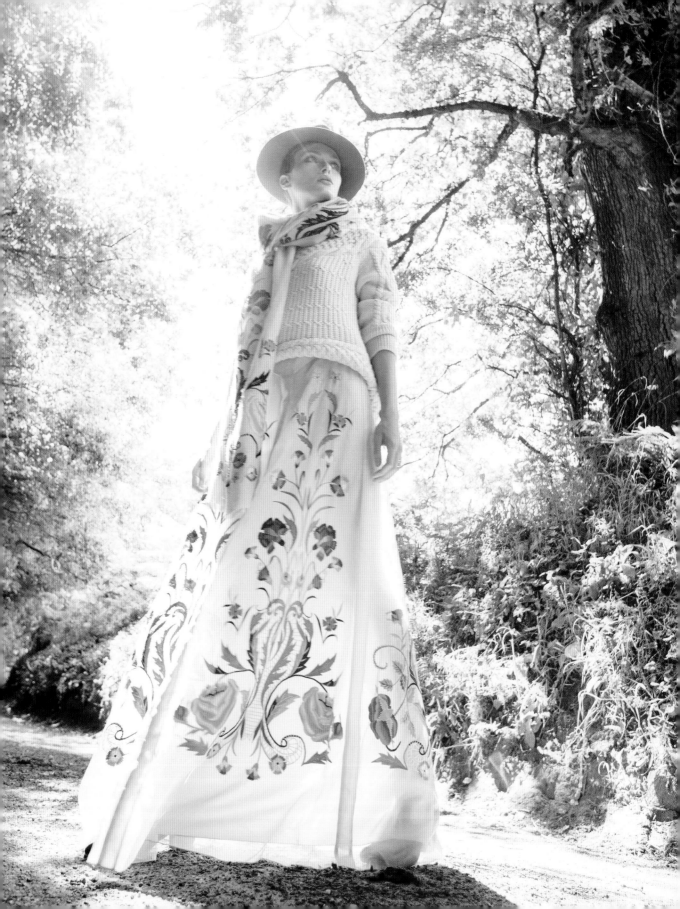

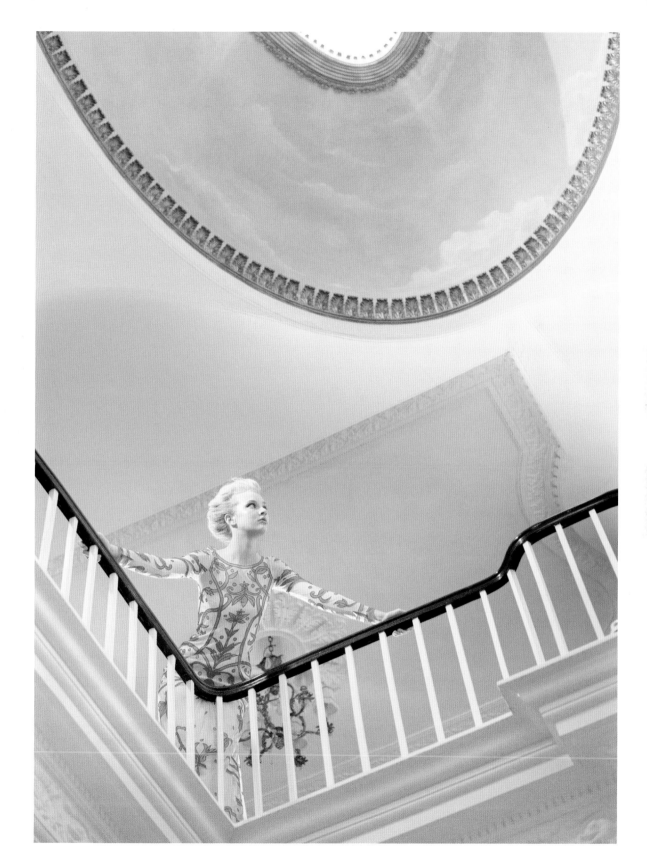

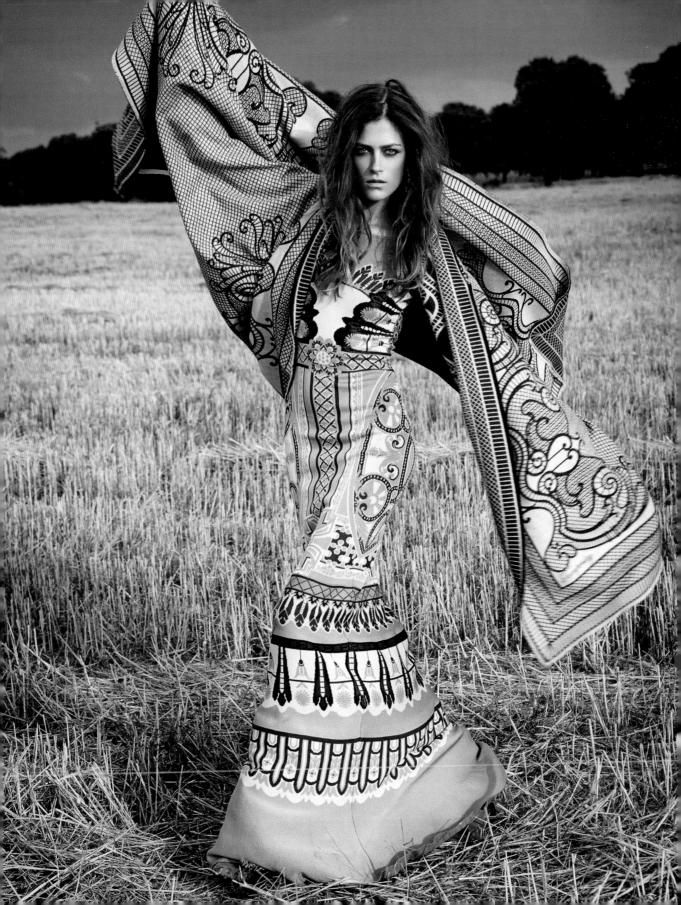

Alice will always return to where she's from, in body, and mind. Each time she does, Somerset burns anew.

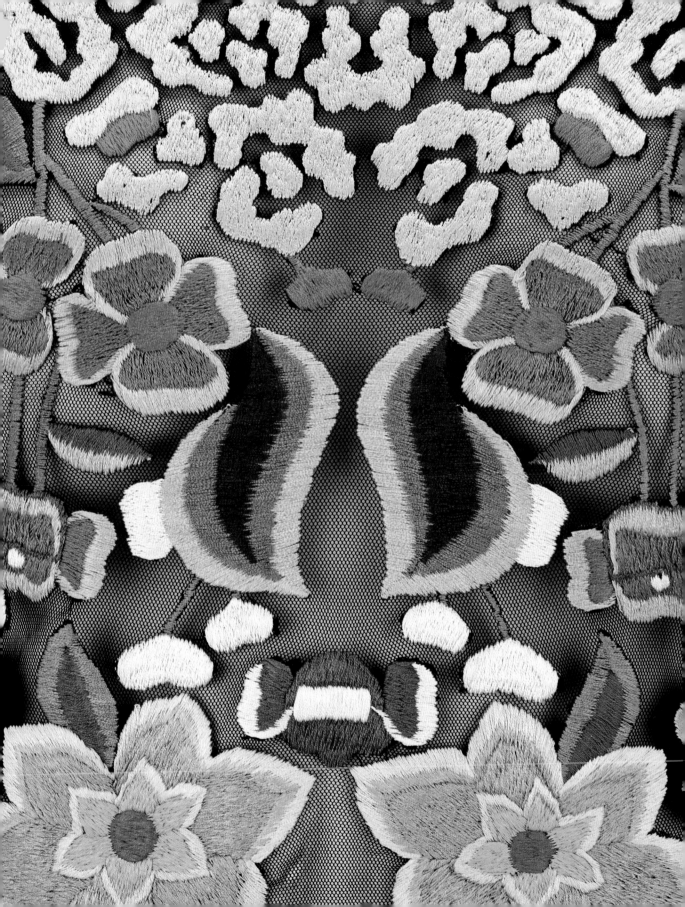

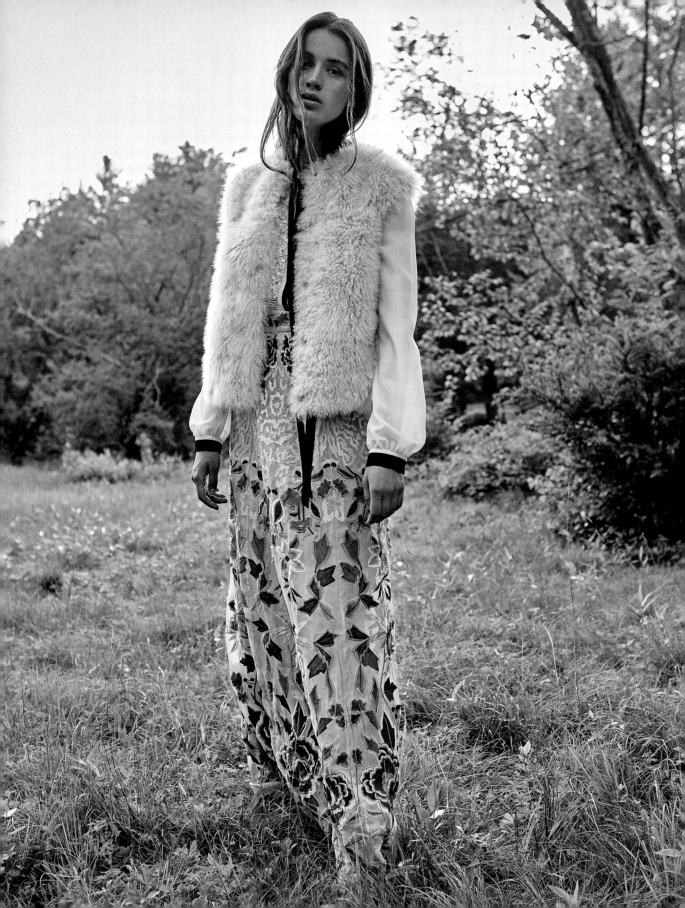

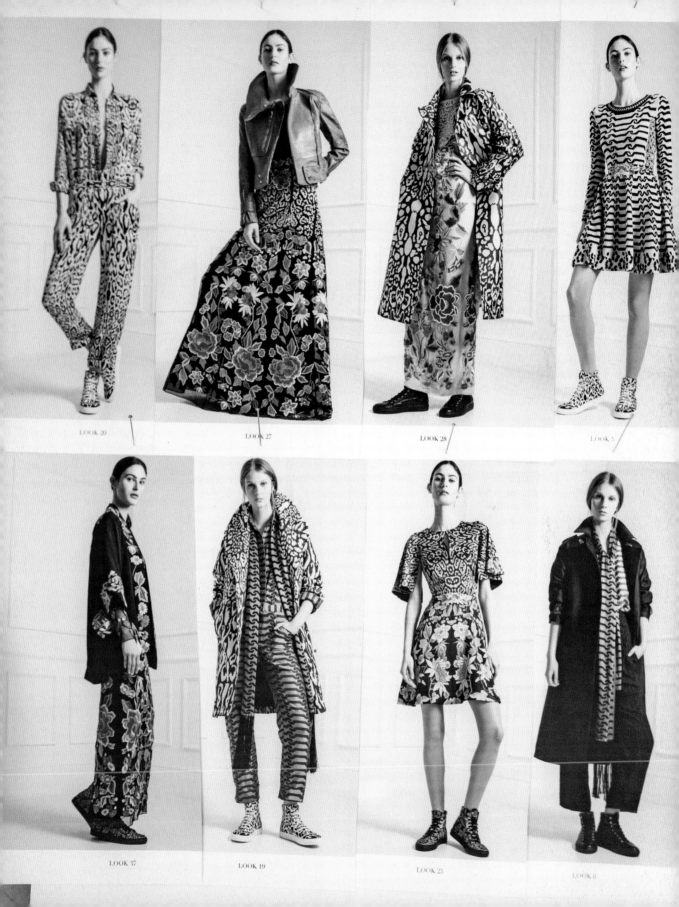

LOOK 20

LOOK 27

LOOK 28

LOOK 5

LOOK 37

LOOK 19

LOOK 25

LOOK 6

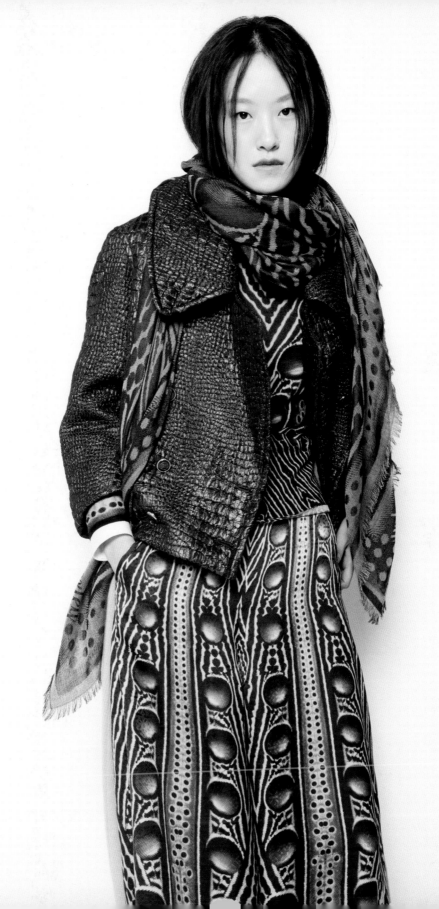

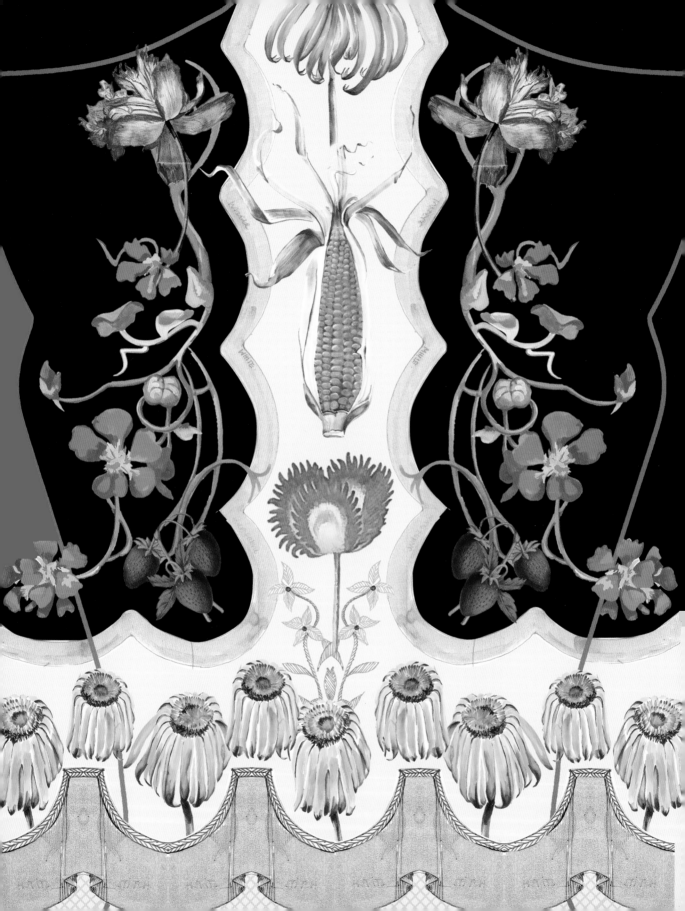

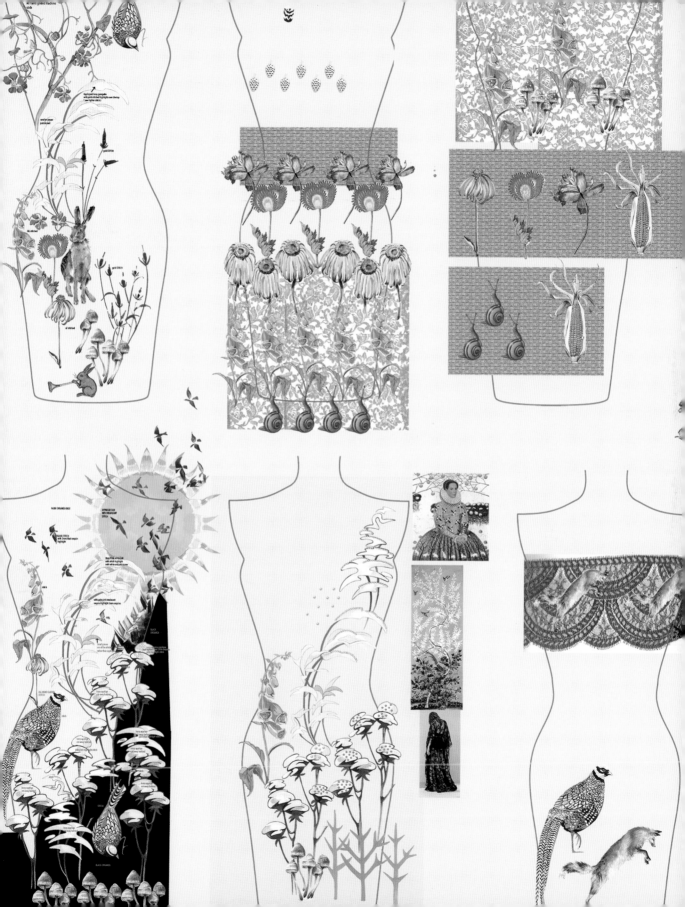

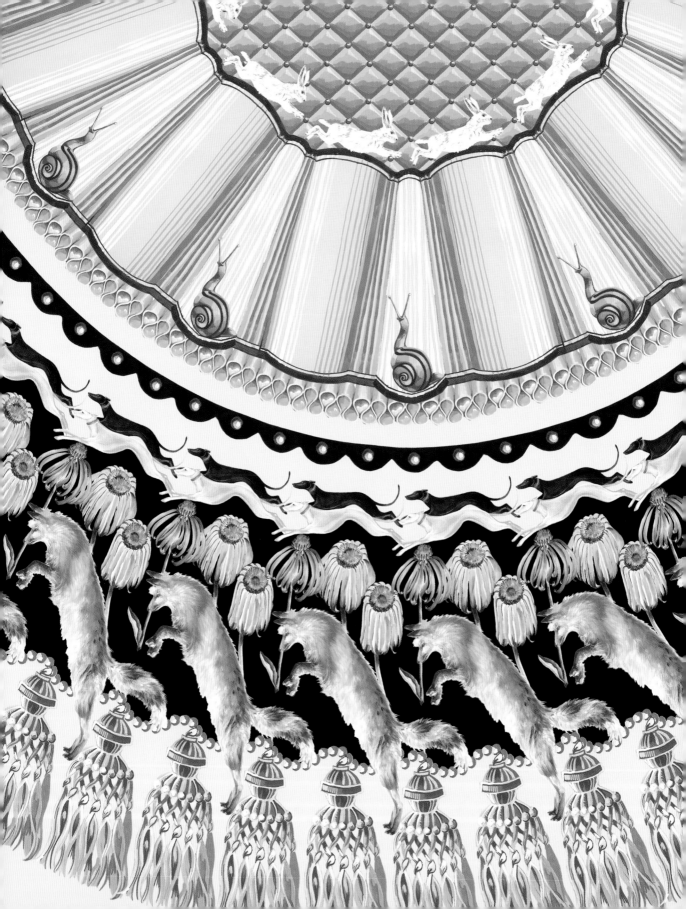

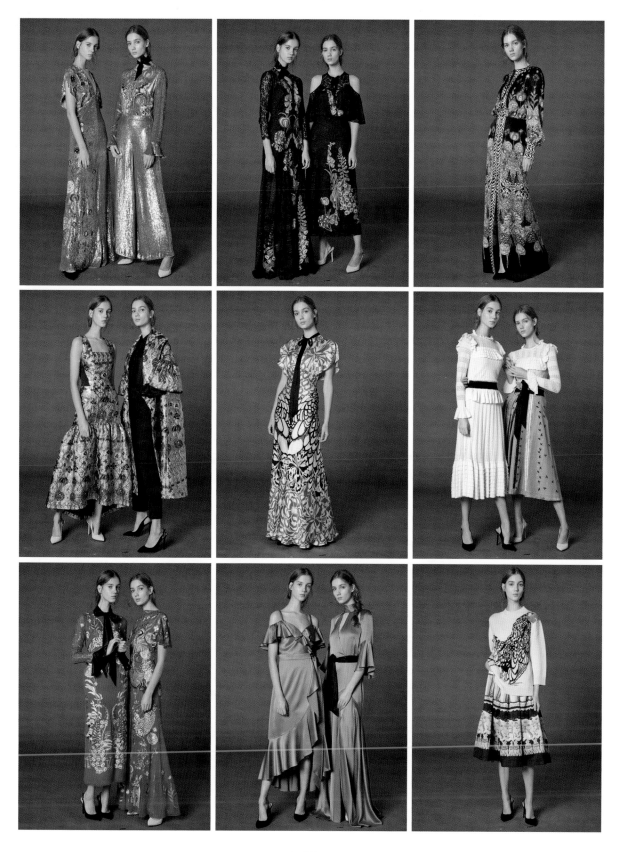

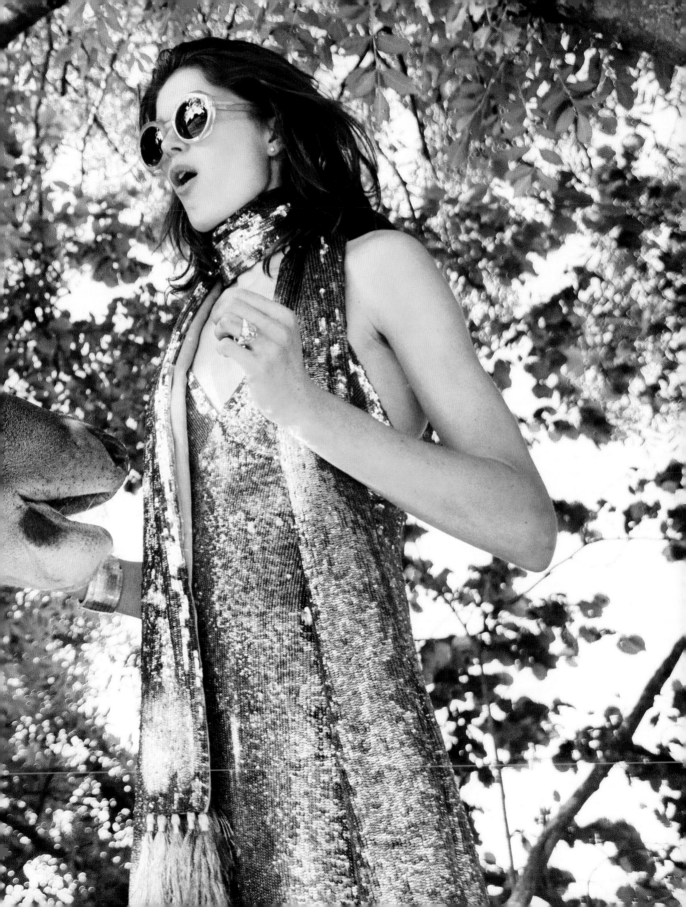

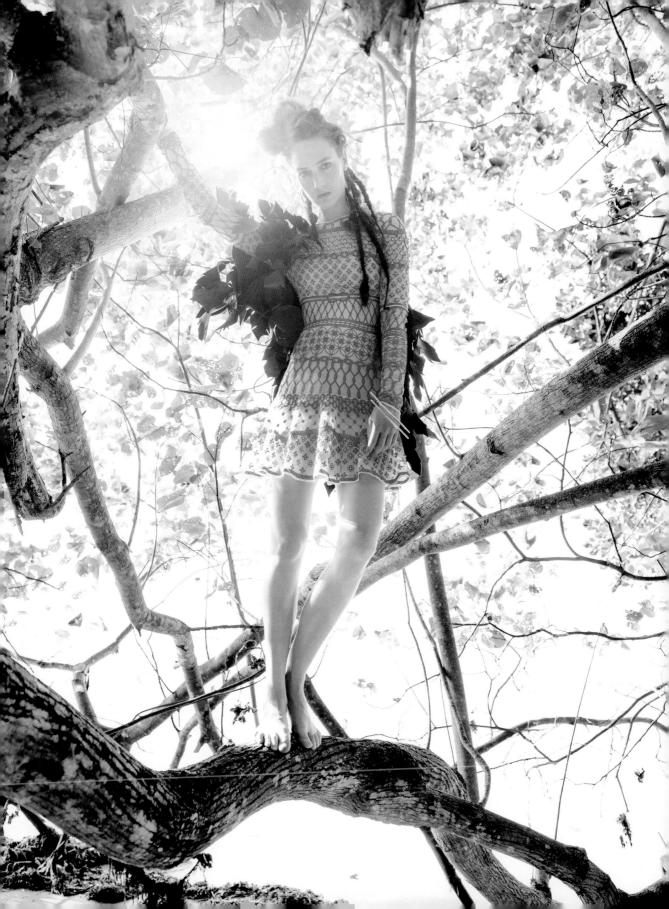

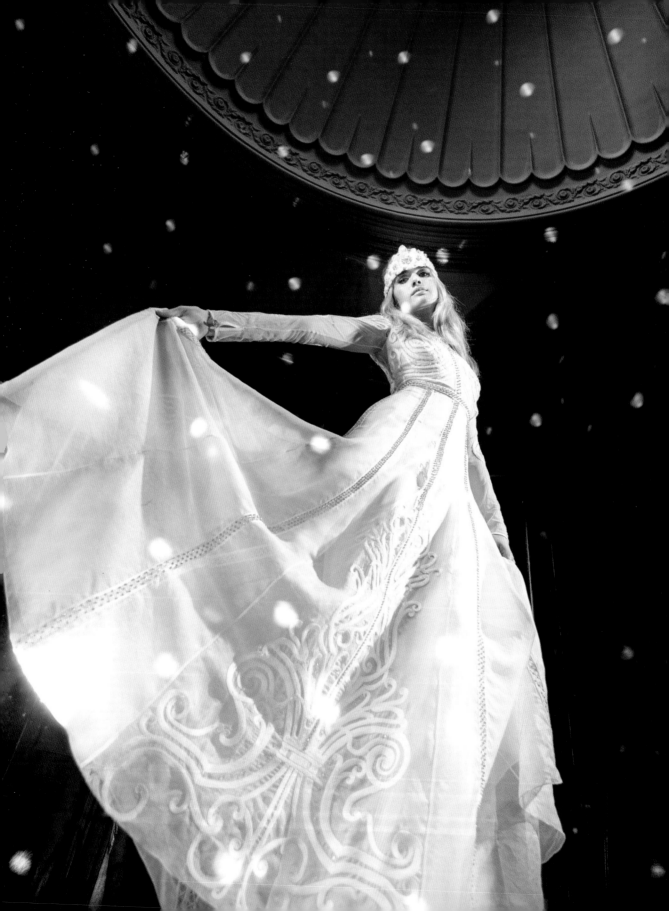

Romance, embellishment,
dreams, lace, and love

n the 1970s, fully aware that Cinderella, Sleeping Beauty, and Snow White (women made helpless and corpse-like in need of a gift, a kiss, a rescue to imbue them with just enough life to wed and serve their saviours) were seen through a patriarchal lens, critics and writers reclaimed the fairy tale as feminist. Rather than switching out myth for cold truth—once upon a time, gender was performative, and they all lived happily ever after in equality, the end—B-side tales that were unsampled for centuries were anthologised; the ones at the forefront were edited, resampled, and bootlegged. Brand-new classics were added to the mix.

Angela Carter set myth ablaze. She turned Beauty into a Beast and had Red Riding Hood slay her grandmother. Rather than fitting the characters into a more egalitarian framework, she wrote them brutal, sexual, corrupt. She made them bad to show how they could be anything. Carter once said, "A wedding dress is like a gift-wrapped girl." A fair feminist critique, but if she has shown us that myths are myriad, and we know that so too are women, then it only extends this logic an inch to say that the maligned wedding dress could, in its multiplicity, also be fierce.

Bridal is where Alice's training in textiles shines brightest. Artisanal techniques brought back into play from the eras or the cultures they had been benched in. New technologies drafted in to freshen the game. The design studio visits the best mill archives in Italy to examine woven jacquard and lace. Hand-worked layers of crystal bugle beads, mirrored circles like some exploded disco ball, bright colours embroidered over layers of tulle, white on white on white— there is no signature style. That is the point. The power of these dresses is in their distinction.

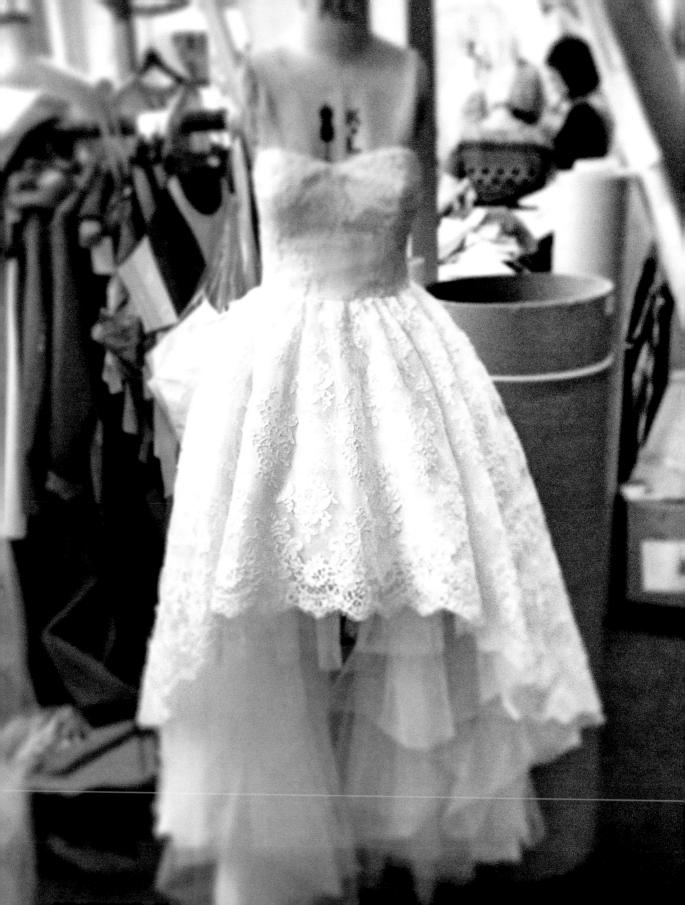

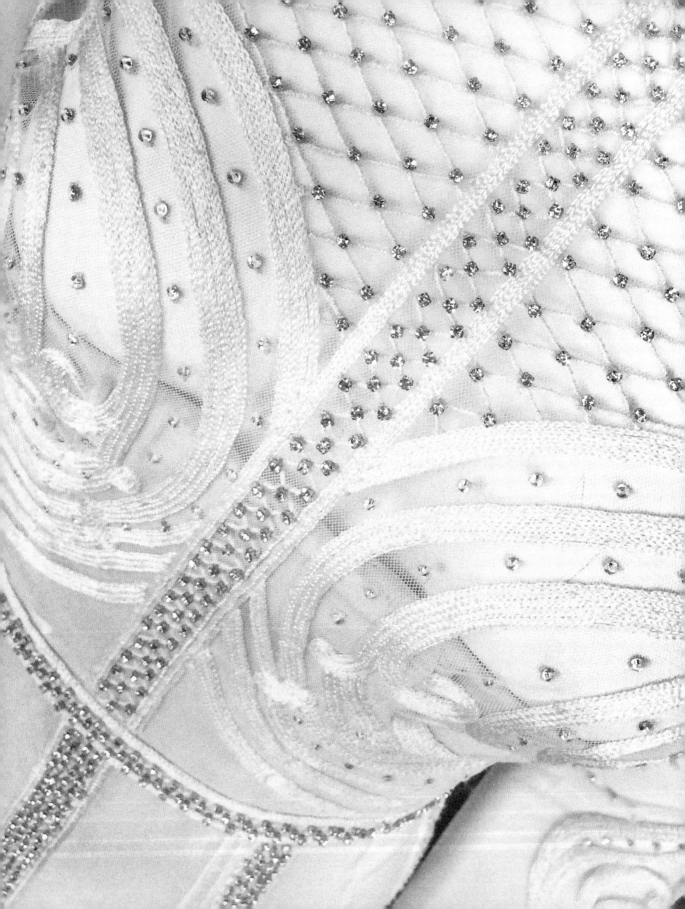

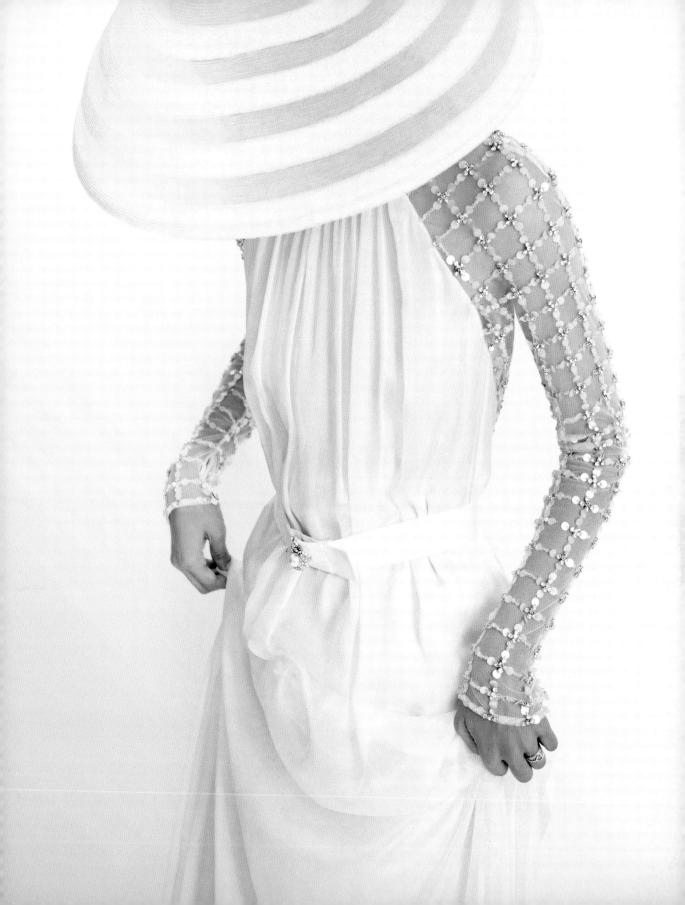

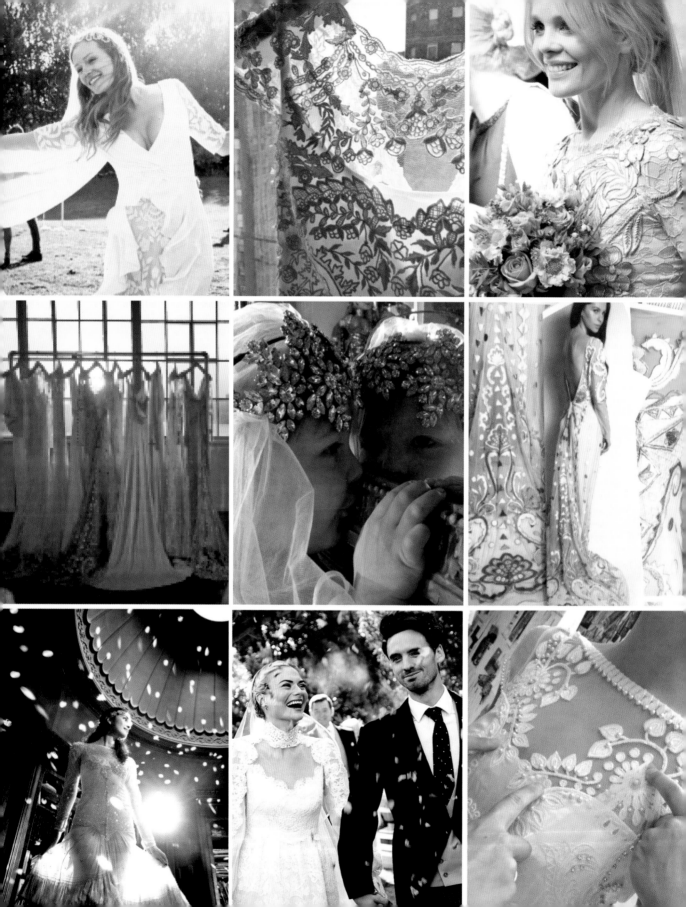

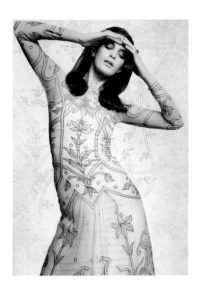

Zoom in, and the difference heightens. Alice stitches symbols into her designs to make a dress personal to its wearer. Her sister Mary, wedding a boat builder Jake Motley, had anchors and ships embroidered onto her veil. Another bride, marrying a singer, wore lyrics woven into the dress. Another still, an appliquéd poem. Favourite flowers have been painstakingly incorporated into the embroidery layouts and tiny blue sequins—something new—hand-stitched to petticoats, invisible but there. When Alice's friend Jacquetta Wheeler married James Allsopp, a veil in Carrickmacross lace—a family antique—was deemed too delicate to wear. Alice traced the forget-me-nots and dog roses of the nineteenth-century design and had them embroidered onto a new dress and veil. Thanks to Alice, Jacquetta walked the aisle in her heirloom.

Alice has dressed a thousand brides. When she says, "All weddings are myths," she demands more of the word than we have come to expect; she means brazen romance. Love like fire. No apologies. Make a woman a legend for one day, and she knows she can be strong, fast, outrageous, savage, vulnerable, unbelievable, smart, political, unwise, unfettered, unreasonable, undone, everything for all the others she lives. Temperley brides don't need their groom, they *want* him.

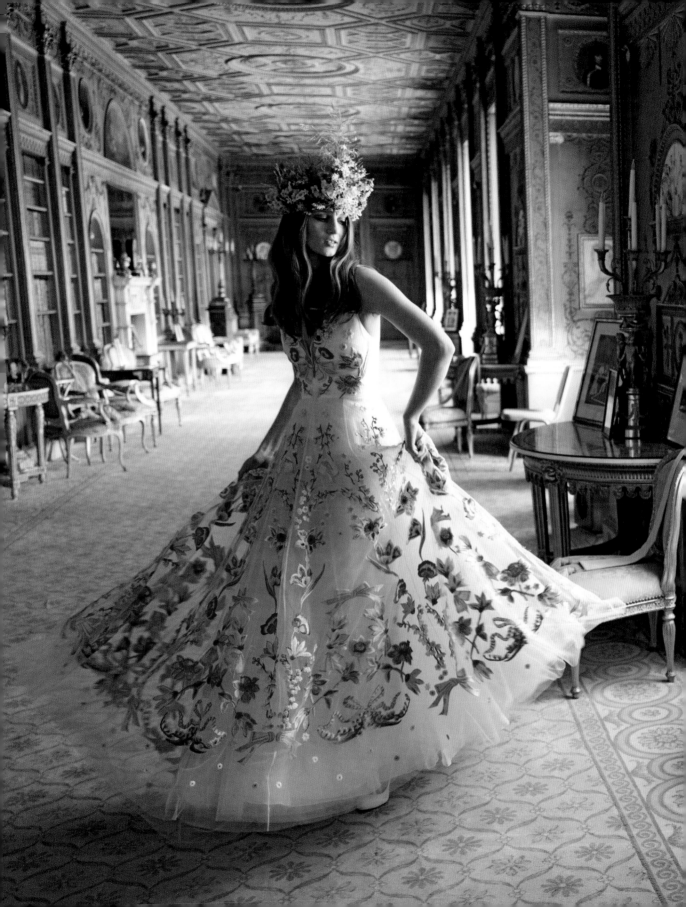

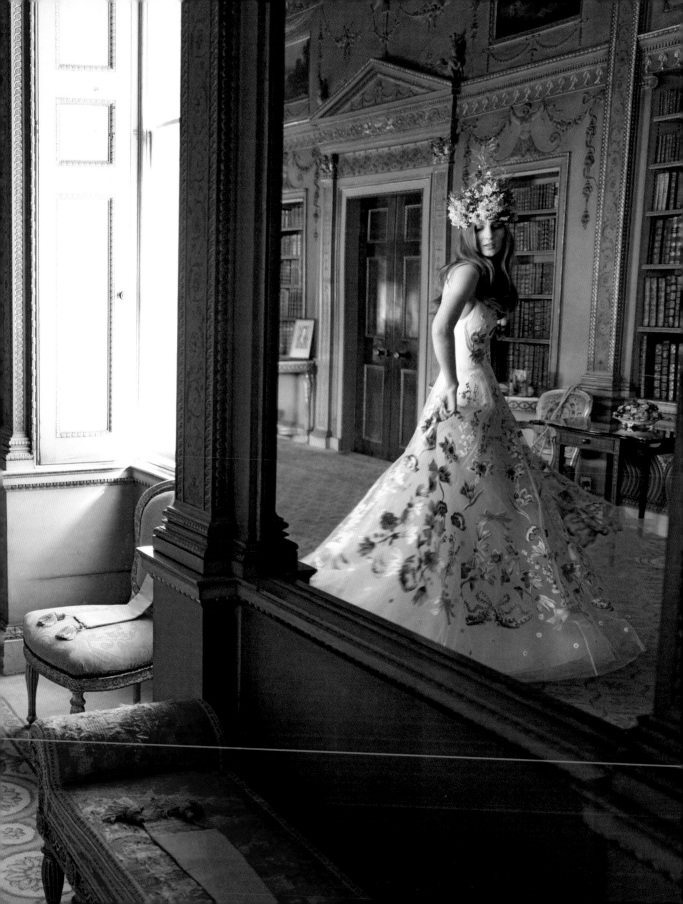

> "I know a bank where the wild thyme blows,
> Where oxlips and the nodding violet grows,
> Quite over-canopied with luscious woodbine,
> With sweet musk-roses and with eglantine:
> There sleeps Titania sometime of the night,
> Lull'd in these flowers with dances and delight."

— WILLIAM SHAKESPEARE, A MIDSUMMER NIGHT'S DREAM (1600)

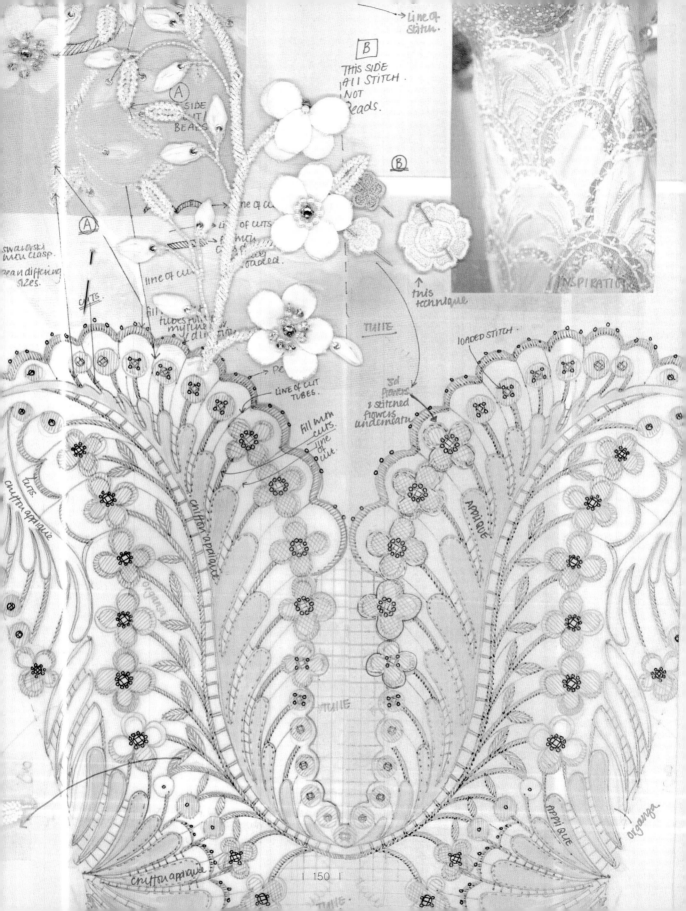

→ Line of stitch.

B
This SIDE
ALL STITCH.
NOT
Beads.

B

A SIDE
COUNT
BEADS.

INSPIRATION

this technique

→ line of cuts
→ line of cuts
→ line of cuts
placed.

line of cuts

SWAROVSKI
with CLASP.
bean differing
sizes.

CUTS.

A

fill in
tubes fill in
my line
direction

TULLE

LINE OF CUT
TUBES.

Fill with
cuts.
line
of cut.

TULLE

loaded stitch.

3d
flowers
& stitched
flowers
underneath

cuts.
chiffon applique

chiffon applique

organza

APPLIQUE

TULLE

| 150 |

chiffon applique

APPLIQUE

organza

TULLE

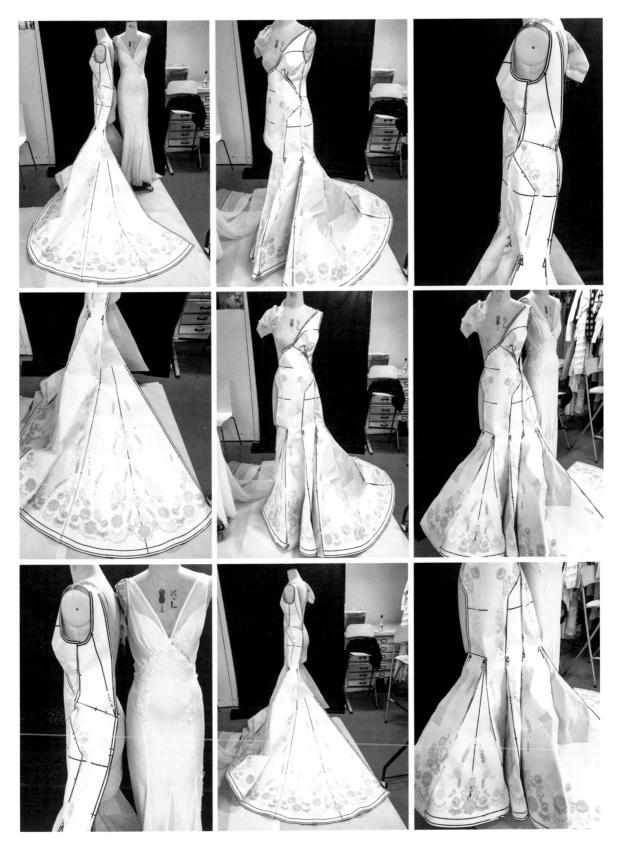

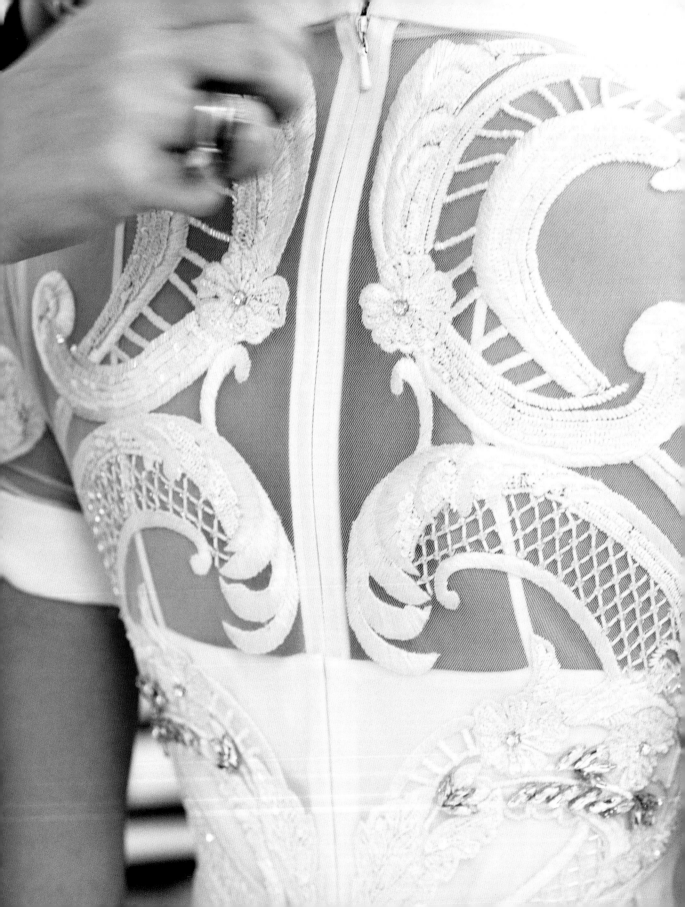

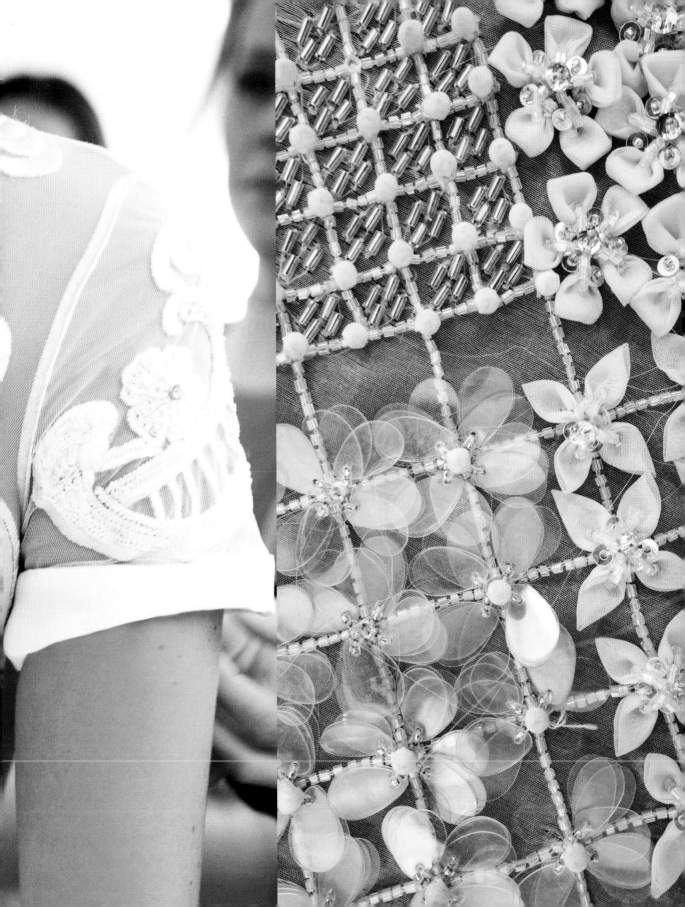

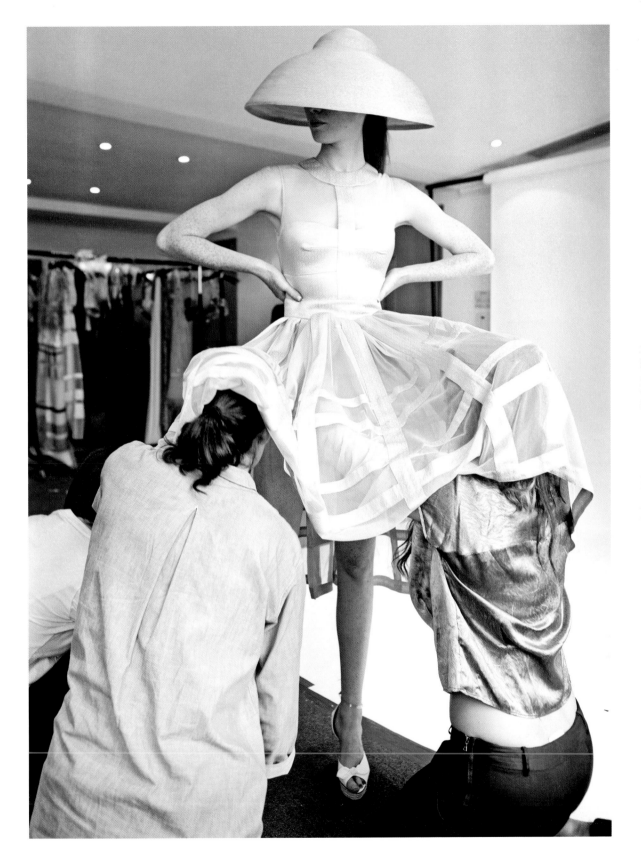

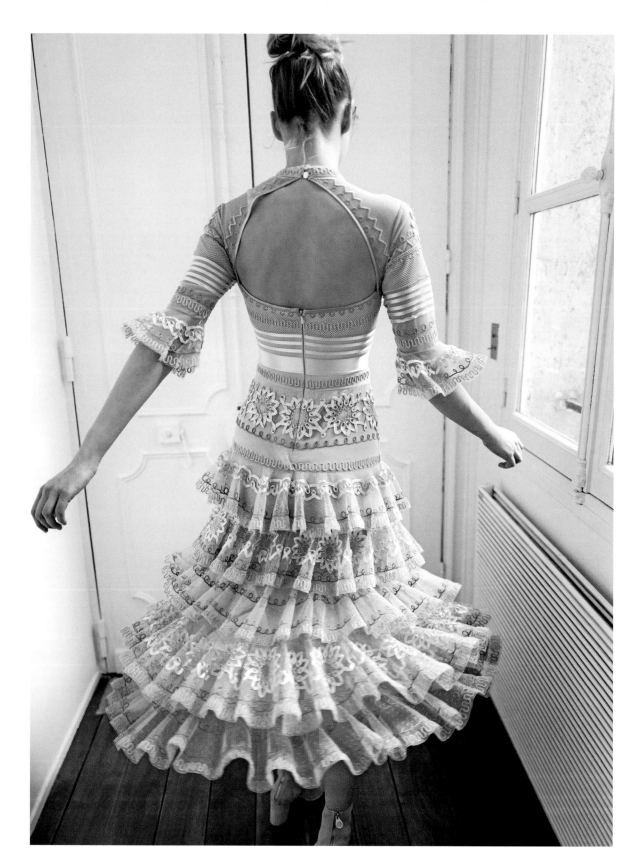

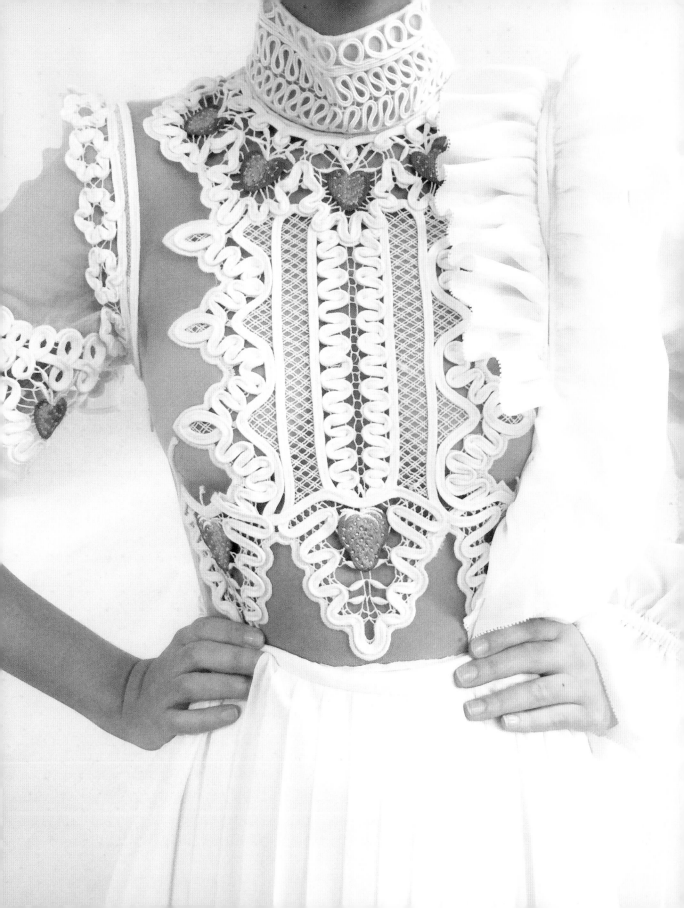

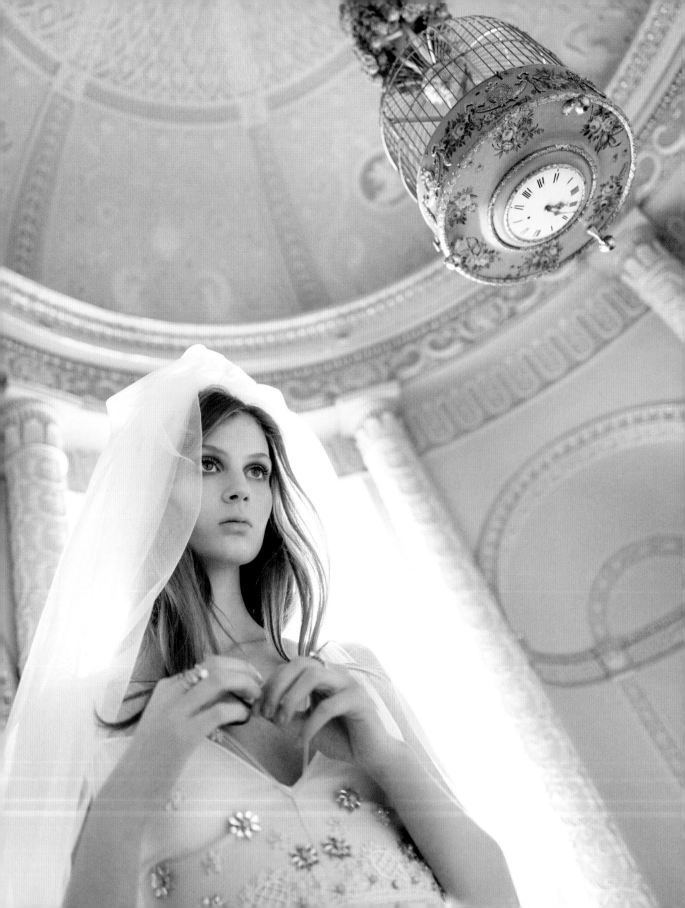

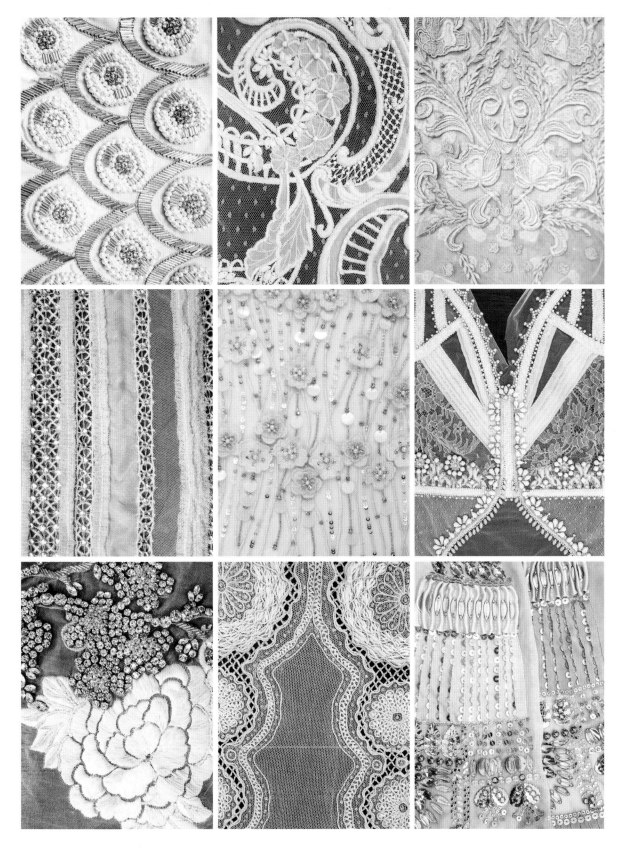

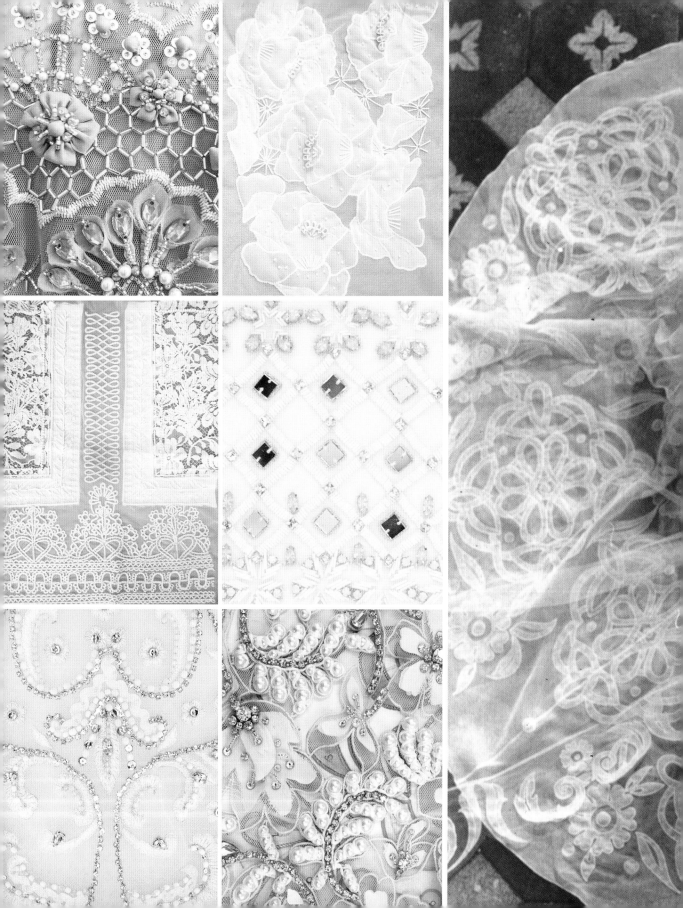

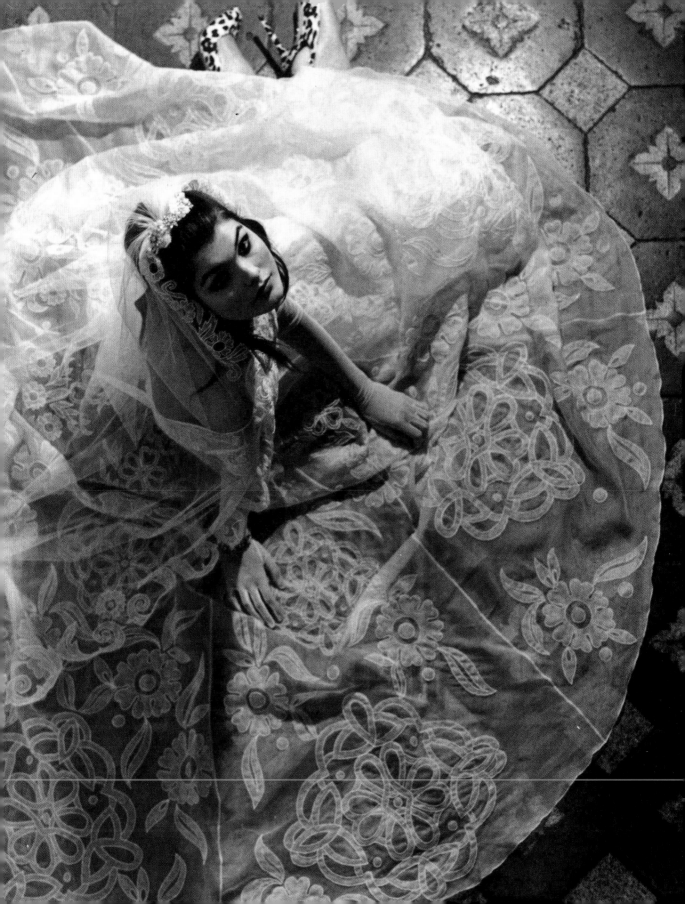

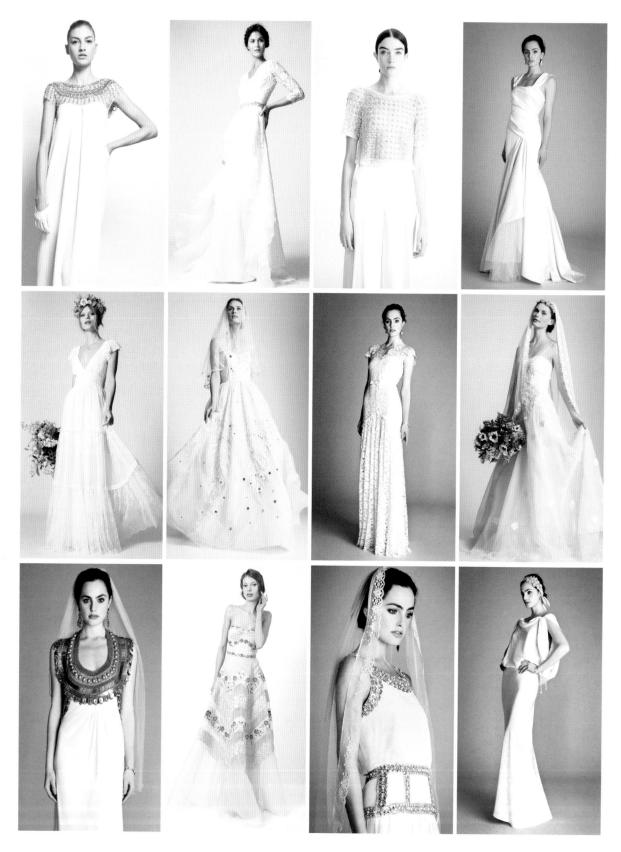

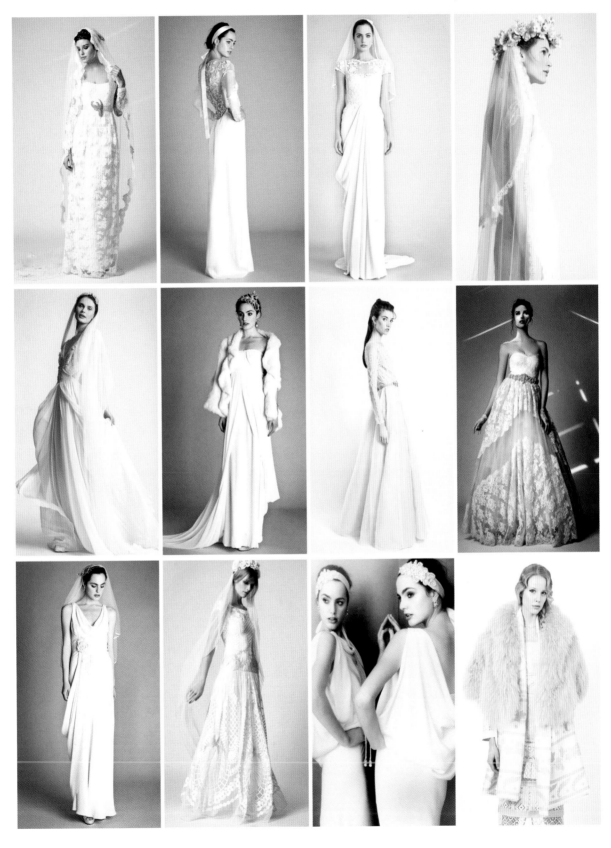

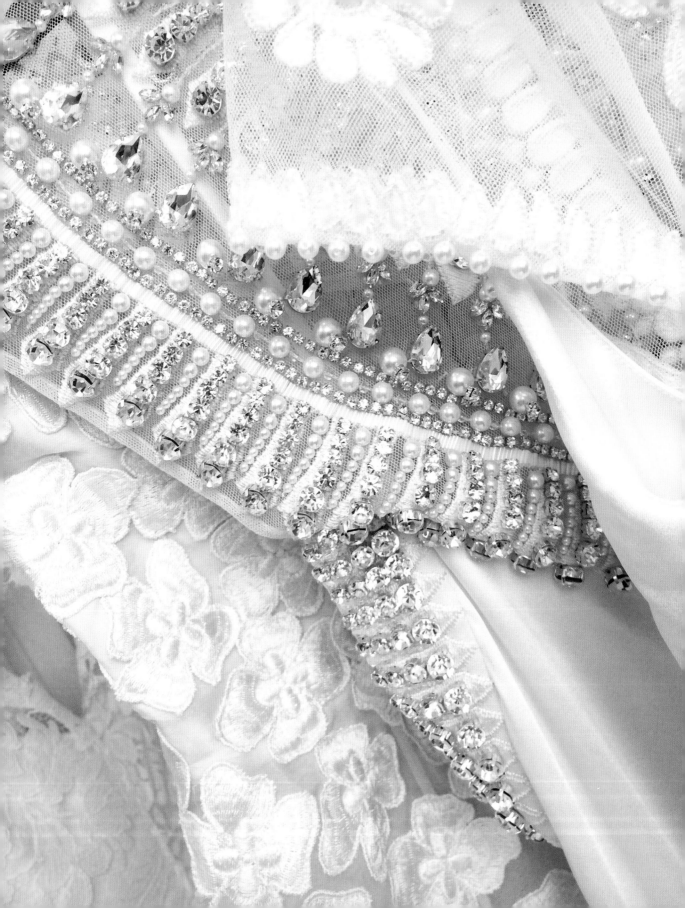

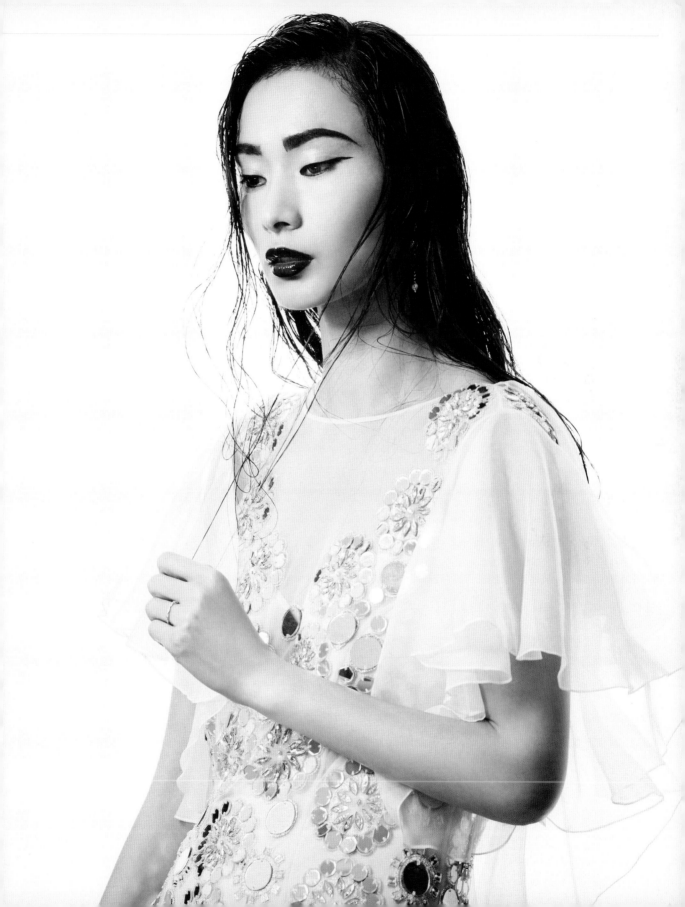

> "Temperley brides don't need their groom, they *want* him."

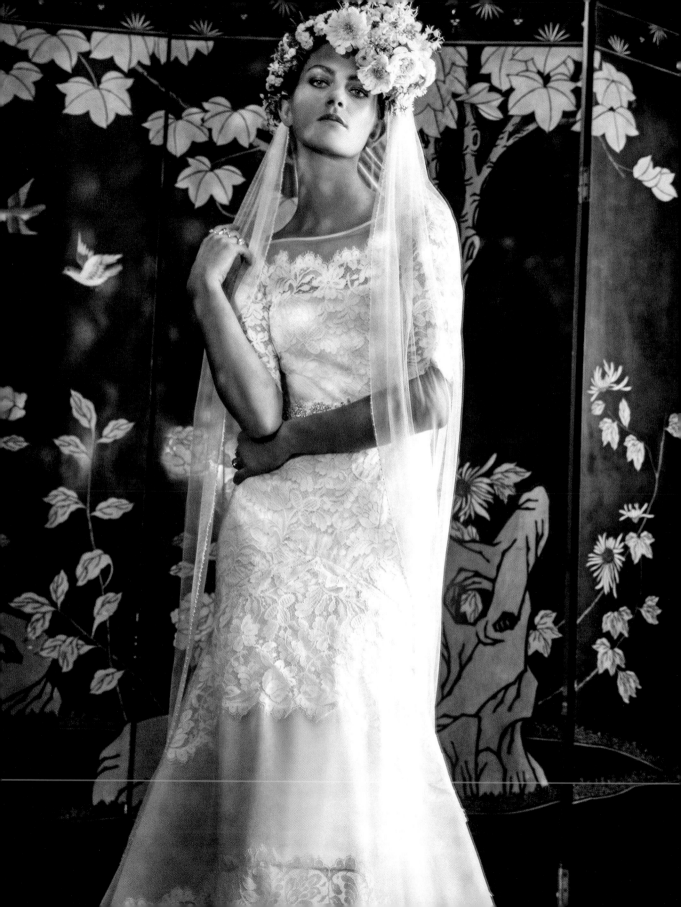

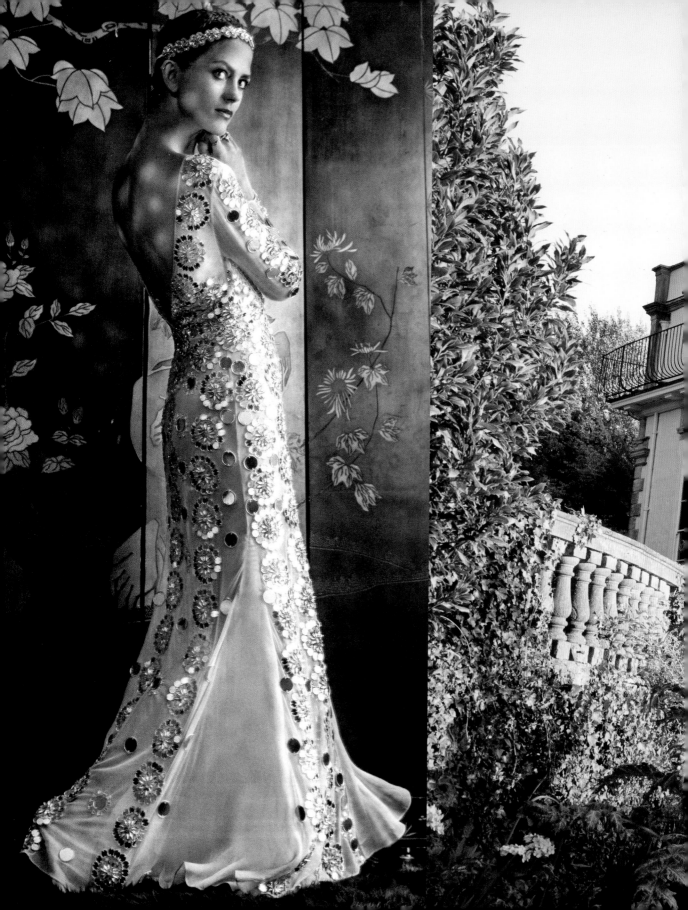

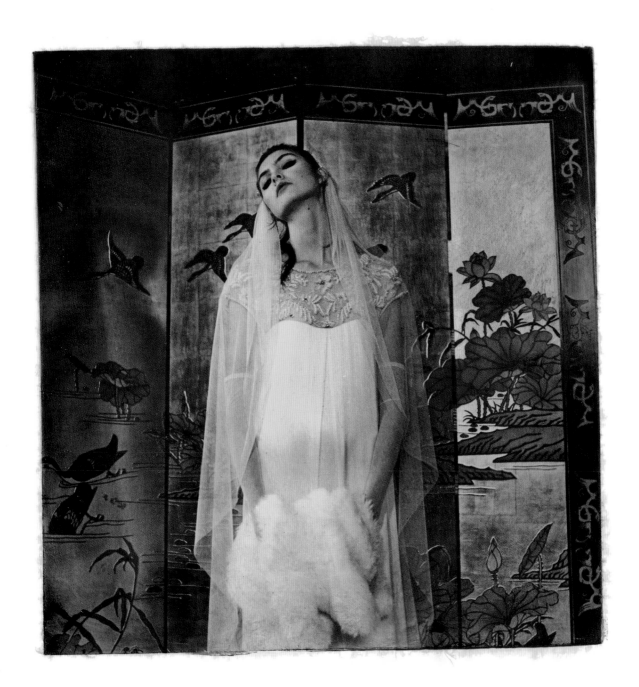

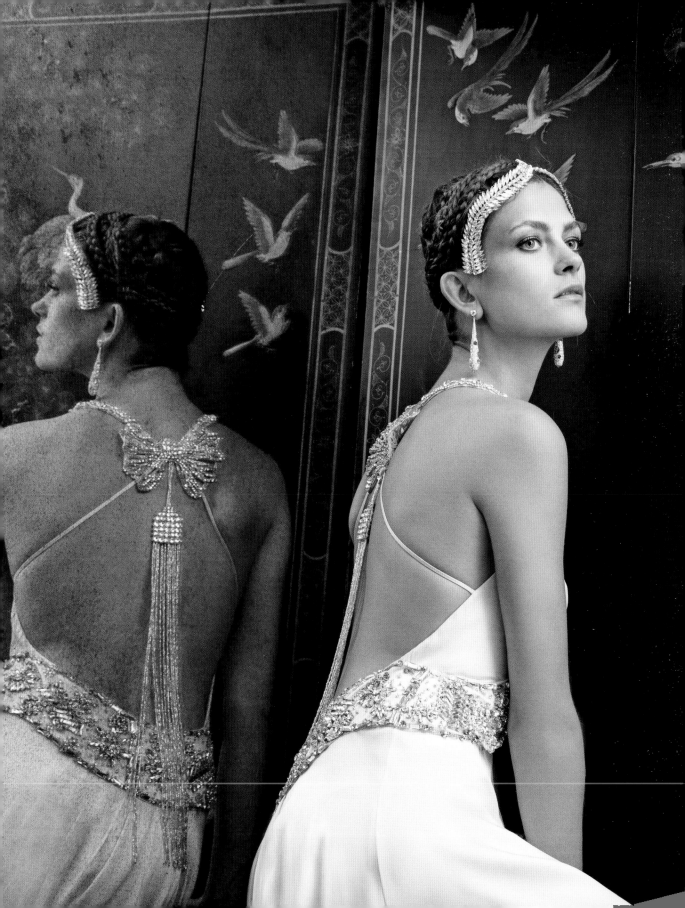

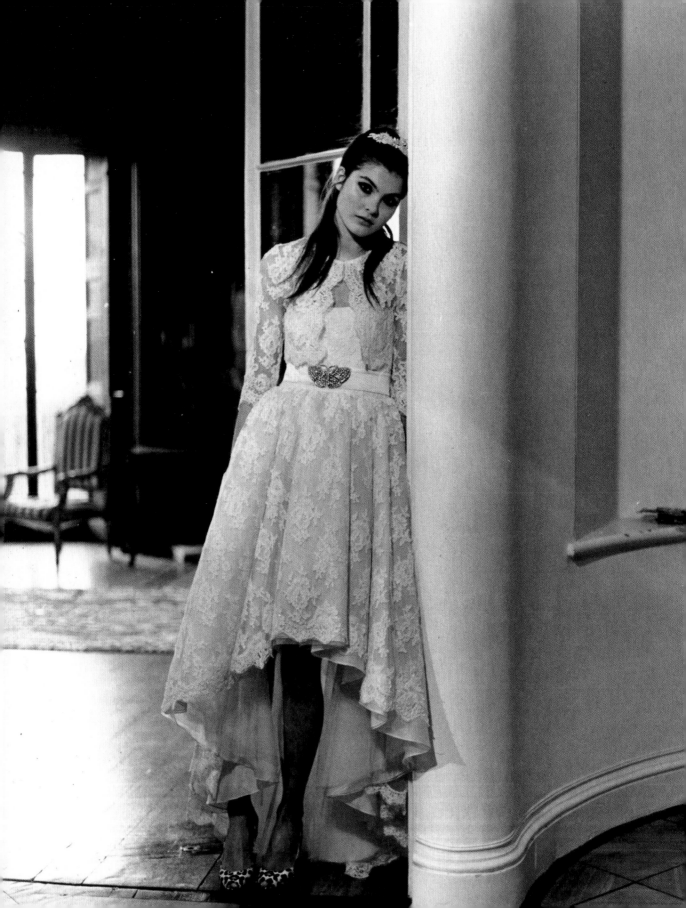

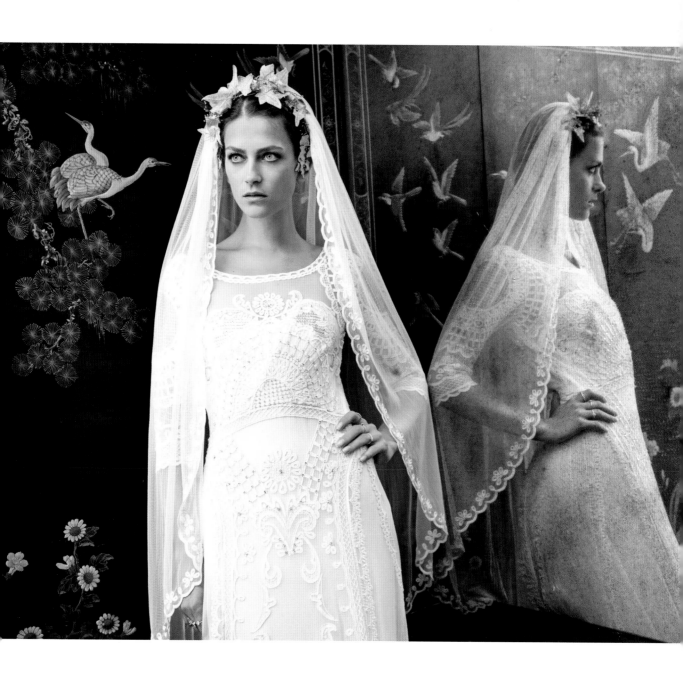

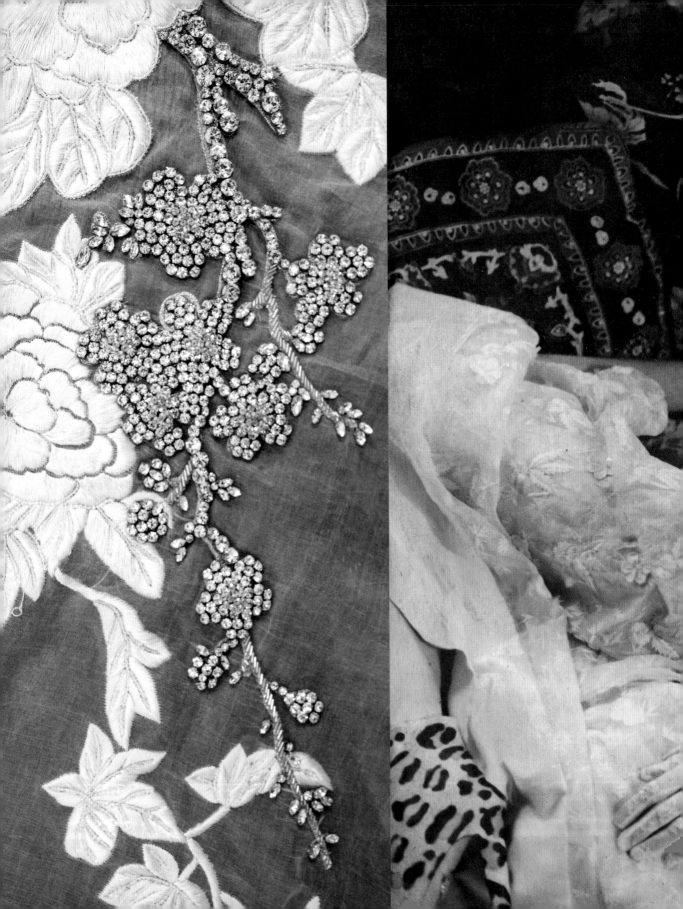

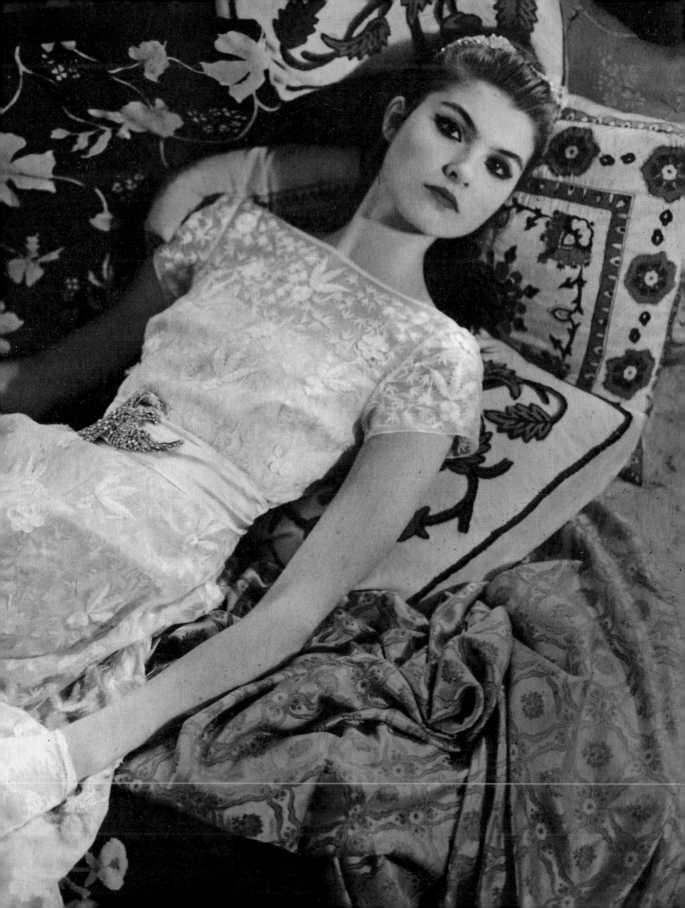

"Make a woman a legend for one day, and she knows she can be strong, fast, outrageous, savage, vulnerable, unbelievable, smart, political, unwise, unfettered, unreasonable, undone, everything for all the others she lives."

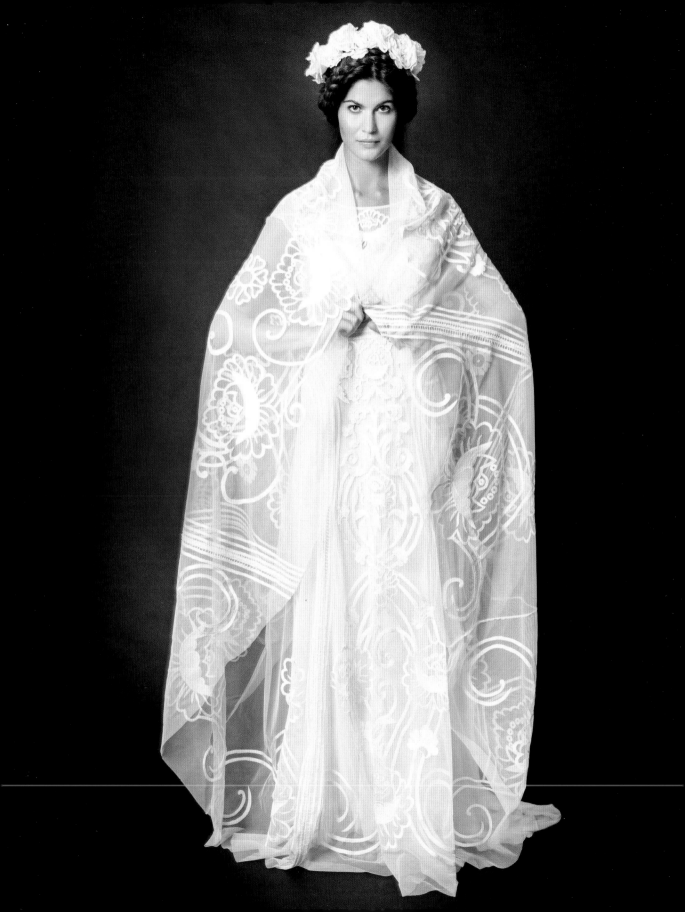

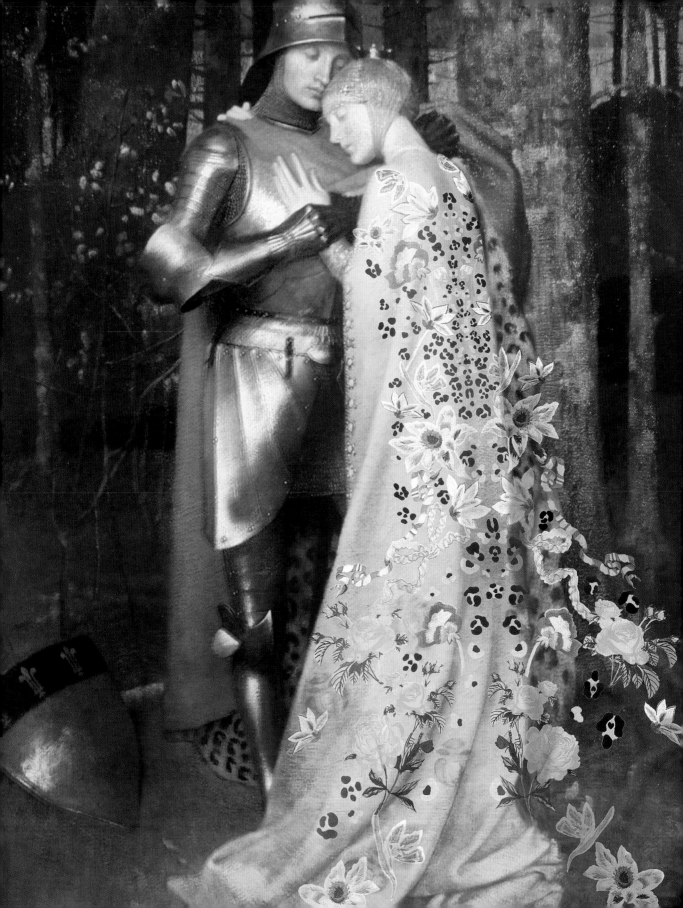

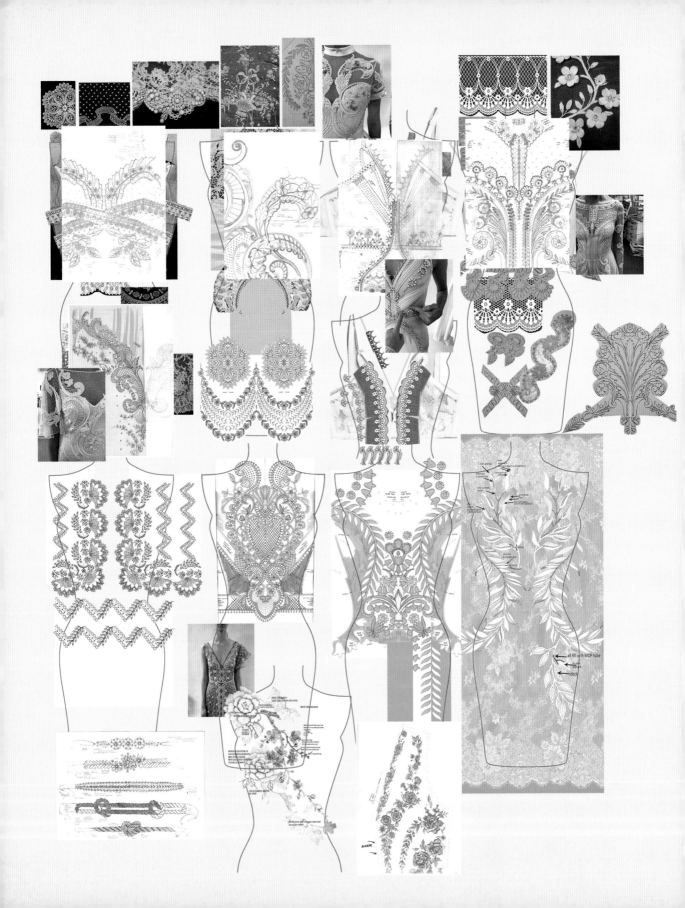

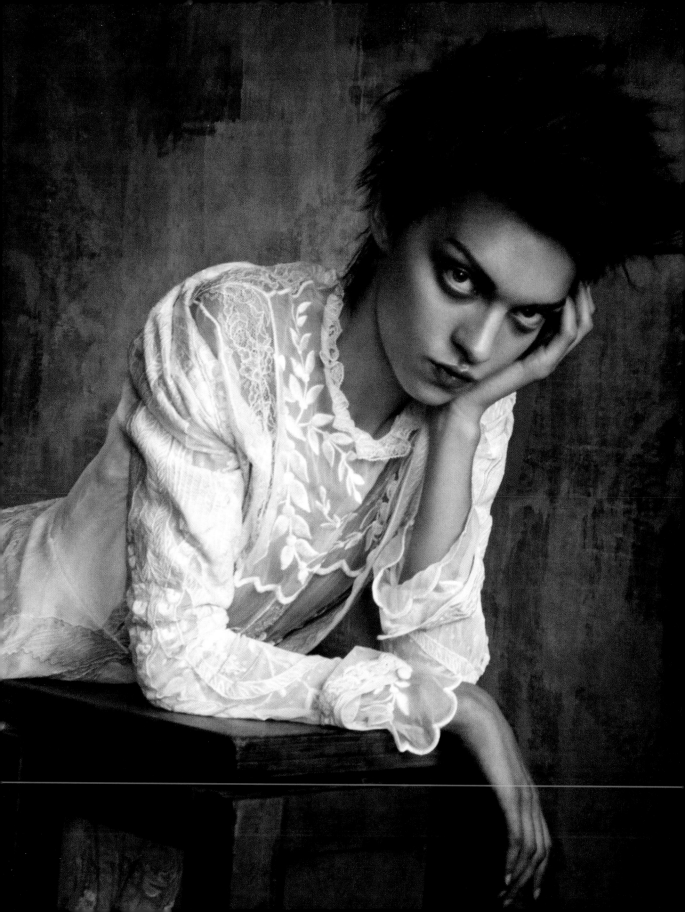

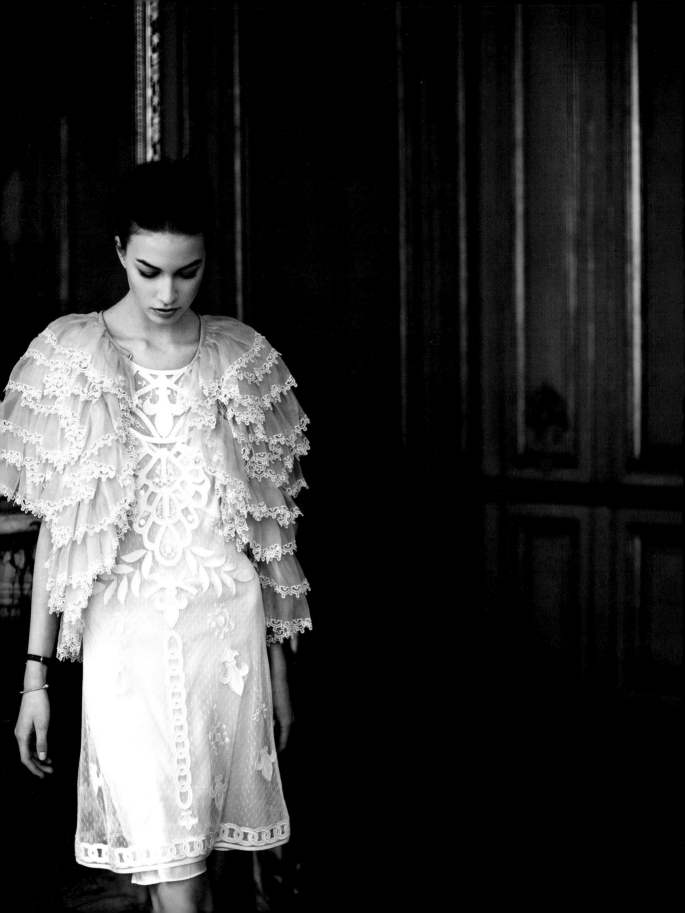

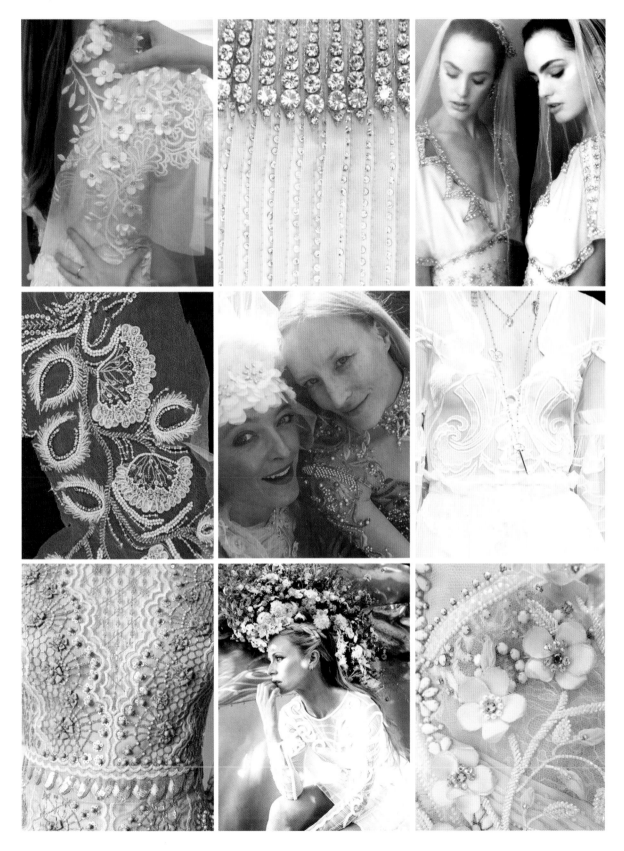

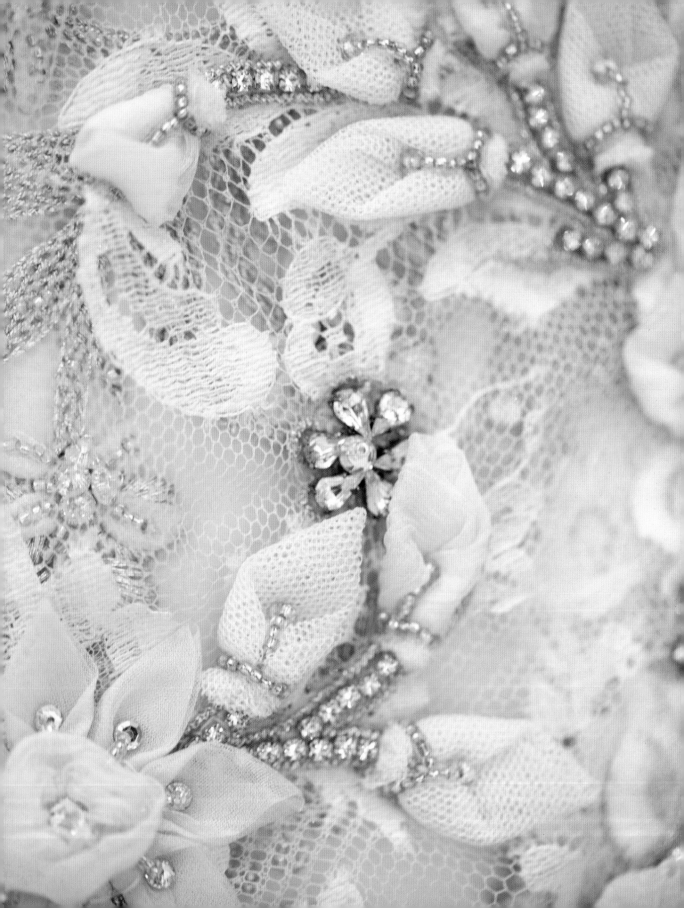

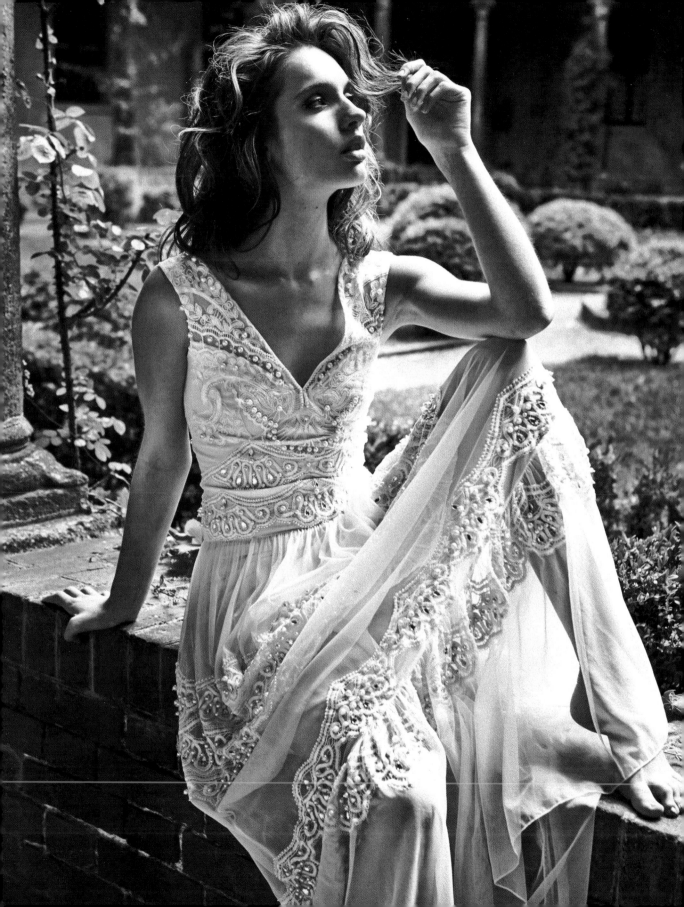

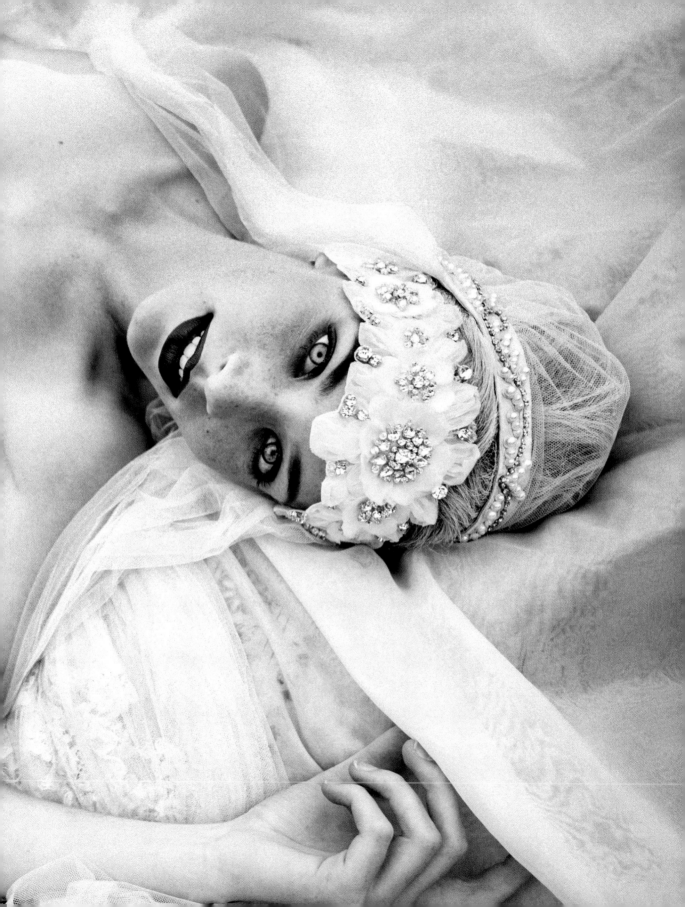

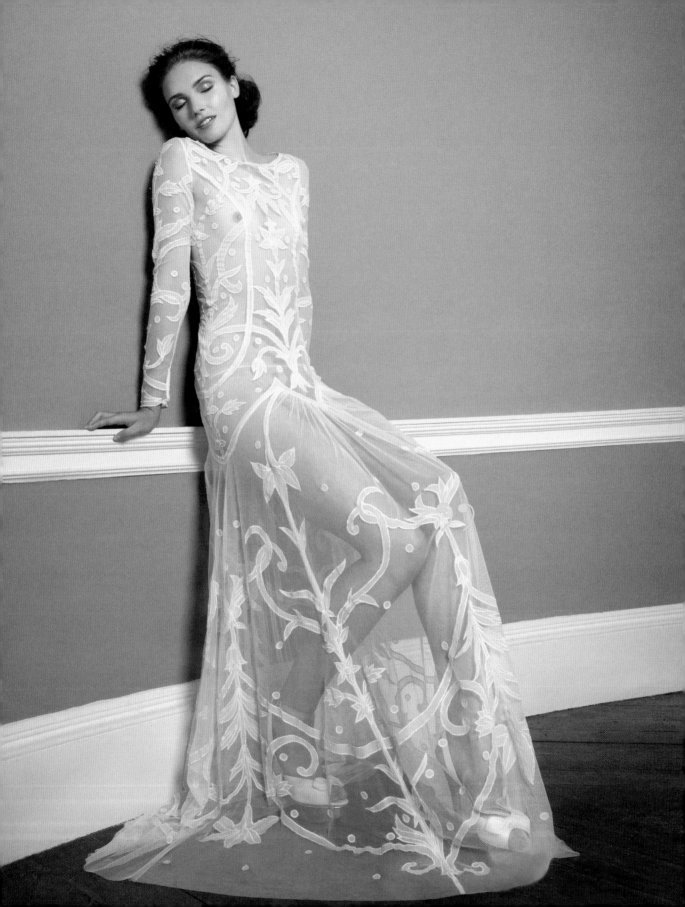

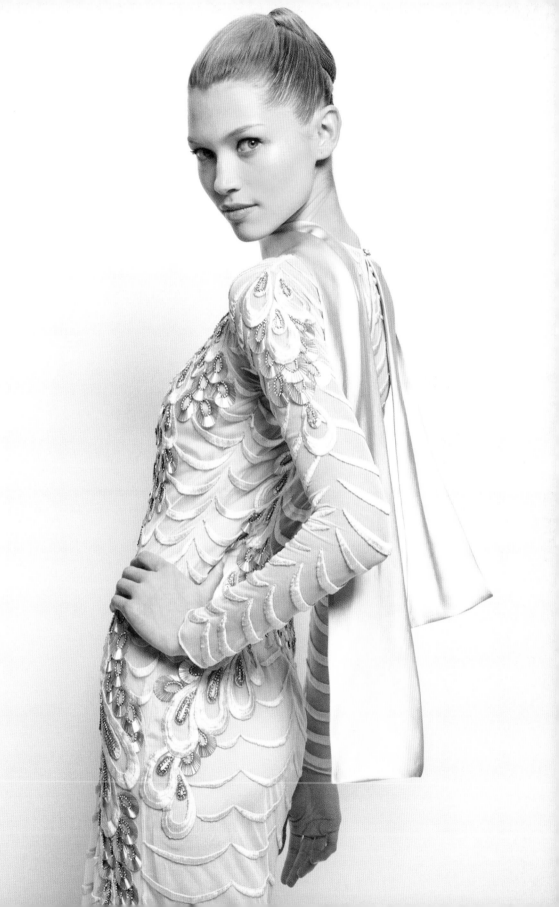

"Within the West Wind's mighty arms, nor woke
Until the light of heaven upon her broke,
And on her trembling lips she felt the kiss
Of very Love, and mortal yet, for bliss..."

— WILLIAM MORRIS, THE EARTHLY PARADISE, (MARCH-AUGUST) (1868)

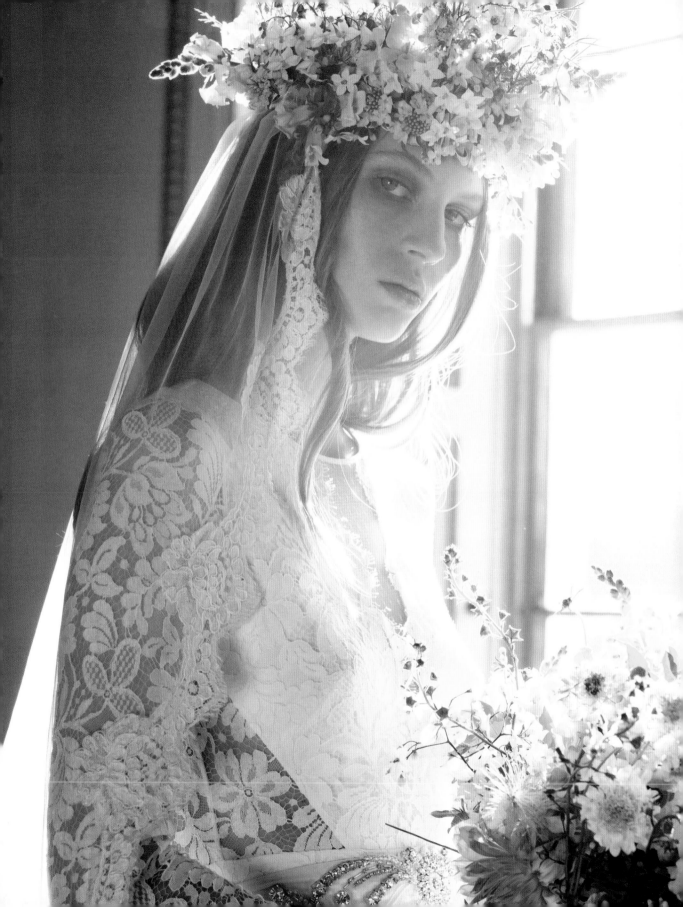

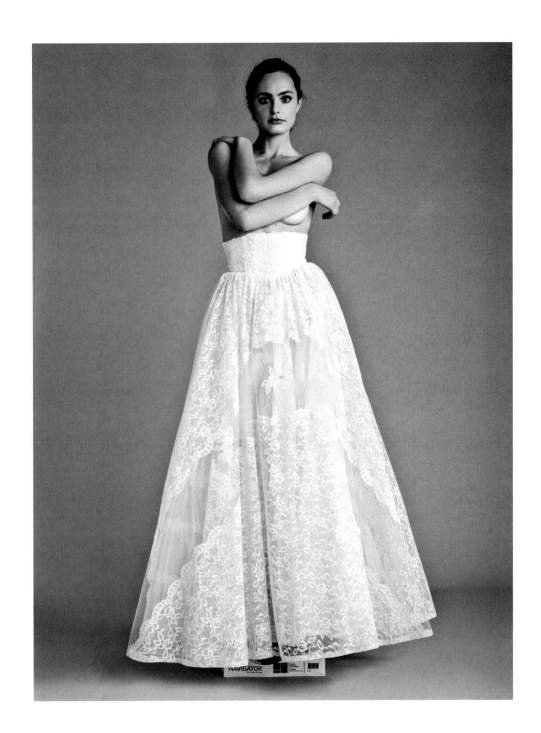

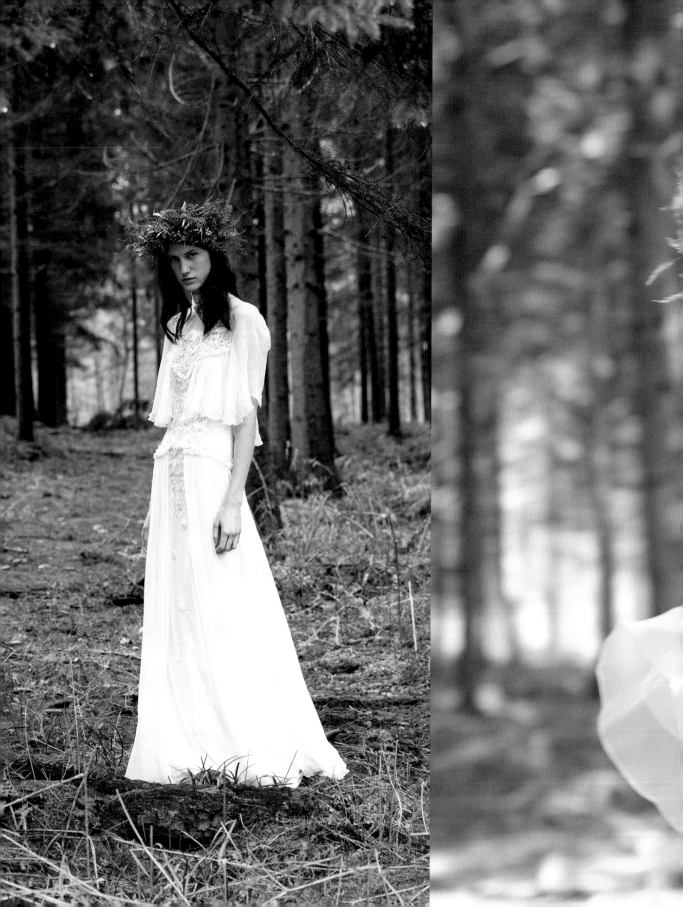

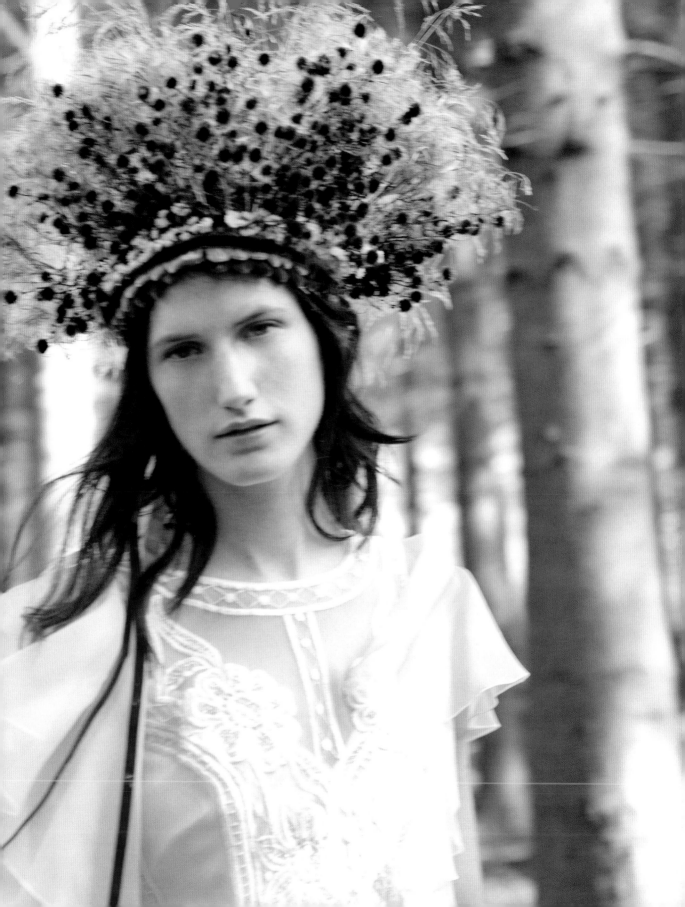

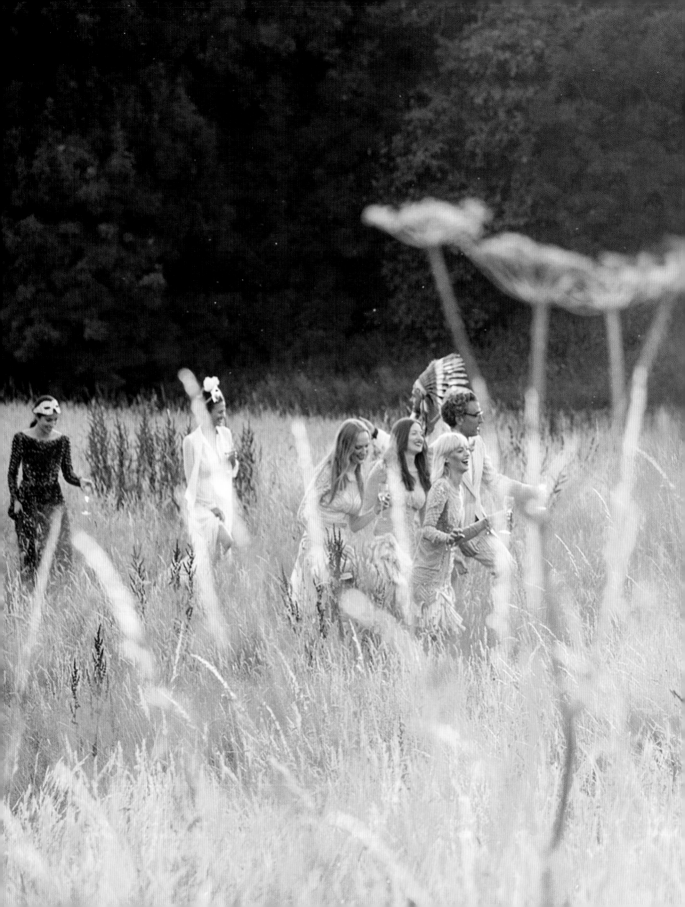

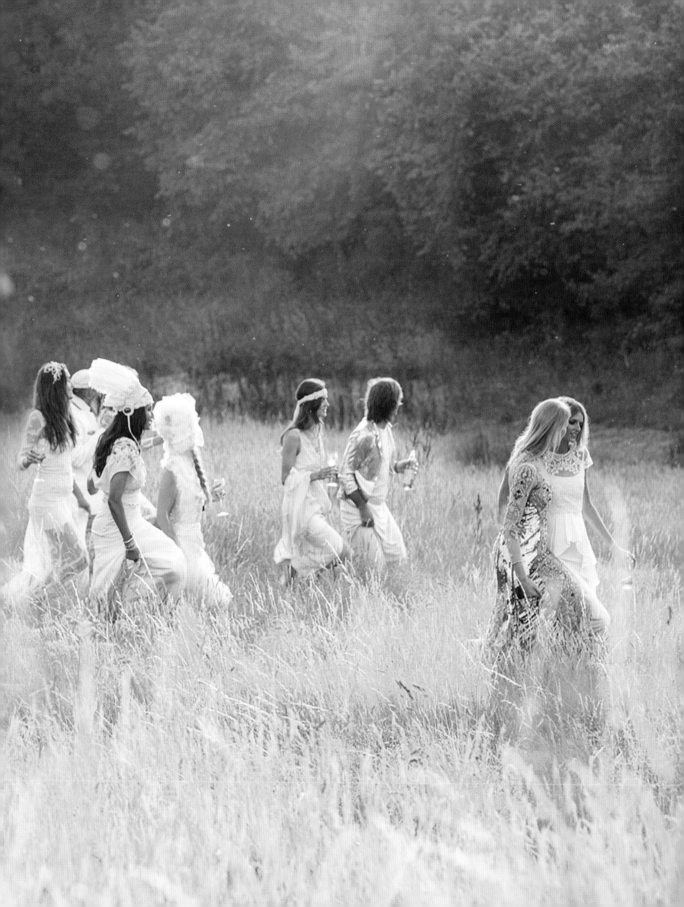

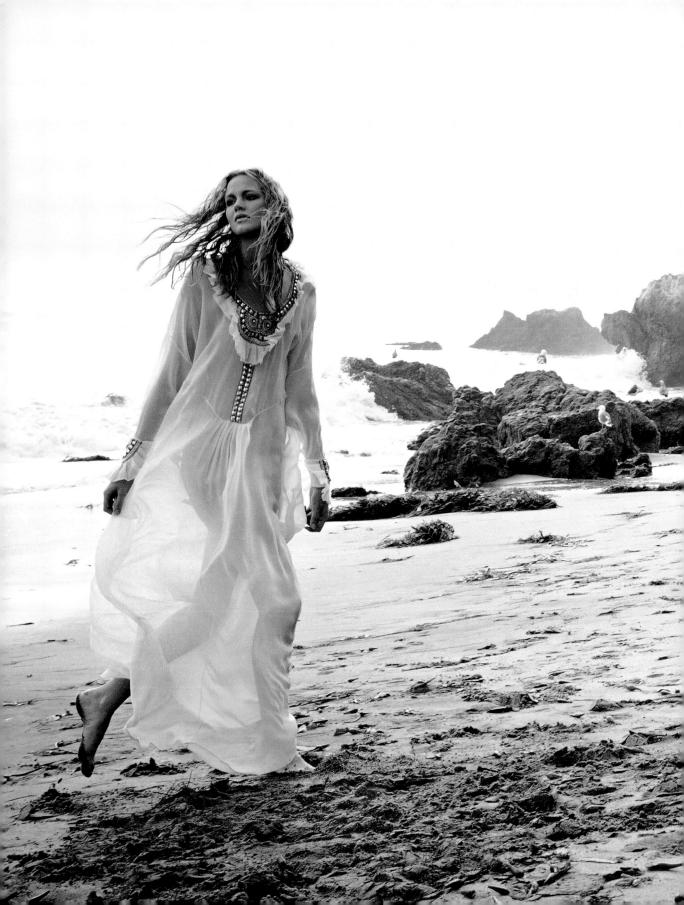

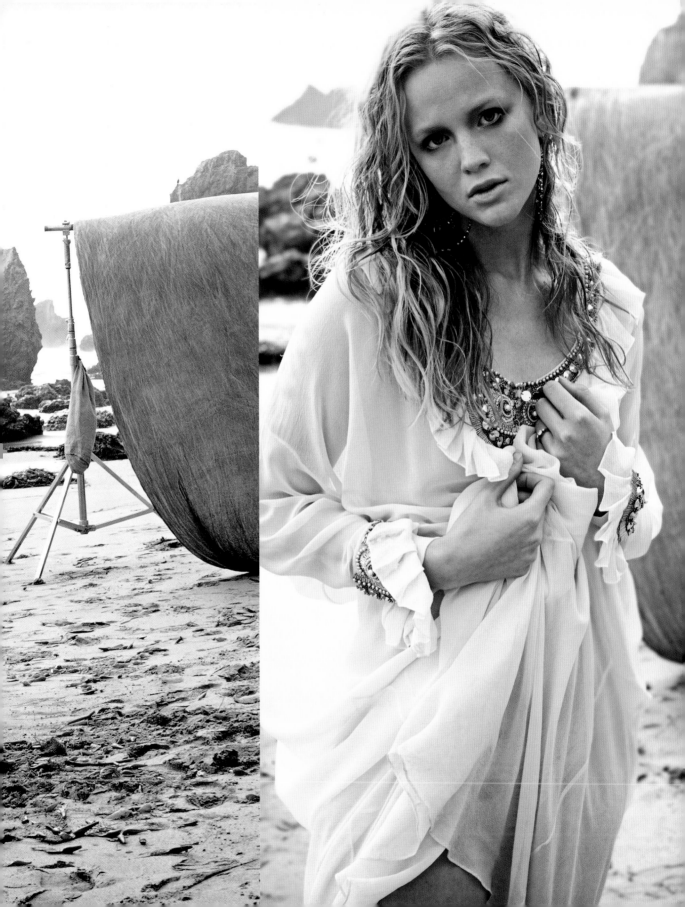

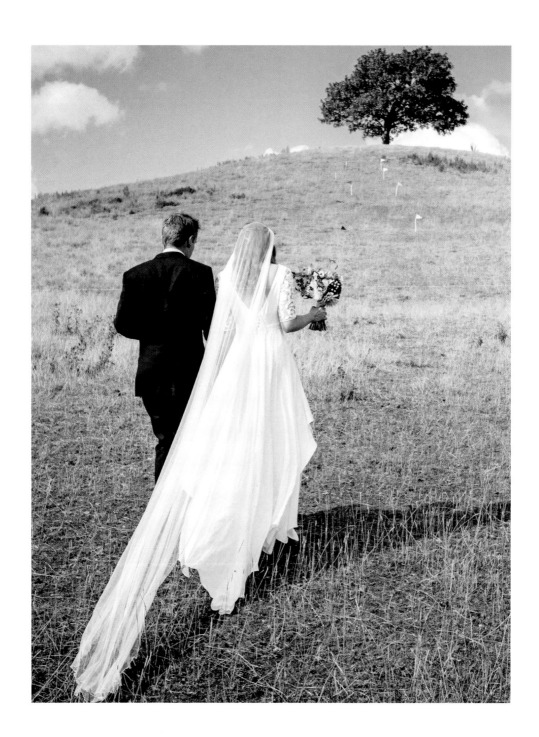

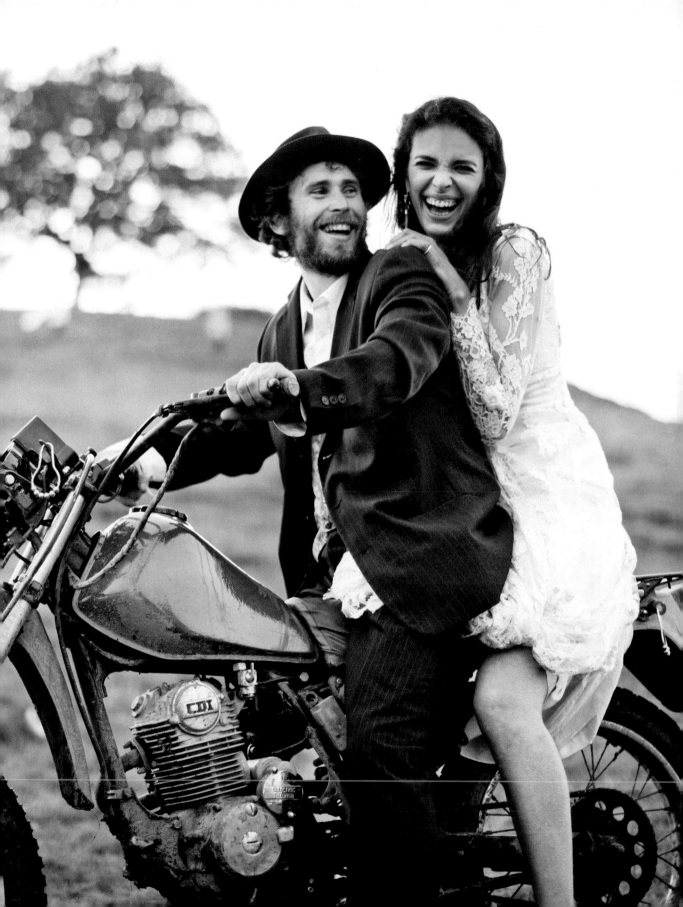

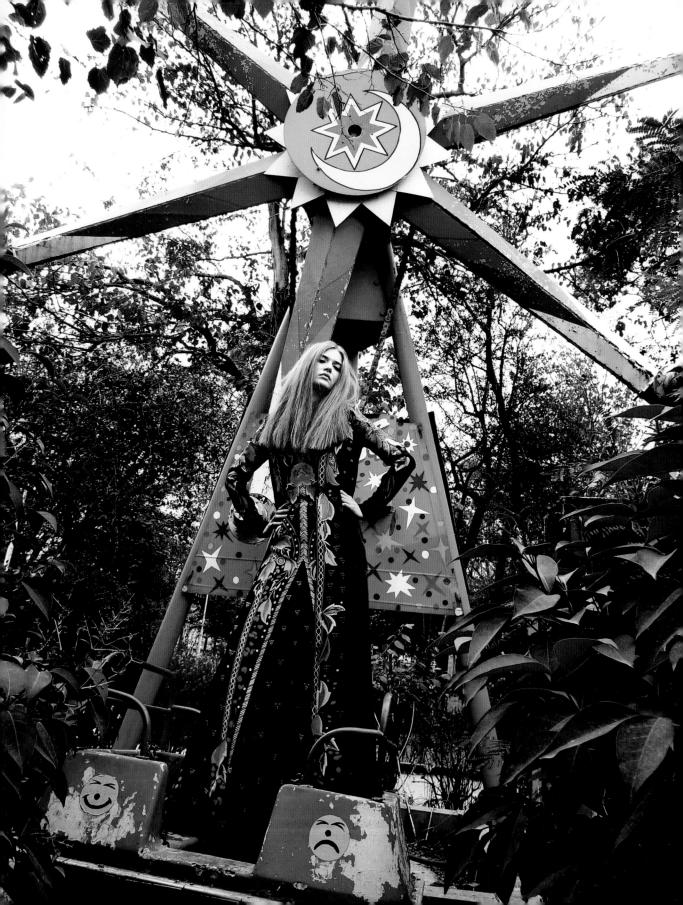

# ALCHEMY

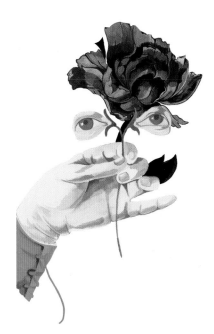

Magic, technique,
illusion, and kaleidoscope colours

phrodite lends her name to any food, drink, or drug that awakens sexual desire. Parvati and Oshun named rivers. Venus a planet. Astarte, another goddess of love, shares hers with a magic trick. Developed in part by William Ellsworth Robinson—a magician who literally bit the bullet on a number of occasions before metaphorically doing so on stage in 1918—Astarte is the act of levitating a woman and letting her spin and move mid-air. Robinson's grey-eyed lover Olive Path took a leg-up, danced while suspended on the breeze, twirled, and allowed a hoop to be passed over the length of her body before she descended to the boards.[5]

Look closer, dear audience. Can you make out the wires? Of course not. This is magic.

The more you look, the less you see. Anyone seeking to run cracks through the illusion should have instead shut their eyes. They would've heard the rumble of machinery behind the curtain: cranes with pivoted arms heavily counterweighted, twisting, turning, and crunching as the diminutive "Dot" moonwalked upside-down across the stage. Instead, they heard what they wanted to hear: the music, the cheers. They saw what they wanted to see: a woman, levitated.

The audience is complicit in the deception. Although the mechanics of a trick are darkly guarded and there are penalties for those who expose even their own devices, there are devices. To be enchanted, curiosity must be staved off in an instance. Just like love, magic requires a bit of give and take.

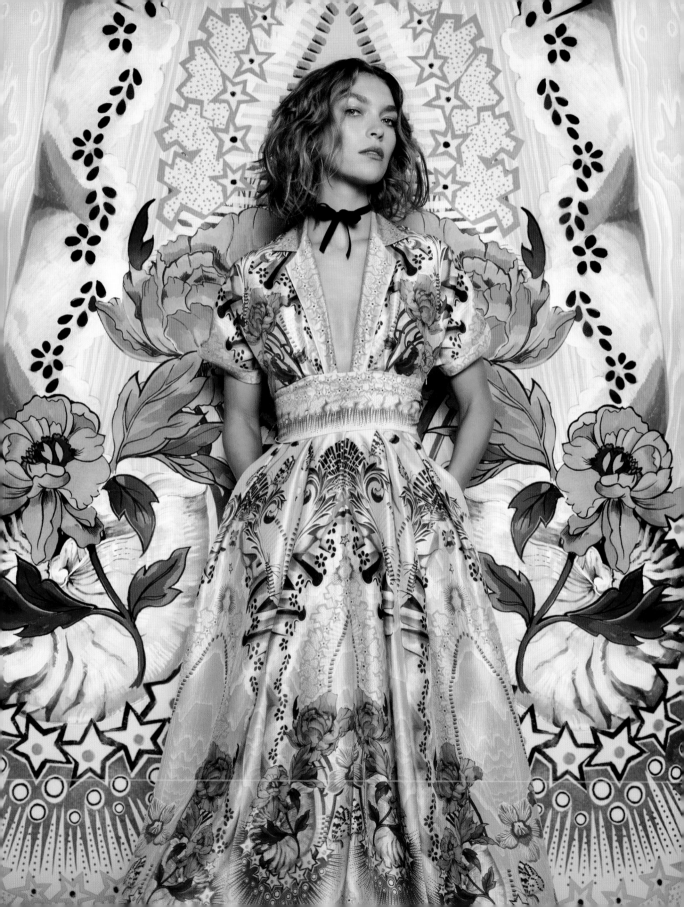

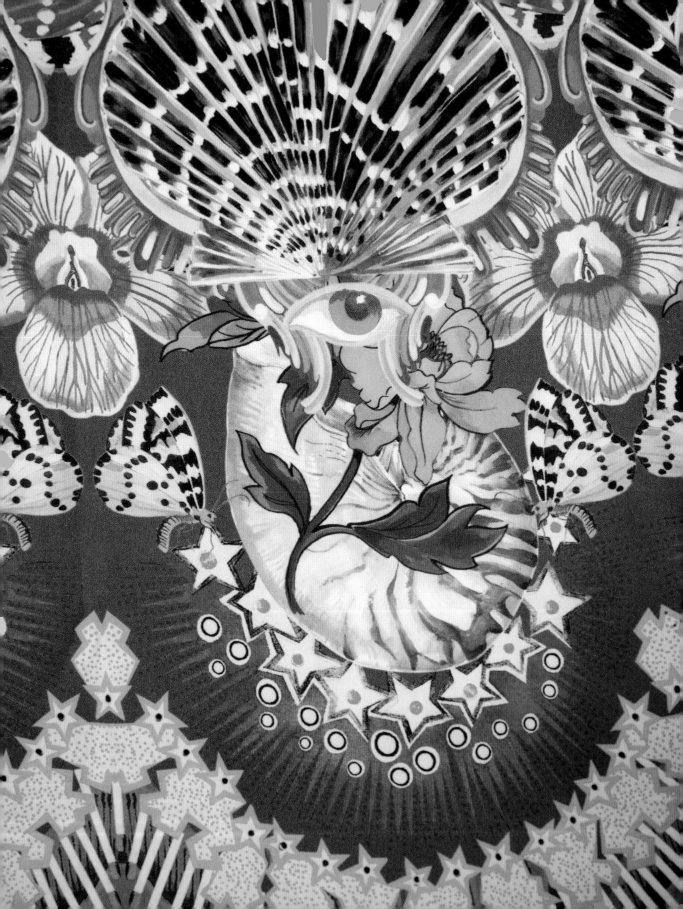

LUCIE    12. SISSI    13. EMELINE    14. JEMMA    15. GRACE    16. FLAVIA    17. ANNA    18. CLARICE    19. SIGNE

NADJA    22 QUIRINE    23. PAULINE    24 IRINA    25. CINDY    26. SANNA    27. SANTA    28. SISSI    29. ANASTASIJA

BARBARA    32 LUCIE    33 ANNA    34. CHARON    35. THEA    36. ALMA    37.    38. CHRIS    39. SIGNE

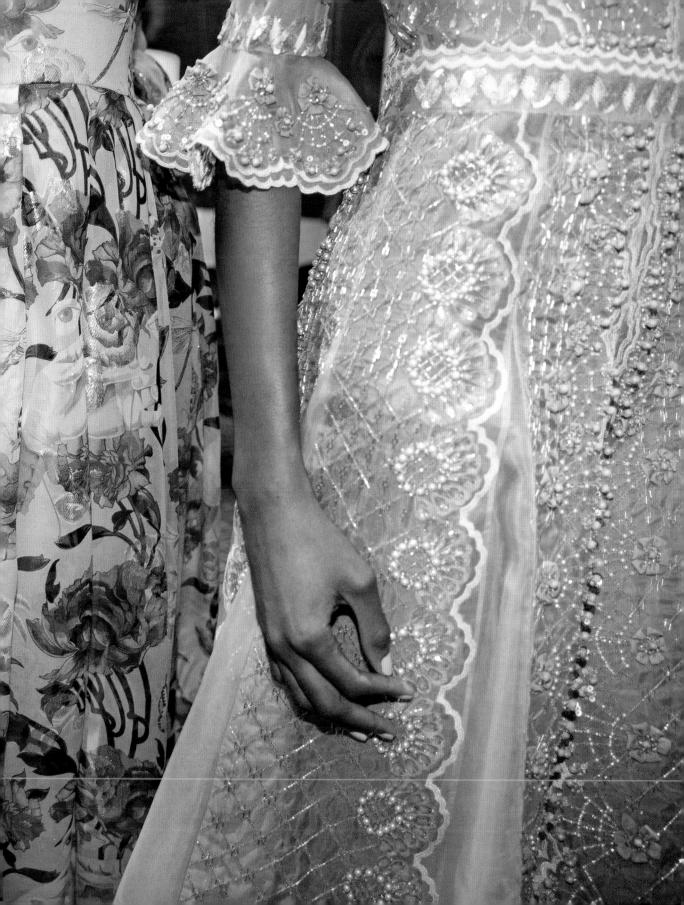

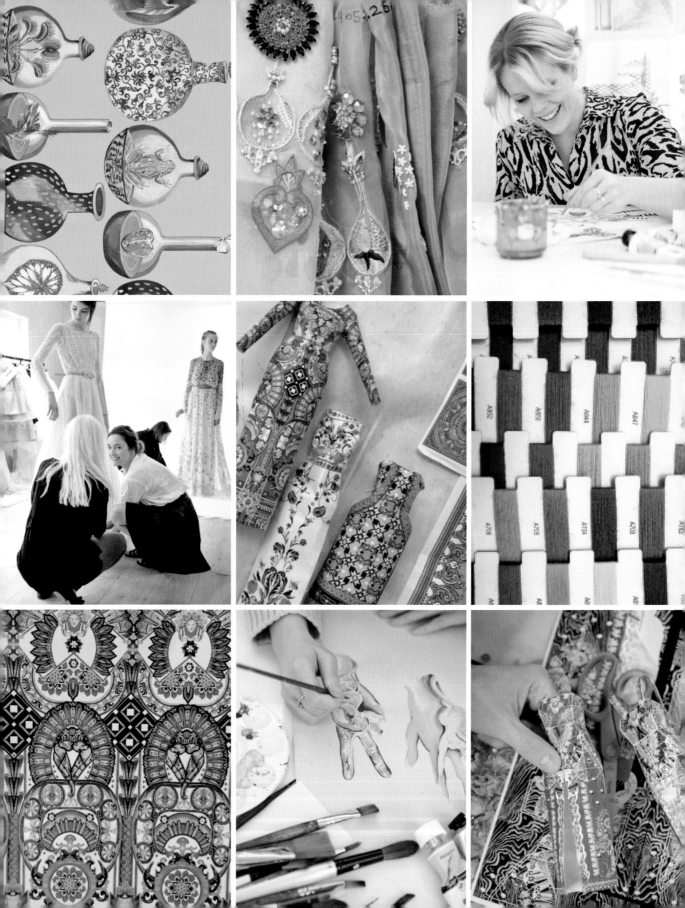

Temperley designs have often drawn from the magic realms, both the glitz of Western stage shows and the more ancient kinds that these appropriate and imitate. Summer 2017 saw crypto-zoological stitch work, a modern tapestry laid over with unknown creatures. No Big Top stripes; instead, finer lines recall maypole streamers in sun-bleached pastel colours. Embroidery traces zigzag the rickrack of outfits worn by village children on May Day. More folklore than cabaret.

The house classic—leopard print—makes its mark this time in neon pinks and violet, paradoxically rendering camouflage, so highly evolved for stealth when hunting, into something that slays brightly in a glance. Sequins are psychedelic. Patterns repeat as though they were drawn in a kaleidoscope. The effect is highly engineered: research and observation, trial and error, followed by an expert execution that delights its audience.

The hero piece of this and every collection is a single gown, made only to order, that epitomises the brand's design methodology. This dress must be passed from master to master to receive its decorative treatments. They are layered on heavy against the fine base material. The patterns are made up of far-flung references that pay no regard to geography or chronology. This is Alice's alchemy, taking ingredients from around the world and through time, with no care for the correct order of things. Instead, a heartfelt appreciation of craftsmanship and skill. From this, she spins gold.

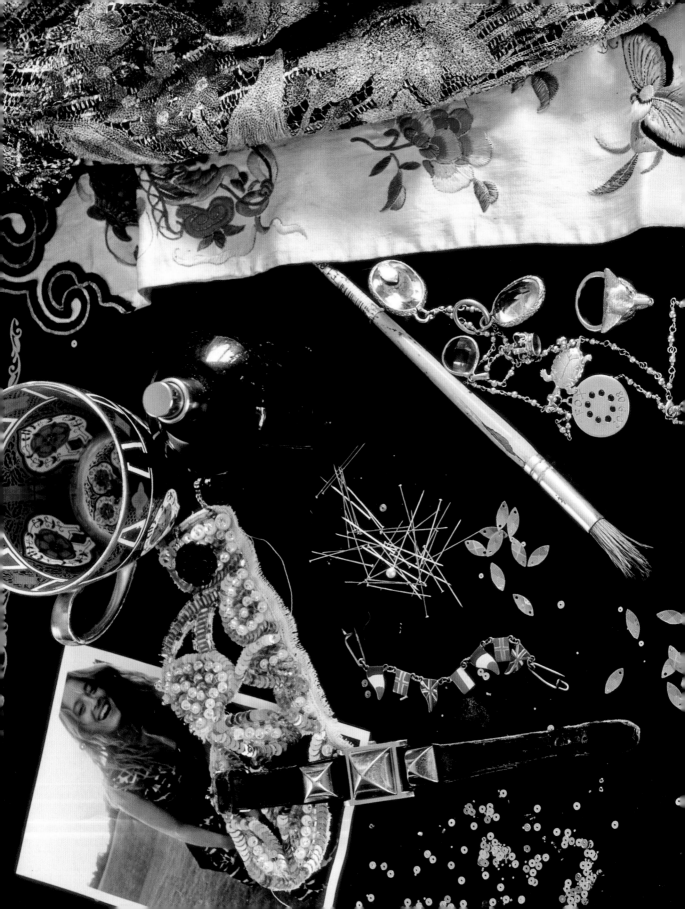

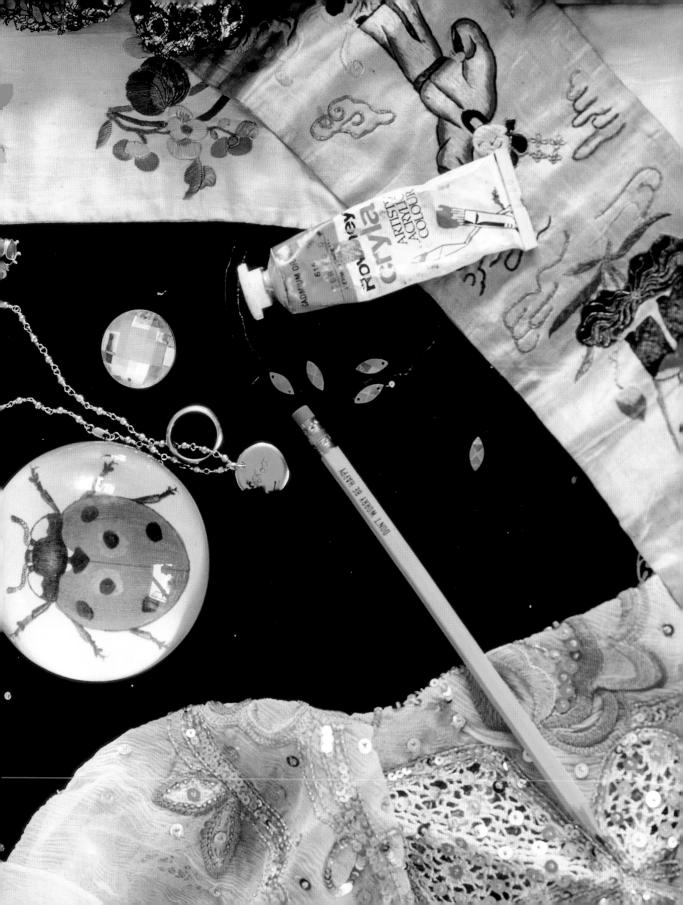

To be enchanted, curiosity must be staved off in an instance. Just like love, magic requires a bit of give and take.

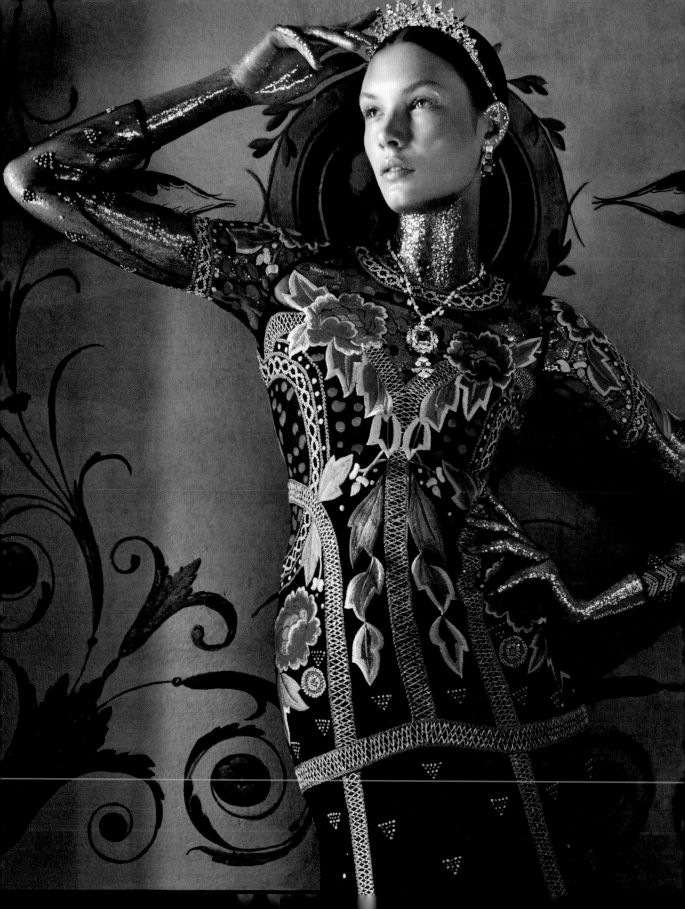

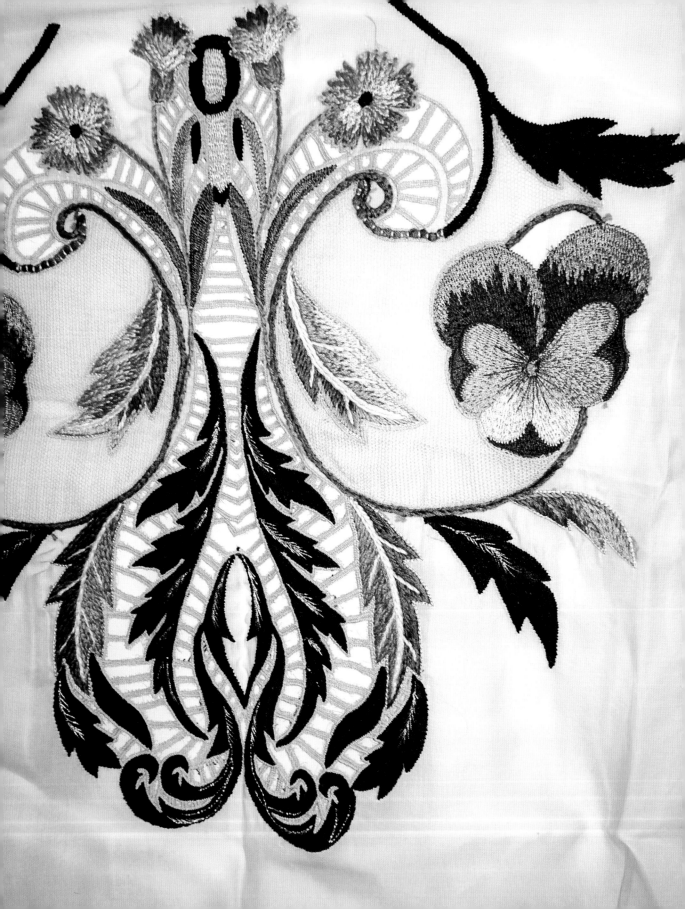

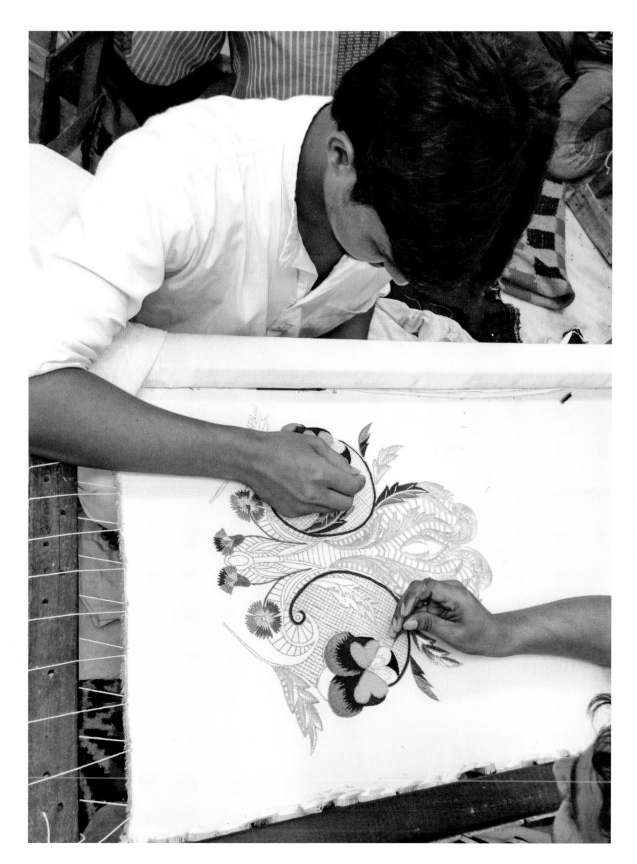

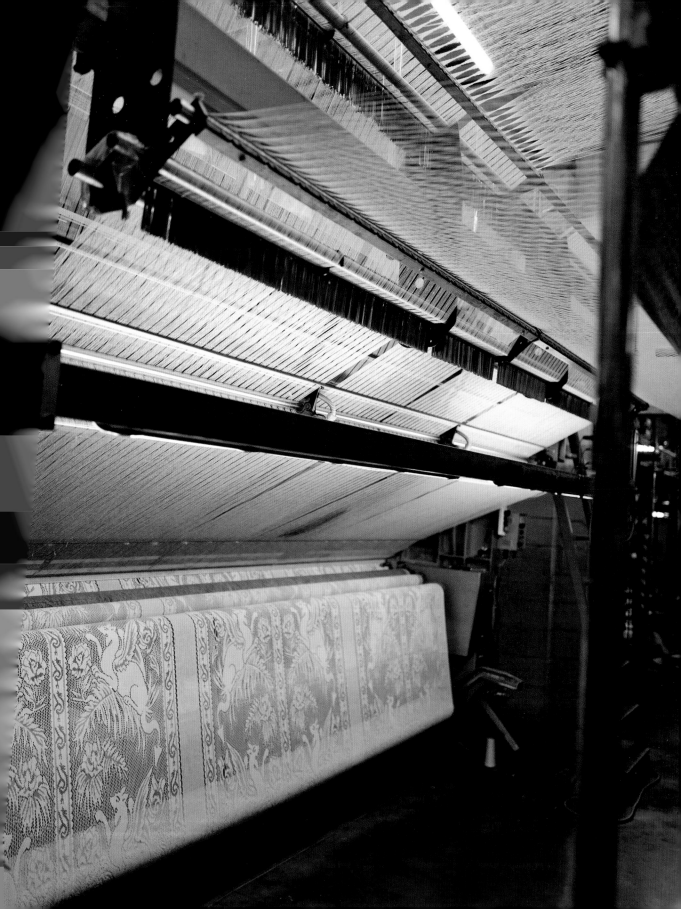

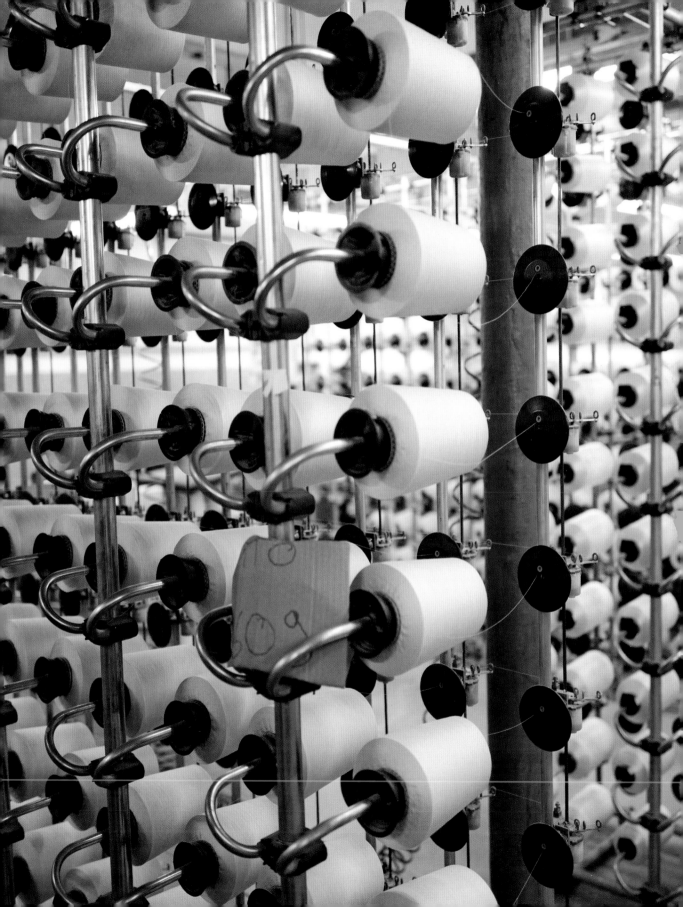

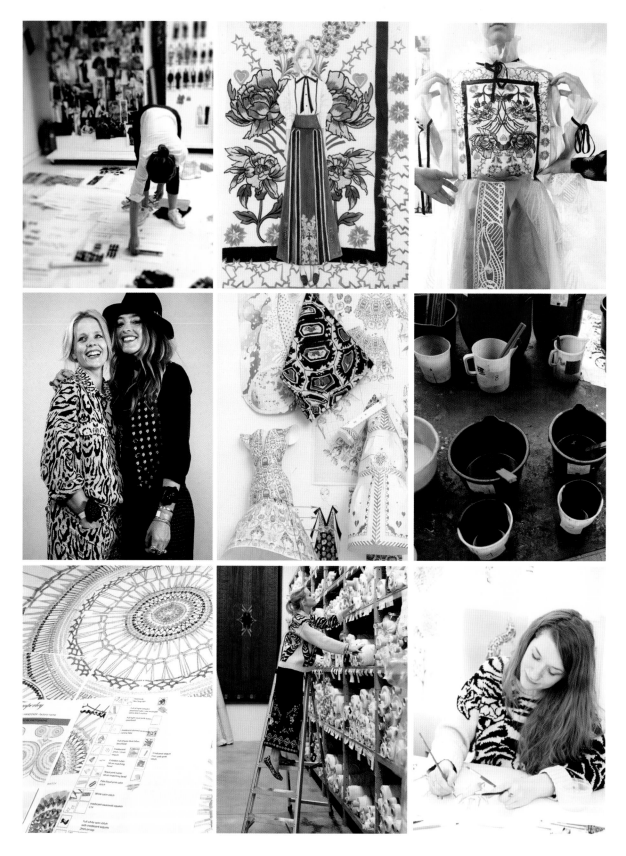

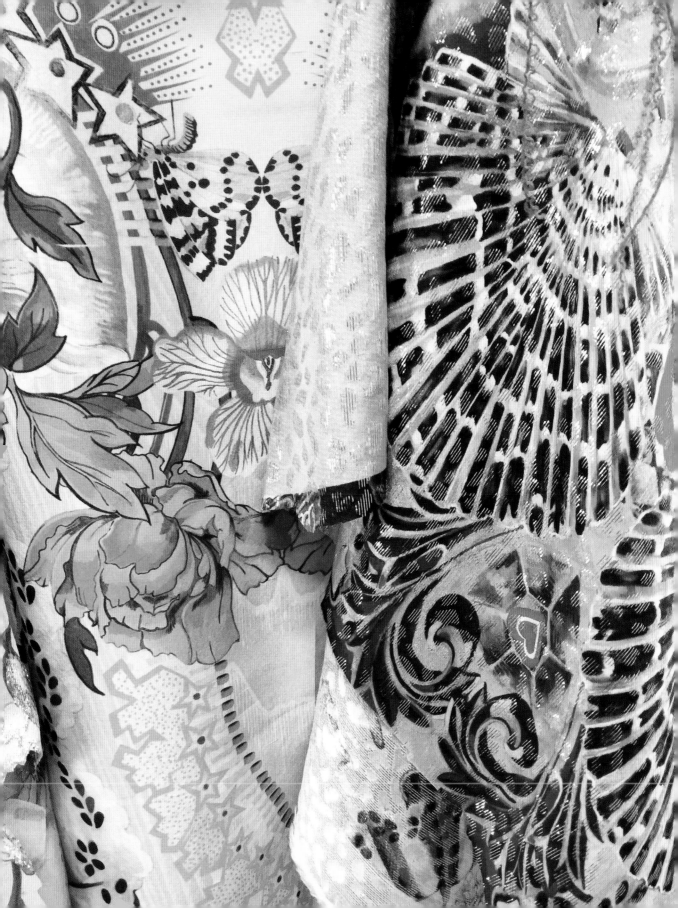

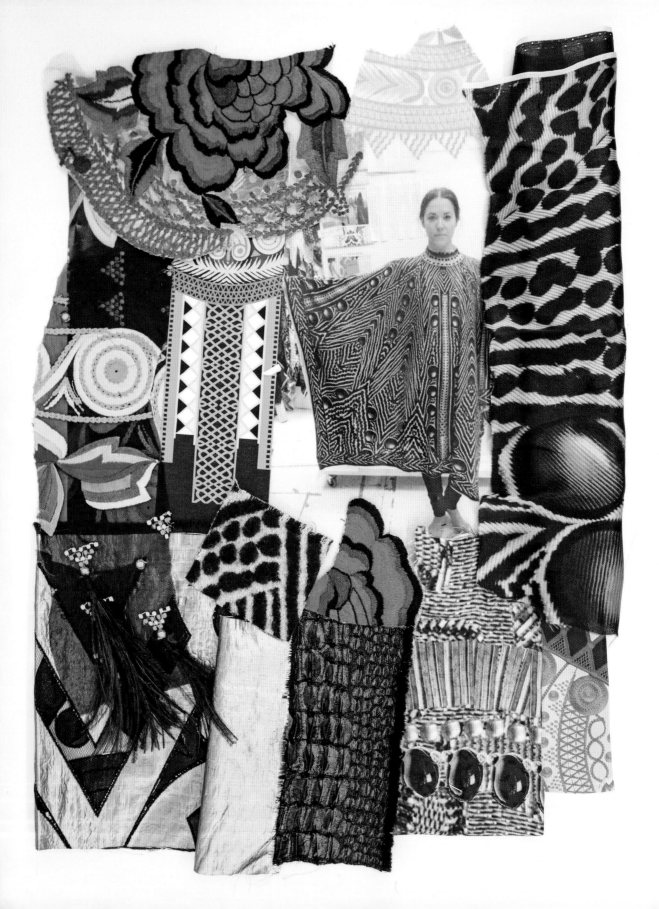

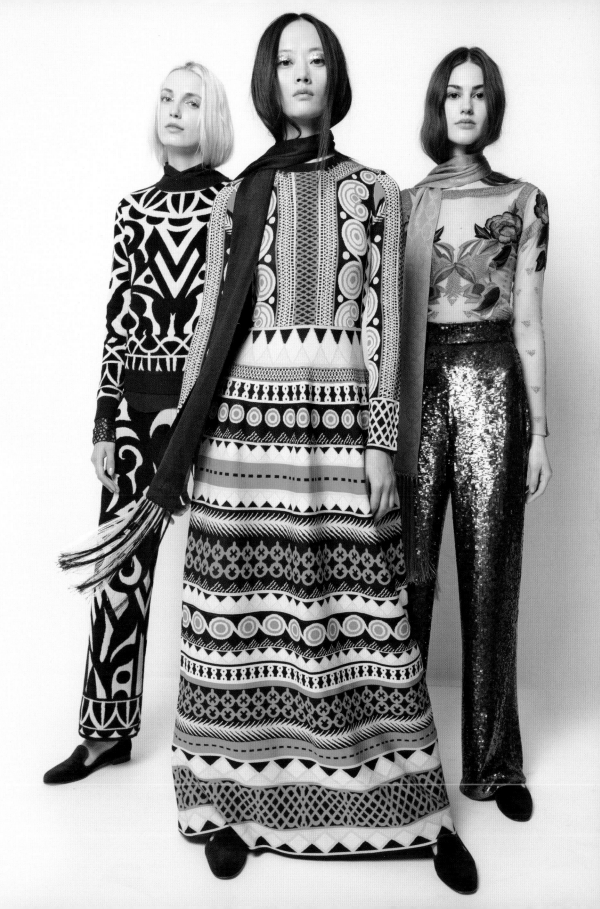

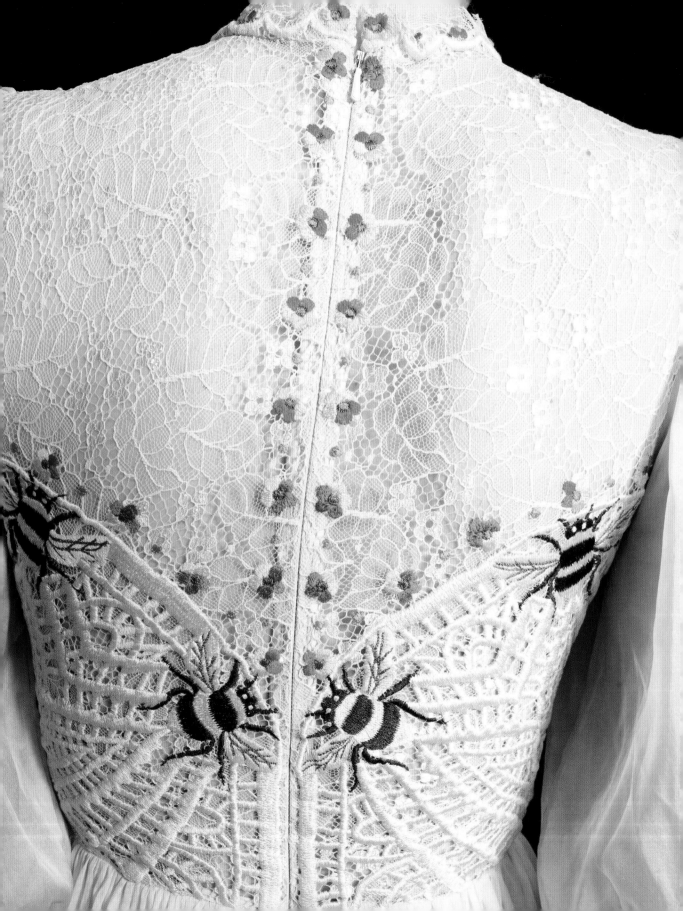

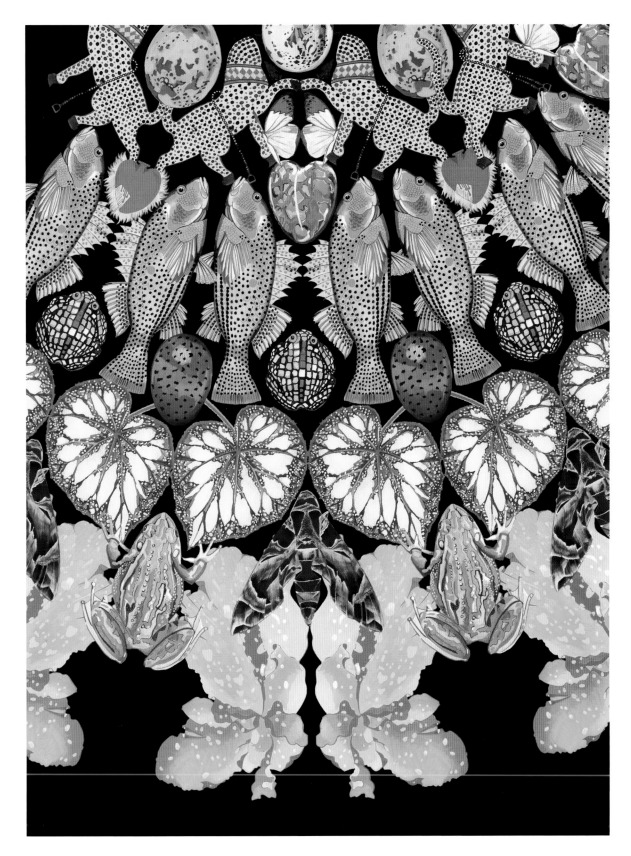

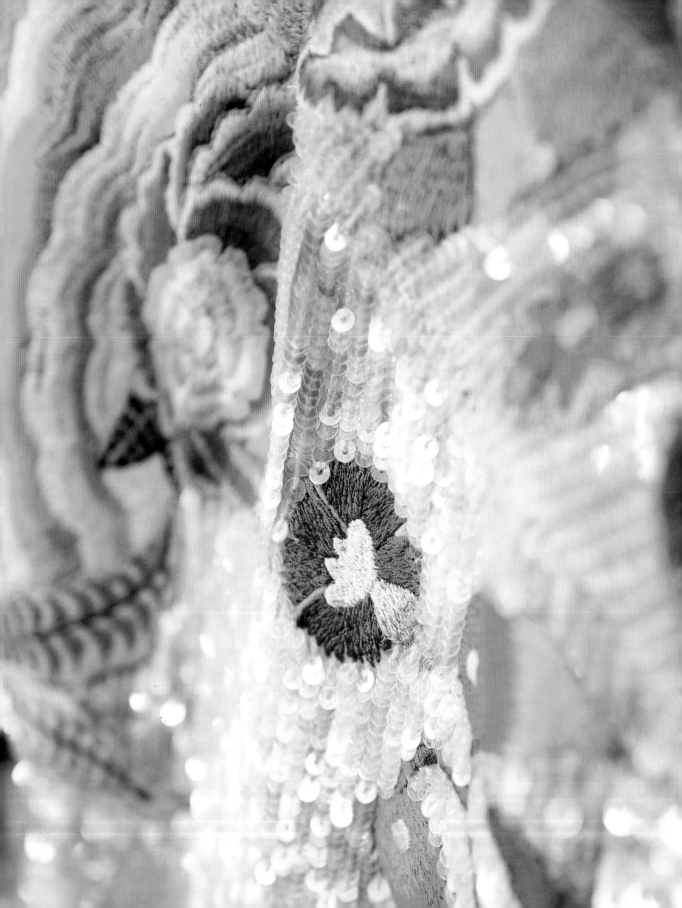

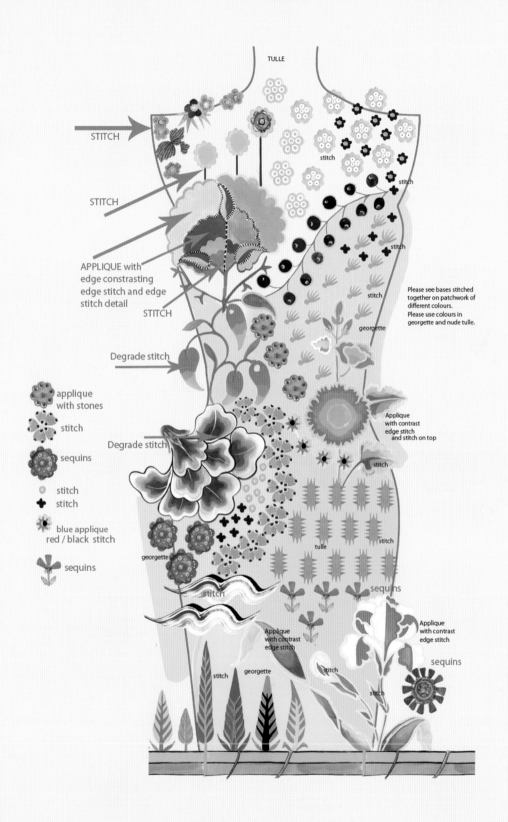

TULLE

STITCH

STITCH

APPLIQUE with edge constrasting edge stitch and edge stitch detail

STITCH

Degrade stitch

Degrade stitch

applique with stones

stitch

sequins

stitch

stitch

blue applique red / black stitch

sequins

stitch

georgette

stitch

stitch

stitch

stitch

stitch

georgette

Please see bases stitched together on patchwork of different colours.
Please use colours in georgette and nude tulle.

Applique with contrast edge stitch and stitch on top

stitch

tulle

stitch

sequins

Applique with contrast edge stitch

sequins

Applique with contrast edge stitch

stitch

stitch

georgette

stitch

| -46 | SM-61 | SM-76 |
| -47 | SM-62 | SM-77 |
| -48 | SM-63 | SM-78 |
| -49 | SM-64 | SM-79 |
| -50 | SM-65 | SM-80 |
| -51 | SM-66 | SM-81 |
| -52 | SM-67 | SM-82 |
| -53 | SM-68 | SM-83 |
| -54 | SM-69 | SM-84 |
| -55 | SM-70 | SM-85 |
| -56 | SM-71 | SM-86 |
| -57 | SM-72 | SM-87 |
| -58 | SM-73 | SM-88 |

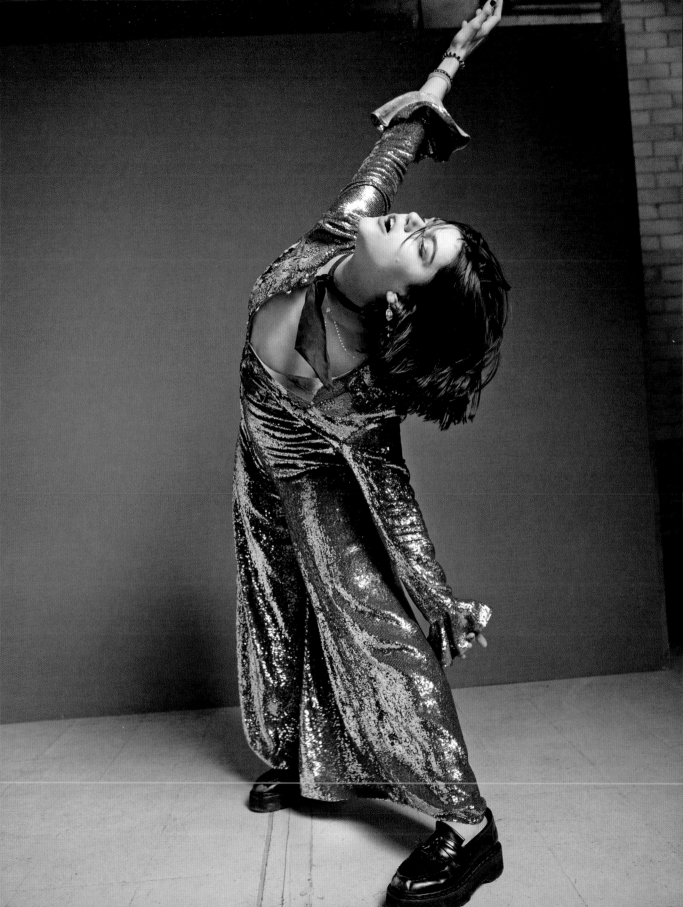

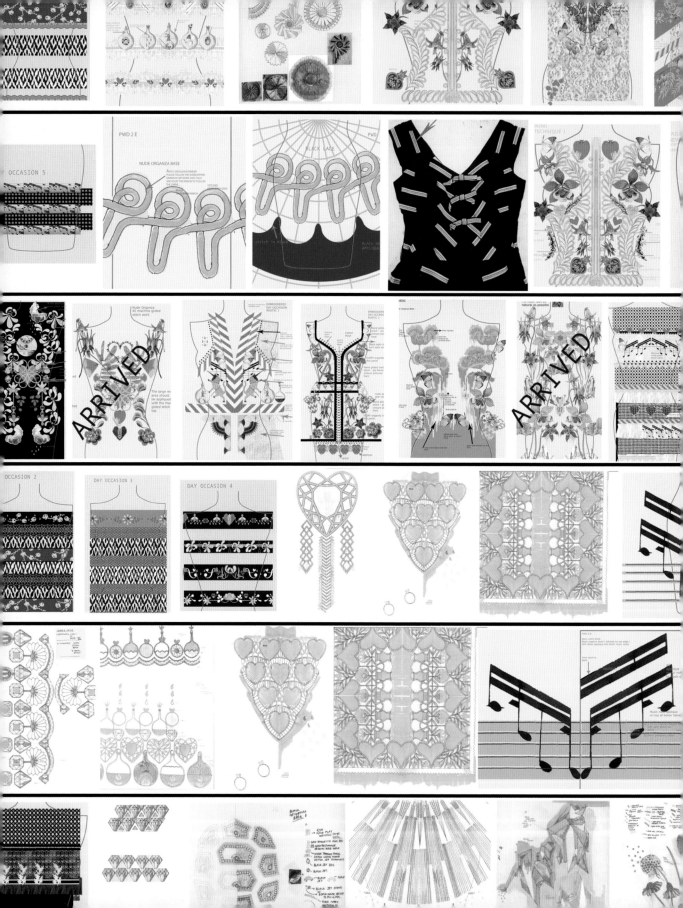

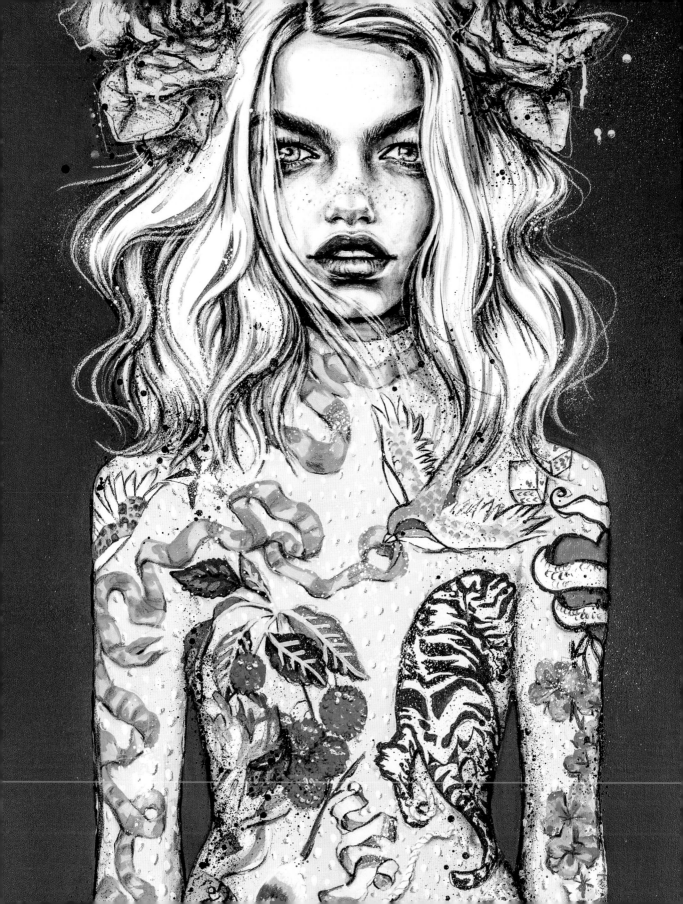

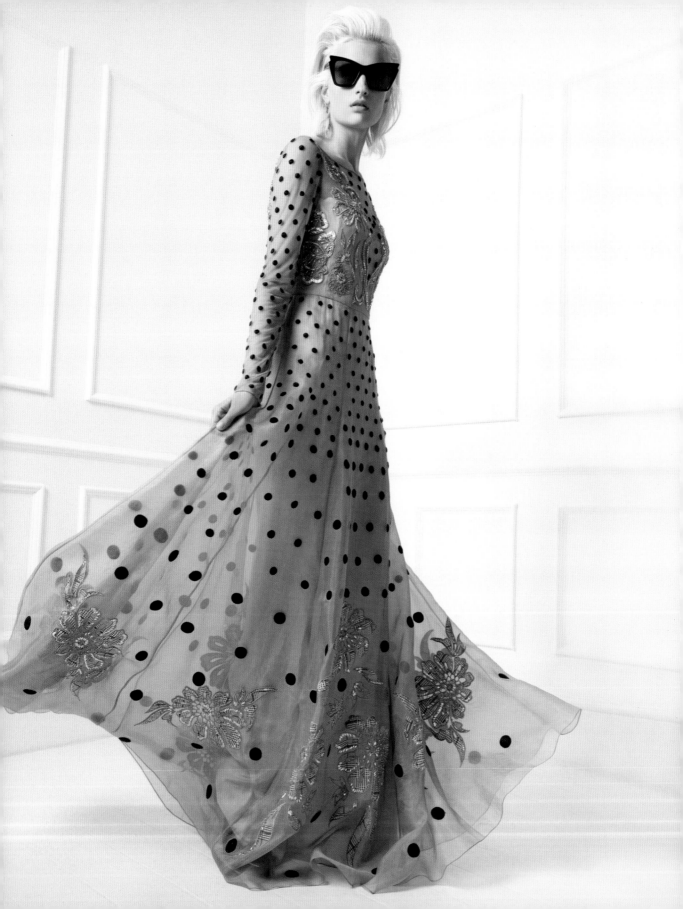

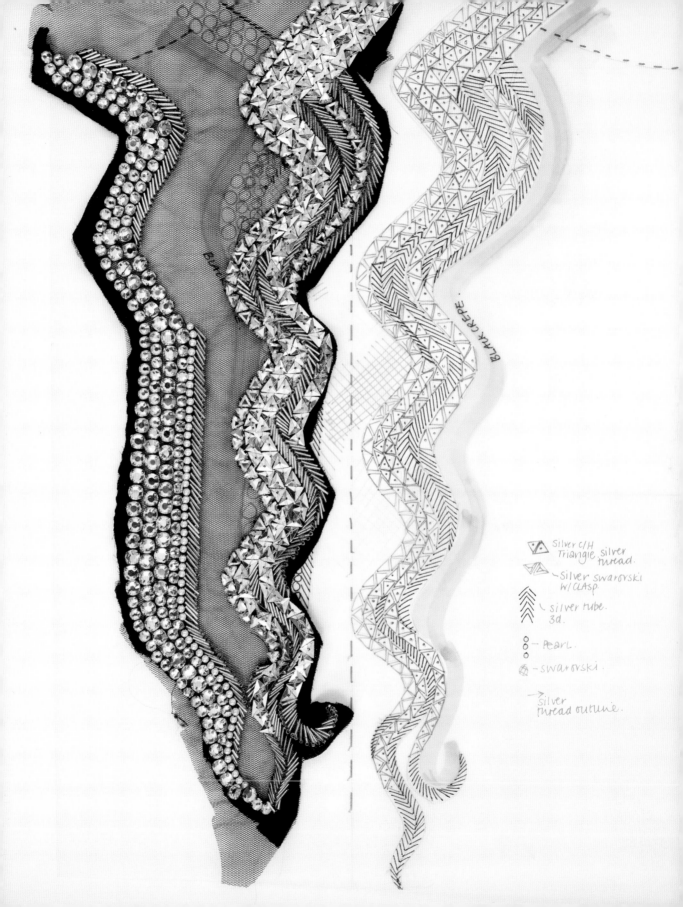

BLACK CREPE.

Silver c/H
Triangle. silver
thread.

Silver swarovski
w/CLAsp.

silver tube.
3d.

PEARL.

swarovski.

Silver
thread outline.

> "I made my song a coat
> Covered with embroideries
> Out of old mythologies
> From heel to throat...""

— WILLIAM BUTLER YEATS, A COAT (1916)

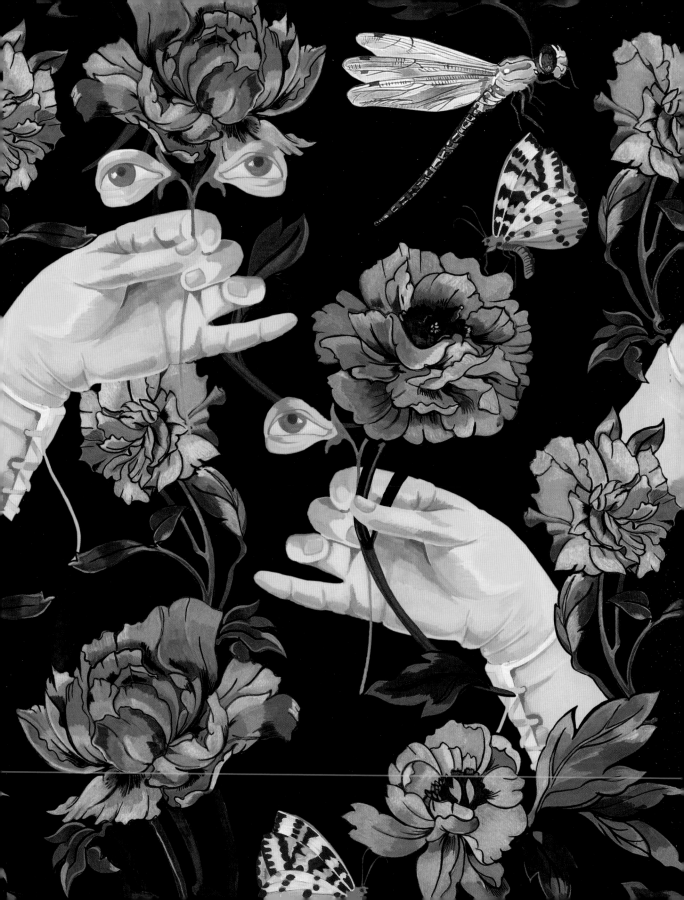

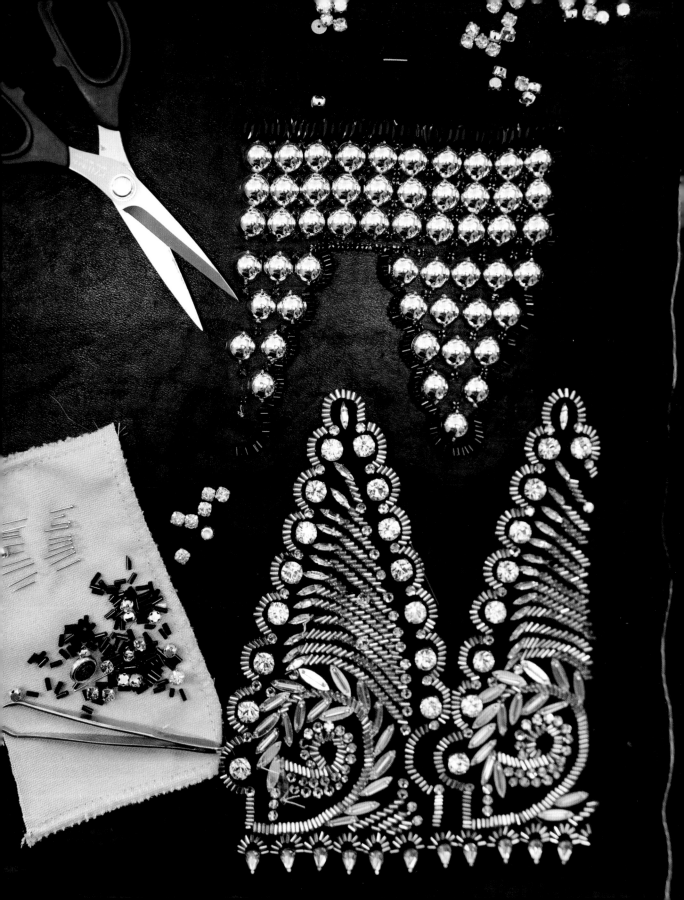

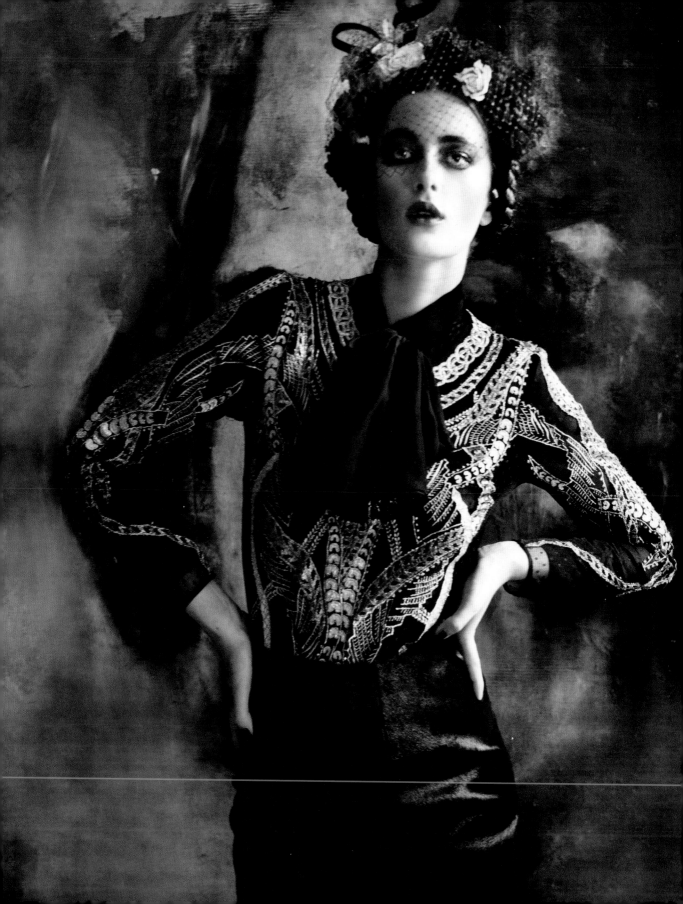

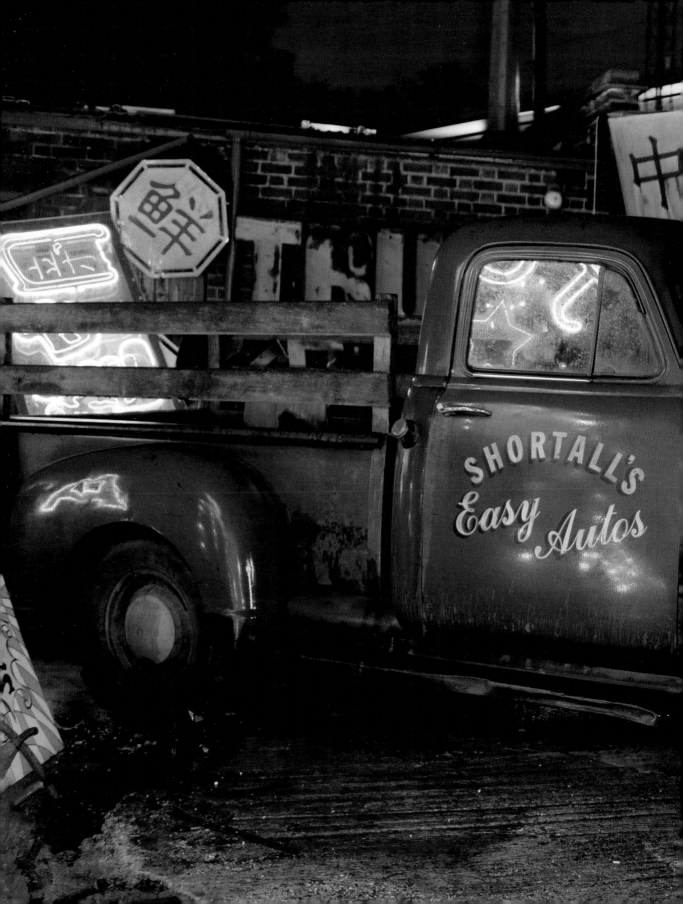

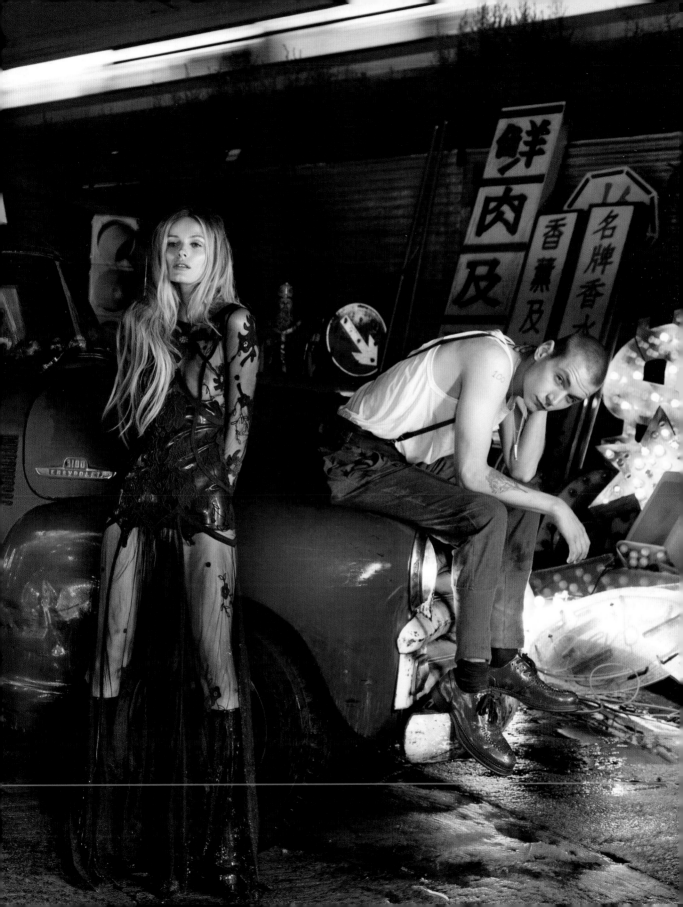

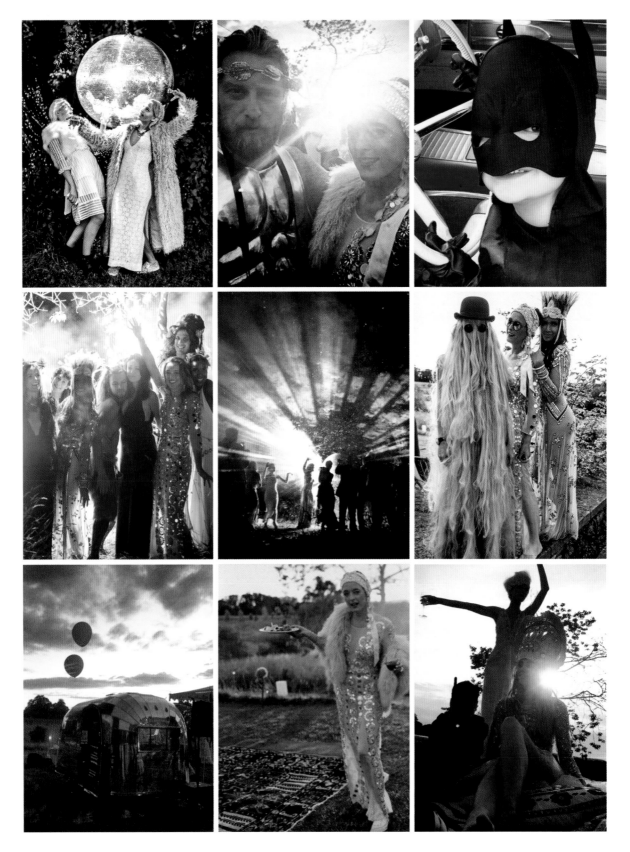

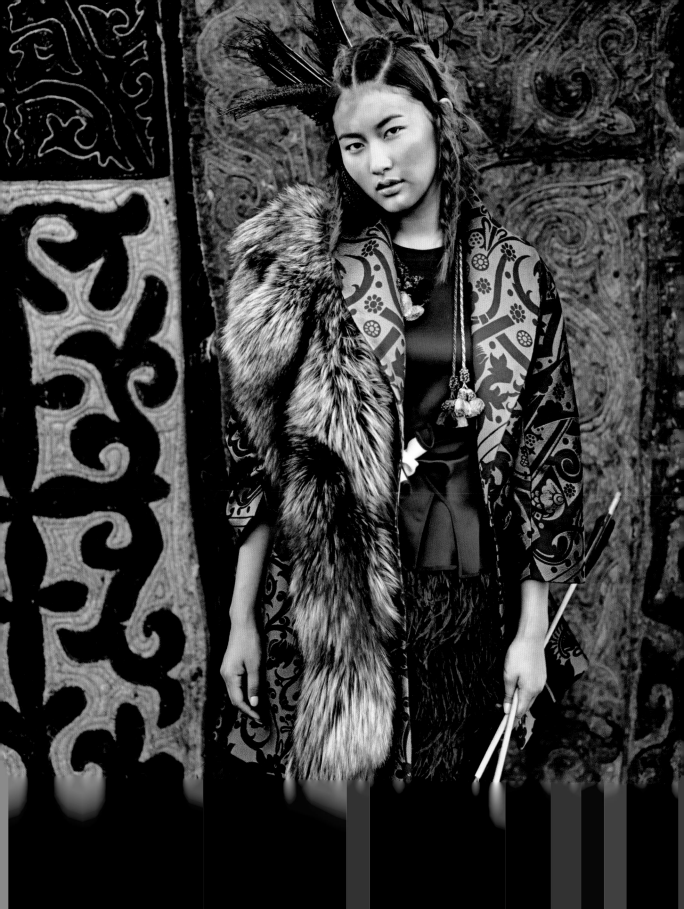

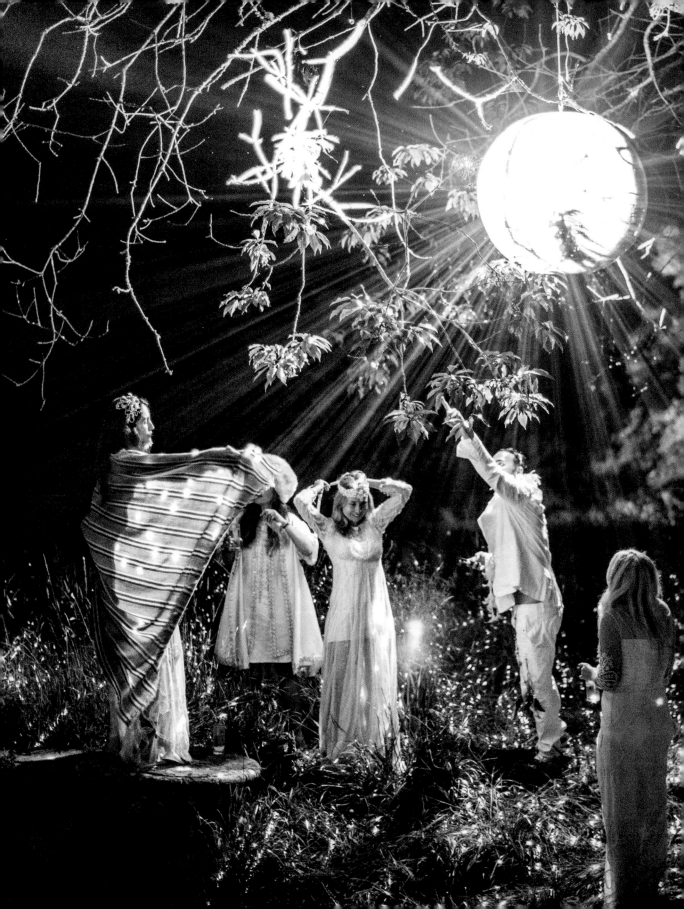

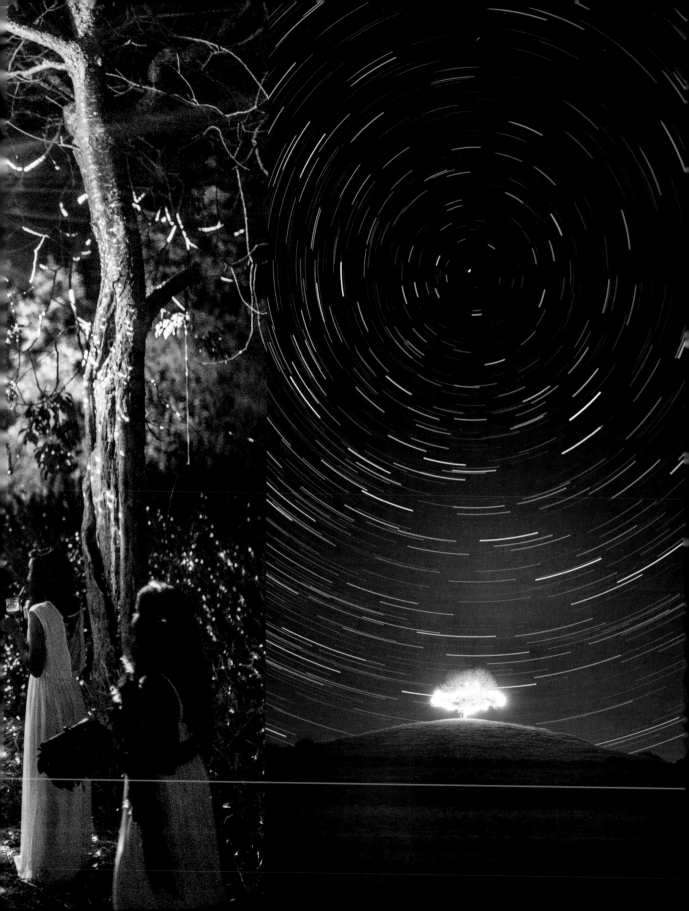

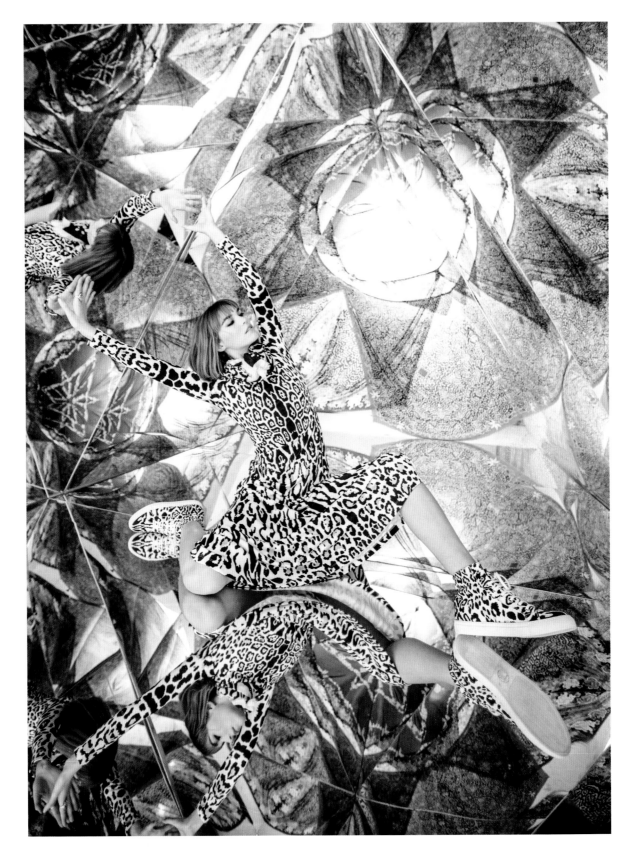

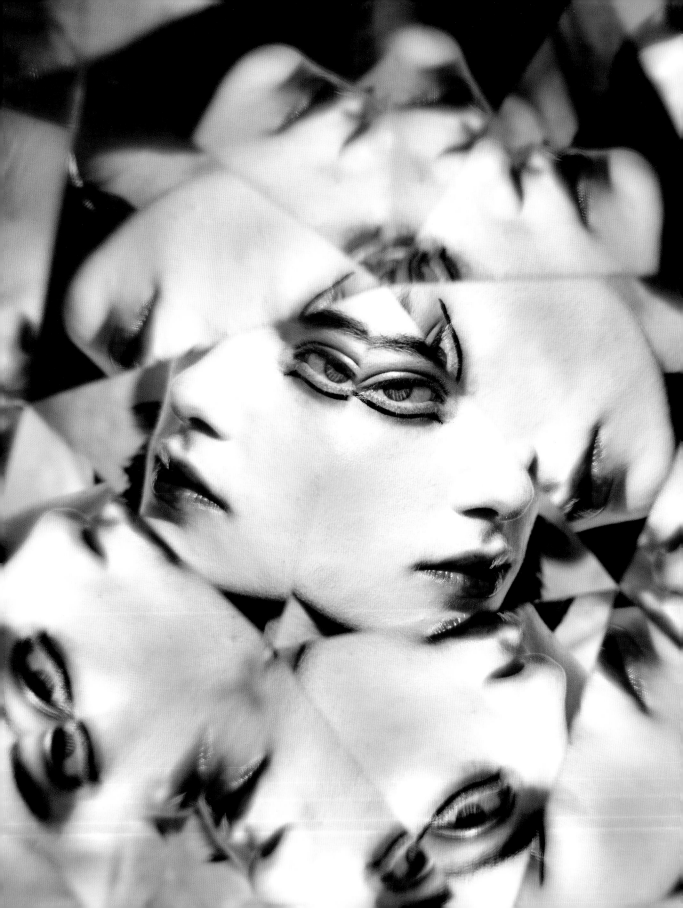

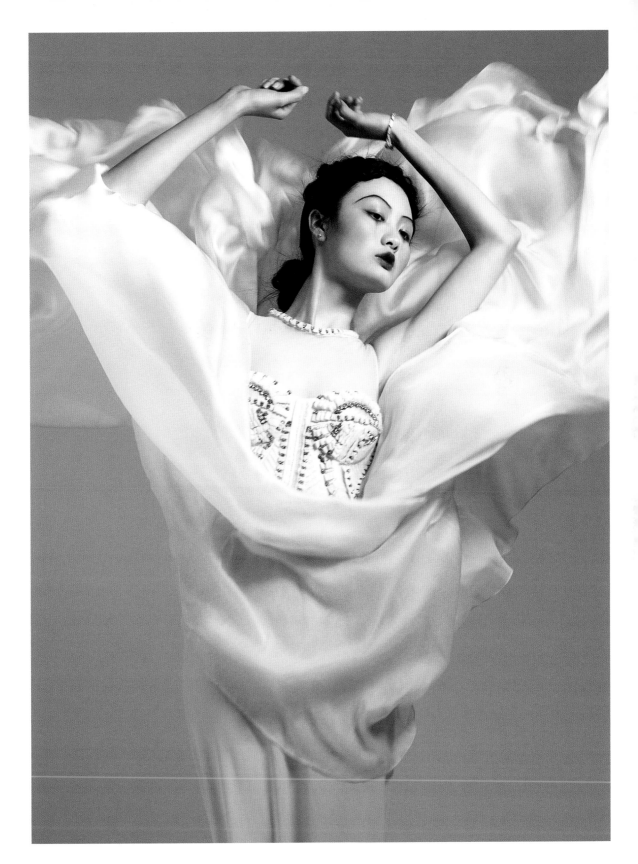

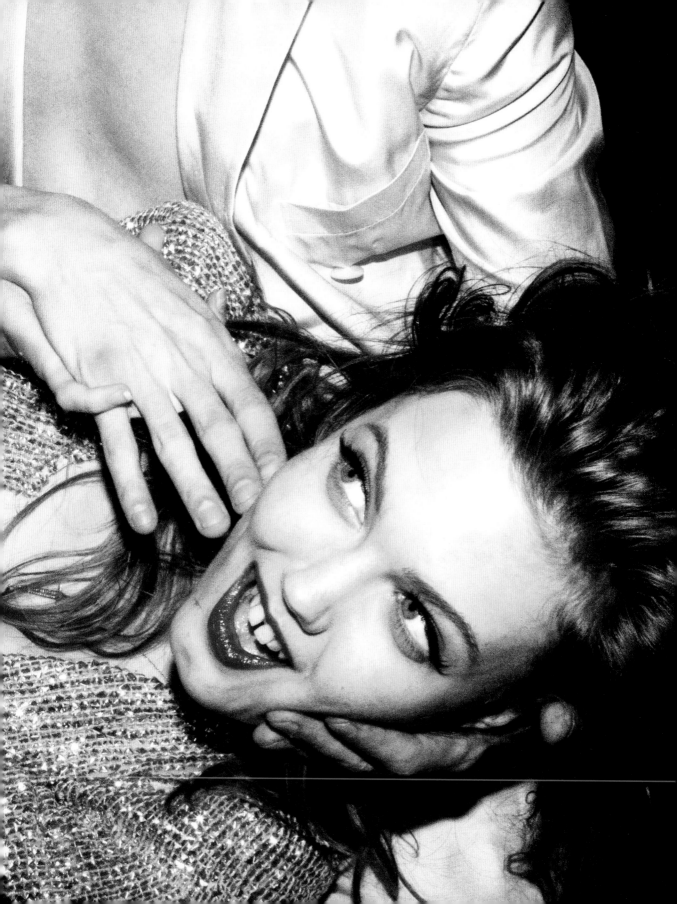

"Look closer, dear audience.
Can you make out the wires?
Of course not. This is magic."

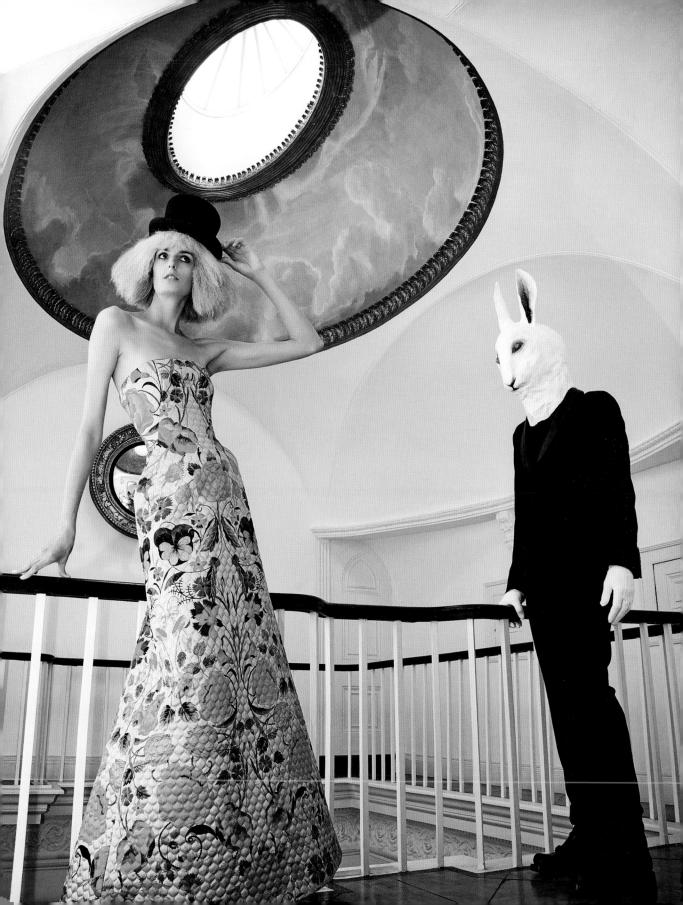

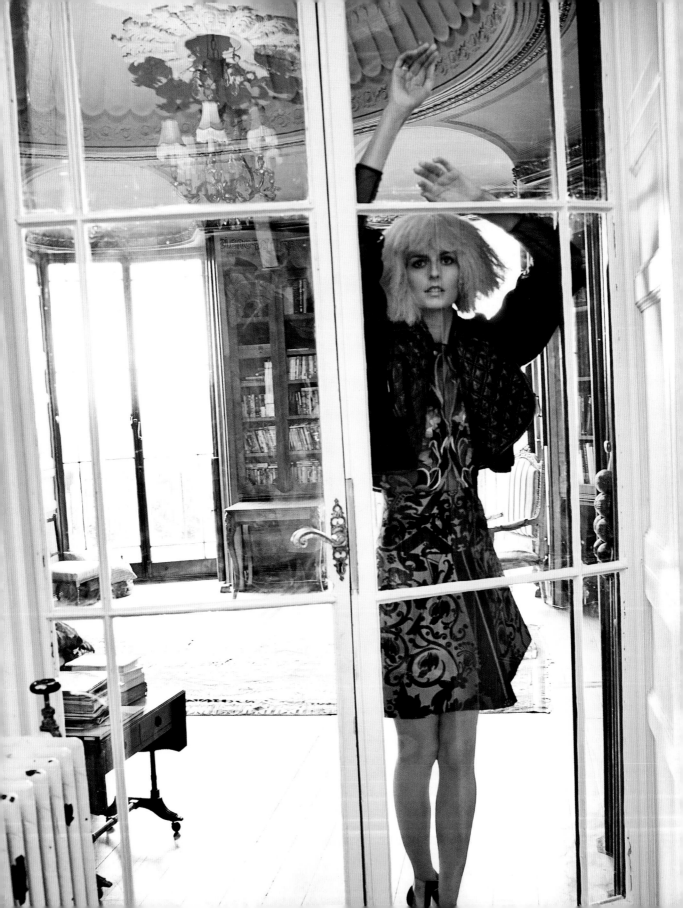

CONTRAST CREPE
IN MIDI & COLLAR DRESS

17XPCM52248

17WPCM52046

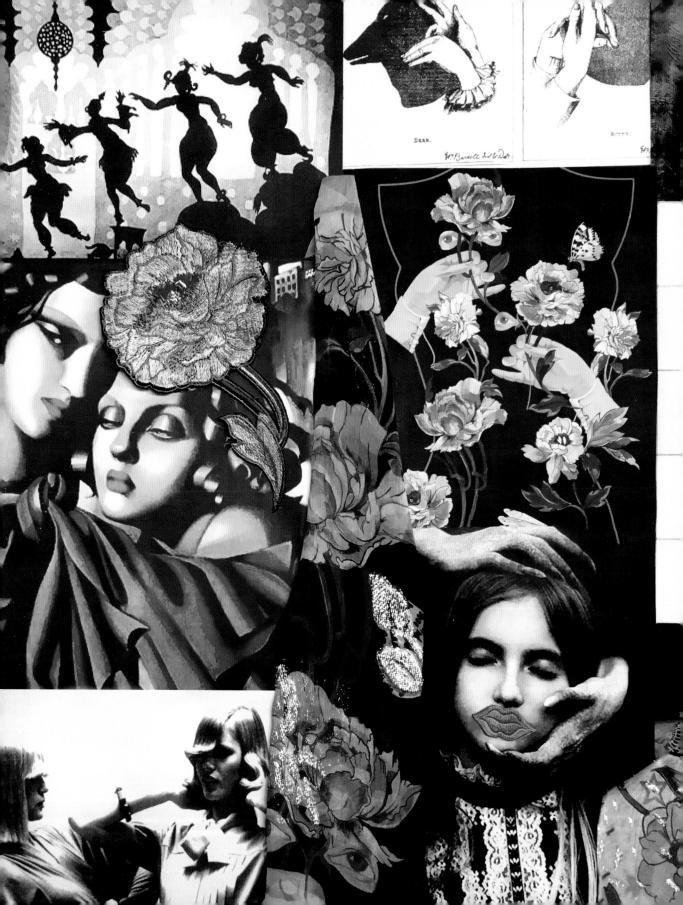

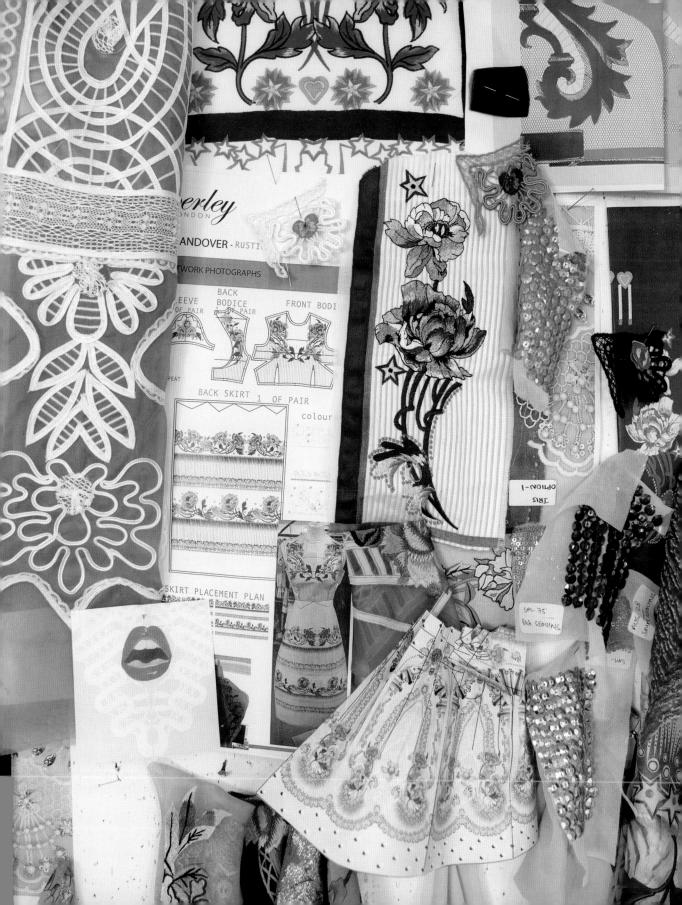

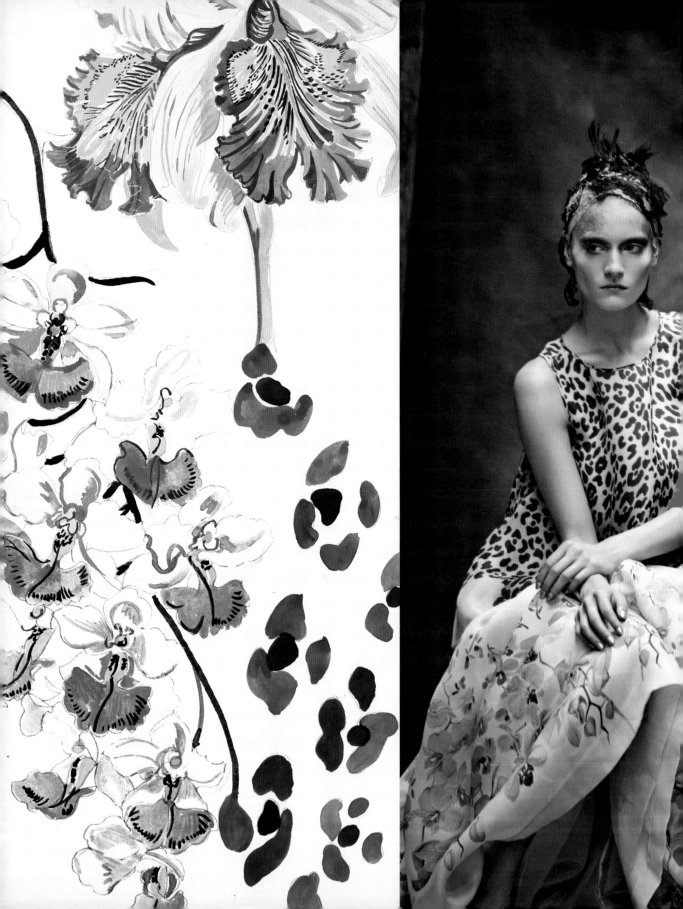

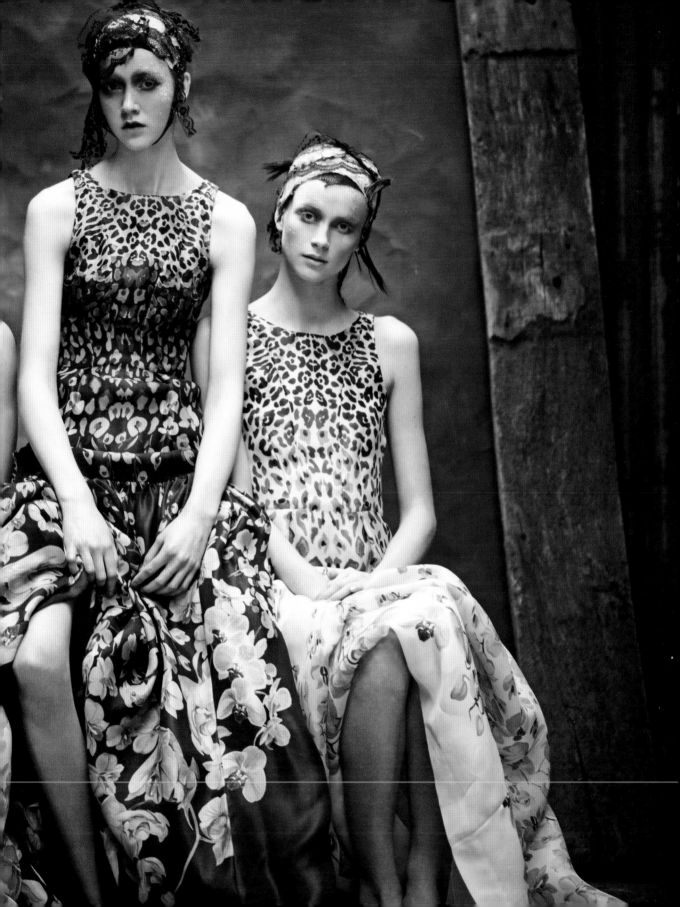

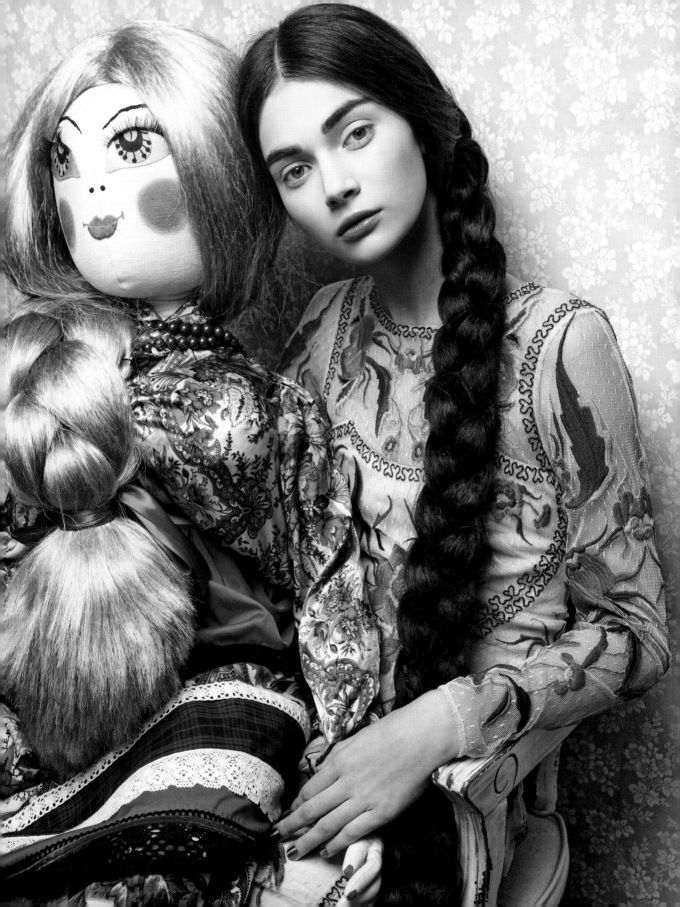

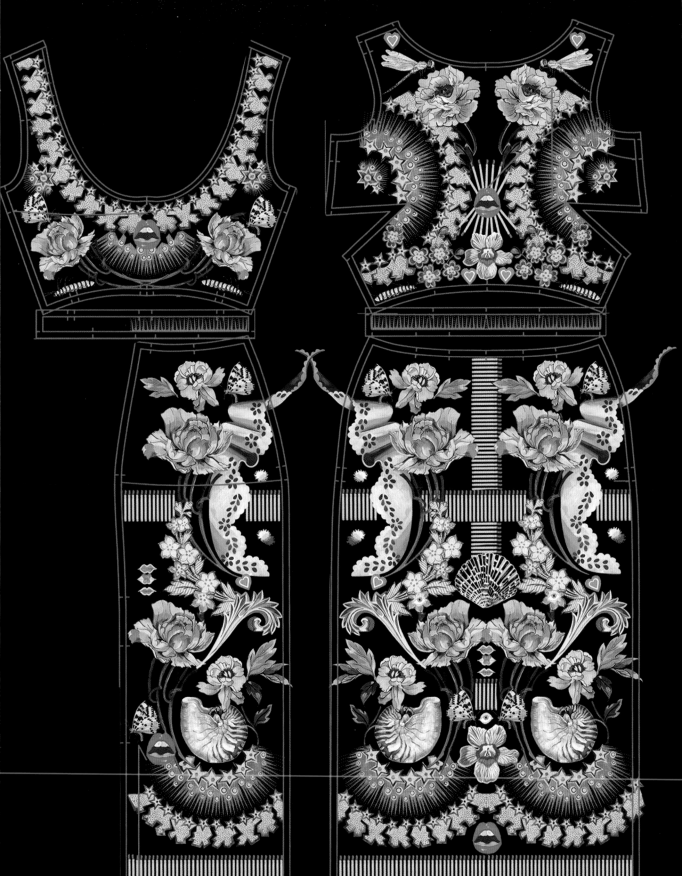

CENTREBACK

neckline

shoulderblade

WAIST

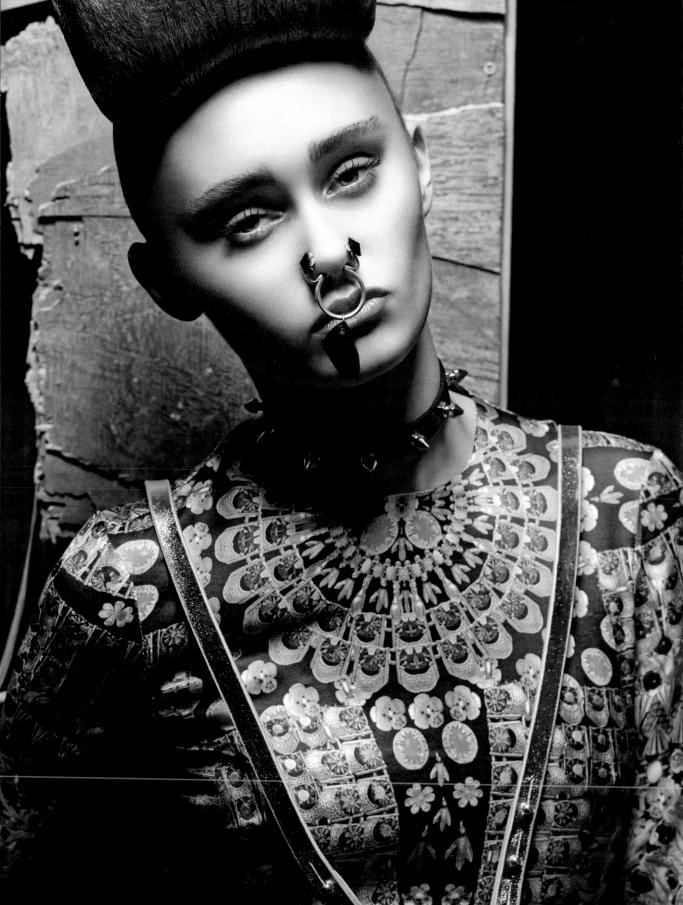

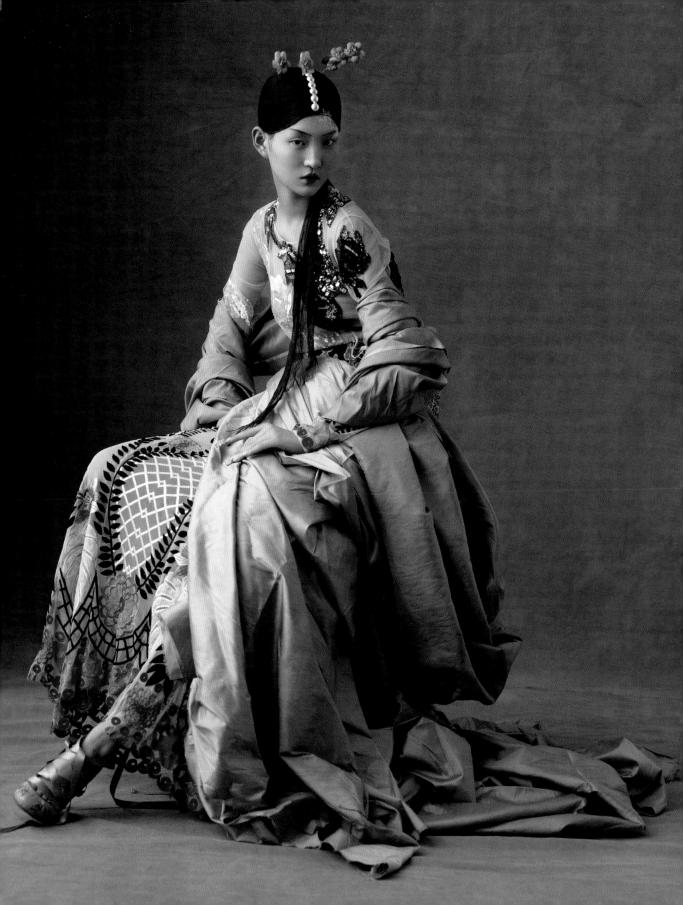

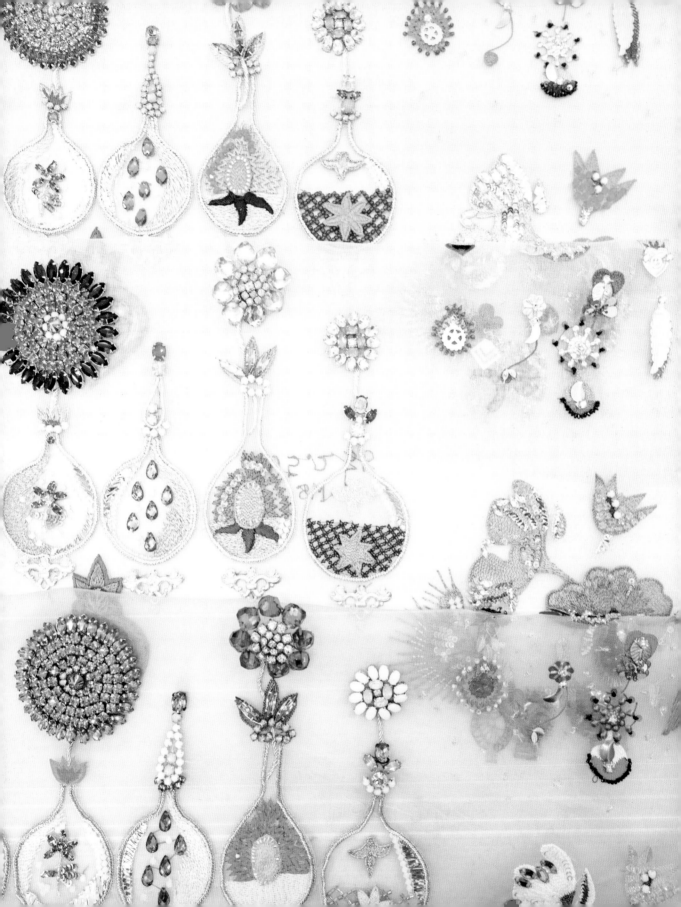

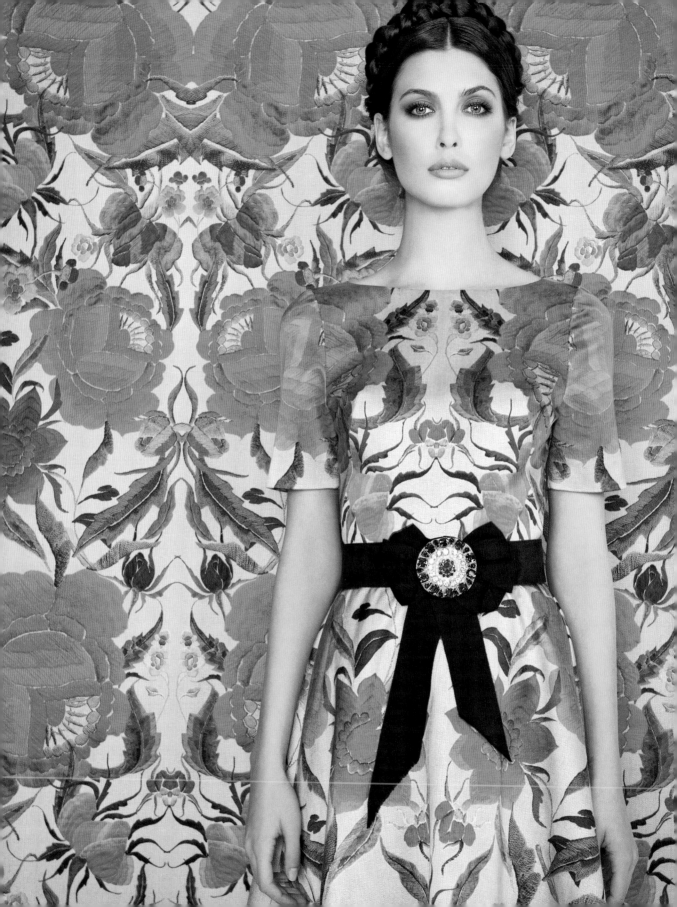

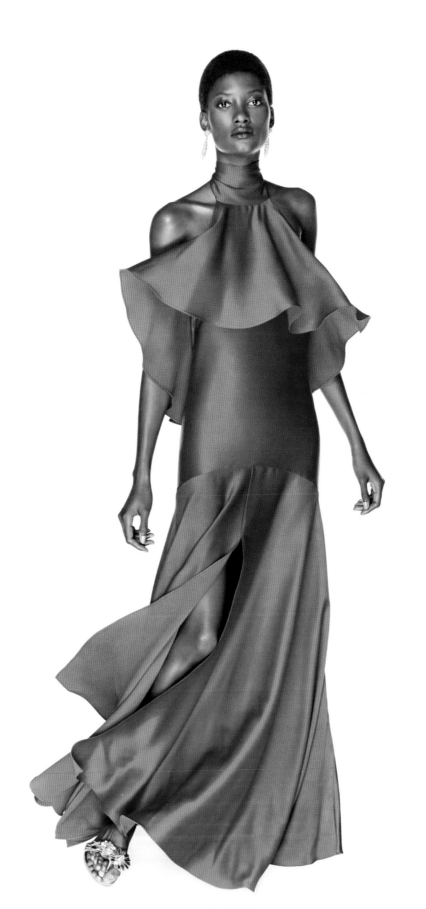

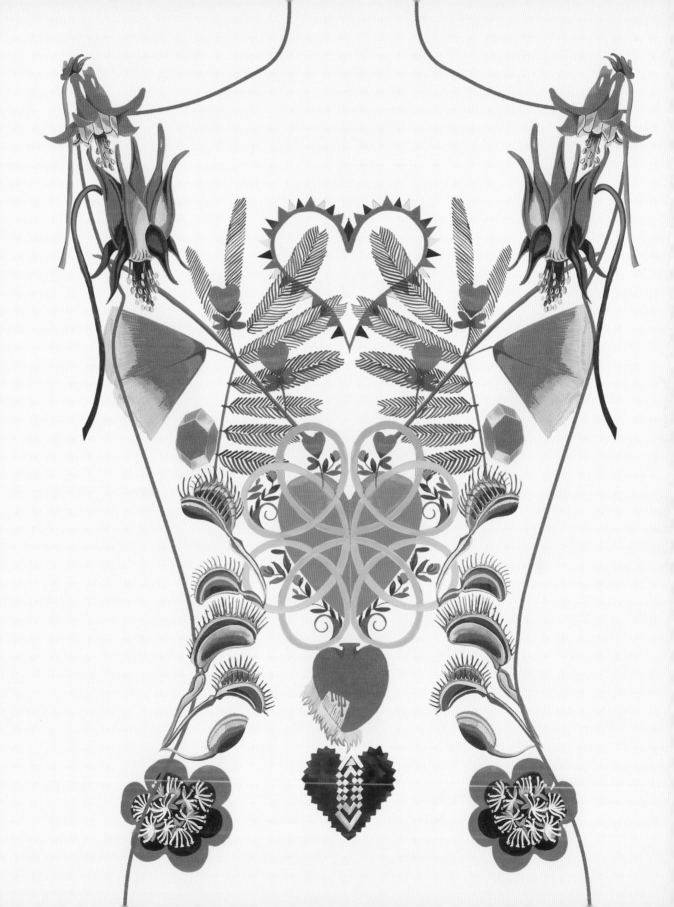

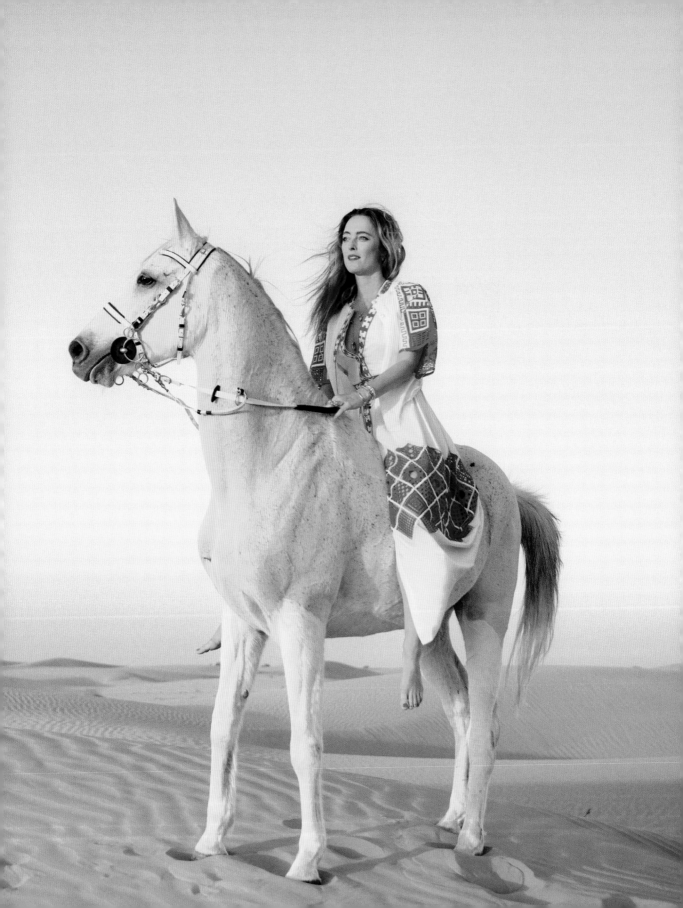

# THE ESCAPE

Desert, mystery,
pattern, print, and adventure

rid, endless, and commanding. In brutal contrast to Alice's childhood home in Somerset, the desert is where she feels most unrooted. Where darkness and the temperature fall suddenly, as if by gravity's force. Where the sky, unframed, shifts perspective and buries trivial worries under sand. The sun in her father's orchards is alchemic: at a certain point in the Earth's orbit, the exact tilt turns the tree tops gold for a moment. In the desert, golden is a day-long affair, to the absolution of all other colours.

If Somerset provides her bass drum, that rhythmic repeat, then travel is where Alice finds her melodies. She packs in a flash, no recourse to Joan Didion (sensible shoes are as likely as sequins) and disconnects the moment she arrives.

In Mexico for a wedding, Alice found pink dreamcatchers, fluorescent interpretations of the Native-American originals. Hoops woven over with a spider web grid that, when hung, catch dreams travelling by air. The good ones pass on through to the sleeper, the bad ones are suspended to be scorched in the morning sun. Back in the studio in London, these irregular handmade objects were traced and the resultant pattern drawn on repeat. Once the dress was constructed, its wearer emerged through the centre of a web like a good dream.

"It bites deep," John Steinbeck said of the hot hillside village of Positano, Italy.[6] In *Harper's Bazaar*, May 1953, he challenged "any dame" to move through the village's abrupt streets with its stairs as steep as ladders in a crisp cotton dress. He hadn't met Alice. She'd skip up the cliff faces barefoot in white and sit down for dinner on the veranda without breaking a sweat. The collection inspired by her trip there, Summer 2015, merged the younger label Alice by Temperley into the main collection. It was a wardrobe from day through to evening, with

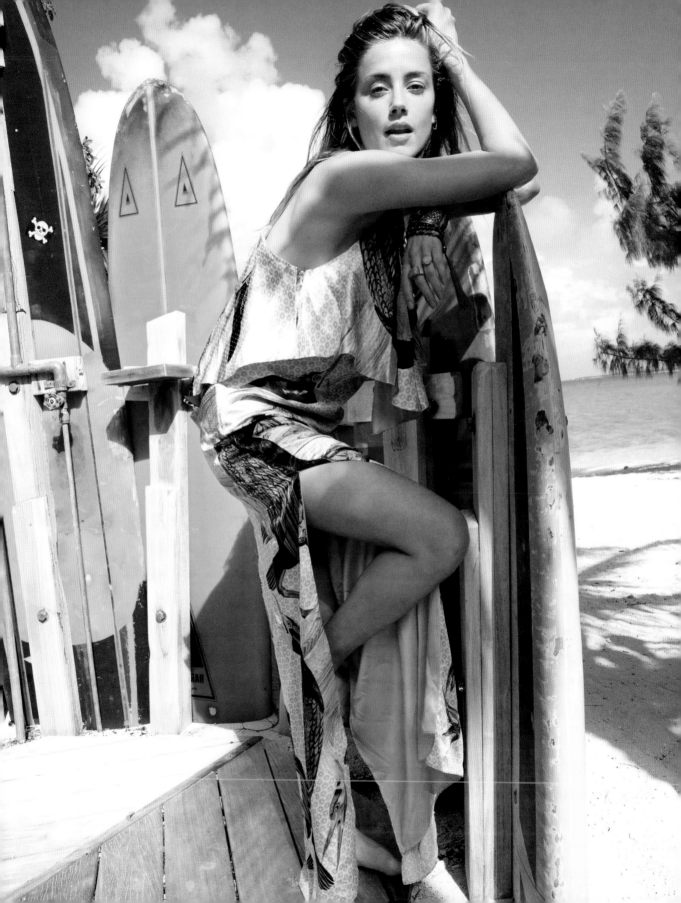

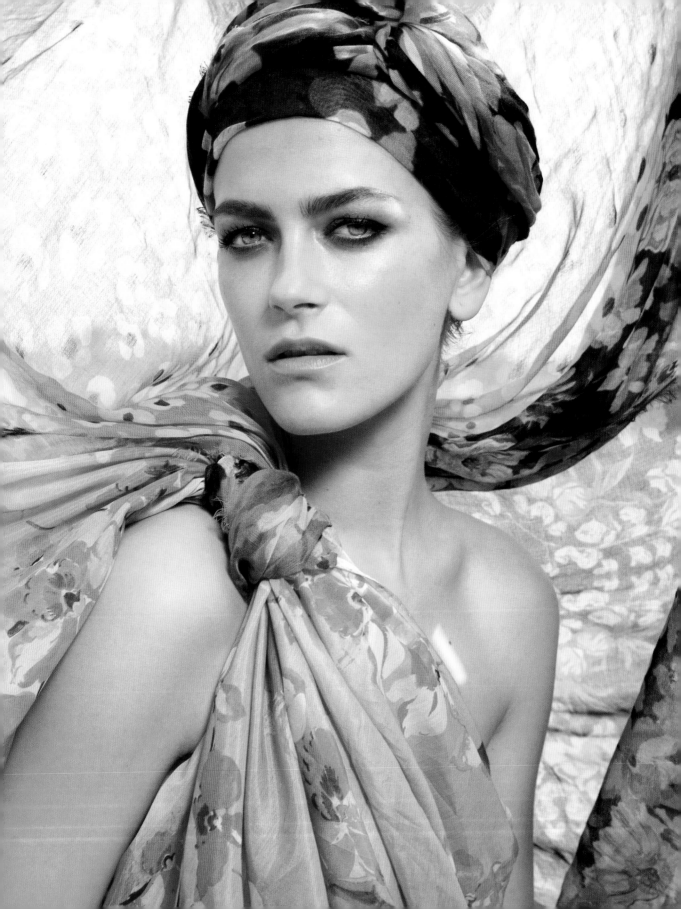

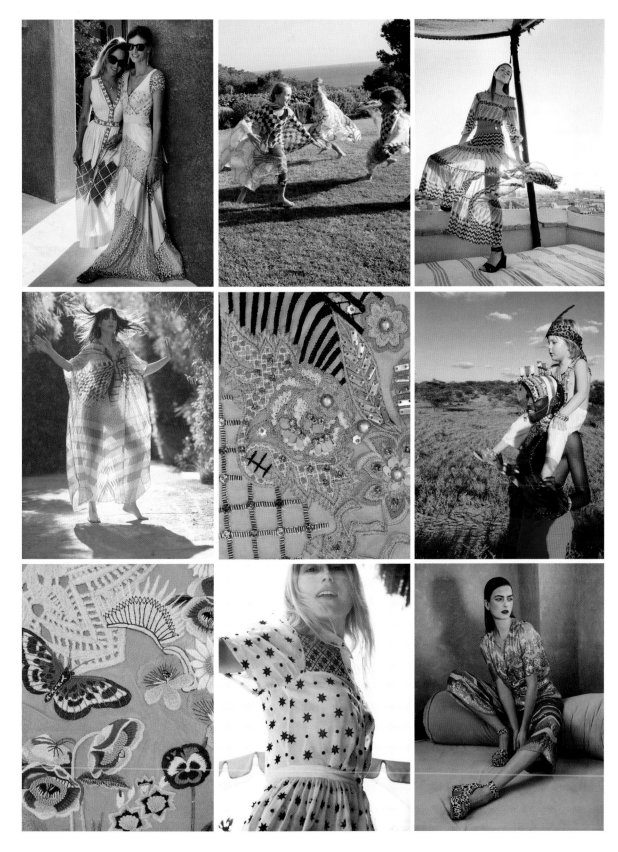

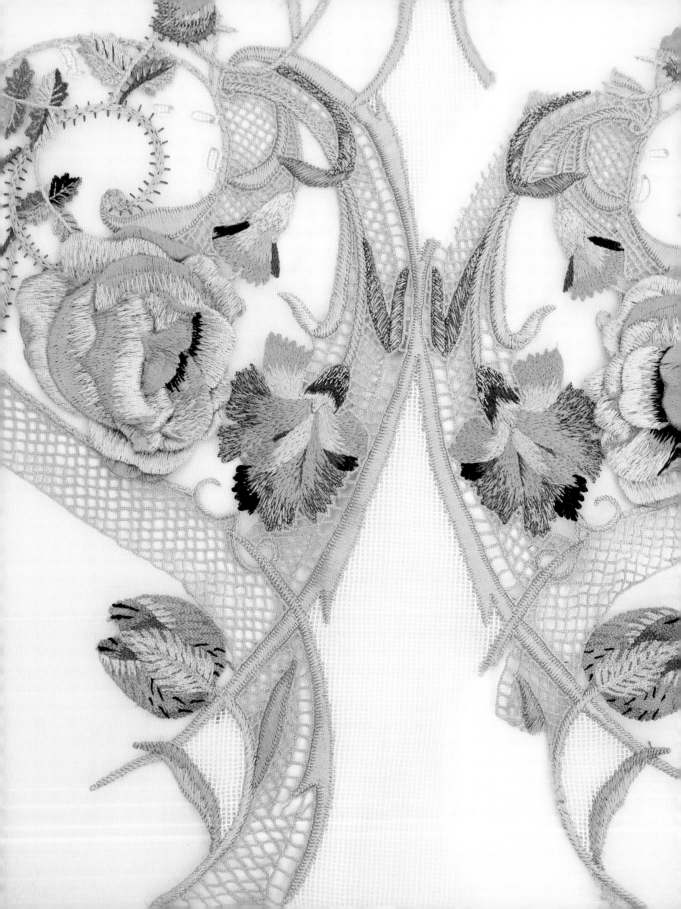

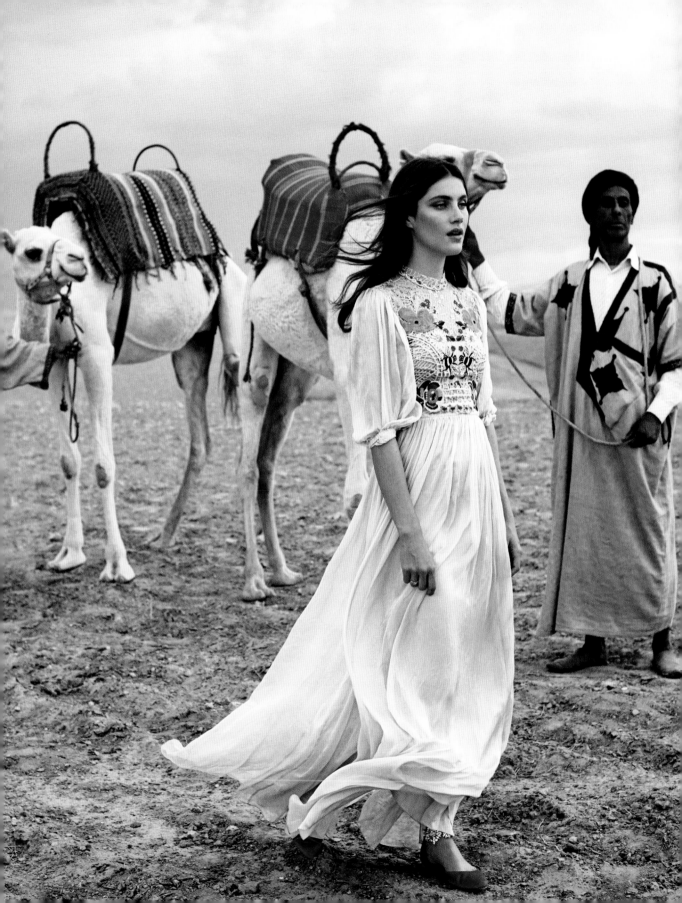

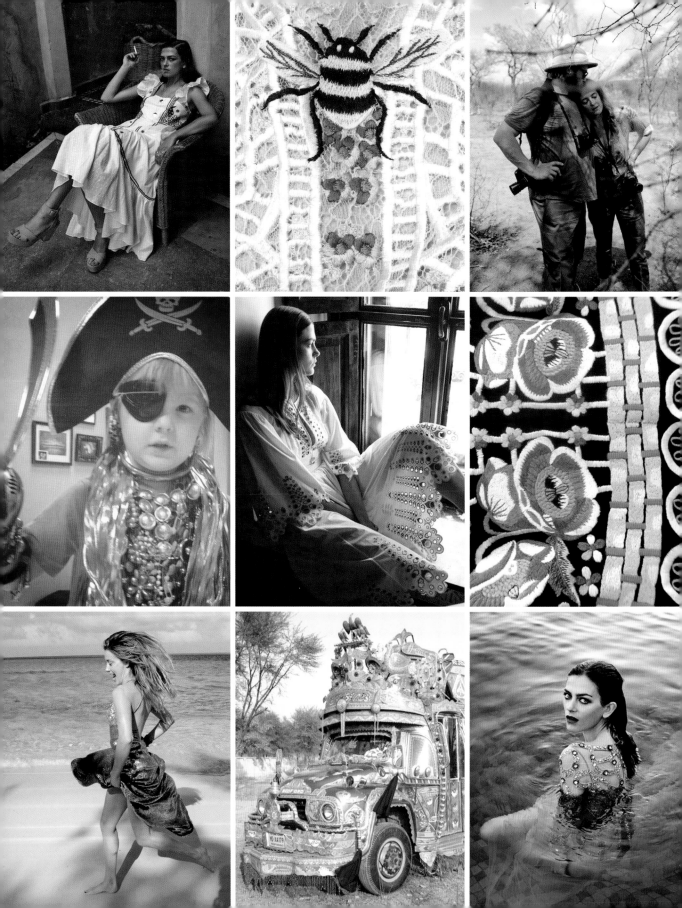

a bright palette inspired by Japanese *shunga* ink paintings, set against that forbidden crisp white. For Steinbeck, a runway first, she paired the tailored separates with lace-up trainers.

The summer collection of 2016 sung to the tune of Cuba. Often, with Temperley, the references are barely visible, the result of a particular perspective in a given moment, some idiosyncratic souvenir—the replica dreamcatchers, a steep walk—distinct from other experiences of a culture or nation. This time the citation was bold and witty. Palm leaves were printed and embroidered, the light silk burned white like the island's beaches beneath lime green, ocean blues, and deep tobacco. The tailoring was loose, cut to let a body move, while complex contemporary lacework let it breathe.

Each design tells the tale of a trip, even if it does so quietly. Wild horse rides across sand dunes and deep sea dives off the Amalfi Coast make their mark, but so too do the scorching bustle of a market and the raw confusion of being lost in another language. Off the radar, Alice is more vulnerable, but also more free. Sponge-like, she soaks in the experiences. Returning, she declares nothing at customs, then spills her immaterial souvenir collection onto the studio floor. Travel disassembles Alice; home puts her back together.

"Each design tells the tale of a trip, even if it does so quietly. Wild horse rides across sand dunes and deep sea dives off the Amalfi Coast make their mark, but so too do the scorching bustle of a market and the raw confusion of being lost in another language."

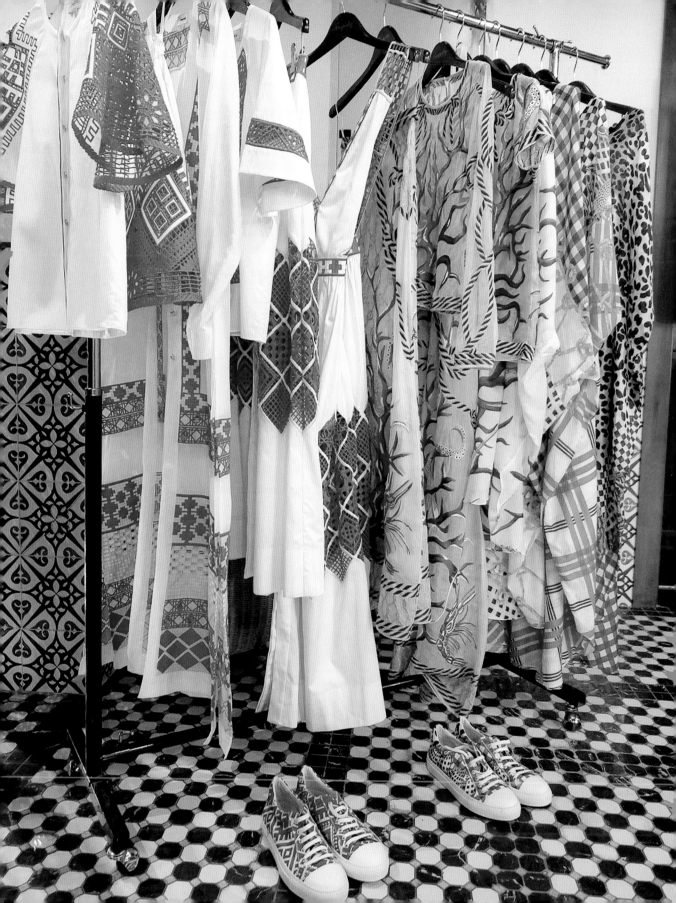

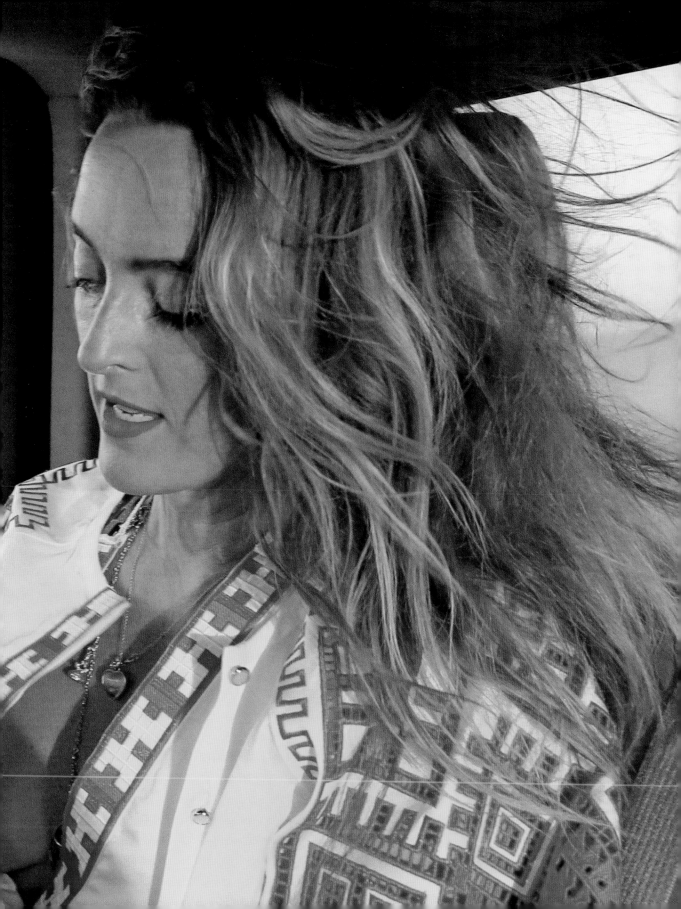

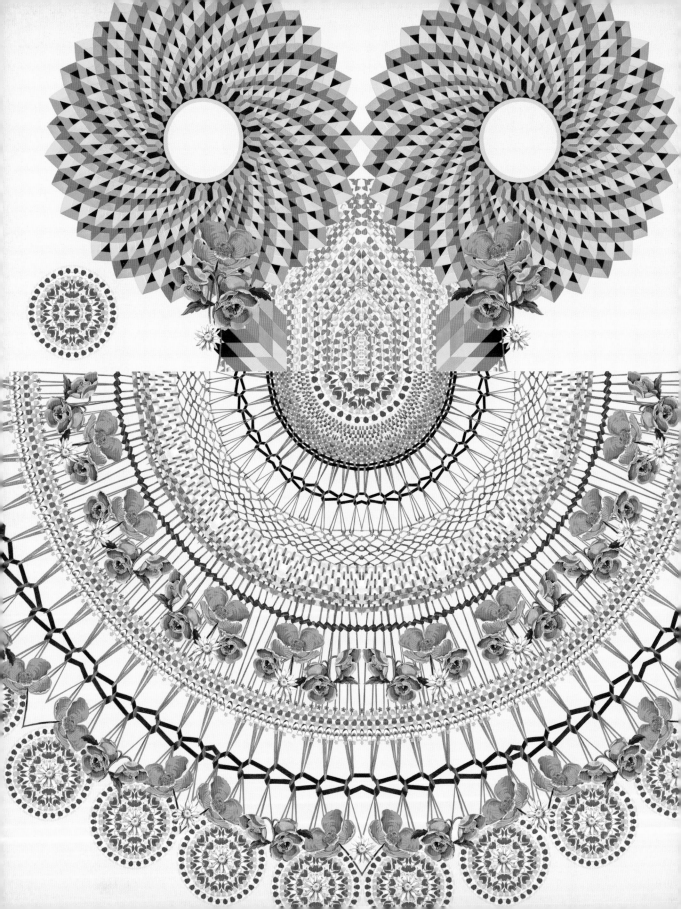

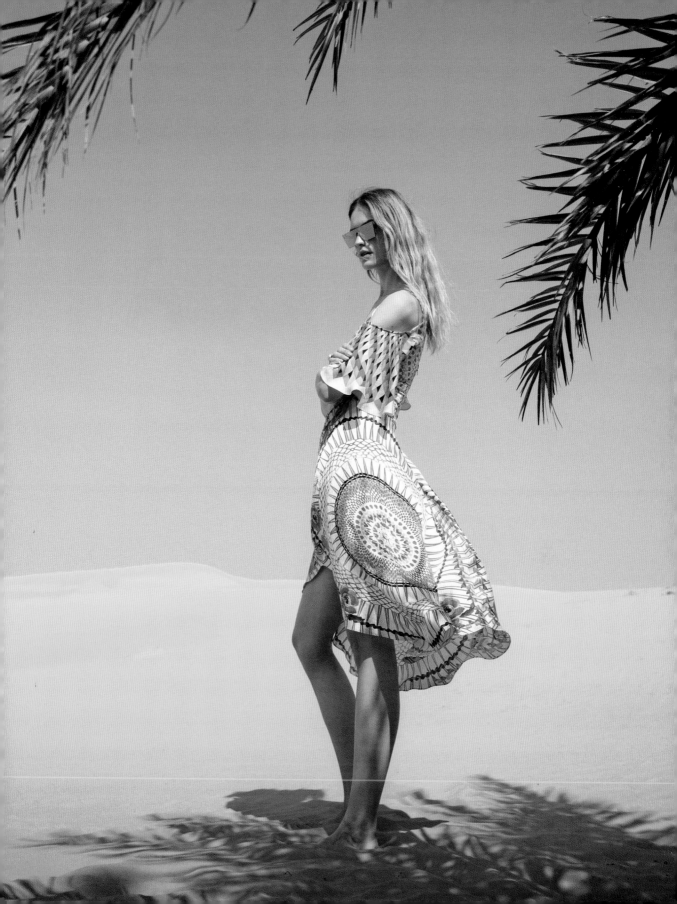

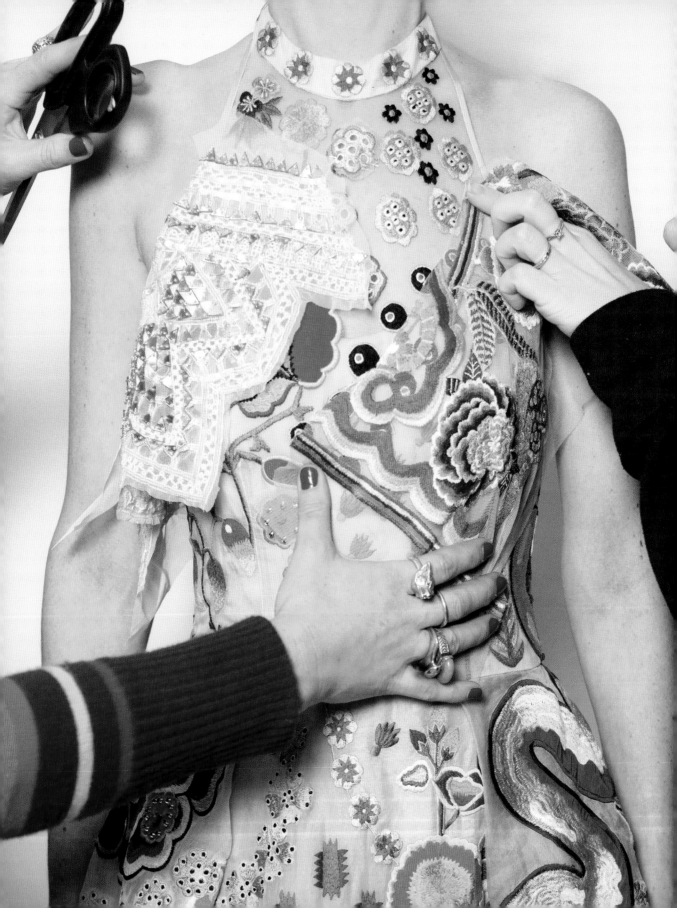

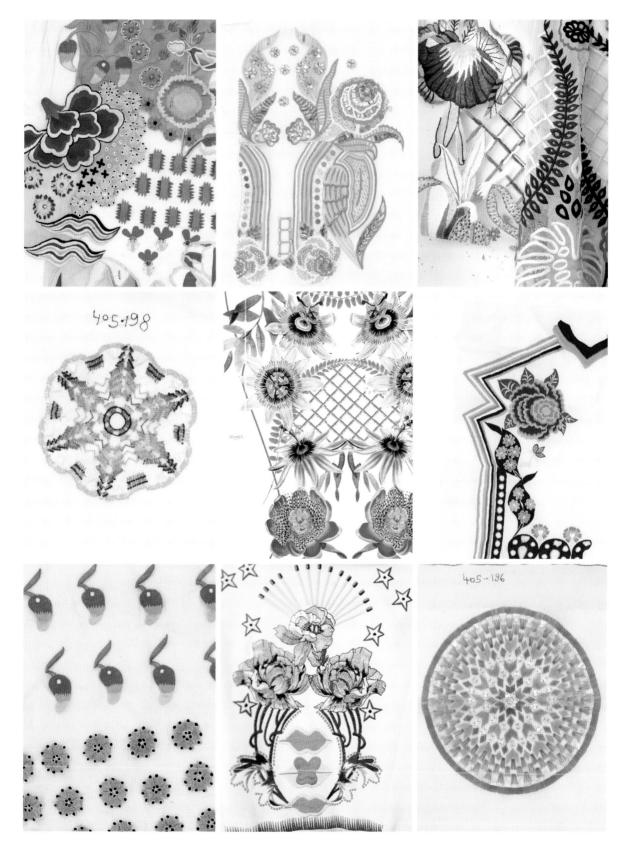

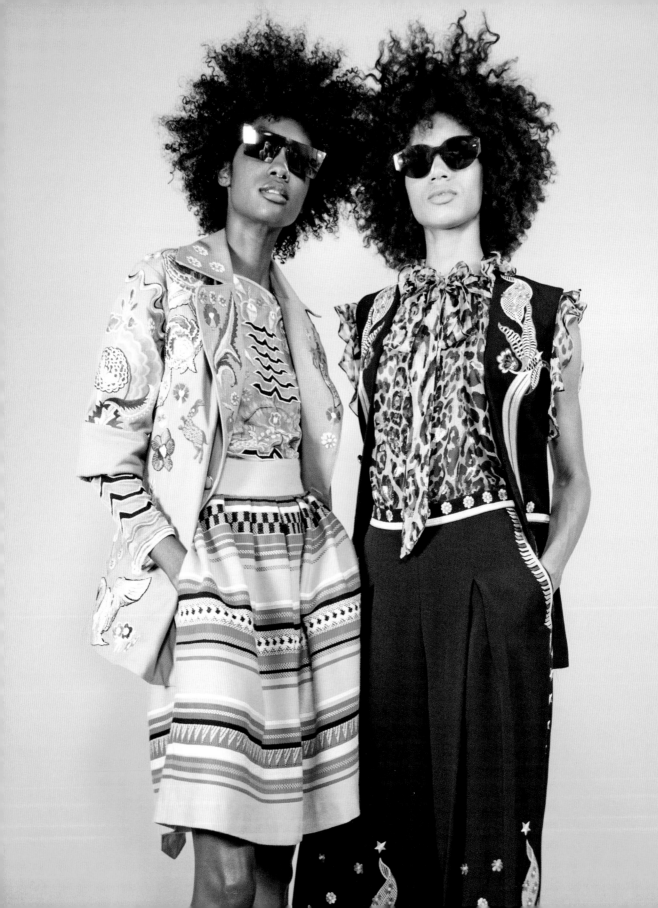

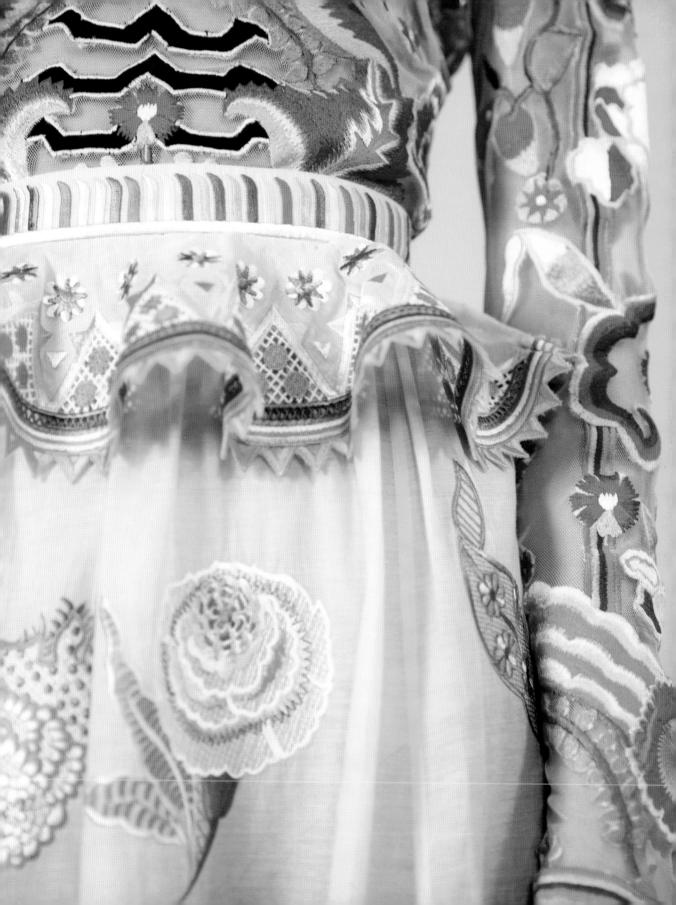

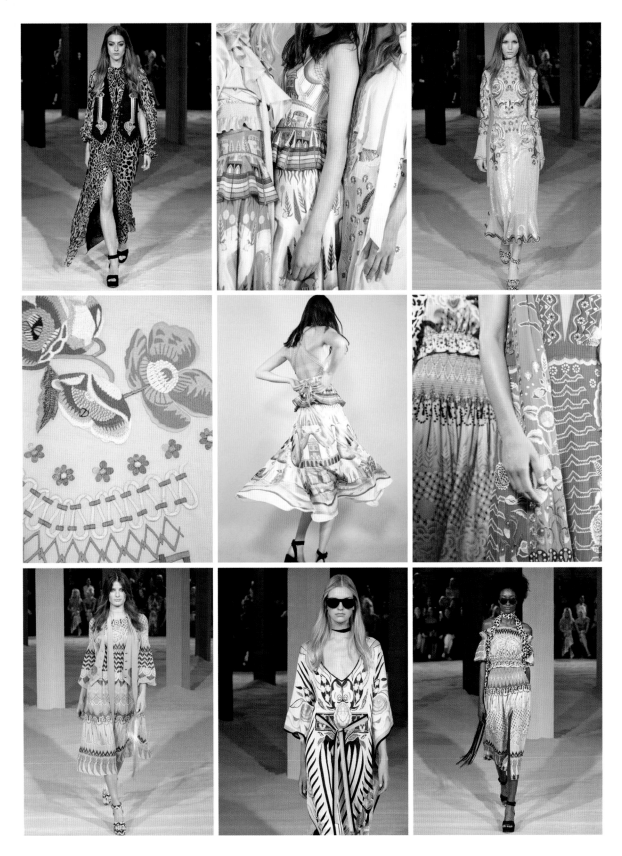

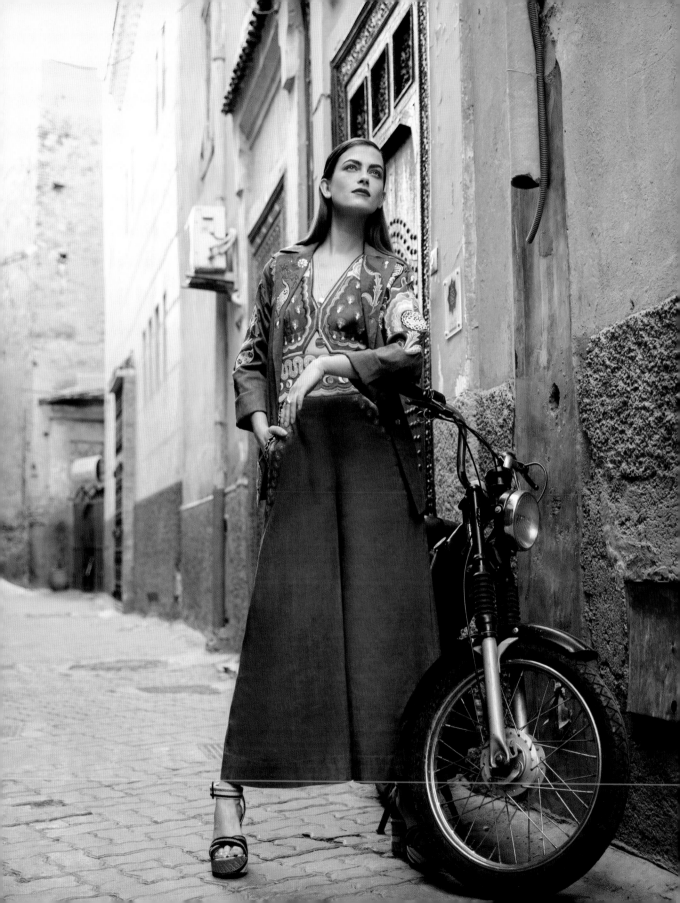

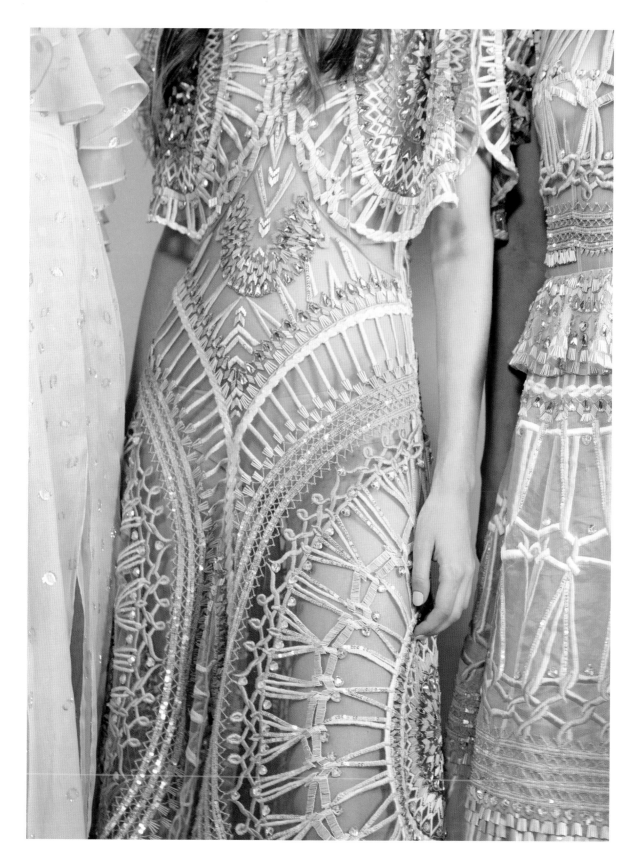

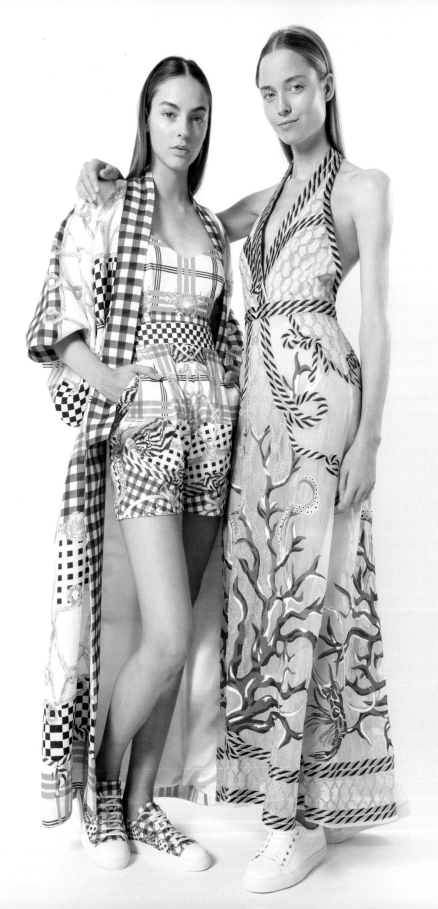

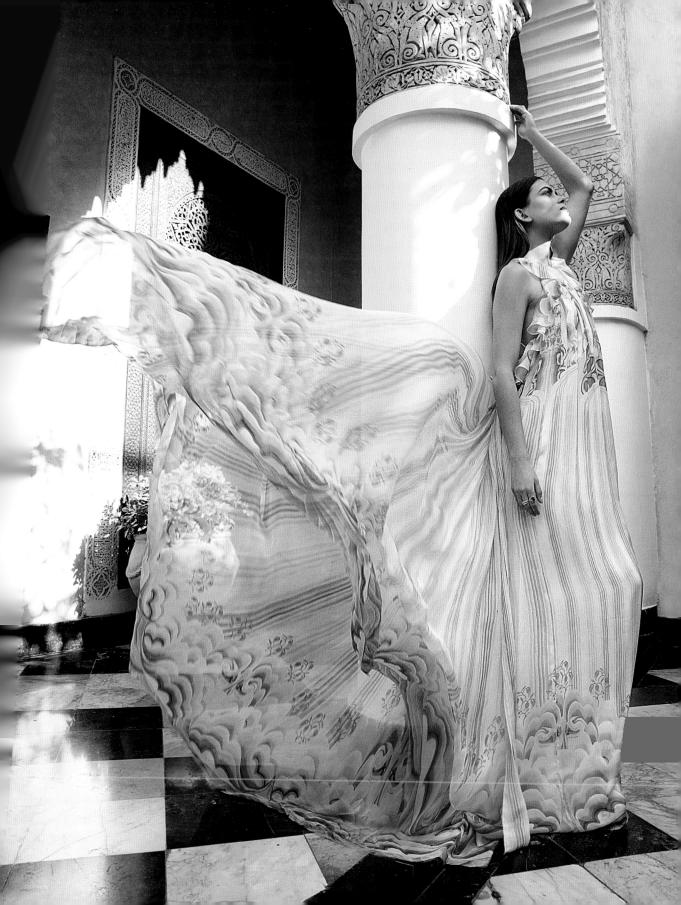

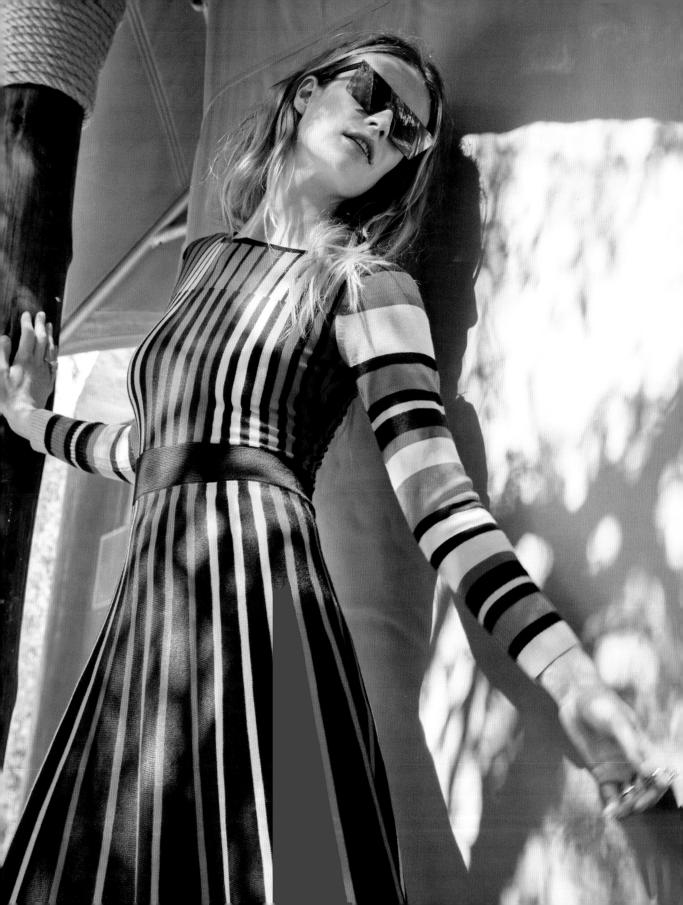

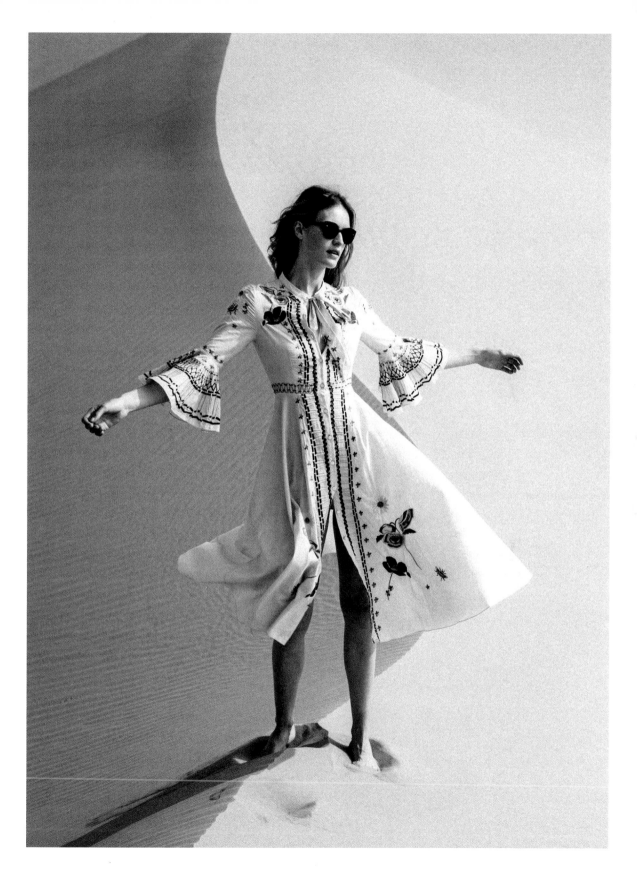

'Where do you come from?' said the Red Queen. 'And where are you going? Look up, speak nicely, and don't twiddle your fingers all the time.' Alice attended to all these directions, and explained, as well as she could, that she had lost her way.

'I don't know what you mean by *your* way,' said the Queen: 'all the ways about here belong to *me* – but why did you come out here at all?' she added in a kinder tone. 'Curtsey while you're thinking what to say, it saves time.'

— LEWIS CARROLL,
THROUGH THE LOOKING-GLASS,
AND WHAT ALICE FOUND THERE (1871)

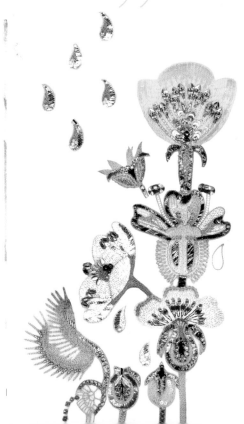

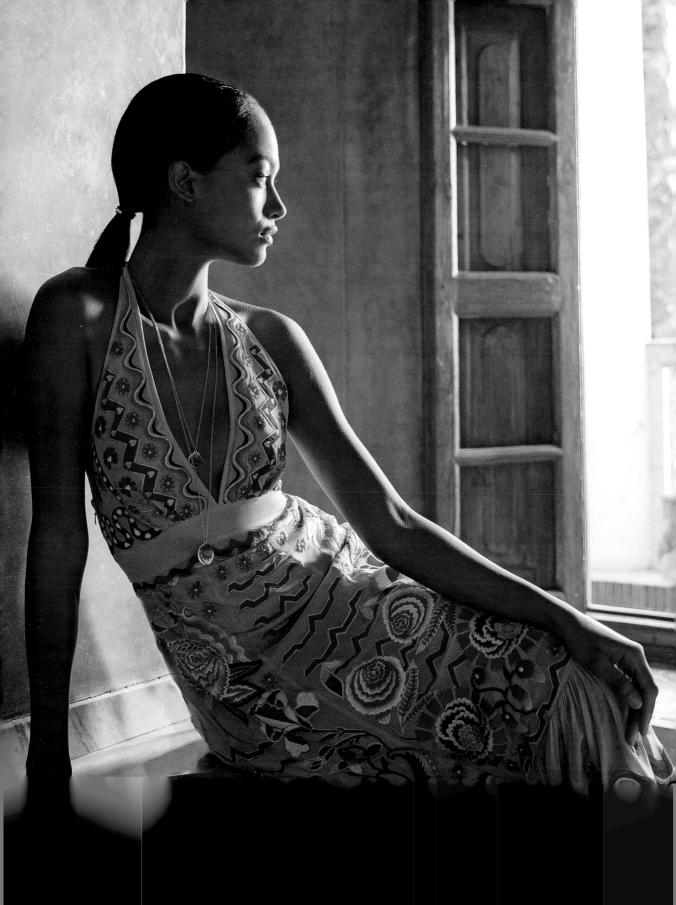

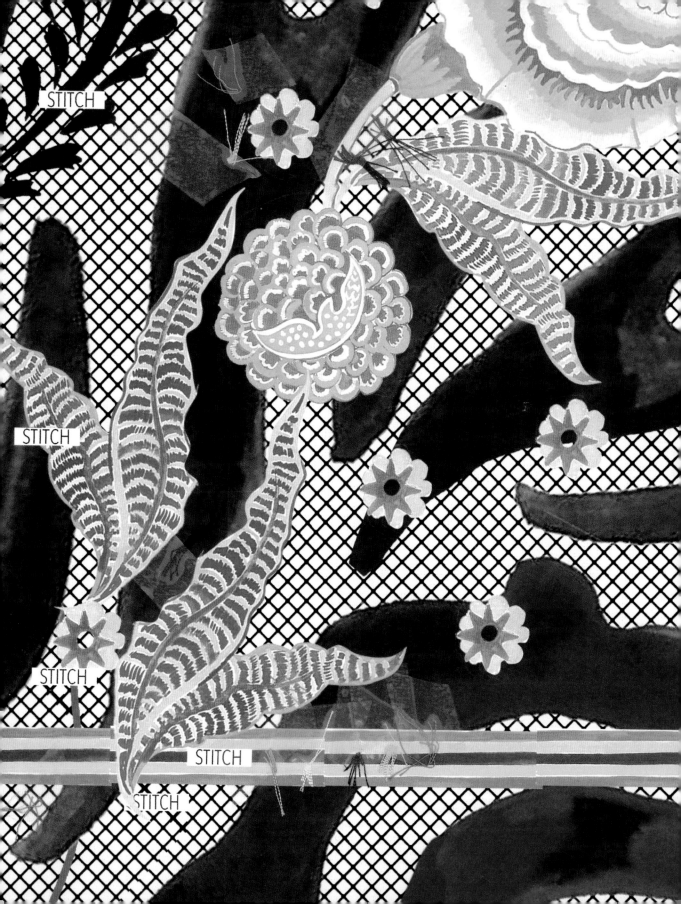

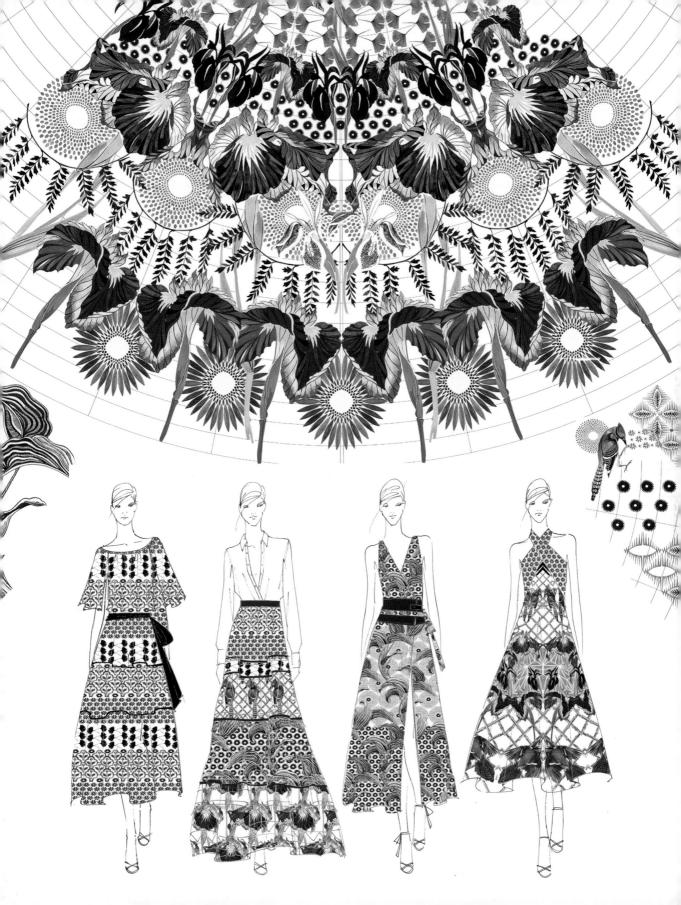

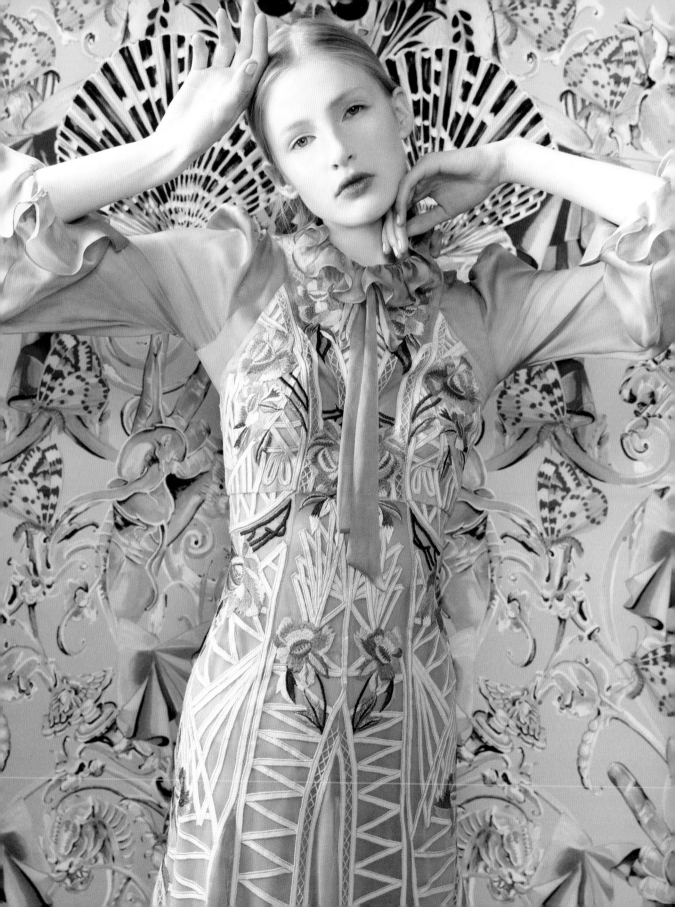

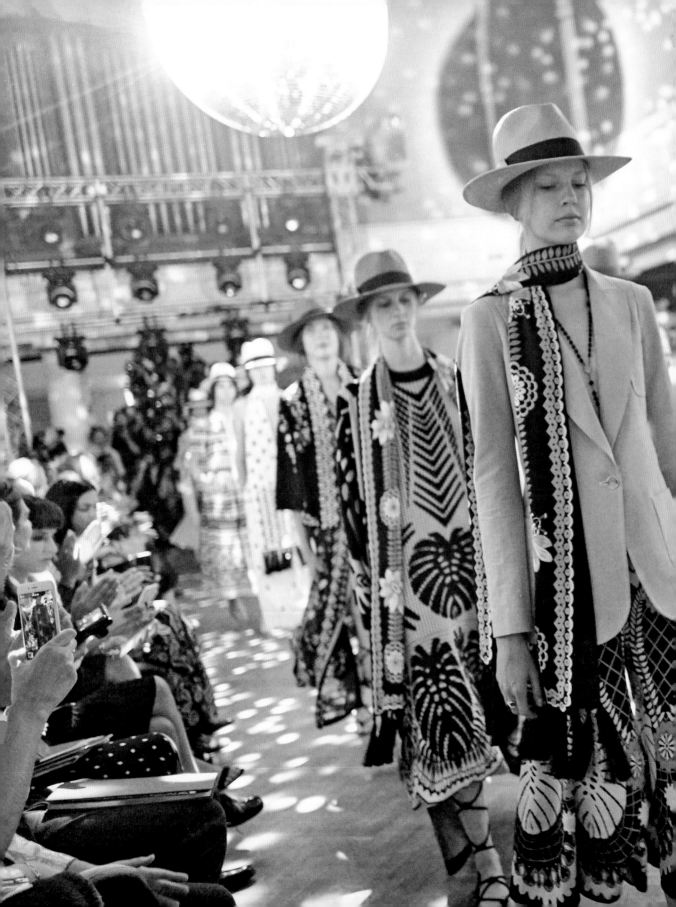

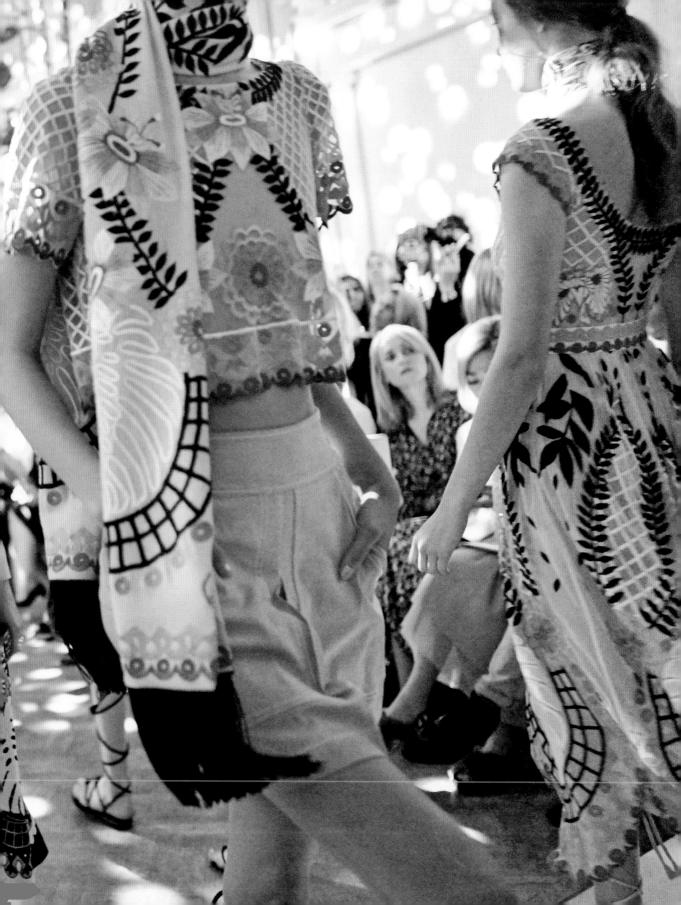

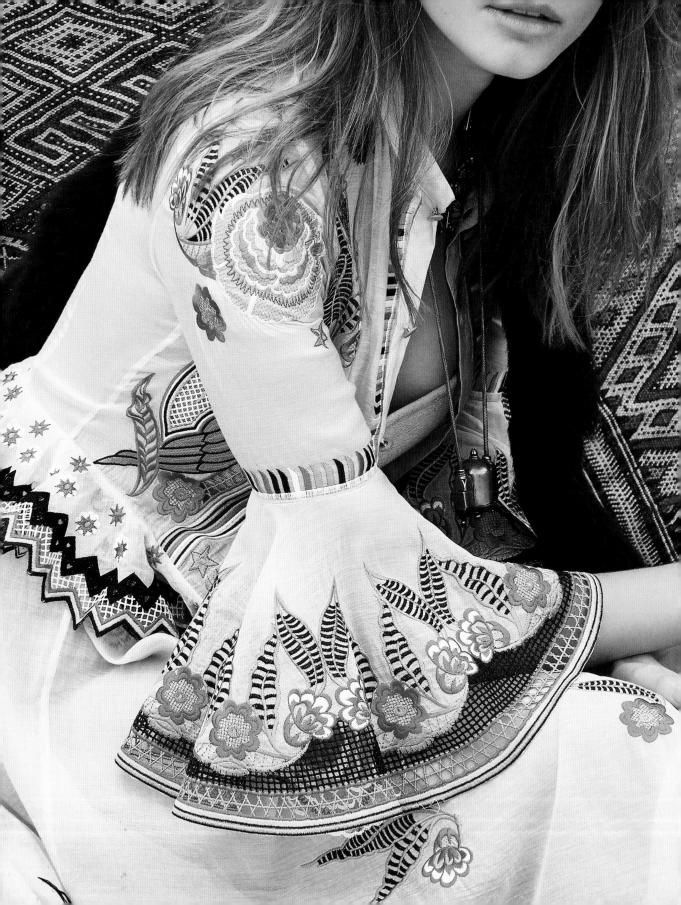

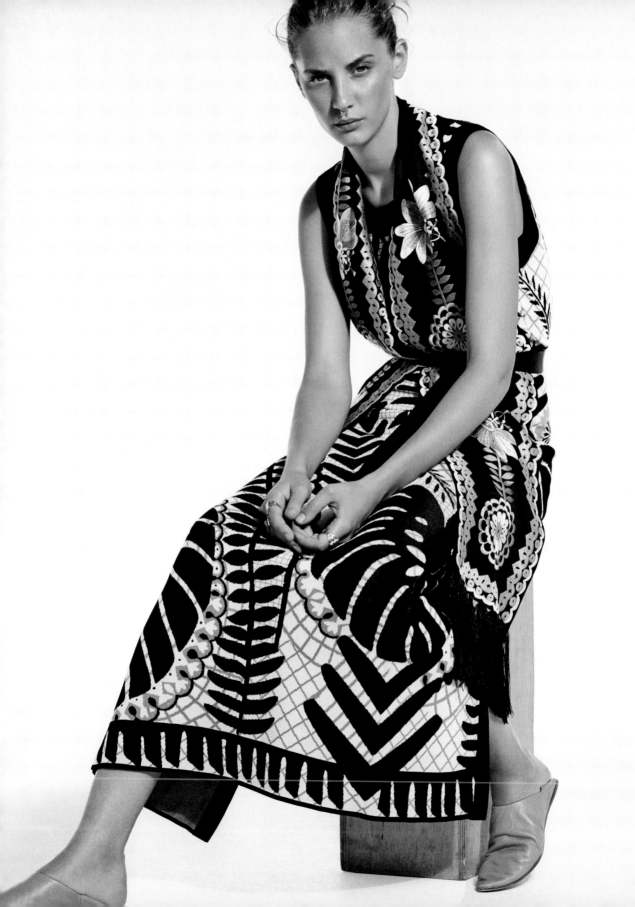

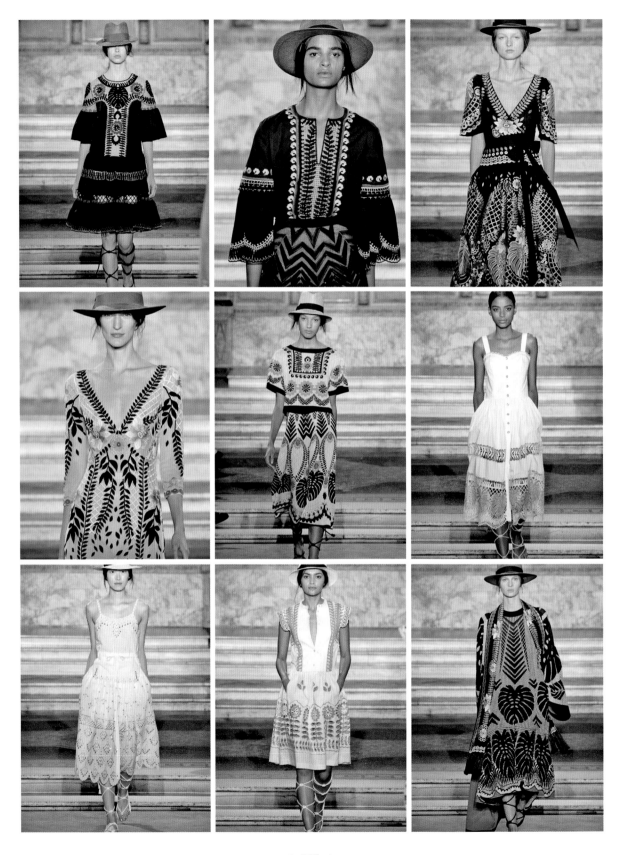

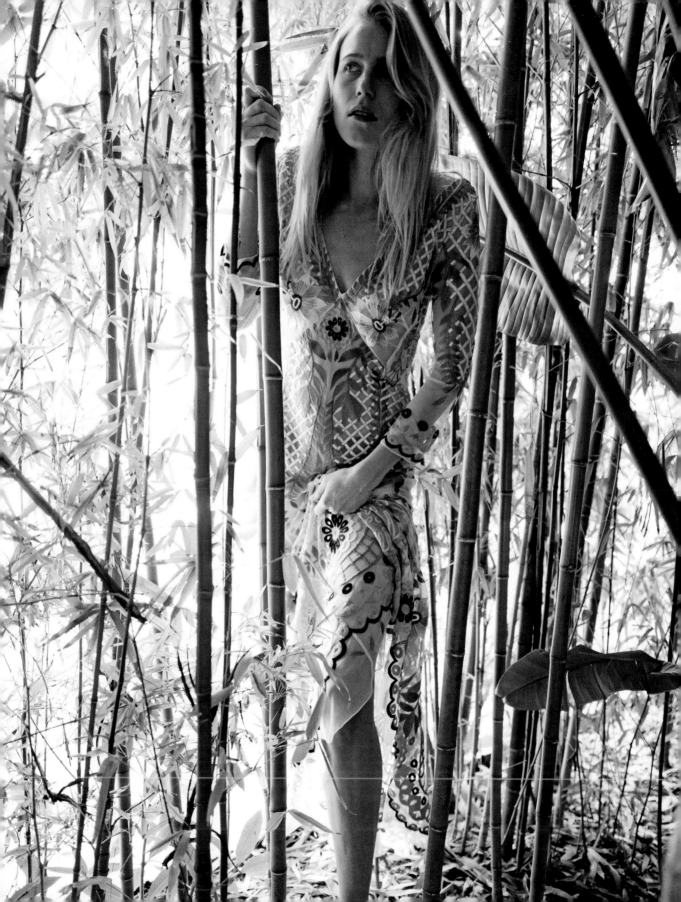

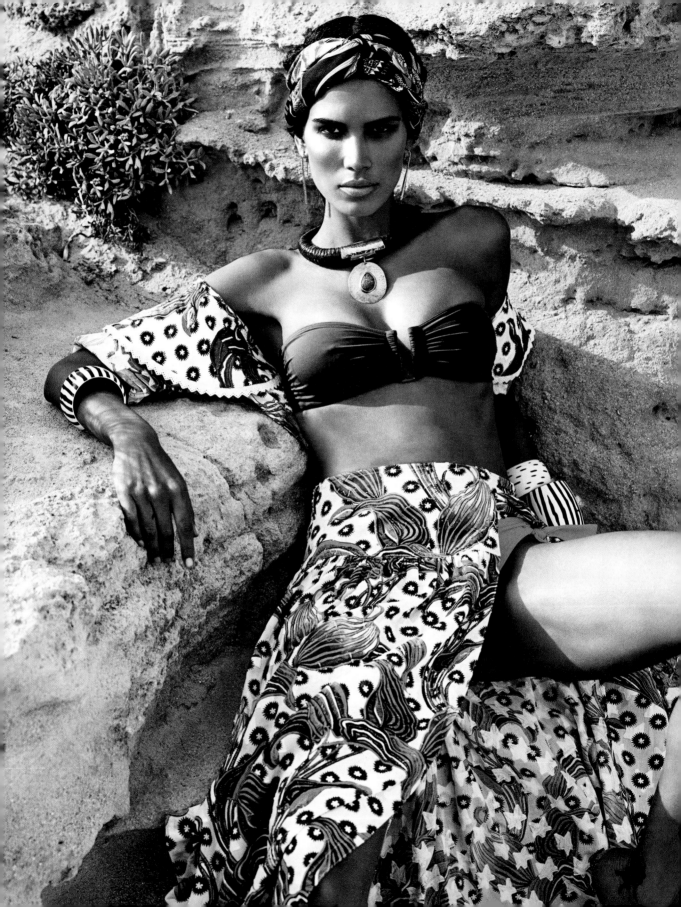

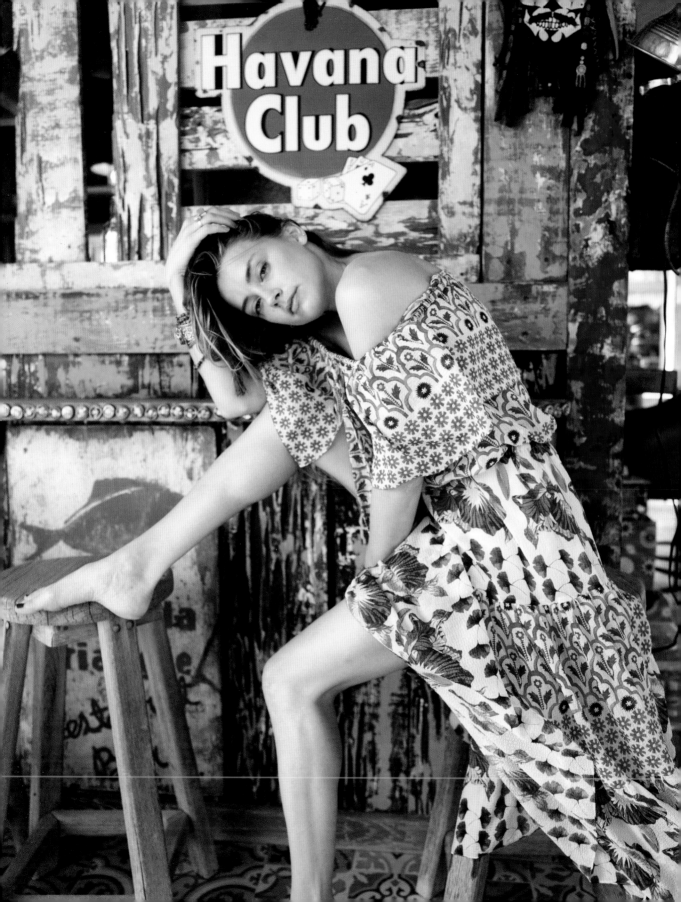

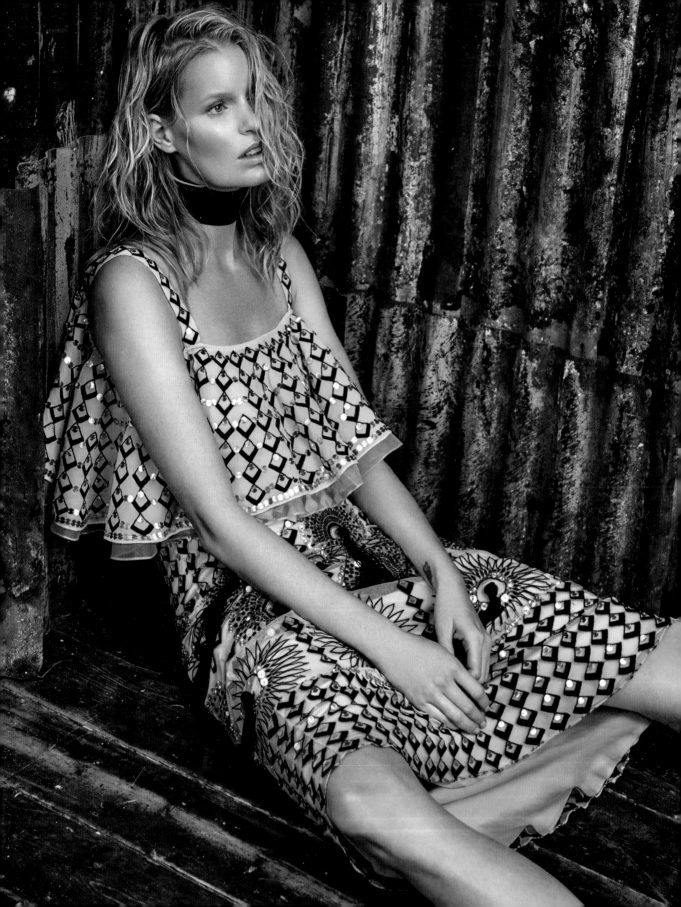

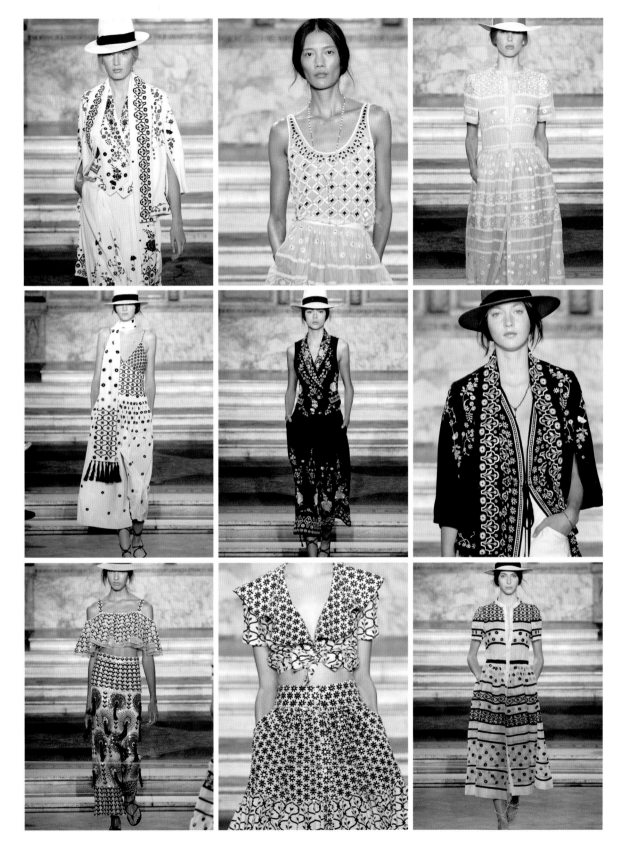

> *To move, to breathe, to fly, to float,*
> *To gain all while you give,*
> *To roam the roads of lands remote,*
> *To travel is to live.*

— HANS CHRISTIAN ANDERSEN,
THE FAIRY TALE OF MY LIFE: AN AUTOBIOGRAPHY

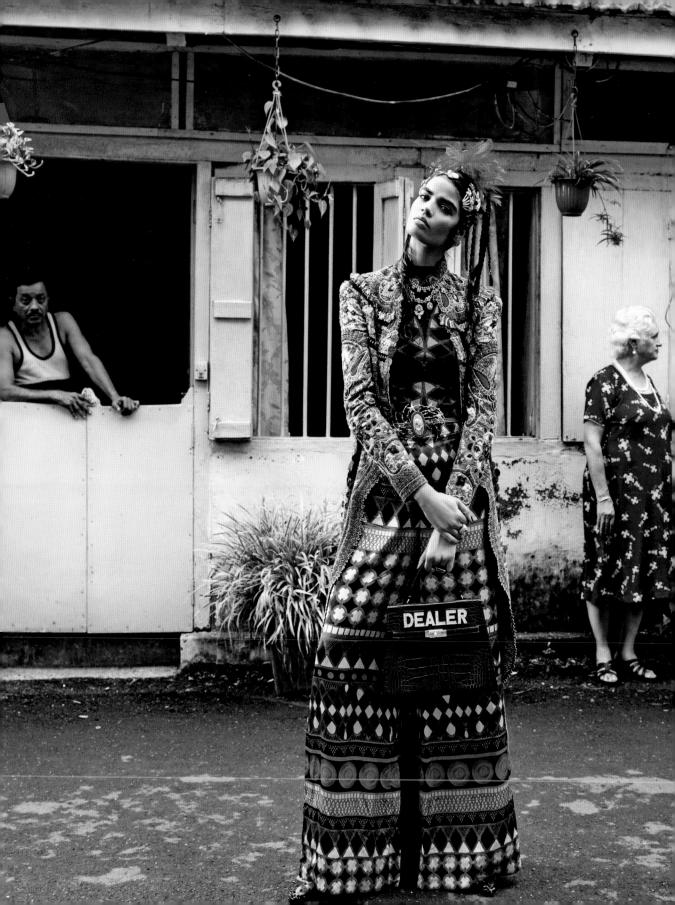

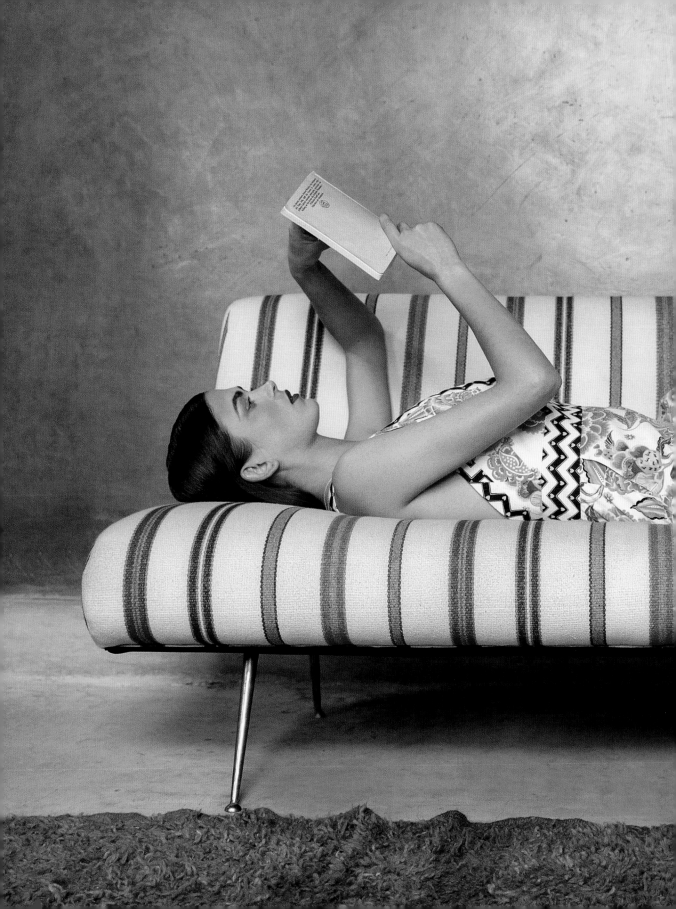

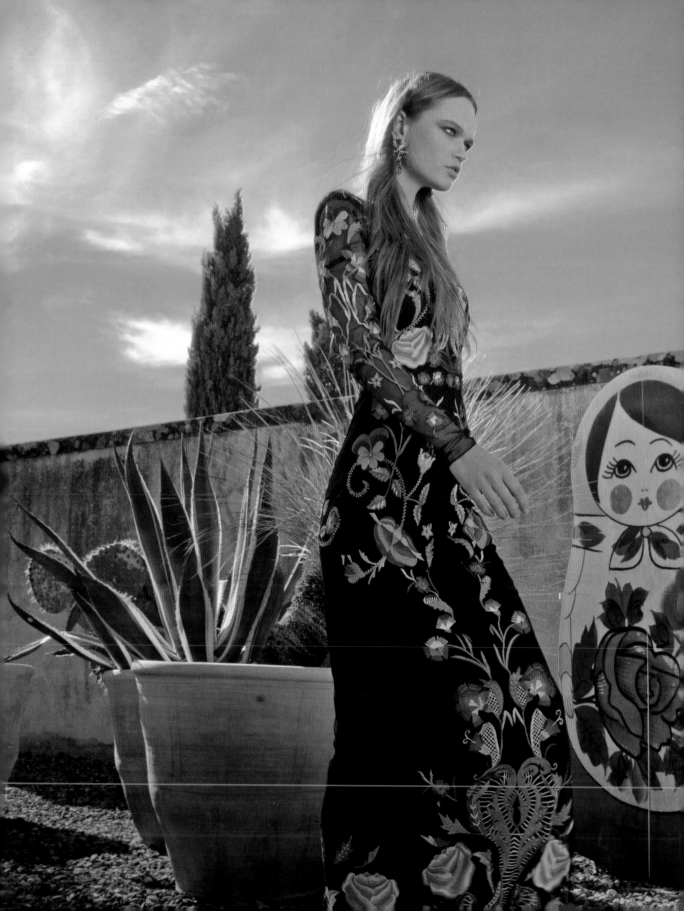

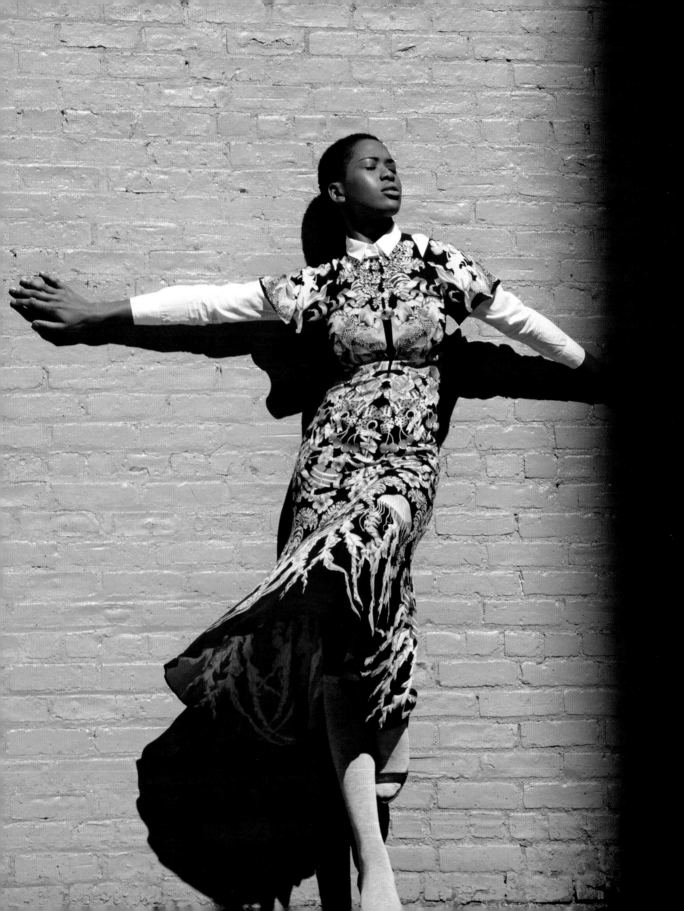

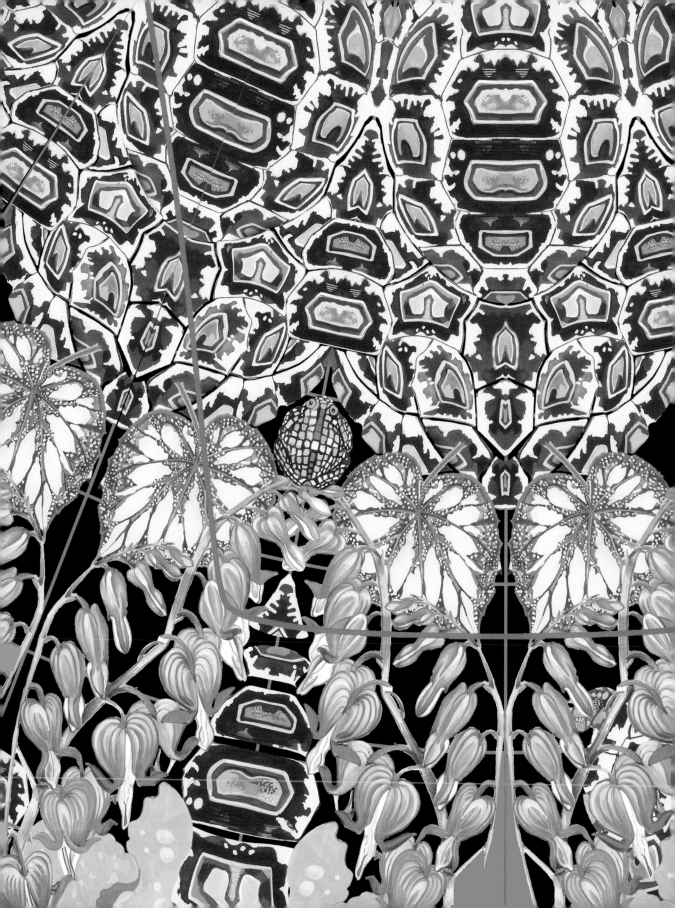

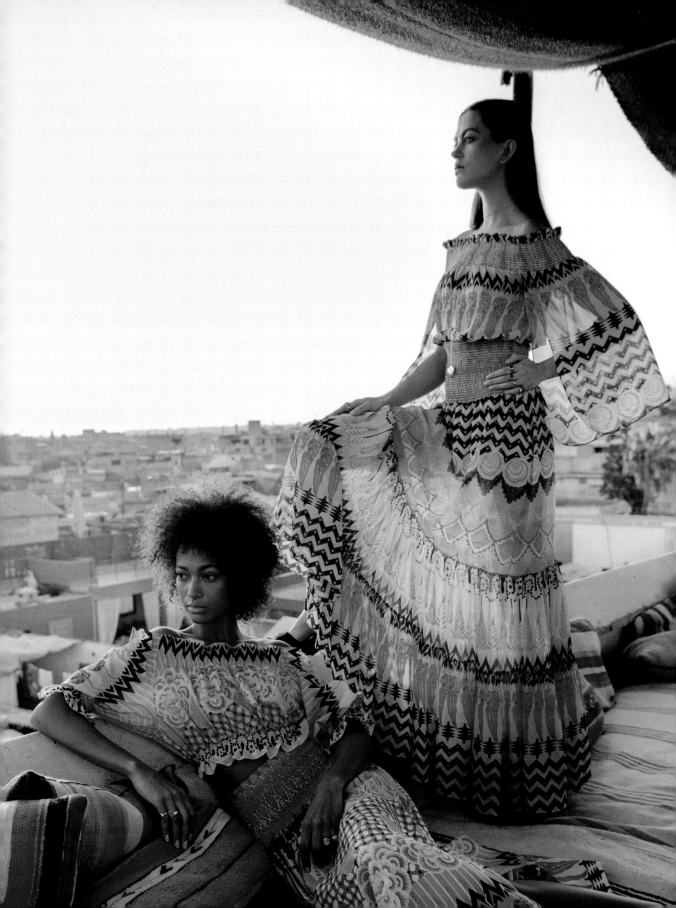

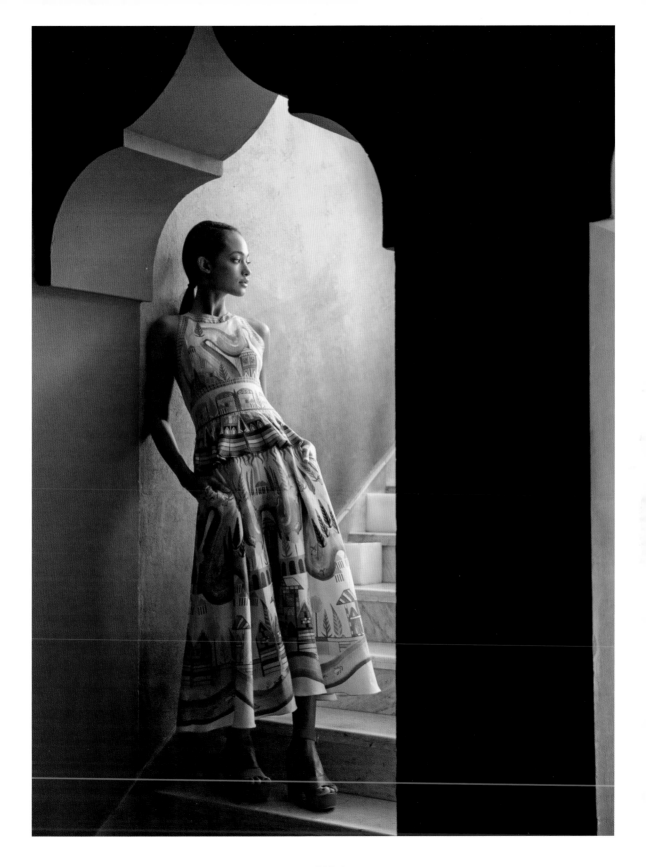

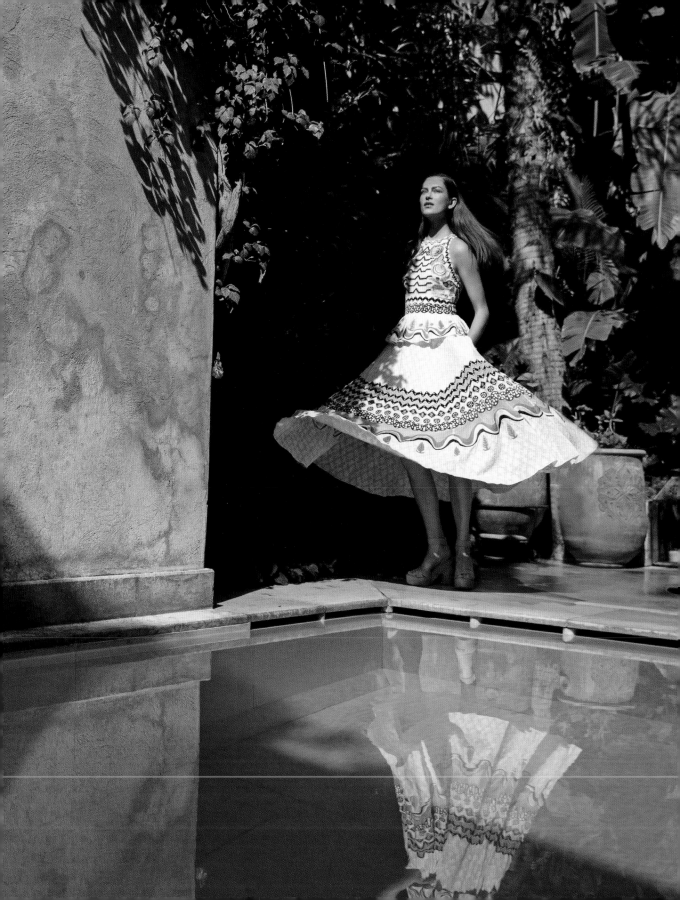

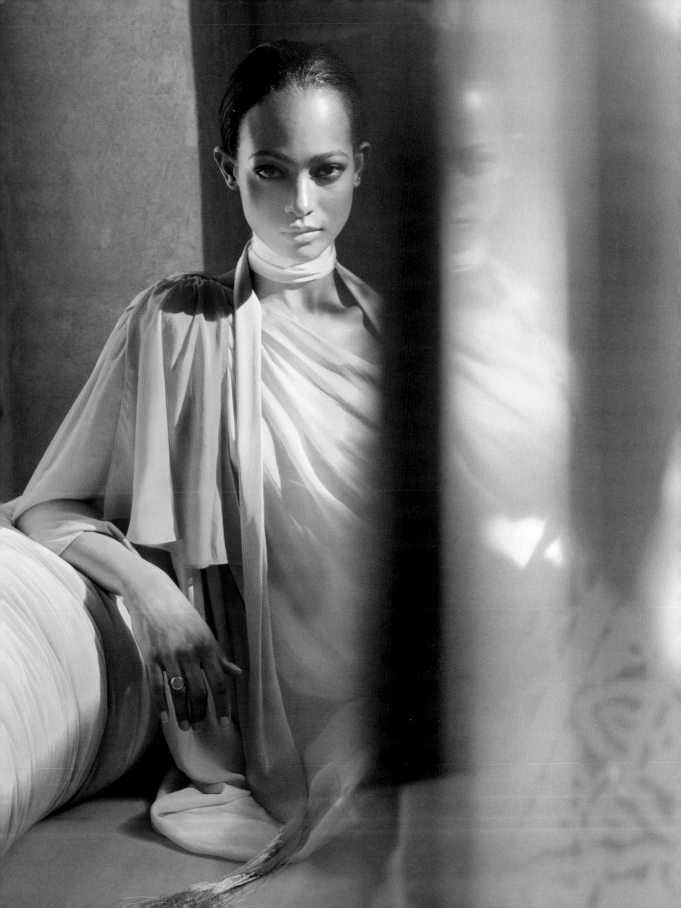

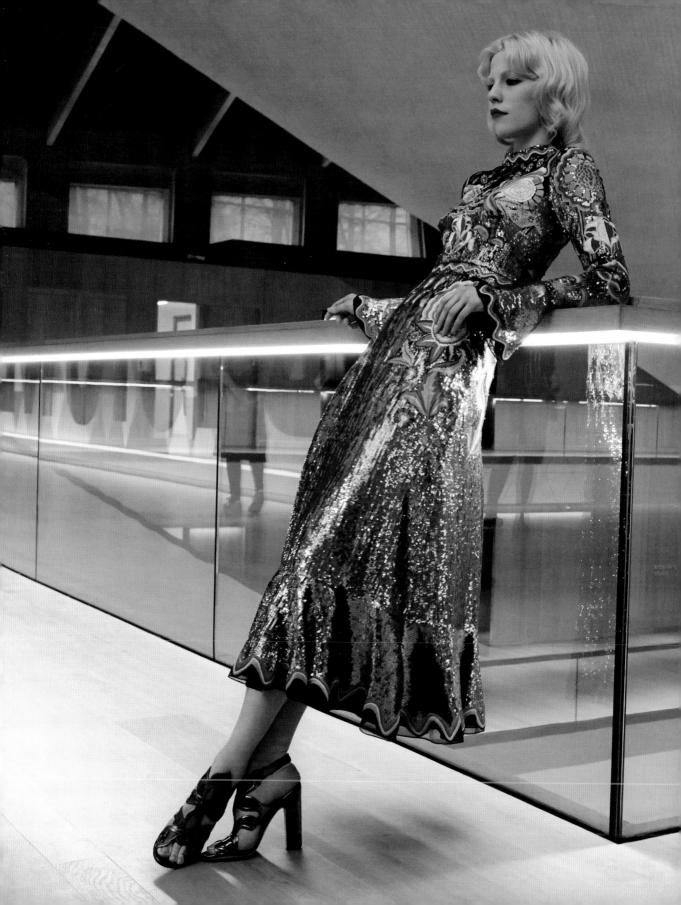

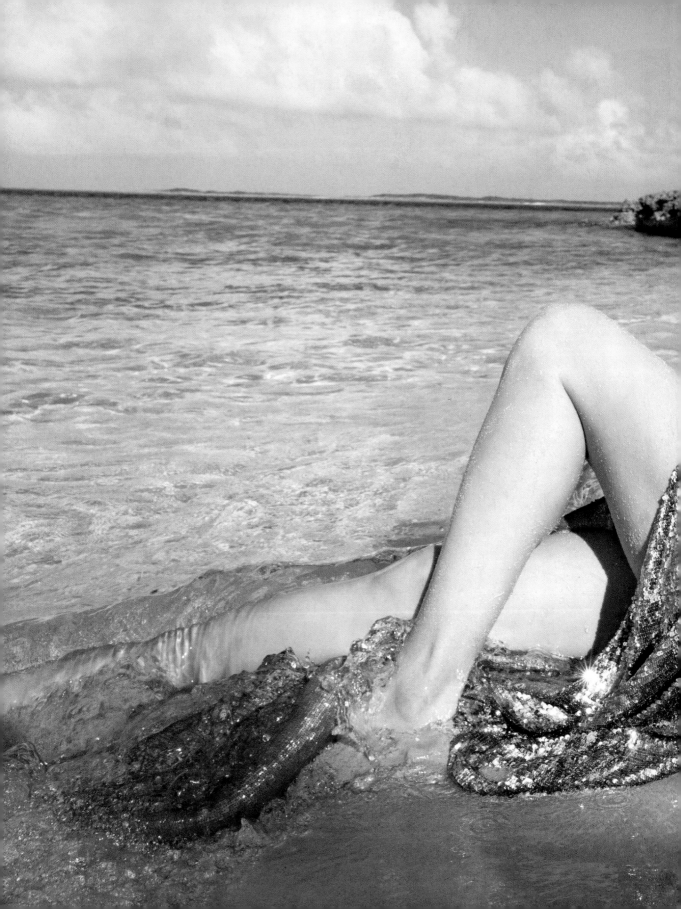

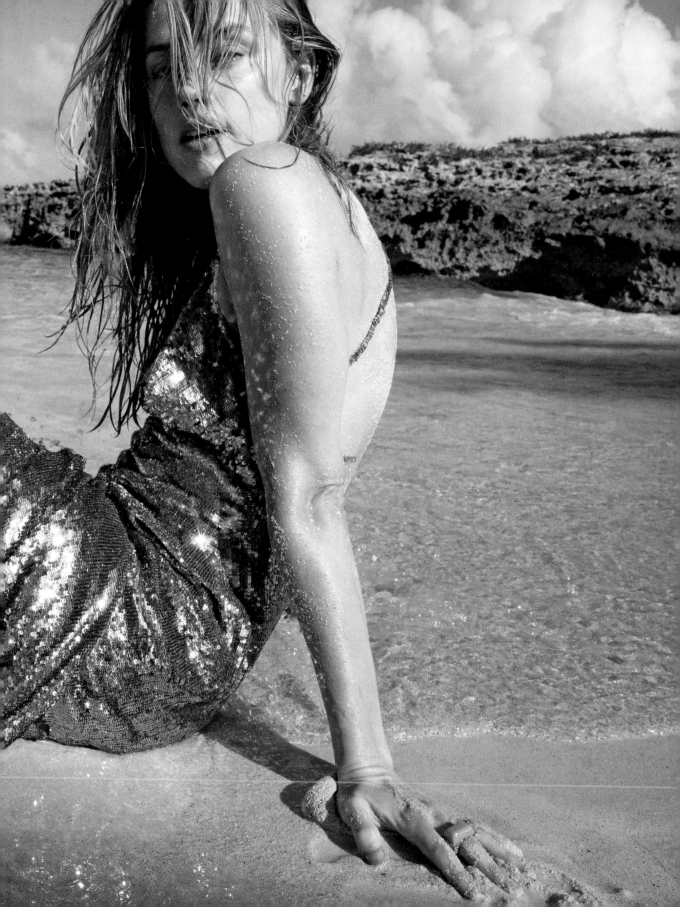

# CREDITS

Wendy Bevan: 202, 313

Kara Chung: 314

Cameron Wilson: 317

Stefan Zschernitz: 321

Greg Swales: 322

Andrea Varani: 330–331

Andrew Yee: 215

Catrine Håland: 74

Photography by Kensington Leverne: 23

Kate Davis-MacLeod : 47

Helen Mildmay-White: 64 (middle centre)

Dima Hohlov: 21,181

Toshio Onda: 185

Benjamin Tietge: 133

Martyn Marler: 106

Jane McLeish-Kelsey: 80 (bottom right), 89, 92

Romeo Mori: 182

William Garrett: 137

Tom Schirmacher/AUGUST: 275

Kate Marin: 329

**Art Direction**

Yossi Fisher: 261

**Model Credits**

Samantha Archibald at Storm Model Management: 10

Sara Witt at Premier Model Management: 10

Victoria Kosenkova at Elite Model Management: 10

Tara Falla at Muse Models: 16

Zoe Huxford at Elite Model Management: 16

Stasha Yathcuk at Elite Model Management: 16

Katya Ledneva at Select Model Management: 16

Lottie Hayes at Supreme Management: 21

Laure Gourlant at The Hive Model Management: 16, 28, 69, 70–71

Claire de Regge at Oui Management: 16, 28, 29, 70–71

Jessica Stam at IMG Models: 30

Dree Hemingway: 33, 309

Florence Koski at Models 1: 38, 63, 127,146–147, 158, 191

Marta Del Cano at Select Model Management: 47

Elinor Weedon at Tess Management: 48–49, 79, 82–83, 139

Laura Dale: 51

Hana Jirickova at IMG Models: 55

Paula Simkuse at Models 1: 61

Santa Urbane at Elite Model Management: 61

Clarice Silva at Next Models: 61

# CREDITS

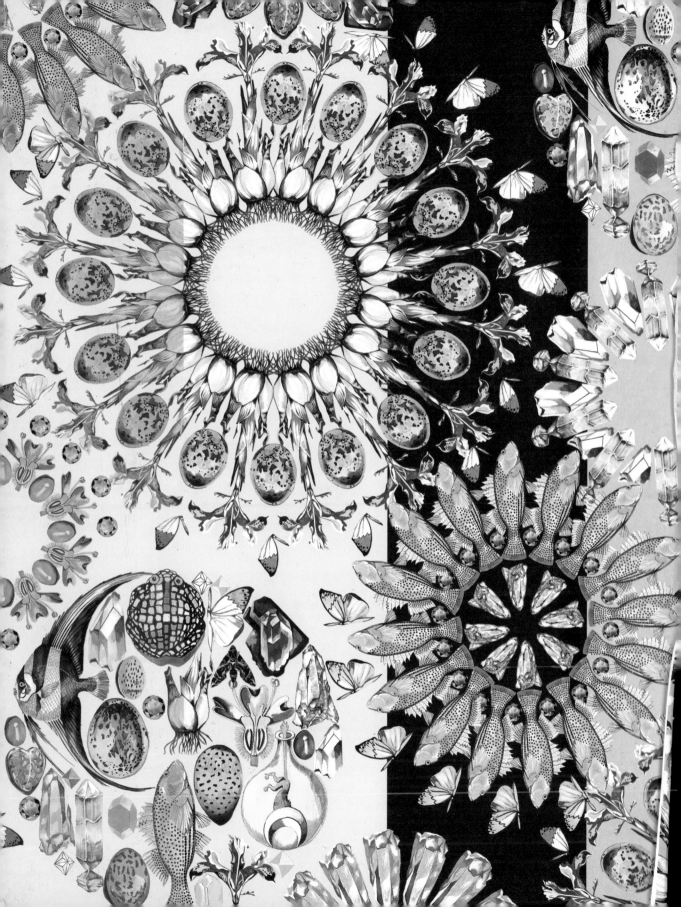